The Collector

THE COLLECTOR
The Story of Sergei Shchukin
and His Lost Masterpieces

NATALYA SEMENOVA
With André Delocque

Translated by Anthony Roberts

YALE UNIVERSITY PRESS
NEW HAVEN AND LONDON

Copyright © 2018 Association La Collection Chtchoukine

Published by arrangement with ELKOST International Literary Agency

For information about this and other Yale University Press publications, please contact:
U.S. Office: sales.press@yale.edu yalebooks.com
Europe Office: sales@yaleup.co.uk yalebooks.co.uk

Set in Adobe Garamond Pro by IDSUK (DataConnection) Ltd
Printed in Great Britain by Gomer Press Ltd, Llandysul, Ceredigion, Wales

Library of Congress Control Number: 2018950320

ISBN 978-0-300-23477-0

A catalogue record for this book is available from the British Library.

10 9 8 7 6 5 4 3 2 1

CONTENTS

CONTENTS

ILLUSTRATIONS

Plate Section

1. Photograph of Sergei Shchukin, early 1890s. Courtesy of Collection Chtchoukine.
2. Photograph of Ivan Vasilevich Shchukin, Sergei's father, 1880s. Courtesy of Collection Chtchoukine.
3. Photograph of Ekaterina Petrovna Shchukina *née* Botkina, Sergei's mother, 1860s. Courtesy of Collection Chtchoukine.
4. Photograph of Lydia Shchukina, early 1890s. Courtesy of Collection Chtchoukine.
5. Photograph of Lydia with her and Sergei's children, 1890s. Courtesy of Collection Chtchoukine.
6. Photograph of the Shchukin family in Egypt, January 1906. Courtesy of Collection Chtchoukine.
7. Photograph of the Trubetskoy Palace in early 1914 by Pavel Orlov. Courtesy of Collection Chtchoukine.
8. Photograph of the music room in early 1914 by Pavel Orlov. Courtesy of Collection Chtchoukine.
9. Photograph of the music room in early 1914 by Pavel Orlov, colourized by Christine Delocque-Fourcaud. Courtesy of Collection Chtchoukine.

Illustrations in the Text

A NOTE ON THE TEXT

The system of transliteration adopted in this book is based on the Permanent Committee on Geographical Names (PCGN) system; however, for the sake of readability, certain elements have been further simplified (for example, no hard/soft signs), and names more familiar to readers in a different form have not been changed.

Dates in the book are complicated by the switch in calendars in Russia in the early twentieth century. In the nineteenth century there were twelve days' difference between the Orthodox Julian calendar used in Russia, and the Gregorian calendar that had been used in Europe and the rest of the world ever since Pope Gregory XIII's reforms in 1582. This increased to thirteen days in the twentieth century. The Gregorian calendar was adopted by Lenin's government on 31 January 1918, at which point the following day officially became 14 February. In this book, therefore, unless otherwise specified, dates regarding matters in Russia before 1918 are given in the Old Style, and thereafter and elsewhere in the New (Gregorian) Style.

Finally, the notes found at the end of the book are highly informative, containing much more than merely textual and bibliographic references. The interested reader is encouraged to consult these at their leisure.

PREFACE

I first met André Delocque, the grandson of Sergei Ivanovich Shchukin, in 1990, on a park bench in Moscow. At that time the Soviet Union was steadily falling apart; there were no café terraces where you could sit and enjoy the sunshine; if you wanted a table, you had to join the queue outside one of the dilapidated canteens, where there was practically nothing to eat or drink.

This was how André and I came to be sitting together beside Patriarchs' Pond, where so many famous Russian narratives have begun. Very soon we were dreaming that together we could resurrect the name of Sergei Ivanovich Shchukin, the earliest important patron of Matisse and Picasso and the first great collector to conceive a museum of modern art.

I related how, many years earlier, when independent research into the history of art was still forbidden in the Soviet Union, the first 'Shchukinists' had appeared on the scene.

Alexandra Demskaya, who in the 1950s was in charge of the manuscripts department at the Pushkin State Museum of Fine Arts, was the first to take an interest in the forgotten life of Sergei Shchukin. By 1960, the study of the history of capitalist merchants and entrepreneurs of the nineteenth century had ceased to present a risk to Soviet academic careers; and so, for the rest of her life, Madame Demskaya fought to shed light, in

general, on the mysterious treasure trove of modern art on public view beneath the vaulted ceilings of the Pushkin Museum; and in particular, on the astonishing intuition of Sergei Shchukin, who had assembled his collection half a century earlier.

The first thing she found was a magnificent album of photographs of the interior of Shchukin's Moscow palace, taken in 1914. Later, researching the memoirs of Muscovites of the period, she discovered a niece of the collector still occupying one room of the spacious flat that had formerly belonged to her parents and which was now occupied by a dozen different families. Using the Moscow telephone directory, she unearthed Georgy Gordon, son of Professor Gavriil Gordon. Gavriil was a high official in the Soviet administration in the early 1920s, who had been close to Ivan and Ekaterina, the children of Sergei Shchukin, and had lived with his family in Shchukin's palace before his arrest during Stalin's purges in the 1930s. Gavriil Gordon did not return from the gulag. His family, having been expelled from the Shchukin palace, nevertheless contrived to salvage a few letters, documents and photographs from the wreck of his life.

Georgy Gordon, impressed by the dogged tenacity of Madame Demskaya, was able to produce extracts from the memoirs of his father, as well as a priceless fragment of Sergei Shchukin's private diary for October–December 1907. These few stray pages telling of the collector's forlorn voyage through the Sinai desert became the most important document in the Shchukin archive, as it slowly came together.

Madame Demskaya tracked down other contemporaries and descendants of Shchukin, and with the information she gleaned from them managed to assemble the first Shchukin foundation. In 1971, I was assigned to help with this work. Unexpected assistance also arrived from the USA, in the form of Beverly Whitney Kean, a 1950s Hollywood star. Mrs Kean was temporarily at a loose end, with plenty of money and no particular project on which to concentrate. While visiting Moscow and Leningrad, she was amazed by the rich modern art collections held by Russian museums. She was even more amazed that nobody could tell her anything about the provenance of the extraordinary works she was seeing. Mrs Kean decided to solve the problem herself, and before long, like Madame Demskaya, she fell under the spell of the shadowy Sergei Shchukin.

In the 1970s, following a period of intense research, she tracked down and interviewed all of the great collector's surviving family: his son, Ivan Shchukin, in Beirut; his eldest daughter, Ekaterina, in Le Lavandou, France; and his younger daughter, Irina, in Paris. Next, Mrs Kean won the backing of Alfred Barr, the founder in 1933 of the second greatest repository of modern art in the world after that of Moscow: the Museum of Modern Art in New York (MoMA).

Under Barr's auspices, she was able to interview the son and daughter of Henri Matisse, as well as many other figures of importance to her research on Sergei Shchukin. This investigation eventually led to Kean's 1982 publication of *All the Empty Palaces*, dedicated to the lives and careers of the great Russian collectors. Marred though it is by chronological errors, *All the Empty Palaces* fairly crackles with sincerity and emotion.

In 1988, I visited Alexandra Demskaya, who was then close to retirement. Demskaya asked me to help her write a book about Shchukin and gave me two wooden filing cabinets containing her catalogue sources related to Russian collectors, which she had patiently assembled over many decades, but which represent only a fraction of Shchukin's archive.

The process of uncovering the mystery of the Shchukin collection was in many ways similar to an archaeological dig, inasmuch as successive strata were slowly brought to light by the combined study of history, art, and family myths and legends passed down by children, grandchildren and contemporaries. Moreoever, the assorted letters, descriptions and memoirs that survive are sketchy to say the least. Methodically and patiently, I delved into the past until I had assembled a vast body of material, enough for several books.

Along the way, I relived the personal tragedies of Shchukin. I accompanied him during his crossing of the Sinai desert on camelback; I stood beside him at the Salon d'Automne and at the Salon des Indépendants in Paris; I followed his negotiations with the great art dealers of Paris – Paul Durand-Ruel, Ambroise Vollard, Clovis Sagot, Josse and Gaston Bernheim, Berthe Weill, Eugène Druet, Daniel-Henri Kahnweiler. I was present at the fairs of Nizhny Novgorod, the annual rendezvous of the *kupechestvo*, the class of Russian merchants who, in the nineteenth century, were responsible for the industrial transformation of Russia. I visited Greece,

Turkey, Egypt and India. And I did all this without leaving Moscow – sorting through Sergei's letters to his brother, his journal of his expedition to the Sinai desert and his correspondence with Henri Matisse. I captured every faint echo that remained of the voice of Sergei Shchukin. And beyond all this, I combed the Russian and French newspapers of the time, as well as the myriad notes and manuscripts and souvenirs and books of Shchukin's contemporaries.

My biographies of Shchukin have been published in Moscow, in Russian: they are *Shchukin's House on Znamenka Street*, written in collaboration with Alexandra Demskaya in 1993; *The Life and Collections of Sergei Shchukin* (2002); and *The Shchukin Mystery* (2010). These three volumes have been abridged, adapted and expanded to form the present single volume by André Delocque.

He, born in 1942, knew next to nothing about the art collection of his grandfather, who died in 1936. As a child, he was told that his grandfather was rich and powerful, until a mysterious horde of blackguards called *bolsheviks* took control of Russia and drove his family into exile. He also knew that Sergei Shchukin had possessed a beautiful collection of paintings, notably by Picasso, then considered to be the world's greatest living painter. Later, as director of cultural institutions and museums (cinema, literature, comic strips, aviation), André Delocque – unsurprisingly – steered well clear of paintings.

Nevertheless he was born and raised in the family and entourage of Sergei Shchukin. His infancy and his introduction to the world took place in the spacious Paris apartment of the great collector, whose widow, his grandmother, kept it just as it was when Sergei was alive. The atmosphere, conversation and way of life within its walls had barely changed at all.

André Delocque grew into a quintessential Frenchman in the France of the 1960s and 1970s, leaving his Russian childhood behind him. But the fateful encounter with me in 1990 brought everything back in a rush. I took him to the Moscow quarter, which is the setting for so much of the story told here. Night had fallen on Znamenka Street, which leads through to the Kremlin. We turned right into Bolshoy Znamensky Lane and stood before the quiet two-storey house with its classical pediment, surrounded by trees – and André fell under its spell.

There followed a fruitful partnership: my research has enabled André to comprehend more fully the figure of his grandfather, the collector, at work, while his childhood memories have made up for the deficiencies in the archival material and have helped to give form and substance to the man who was Sergei Shchukin. The twenty-five years of Shchukin studies we have shared has culminated in a great exhibition at the Louis Vuitton Foundation in Paris and the book you hold in your hands. This represents nothing less than the total rehabilitation of one of the greatest collectors of art the world has ever seen, whose memory had been deliberately strangled, buried and forgotten eighty years before.

<div align="right">Natalya Semenova
May 2018</div>

Prologue

Yesterday evening, we went to the Shchukins' to view their collection of paintings. I was able to see Monet's *La Cathédrale de Rouen le Soir*, his seascape, and lots of other things by Brangwyn, Renoir, Degas, Cottet, Carrière and Whistler; and finally a picture by Puvis de Chavannes himself, *Le Pauvre Pêcheur*. I was filled with joy. My heart was ready to burst with the triumphant truth of what my eyes were seeing. I was transfixed. It was an odd, contradictory feeling . . . by the end I was shaking like a leaf, or like someone with a high fever. There were so many impressions that were new to me . . . The house itself is very interesting; it is two hundred years old, with original decoration by an artisan who worked on the restoration of Versailles. I forgot that I was in Moscow and so was completely stunned when I stepped back into the black, thawing mud of Znamensky Lane. The impressionists whose works I had seen at Shchukin's had penetrated my very soul . . . I can no longer ignore their quest for beauty, nor continue to be blind to what they have seen.[1]

This description, dated 11 February 1903, comes from the journal of Margarita Sabashnikova, who was deeply moved by what she saw at the Trubetskoy Palace, Sergei Shchukin's home at the time. It was her first

1

encounter with impressionism. Margarita was markedly less enthusiastic about the man who had collected the pictures:

> The master of the house was polite, lighting this or that chandelier whenever necessary and explaining the different merits of his pictures. He resembled a crafty *maître-d'hôtel*, with white hair carefully combed over his brow and little eyes like mice popping from their holes. There was a strange contrast between his very refined understanding of art, the choice and nobility of his paintings, and his prosperous farmer's manner.[2]

Indeed, 'strange contrasts' and unanswered questions have surrounded the name of Sergei Shchukin. His history, until now, has remained a secret.

How was it that a Muscovite merchant plying his trade in manufactured cloth, a man whose entire life was completely foreign to that of European art, managed to penetrate to its absolute heart? How did this descendant of a simple shopkeeper come to buy so many out-and-out masterpieces and dare to bring home a canvas by Matisse teeming with naked human bodies?[3] From whom did he acquire an intuition so powerful that it shook the conformism of most of the world's artists, historians and critics to its very foundation? How was it that he acquired the works of Gauguin, Cézanne, Matisse and Picasso at a time when such works aroused at best indifference, and at worst sarcasm and outrage in the country where they were painted, exhibited and offered for sale?

Fortunate are the biographers of writers and poets who have rough drafts, journals and correspondence to which they can turn for reference. Sergei Shchukin, by contrast, was a figure who left nothing behind him but a few postcards, a correspondence with Matisse, a dozen letters to his brother and fifteen pages of a private diary covering the months from October to December 1907. There remain no quotations of any kind; only the paintings and (if we are lucky) a date of purchase and a price. Behind the tale of innate Russian talent, colossal fortune and disappointed ambition, there has to be some kind of answer to the many questions surrounding Shchukin.

One explanation lies in the fact that Sergei Shchukin was the scion of a family of wealthy merchants and was able to indulge a passion for modern

art in a way that no Russian aristocrat, bound by prejudice and family strictures, could even contemplate. Genius doesn't come from nowhere. Sergei Shchukin's collector brothers were significant factors in his progress; he did not become a prosperous Moscow merchant who assembled the world's most stupefying collection of twentieth-century modern art just because nature had given him the instinct for an opportunity and an eye for beauty. He stands out as the most successful of a highly trained fraternity of remarkable men who lived and breathed art from their earliest childhood. They studied in Europe, spoke many languages, knew all about painting and were more or less familiar with the entire Moscow business world in the late nineteenth century. Above all, Sergei and his brothers had a very wealthy businessman father, who was himself an extraordinary self-made man.

Before looking at the great collector himself, then, we shall turn to Sergei Shchukin's father and brothers, who formed the familial context that made Sergei the man he was.

The Shchukin family

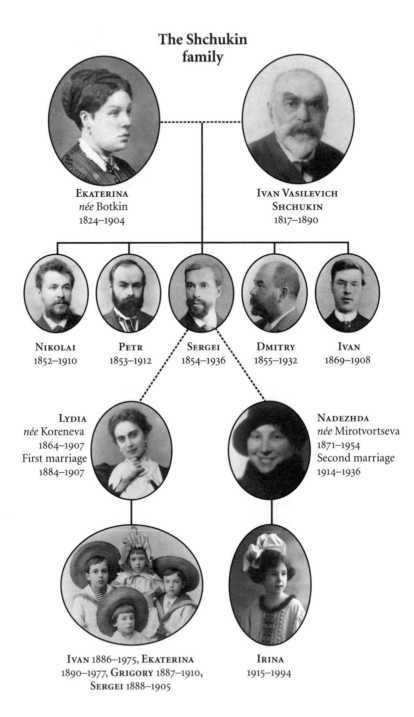

EKATERINA
née Botkin
1824–1904

**IVAN VASILEVICH
SHCHUKIN**
1817–1890

NIKOLAI
1852–1910

PETR
1853–1912

SERGEI
1854–1936

DMITRY
1855–1932

IVAN
1869–1908

LYDIA
née Koreneva
1864–1907
First marriage
1884–1907

NADEZHDA
née Mirotvortseva
1871–1954
Second marriage
1914–1936

IVAN 1886–1975, **EKATERINA**
1890–1977, **GRIGORY** 1887–1910,
SERGEI 1888–1905

IRINA
1915–1994

PART ONE

The Collector Brothers

The Gentleman Who Slept in His Box at the Bolshoy

The town of Borovsk, on the boundary between the *guberniyas* (administrative regions) of Kaluga and Moscow, has been known as a bastion of the Old Faith ever since the religious schism of 1654. It was to a monastery in Borovsk that the rebel arch-priest Avvakum was banished in the mid-seventeenth century; here also his loyal disciples, the wealthy *boyarina* Morozova and her sister, were thrown into a pit to die of hunger. And it is here that the story of the Shchukins begins.[1]

The Shchukins were Old Believers whose name first appeared in the land registers of Borovsk in 1625, just after the Time of Troubles.[2] At the beginning of the nineteenth century, the Shchukin family owned several houses and shops, as well as a glassworks, and were considered to be the richest family in Borovsk.

But everything changed for them in October 1812. Napoleon, retreating from Moscow with his Grande Armée, attempted to take a different route to the one his troops had already ravaged on their way north. This road, known as the Old Kaluga Highway, was barred to him by his Russian opposite number, Marshal Kutuzov, who had positioned his forces nearby after abandoning Moscow. At the battle of Maloyaroslavets, on 25 October, the Russian vanguard mounted dogged resistance and the French were only able to take the town of that name after sustaining heavy losses. Napoleon

had the option of provoking a general engagement the next day, with the possibility of defeating the Russians and forcing a path along the still-intact highway. He prudently decided that the risk of losing what remained of his force was too great. He did not know that Kutuzov, just as prudently, had retired during the night, leaving the highway wide open. In the event, Napoleon's men advanced only as far as Borovsk, where they turned back. At that moment and place the fate of the Grande Armée – and of Napoleon's empire – was sealed.

At war's end, the Shchukin family were scattered all over Russia. Vasily Petrovich Shchukin, the grandfather of Sergei (born in 1775), had settled in Moscow at the end of the eighteenth century. He now returned to take part in the reconstruction of the city which, after the general conflagration of 1812, was entering its golden age as the economic and industrial capital of the Russian Empire. The Moscow Shchukins took full advantage of this expansion. In 1836, the six sons of Vasily Petrovich inherited the family business. They essentially worked as salesmen, 'awaiting clients in the warehouse'.

The third son, Ivan Vasilevich, was a born entrepreneur and a brilliant trader. He quickly accumulated a pool of capital that allowed him to set up a business of his own; in addition to wholesaling merchandise, he traded in products ordered directly by him from weavers and dyers. To begin with, he lived in the Taganka district,[3] then exclusively occupied by the Muscovite merchant community, where he occupied two rooms. One contained a bed and a desk; in the other stood two looms for weaving muslin. These had been financed in partnership with another Old Believer merchant, Kuzma Terentevich Soldatenkov.

By 1856, 'merchant of the First Guild'[4] Ivan Vasilevich Shchukin had prospered and set up in the business district of Kitai-Gorod.[5] After the fire of Moscow in 1812 the Russian nobility had moved away from Kitai-Gorod, leaving the old quarter at the foot of the Kremlin to traders and merchants. The reforms that followed the abolition of serfdom in the 1860s eventually turned it into the city's business centre, a gigantic complex where entrepreneurs, traders, buyers, private banks and insurance companies hustled cheek by jowl.

Ivan Vasilevich Shchukin came to be considered 'one of the most brilliant commercial and industrial entrepreneurs in Moscow', writes Pavel

Buryshkin.[6] His business was one of the ten largest Russian textile concerns. Ivan Vasilevich became one of the founders of the Société de la Manufacture d'Indiennes Albert Hubner.[7] He was also the principal shareholder in the Zindel and Prokhorov cotton mills. When discounting and credit began to develop in Moscow, he appeared on the boards of several banks. He was a keen beer drinker, so much so that in 1875 he and his associate Kuzma Soldatenkov (who had also made a fortune in textiles and banking) founded the Trekhgornaya brewery, which quickly became the biggest brewery in Russia and one of the largest in Europe. An influential member of the Company of Merchants and a judge at the Commercial Tribunal, in 1888 he was awarded the honorary title of 'commercial councillor', which admitted him to the complex hierarchy of the Table of Ranks and made him a noble for life (though not a hereditary noble). Buryshkin comments: 'Few Muscovite figures can boast of inspiring the kind of respect that Ivan Vasilevich achieved through his exemplary reputation.'

The father of the Shchukin brothers was not a buyer of paintings; nor was he a patron of artists. He had no known personal passions, apart from his love of good food and drink, his commercial drive and his special interest in rigorously educating – or rather training – his children in commerce and the textile industry.

Ivan Vasilevich rose early and went to bed early, except when he went out. He had, as we shall see, several ways of relaxing. His first concern, when he awoke, was to summon his extremely pious cook (who would pray while waiting for the call). Together they would decide on the menus for the day and select the wines. After breakfast, Ivan Vasilevich would walk through his offices and check the accounts. Woe betide any employee who made a mistake! Ivan Vasilevich watched everything with gimlet eyes gleaming under his bristling black brow. The smallest slip resulted in a serious reprimand, which ensured that the atmosphere would be diligent and subdued for the rest of the day (and at the same time gave the boss great satisfaction). Later, he would pay a visit to one of his three factories: Hubner at Deviche Pole, Zindel at Kozhevniki, or Prokhorov at Tri Gory (Trekhgornaya), next to his eponymous brewery, where he would drop in from time to time to inhale the odour of malt, '. . . whence he returned home, walking part of the way on foot, with his carriage following behind'.[8]

In the afternoons, Ivan Vasilevich rested. Long before the seminars of Harvard Business School, he followed the golden rule of delegating management: 'Do nothing; have everything done for you; leave nothing unattended.'

In the evenings, he worked. He also went to the theatre, and visited the magnificent English Club (known for the excellence of its wines) or the more relaxed Kupets Club (known for its delicious food). He would some-times organize dinners in his own home, serving fine wines and dishes. His invitations were much prized; but they were not hard to get, so direct and straightforward was his attitude. He was a man who was 'always ready to give bread and salt', as the Russian proverb goes. His only condition was that nobody should try to pressure him. His son Petr Shchukin remembered how on one occasion an acquaintance declared:

'I'll come to dine at your house on Thursday.'

'I shall be delighted,' replied Ivan Vasilevich, 'but we will not be there.'[9]

The fact that he spoke no French and – like the friends and relations of his generation – had received no formal education did not bother Ivan Vasilevich in the least. When he went abroad to France, Belgium or Italy (as he often did) he simply took with him one of his sons, or some other relative, to serve as an interpreter.

His closest friend was Kuzma Soldatenkov, who was the very model of an enlightened *kupets*: self-educated, he was an industrialist, publisher, patron and collector. Soldatenkov was nicknamed 'Kuzma di Medici' on account of his lavish support for the arts and assorted good works.[10] The two men shared a box at the Bolshoy Theatre, with a tiny salon behind it containing a crimson sofa, upon which Ivan Vasilevich would often snooze through the Italian operas.

Ivan Shchukin was able to follow the debates that shook the small circle of collectors and patrons belonging to the Muscovite *kupechestvo* through the relatives of his wife, the powerful Botkin family, known as the 'Tea Kings'. The Shchukins and the Botkins saw each other because of their mutual friends, the Soldatenkovs, and because all three families spent their summers at Kuntsevo, where they maintained dachas. This brings us to Sergei Shchukin's mother and her remarkable family.

A cup of tea

In 1849, Ivan Vasilevich Shchukin married Ekaterina Petrovna Botkina. Ekaterina belonged to an old *kupets* family originating in the small town of Toropets, in the Valdai Hills. In 1791, at the end of the reign of Tsarina Catherine II, Konon Botkin moved to Moscow with his sons Dmitry and Petr. Petr Kononovich Botkin (1781–1853) built up the fortune of his family by setting up a commercial venture at Kyakhta, beyond Lake Baikal, in today's Buryatia, trading with the Chinese. While other merchants travelled to China to find silks, porcelain and sugar, Botkin specialized in tea, betting on the trade in an exotic product that weighed very little and was thus ideal for caravan transportation. In later years, the sons of Petr acquired tea plantations of their own and diversified into the sugar industry.

Petr Botkin had two very happy marriages and sired twenty-five children, fourteen of whom survived to adulthood. The Botkin children and grand-children made their name as famous as their tea. Their gifts in all areas were prodigious. On the one hand, they were known as 'chips off the purest Russian block'; on the other, they were reproached for their westernizing tendencies.

Following their father's death in 1853, the last Botkin children were brought up by his eldest son, the erudite and progressive philosopher Vasily Petrovich Botkin (1812–69), who orchestrated the educational programme of his younger brothers and sisters (which was naturally conducted in French). Ekaterina Petrovna was brought up in this way, before she became Madame Shchukin.

Vasily Petrovich worked in his father's office. As soon as the warehouses closed, he turned to his commentary on Hegel (in German) or wrote (in English) his analyses of Shakespeare's plays. He would also write letters to Karl Marx, whom he knew. He wrote for the magazine *The Contemporary* (*Sovremennik*) along with the poet Nekrasov, and fired up the young Count Leo Tolstoy with his progressive ideas.

At that time, it was no easy matter for members of the merchant class to mingle with princes. But while the aristocracy did not welcome the merchant class into its homes and kept its distance from the world of finance and money, it doted on Vasily Petrovich. On one occasion at the house of the Baroness von Mengden, a grand visitor exclaimed on seeing

Vasily Petrovich walking out of her salon: 'Surely you don't buy tea from Botkin yourself?' The baroness replied proudly, 'No, he just comes to drink it here.'

Thus the new Madame Shchukin had been raised as a fervent European who appreciated everything French. Without being a true beauty, the photographs show her to have classic Russian features; to be sure of herself and nobody's fool. Her second son, Petr Ivanovich Shchukin (1853–1912), was to be the historian of the Shchukins, leaving a host of detailed memories abruptly cut off by his death, at a point when his memoir had advanced no further than the mid-1890s. He describes a somewhat introverted woman, seldom warm or affectionate to her children, but always favouring the most physically vulnerable at a time when child mortality was a threat at every level of society.

Ekaterina Botkina bore Ivan Vasilevich ten children – six boys and four girls. These only met their famous Uncle Vasily once, but they had frequent contact with their mother's other siblings. The Shchukins were especially close to the family of Dmitry Petrovich Botkin, a great collector of European art, like his friends the Tretyakov brothers.

Luther's Bible

After they were married, Ivan and Ekaterina Shchukin rented a town-house before buying another one, where they lived until 1874. In that year, they set themselves up in real splendour, moving from the trading district of Kitai-Gorod to Prechistenka Street. This was an area that had been fashionable ever since the seventeenth century among Moscow's aristocrats. From 1883, it had been the scene of a gigantic building project – the Cathedral of Christ the Saviour.

Petr Shchukin wrote that his father had paid too much (250,000 roubles) for his magnificent palace, which had previously been placed at the disposal of the Austro-Hungarian ambassador, the extravagant Paul III, Prince Esterházy, for the coronation of Tsar Alexander II in 1856. It was a big stone building on three levels, entirely furnished, with a garden and an orangery. On the ground floor were the servants' quarters, the staff tea room and a kitchen so immense that 'fifteen chefs could work there, preparing dinners for many guests'.[1] The bedrooms of the older children, governesses and chamber-maids were housed on the first floor, along with the refectory and the company offices. The second, or main, floor consisted of the staterooms and private apartments of the parents and their youngest offspring.

Ivan Vasilevich had set up his office and reception area in one very large room. The effect was spectacular: a garnet-red ceiling with a decorative frieze

the gilt trim of which harmonized with the yellow silk fabrics of the sofas, armchairs, draperies and doorways. An arcade separated this room from the 'Red Salon' with its padded silk walls, in the style of the 1870s; further on were the 'Blue Salon', where the furniture was all in plain wood, and the dark-panelled Scottish baronial-style billiard room, very much in vogue at the time.

Beyond this area were the ladies' apartments, notably the white satin boudoir and bedroom of Madame Shchukin. Petr does not mention the paintings, but he does remember the Italian ceiling frescoes featuring tigers prowling through a lush jungle. The merchants of the time lacked for nothing when it came to luxury; quite the contrary. The Shchukins lived every bit as well as their aristocratic neighbours. They were already well established, with a fortune estimated in the millions of roubles.[2] They were not just well off – they lived in serious opulence. This, indeed, was the message that Ivan Vasilevich wanted to send to Muscovite society, and more especially to his elegant in-laws.

We should emphasize that, as children, the senior Shchukins – Nikolai, Petr, Sergei, Dmitry and their sisters – were surrounded by the hubbub of Kitai-Gorod between 1850 and 1860, before they moved into the more sedate premises in Prechistenka Street. This was especially significant for Sergei, who was later to break completely with the traditional Russian taste in art. The future admirer and passionate collector of Matisse and Picasso was born in 1854, around the time when his uncle, Vasily Petrovich Botkin, was receiving the writers Alexander Herzen, Ivan Turgenev and the young Leo Tolstoy in his candlelit salon. Petr's memoirs contain a pictur-esque detail: 'Candles, tallow lamps, paper chandeliers burn well, burn beautiful,' sang the young delivery men, while the merchants sang in reply, 'Burn well, melt well and cost nothing!'[3]

Petr also recalls that when they were children, three-storey houses were rare in Moscow, a city with streets that were poorly lit by pale, flickering lamplight. The night-watchman holding a halberd in his sentry box would call out 'Who goes there?' if you returned home late, and you replied: 'I live here.' If you didn't, you'd be taken to the police station. During the day, the merchants 'played draughts in front of their stalls, in their top hats'.[4] From time to time they would hail passers-by and pull them into their shops without ceremony; if they bought nothing, they were quickly shown the door.

The young Shchukins were educated by governesses; a Frenchman gave them courses in gymnastics; and a dancing master taught them the waltz, the quadrille and the mazurka. The nanny was an elderly German. If a psychoanalyst were to investigate the mystery of why people acquire a passion for collecting, taking the life of Petr Shchukin as an example, he might find the explanation in the absence of tenderness on the part of Petr's distant mother, in his separation from his family, and in the years of privation imposed by a wealthy father who swore by the culture of the Old Believers and who held that money should be dispensed with the utmost parsimony to those who had not earned it. Petr Shchukin was never able to forget his childhood suffering, and nor did he forgive his mother, who never gave him a gift or a hug, but instead showered him with blows for the smallest mistakes in his dictation exercises:

> Ekaterina Petrovna had a difficult character; some of her children she liked, some she did not. She was severe, reserved and so harsh that she never revealed her feelings. She disliked her daughter Nadya, but she liked Sergei . . . we all adored our father, who only reproached us when we actually deserved it . . . he spoiled us . . . the merest glance from him was so expressive that it would stop us yelling in an instant.[5]

Ivan Vasilevich Shchukin believed in the German brand of education. He would often speak halting German at home, which displeased his wife. Ekaterina was a fervent Francophile who deplored Ivan Vasilevich's total ignorance of French, which constrained him to silence in polite society (a state of affairs he probably preferred). Ivan Vasilevich's educational principles consisted in sending his children to Germany, the economic model for Russia, where the textile industry and trade were surging ahead. He planned to train his children in these disciplines like top athletes. The vital principle of the *kupechestvo* was to have a large family and then ensure that all one's children were rigorously apprenticed; this in turn would start a process of natural selection and an heir would emerge. As a rule this was the oldest, unless the character and gifts of some other child came to the fore, whereupon the rest would become the loyal collaborators of the designated family head. The very name of 'I.V. Shchukin & Sons' or 'P.K.

Botkin & Sons' testified to this tradition. And Ivan Vasilevich was a product of the system: he took one of his brothers as his assistant and pensioned off another who had ruined himself.

Back in the early nineteenth century, the harsh circumstances in the Taganka district had obliged the young Ivan Vasilevich to learn on the job, as he went along. Times had changed, and so had the scale of Ivan's resources, but for a life in business he still believed in the superiority of practical training over academic learning. As a businessman, Ivan Vasilevich was like a bird of prey, watching from a distance before pouncing. Such a man would leave nothing to chance in preparing his sons to succeed him.

The boys were forced to grow up fast. Immediately after his tenth birthday, each one was sent to Vyborg in Finland, which was then part of the Russian Empire. Vyborg was an ancient frontier fortress 100 kilometres from St Petersburg, and it was home to a German boarding school for the sons of the bourgeoisie, who were expected to go into business later. At that time, the Behm School was run by its founder's widow, Frau Behm. Thus the boys were sent a long way from Moscow to the misty northern marches of the empire, and they stayed away for a long time. Their father accompanied them as new boys, taking the train to St Petersburg and then the ferry to Vyborg. Petr recalls that the strictest discipline was applied, and all lessons, including gymnastics, were taught in German. Everything was learned by heart, in the German way: physics, history and the Lutheran catechism, with whole sections of the Lutheran Bible memorized word for word. Although he was extremely pious, their Old Believer father had never been particularly attentive to ritual and saw no reason why his sons should not attend the services of the Lutheran Church, whose ascetic spirit and bare-bones theology were not without parallels in the Old Faith.

The punishment for inattention in class was German verse composition. If you behaved badly, your fingers were rapped with a ruler; if you offended again, you went without lunch and dinner. Serious offences could get you locked away in solitary confinement.

The establishment had an excellent reputation among merchants who shared Frau Behm's views on how children should be educated the German way, in the German language. After their time in Finland, the boys completed their secondary studies with four years in St Petersburg, at the

Lutheran boarding school of Dmitry Girst in the port and university area of Vasilevsky Island. This school was every bit as Teutonic as Frau Behm's and every bit as strict; nevertheless, it was in the city, half an hour by horse-drawn omnibus from Nevsky Prospekt and all the temptations of the imperial capital. Here, the boys' principal concern was their still-meagre pocket money; but fortunately they were regularly invited out by their father's friends and by one of their Botkin aunts, who lived nearby.

Ivan Shchukin sent three of his sons through this boarding-school system: Nikolai, Petr and Dmitry. As soon as they resurfaced, they were put to serious work. All three did stints in trading houses and manufacturing plants abroad. Ivan Vasilevich had devised a special itinerary for each of his sons that covered as many commercial institutions, firms and textile producers as possible. Nikolai was sent to Mulhouse in France, where the best craftsmen in printing on jute fabrics were to be found. Petr spent two years in Berlin, working at a textile trading company. To Dmitry fell the task of studying accounts and statistics, taking a more theoretical course of instruction at the Dresden Institute of Commerce. It was only the Shchukins' youngest sons, Vladimir and Ivan, born (after three daughters) in 1867 and 1869 respectively, who were permitted by Ivan Vasilevich to go on to higher education at the University of Moscow.

The only boy who was spared the boarding schools of Vyborg and St Petersburg, and who remained at home to study with his sisters, was Sergei Shchukin. Nobody could have foreseen that this ailing little stutterer, skinny and with a disproportionately large head, would outlive the rest of his family (with the exception of his sister Nadya, who died in Moscow at the age of ninety-eight). His parents feared for Sergei's life, and so they spoiled, cosseted and cared for him more than the others. Petr was frankly jealous: he reports that his mother expressly demanded that he should be sent to Vyborg, like Nikolai, but that her 'darling' Sergei should stay close to her. So Sergei's childhood was spent with his mother, father and sisters; he in turn envied his brothers, who only came home for the Christmas and summer holidays, bringing with them all the news and mystery of the real world outside.

But Sergei was a fighter. When it became clear that his father was against sending him to the *gymnasium* (the Russian *lycée* or grammar school), he put up a fierce resistance. Well before the invention of fitness and the cult of

17

health, the advantages of physical exercise, endurance and good diet were perfectly understood. With nowhere to exercise and no special guidance, through sheer willpower and determination he managed to transform himself by practising daily gymnastics, sleeping with his window wide open (even in the coldest Moscow winters), eating in moderation and following a strict vegetarian diet. His favourite dishes were mushroom soup and boiled buckwheat – to which he would occasionally add a spoonful of meat broth, murmuring that it was 'a sin'.[6] In total opposition to the world of commerce in which he grew up and which was supremely unconcerned with the effects of rich food on the human metabolism, Sergei became a lifelong vegetarian and devotee of physical culture. This deeply impressed his father. In the spring of 1873, he took the boy to Burgsteinfurt, near Münster, to see Doctor Denghart, Europe's greatest living specialist in the treatment of stuttering. The journey was not in vain: Sergei's obsession with his handicap subsided and he began to speak more easily. Indeed, his residual faint stutter was more charming than anything else. 'He had a stutter still, but it didn't prevent him from being a most engaging conversationalist,' was the verdict of many who knew him. Also in 1873, he entered the School of Commerce in the town of Gera, in the province of Thuringia (Germany), famous for its textile industry.

Within four years, the timid and delicate boy had metamorphosed into an elegant young man eager to succeed in life. He began by joining the family business, which nobody had expected would ever happen. While his brothers were still abroad gathering experience (Petr in Lyon, Dmitry in Riga), Sergei spent two years absorbing the subtleties of commerce, as taught to him by his father. His sense that he was somehow inferior made his commitment to the family firm even stronger.

In 1878, when Ivan Shchukin set up I.V. Shchukin & Sons, his hopes still rested on his eldest son, Nikolai, who was expected to take over the firm, even though he had fought tooth and nail to free himself from his father's influence. The story was not unusual: when the eldest son in a great family sheds the role planned for him, it is often the least likely figure who takes his place. Fate gave Sergei just such an opportunity, and he seized it with both hands.

The Tragic Tales of the Older Brothers
Nikolai and Petr

The obstinate determination of Nikolai, the eldest Shchukin brother, to turn aside from the destiny so carefully charted for him perhaps originated in his dread of disappointing his father.

The dice were weighted against him from the start, for Nikolai was not the first son of Ivan and Ekaterina. There had been another Nikolai before him: born on 3 January 1850, he had died on 11 January 1851 while Ekaterina Botkina was expecting her first daughter Alexandra, born barely a month later on 13 February. One can readily understand that, having endured the worst suffering possible – the loss of her first baby (made all the more agonizing by anxiety for her unborn second child) – the young mother never again felt totally at ease with her role as a bearer of infant merchants. Thereafter she reserved all the tenderness she could muster for the most fragile of her children – Sergei, Vladimir and Ivan – in the process grievously wounding the healthy ones.

Moreover, the parents might have found a more tactful name than Nikolai for their second son, born on 15 February 1852. But they did not. As a result, from the moment he was born, the new Nikolai was haunted by the ghost of the beloved first-born, snatched from his mother after only a year. The replacement Nikolai of 1852 saw himself as an imposter ever after.

The rare photographs of Nikolai that survive show a man with a tall, elegant, European physique and a sparse beard; in aspect, he was much more of a Botkin than a Shchukin. He was the first to endure his father's strict educational programme, and the first to find himself completely isolated among German Lutherans at the Behm School on the Finnish coast. During the 1880s, the family expanded rapidly, with the arrival of Petr, Sergei and Dmitry, all of whom looked more like their father. Nikolai, every Christmas and every summer, dreaded having to face his mother's unhappiness; for she was painfully reminded of the first Nikolai every time she saw the second. Above all, he feared that he would prove unworthy of the hope he saw in the eyes of his father, then in his prime, who was building a great enterprise solely to pass it on to him.

Nikolai's 'voluntary service' (internship was a concept still far in the future) at the Hubner works in Mulhouse, France, was interrupted by the outbreak of the Franco-Prussian War on 29 July 1870. Luckily, the fighting coincided with Nikolai's summer holidays in Moscow. The following autumn he was sent by his father to Leipzig, in Saxony, far from any further upheavals. Mulhouse became part of Germany, along with the rest of Alsace. Petr, the only Shchukin who left any description of that time, does not enlarge on this matter, and we can only guess at how Nikolai felt about it. He was a young man of twenty; perhaps the first major historical event in which he was concerned exacerbated his own complex feelings on the matter of identity. The harsh rule imposed by his father, his long separation from his family and his relative penury all called for a force of character that he did not possess. It awoke in him the classic obstinacy of the weak: a spirit of passive resistance and a dull determination to forge his own destiny.

It became quite clear that Nikolai didn't share his younger brother's eagerness to prepare himself for the succession, even when, in 1878, he joined his father and brothers Petr and Sergei on the board of I.V. Shchukin & Sons.

Nikolai Shchukin was thoroughly trained and he bore his father's name. There was no need for him to go back to square one if he wanted to work for another firm within the framework of an agreement between merchants. And so in 1884 he became one of the four directors of the Danilovsky mills, the largest textile manufacturer in Russia. This job was probably

arranged for him by Kuzma Soldatenkov, one of Danilovsky's principal shareholders and the closest friend of Ivan Vasilevich. Naturally, the move was made with the full agreement of Ivan himself, who had had enough time to realize that Sergei was surely the one who would succeed him, being the most gifted and the most motivated of his sons. For Nikolai, this development was not so much a dead end as an opportunity to settle down. From being the heir to I.V. Shchukin & Sons, he became a fulcrum of support outside the firm, which depended heavily on the Danilovsky mills for its flow of supplies. A few years later, Nikolai also became one of the three directors of the Trekhgornaya brewery, the gigantic concern founded by Shchukin Senior, Soldatenkov and their beer-drinking friends. Thus Nikolai appears to have been professionally satisfied, as well as accepted in a role that suited him. He was an efficient, respected manager; but he was not by any stretch of the imagination a capitalist entrepreneur – and certainly not within the context of his family's business.

Nevertheless, Ivan Vasilevich – a man who wore his heart on his sleeve – experienced in his eldest son's departure the failure of his dreams for him. It was also a painful parting of the ways: Petr recounts that at the same time as Nikolai's change of professional course, he moved out of his father's big townhouse into a smaller place nearby, on Volkhonka Street, a fashionable thoroughfare close to the Cathedral of Christ the Saviour. Ivan Vasilevich, an early riser, suffered so much from his son's absence that he would pay him a visit every morning at 8 a.m. sharp. Nikolai, not surprisingly, was in two minds about this. Eventually he devised a strategy that in a way encapsulates the ambiguity of his relationship with his father: he would hang a lady's bonnet on the hatstand in the hall, so that Ivan Vasilevich would see it and beat a tactful retreat.

For a while, Nikolai was a desultory collector of silverware and old paintings. He was a big spender, buying furs and jewellery for young leading ladies of the theatre and gambling with abandon at the English Club. In 1889, he married a widowed Botkin cousin, before succumbing to prolonged ill-health, which forced him to stop working and go to Germany for treatment. He died in Heidelberg in 1910, at the age of fifty-eight.

Nikolai had been the imperfect prototype of his father's educational programme, probably because he had been the first to enter it and too

much had been expected of him. He had reacted by claiming his independence and living a life of his own. In sum, he had stepped aside, but had been none the happier for it.

A Russian Tintin

Petr Ivanovich Shchukin was the second brother in the Shchukin dynasty and a highly successful product of the special education planned by his father.

Petr kept a journal full of fascinating details about its author's travels all over Europe and beyond: Moscow, St Petersburg, Paris, Lyon, Madrid, Lisbon, London, Rome, Algiers and Tunis. It also contains a fascinating account of the Nizhny Novgorod fair. The down-to-earth descriptions reflect the personality of the author, a discreet, measured and methodical man, like his father before him. Petr was an eternal visitor: a visitor not so much to places as to life. He far preferred observing people, their manners, habitats and daily lives, to gazing at monuments and landscapes. He observed the smallest details: 'From Cherepovets, we took the boat, on which we were served delicious, juicy sturgeons . . . at Kirillov, I found a very good French red wine in a colonial store.' Sometimes we note an ecological awareness that is ahead of its time: 'Back then, the Oka and the Volga were not yet poisoned by oil and the fish had a very pure taste, the shellfish had meat and consistency – they weren't the hollow, mingy things we see today.'[1]

As a young apprentice abroad, Petr lived frugally – whether he was hunting for lodgings or having a meal. In Berlin he went dancing; in Lyon he would spend his evenings with the silk-workers. Wherever he was employed, he would criss-cross the country using the cheapest forms of transport available: on foot, on noisy ferries or in third-class carriages. But he never missed a chance to go out and see things. While he was based in Berlin he managed to visit Hamburg, Leipzig, Dresden and Stettin. During his period in Lyon he saw Marseille, Toulouse, Bordeaux and the Alps. He also took advantage of his father's custom of bringing one of his children with him whenever he travelled. Thus Petr visited Paris frequently as Ivan Vasilevich's secretary/interpreter, and together they went by train

from Paris to Brussels to see the Belgian operetta *La Fille de Madame Angot*, a century or more before the high-speed rail link. Petr was even with his father and Sergei when they went to see the German doctor who eventually cured Sergei of his stutter. Petr was a Tintin figure in a suit: he had no rough edges, no strong personality of his own, and no particular opinions about the world he described.

But he was also a man of the world. Delicately and without vulgarity, with never a word out of place, he outlined the salty side of his life. In Lyon, the place to go was Place Bellecour; at Sidi Bel Abbès (Algeria), the fun was organized by the Legionnaires who ruled the roost in their white *képis*. In the desert, Petr heard of an oasis that was famous for its belly-dancers; after going there, he noted that they were 'quite approachable'. In London, he frequented the theatre foyers of the West End. In Paris, the second-youngest Shchukin son, Vladimir (who died of tuberculous meningitis in 1895 at the age of twenty-seven), fell madly in love with the actress Cécile Sorel. It was forty years later that she delivered her famous remark, on the steps of the Casino de Paris: '*L'ai-je bien descendu?*' Vladimir's early discovery of Sorel was perhaps another example of the family flair for getting in at the start of things. In any case, Petr reports that Vladimir went to the theatre every night to see her act, invariably sitting in the front row. Vladimir's first approach to the actress was during the interval. He paid one of the ushers to carry a note to Mademoiselle Sorel containing his calling card, an invitation to dinner after the play and a 1,000-franc note. Petr concludes, drily: 'The invitation was accepted.'

Petr's first job, in Lyon in 1874, was as an unpaid apprentice with the Protestant firm of Sevin and Barral. His work was to '*faire des sconettes*', meaning that he had to unpack and inspect the pieces of raw silk, spot any impurities in the silk moiré, set in threads to mark them, and then carry the fabric to a specialist who would remove all imperfections. This he did from 8 a.m. to 7 p.m., six days a week. Plenty of exercise for the eyes.

At the same time, he deepened his knowledge of the profession, leaving Sevin after a year and signing up for a private course in the theory of silk manufacture. Thereafter, he learned to weave silk by hand at a velvet-maker's in Saint-Clair. In 1876, he was offered a job (paid, this time) in the Lyon branch of Warburg & Company, a major Hamburg firm.

By 1881, Petr was in the process of setting up his own silk brokerage company in Lyon when his father summoned him back to Moscow to join I.V. Shchukin & Sons, the firm he was founding in partnership with his other sons. This brought Petr's informal apprenticeship to a close.

The tsaritsa's kettledrum

Petr's childhood and youth, largely spent away from home, had a lasting effect on his character. Living as he did in a state of constant penury, he developed a degree of stinginess that made him the laughing stock of his contemporaries. But in Lyon, as soon as he was able to assemble a little cash, he would use it to hunt for antiques, buying any lithographs and daguerreotypes that caught his eye. He rummaged through the antique shops and bookstalls that teemed in the Brotteaux district, where he had lodgings in the home of a local widow. Gradually his taste grew more refined and he began to purchase rare illustrated books and engravings, which were freely available in France at that time.

On his return to Moscow, his hunting ground broadened to include other exotic objects: Persian carpets, Chinese porcelain, Japanese screens, Indian bronzes. He took full advantage of the general migration to the Nizhny Novgorod fair, an annual event that every self-respecting merchant and broker in the Russian Empire attended. I.V. Shchukin & Sons had a warehouse of its own among the galleries built on the famous alluvial island in the Volga. It was there at Nizhny Novgorod, during a lull in the furious dealings with Armenians, Germans, Jews and Caucasians, that Petr acquired the first piece of what was to become his collection of Russian antiquities: a silver kettledrum given by the Tsarina Elizabeth to the *hetman* of the Cossacks of Yaitsk (today's Oral) in Kazakhstan. Within a short time, the Shchukin collection of Russian silver became known as one of the most notable in Russia.

The collector Alexei Bakhrushin viewed Petr as the most professional of his colleagues:

> He never collected anything until he had put together whole libraries on the articles that interested him. Thus he went out to study old

everyday objects from China and Japan, the finely worked belts worn by the Polish nobility, Russian brocade craftsmanship, or postage stamps. On every one of these subjects he could hold forth at length at the drop of a hat. Backed by such erudition and by such huge resources, he was able over the relatively short period of eight years to put together a marvellous and very important collection.[2]

The word that best describes Petr as a collector is 'eclectic'. He was as passionate about the exoticism of Persian, Indian, Japanese and Chinese art as he was about that of Russia. Gradually, though, a fascination with the history and art of his own country gained the ascendancy and became his principal interest. It was no coincidence that the Petr Shchukin Collection later became the Museum of Ancient Russian History.

Most of the artefacts that make up this 'history' originated in the celebrated Sukharev market north of Moscow, described by the journalist Vladimir Gilyarovsky:

Every Sunday, a huge unofficial market was held close to the Sukharev Tower. Muscovites flocked to it, along with local farmers and provincials passing through. Hundreds of tents sprang up during the night in front of the sumptuous Sheremetev Palace, where they remained all the following day. From dawn to dusk, a sea of heads advanced and retreated, leaving narrow passages in both directions along the Ring Boulevard, which was very broad at that point . . . at that time there were over thirty booksellers' tents . . . along with the antique dealers, who were known as 'merchants of old stuff', the second-hand booksellers constituted what might be called the aristocratic sector of Sukharev . . . there was none of the chaos surrounding the other tents. The public in general were more genteel, consisting largely of collectors and book lovers from the leading *kupechestvo* families . . .

The most eminent buyer of all was Petr Ivanovich Shchukin. He seldom appeared in person. Pieces were brought to him at his residence. The door of his office, which was otherwise closed to all comers, was invariably open to dealers in antiques. They had only to appear at his warehouse gate with their huge sacks of goods and they were immediately

ushered into his presence, unannounced. Amid clouds of dust, Petr Ivanovich would dive into the piles of junk spilling out of the sacks. He bought the best of it, and what remained ended up in the tents at the Sukharev market, or in adjoining open-air stalls.

There were many stories, related by dealers, of Petr's sheer voracity: 'I felt it was my duty to show the best and most interesting items. I came across to Petr Ivanovich ahead of everyone else,' remembered the antique dealer Savostin. 'He never bargained with me, nor did I ever turn a whisker at what he offered, or ask for a penny more.'[3]

Tales of Old Russia

The collection grew day by day, and with it grew the need for ever more space. Petr wanted much more than a roomy private townhouse. His dream was a specific building, in the Old Russian style, which would be perfectly adapted to the nature of his collection.

When he inherited his share of his father's fortune in 1890, Petr was able to make his dream come true. He bought a property on Gruzinskaya Street, in the old Georgian district. Assisted by the architect Boris Freudenberg, a master of the 'pseudo-Russian style', he plunged into his books in search of decorative detail. The two men travelled together as far as Yaroslavl to find this or that original architectural feature that they could copy: here the sweep of a flight of steps, there a banister, a painted door or the graceful motif of a ceramic tile. The arches of the rooms in Petr's new museum were covered in frescoes reproducing the vegetal pattern typical of seventeenth-century Russia. Even the painted eagles on the beams of the floor above were copied from letters patent from Peter I to one of his favourites.

The museum was built in record time, and soon enough its green-tiled towers and domes could be seen from the boulevard.

In 1895, Petr Shchukin finally opened the doors of his red brick palace, its roofs crowned by double-headed eagles. One of the museum's most loyal denizens, the architect Ilya Bondarenko, recalled:

Entry to the museum was free of charge, but there were few visitors. In the hall, at the foot of the stairs, a smallish, middle-aged figure awaited

me. Petr Shchukin had a bald pate and bright, piercing eyes; he showed me the illuminated manuscripts I had come to see and invited me to work in the library if I wished.

The museum was open throughout the year, with the exception of New Year's Day, Easter Day and Saint Peter's Day (Petr's Day).

At 10 a.m. precisely, the museum doors were opened; at noon, with a screech of steel they closed. Petr then went for lunch in his apartments, before heading to 'the warehouse', the offices of I.V. Shchukin & Sons. Following a long-established ritual, his servant summoned a coachman, who was always paid twenty kopecks – no more and no less. Petr remained at the warehouse until 5 p.m., then returned home by the same cheap mode of transport. In the evenings, if he was not immersed in some book on history or archaeology, he would go to the English Club, which he had become a member of in the footsteps of his father.

The main room of the museum was filled with exclusively Russian objects. In the middle and all around the walls were display cases filled with brocades, embroideries and portraits; near the four supporting columns were antique weapons and incense burners. The cases also contained miniatures, enamelled pieces, objects in carved bone, silver goblets, porcelain and crystal. At the entrance stood a simple table spread with manuscripts and parchments which was presided over by Madame Ekaterina Kudryavtseva (the secretary, and the only woman in the house, Petr being officially a hardened bachelor who employed men only). Her job was to take dictation from the boss, who sat on a huge iron-bound chest as he spoke. One day, when I needed to design a pair of earrings, I asked him to show me some. A big biscuit tin was brought out of a cupboard. It was packed with pearls, rings, earrings and medallions of the Virgin encrusted with diamonds.

'Take your pick, you can draw them in the library,' said Shchukin.[4]

There were few visitors to the museum because it was principally of interest to researchers, architects and artists. Unlike most collectors, who wanted above all to demonstrate their possession of great treasures, Shchukin was averse to showing people around. 'By all means look around

by yourselves,' he would say. 'You can examine anything you like.' He hated to be disturbed; if a visitor, particularly a newcomer, turned up at a moment when he and Kudryavtseva were having difficulty in deciphering a seventeenth-century letter written by hand and in haste, Shchukin would receive them rudely: 'There's nothing to see. I don't know why you've bothered to come.'

'He loved art and he knew how to enjoy it. He bought a big canvas by Tiepolo and hung it temporarily in the museum vestibule. Every time he went in or out the building, he would pause for a moment to admire it.'[5]

As the years went by, Petr's thirst for acquisition became seriously manic. His museum was unable to accommodate the constant flow of new pieces. Antique dealers, booksellers and ordinary rag-and-bone men brought him anything they could lay their hands on and which they thought might be of interest. Cartloads of books, archives, manuscripts and objects of all kinds converged on Gruzinskaya Street. Petr's desire to possess things took precedence over all else.

Like so many obsessive collectors, the owner of all these treasures was completely indifferent to his own personal comfort: he would dispute the price of bottles of wine, and equipped his own home with cracked teacups and lidless coffee pots. In his bedroom, as if in some rundown, provincial hotel, a simple walnut divan faced a pair of ugly cloth-covered armchairs. All this exasperated Princess Maria Tenisheva, a St Petersburg aristocrat who happened to be visiting. But what was the princess doing in Petr's bedroom? People wondered if she had been invited to admire certain masterpieces that the collector preferred to reserve for adults – such as Renoir's *Jeune Femme Nue* or Degas's *La Toilette*.

Still the museum grew, and still Petr bought.

In 1898, he erected a second building, also in the Old Russian style, which he connected to the first one by way of an underground gallery. This second construction was called the 'new museum' and resembled Sleeping Beauty's palace. As Bondarenko recalled:

When I had to fetch something, Shchukin usually gave me the key to the street building. 'Use the tunnel!' he would cry. 'In the second room of the new building you'll find a low chest of drawers. Have a look

there . . .' The passage was deserted . . . there was an old, rickety sleigh leaning against the wall and nobody in the stairwell, with its ceramic tiles. Everything was quiet. On the walls and in the display cases of the four rooms on the ground floor were pieces of oriental art. On the wall hung the giant Tiepolo, along with some French paintings and portraits. The first floor was taken up by apartments, which were also filled with museum pieces.[6]

And still the museum grew. Nothing could stand in the way of Petr's consuming passion.

Gradually his compulsion to accumulate and the absence of any museological method behind his self-taught eye came to spoil a collection that had started out so well and so scientifically. The really extraordinary pieces were drowned in an ocean of mediocre objects, which transformed Petr's two Russian fairy-tale palaces into a gigantic repository of old weapons, keys, samovars, fans, decorations, medals, fabrics, carpets, jewellery, manuscripts, postcards and vulgar tat.

Even so, despite the avalanche of compulsive purchases, the collection was extraordinary and the 'Shchukin eye' still contrived to seek out many objects that were quite unique. The religious section contained an assembly of icons that included several very rare pieces dating from before the Mongol invasion. The masterpiece of Petr's manuscript collection was an illuminated thirteenth-century New Testament. In addition, there was an original manuscript of Radishchev's *Journey from St Petersburg to Moscow*; the entire correspondence between Gogol and Alexandra Smirnova-Rosset (a friend of Pushkin's and Lermontov's); the letters of Ivan Turgenev; and even some missives from the Dalai Lama. Somehow, Petr had also managed to secure a detailed archive of the Decembrist Conspiracy, along with an exhaustive collection of documents concerning the war of 1812, including quantities of letters by Stendhal, which – just as the writer complained in his journal – had been intercepted by Cossacks. Petr unearthed them at the Sukharev market eighty years later.

The objects continued to arrive. In 1905, a third storehouse was added, which relieved some of the pressure on the museum. The time had come to take stock and create a coherent catalogue. Each of the museum's many

sections was unique in itself, yet its owner had never found the time or the energy to create an inventory or to describe his treasures on paper. He finally tackled this task, publishing as he went along. The resulting vast archive came to be known as the 'Shchukin Volumes'.

This was the principal occupation of Ekaterina Kudryavtseva, as noted by Bondarenko. Every morning from ten till noon she had to transcribe Petr's dictated notes of the contents of old documents, along with descriptions of objects. This rigorous, tenacious approach eventually bore fruit: eighteen years of work, carried out daily, resulted in the publication of no fewer than forty-three volumes of annotated inventory.

Petr Shchukin was nothing if not modest. In his view, the publication of this work was a simple but imperative duty. He didn't sell his volumes; instead he published 300 copies of each, using the same typography, the same format and the same binding. He donated them to museums and libraries, to the people with whom he worked and to a few chosen acquaintances.

The resplendent Petr Shchukin

In 1891, before his museum had begun to take shape, Petr wrote in his first will that he wished to bequeath his collection to the city of Moscow. When, in 1905, Moscow was gripped by revolutionary insurrection, he decided he could wait no longer. That spring, he petitioned the Duma (parliament) to accept the donation of his property, including 'all the buildings, the collection of Russian and foreign antiquities, the oriental collections, the gallery of paintings, the library, the manuscript archives, all furniture and decoration, plus the funds required for their future maintenance'. In April 1905, the collection – which by then amounted to about 45,000 items – became a branch of the History Museum, under the name 'The Petr Ivanovich Shchukin Museum'.[7] Petr retained the use of all the buildings and the collection until his death, just as the great art collector Pavel Tretyakov had done when he donated his gallery to the city of Moscow in 1892.

The Russian newspapers were full of Petr's generous and selfless gesture. At the behest of the Ministry of Public Education, Petr Shchukin was given the rank of Civil Service General and State Councillor in

Ordinary – which, for a merchant, was a phenomenal achievement. Petr was inordinately aware of the fact: 'Every morning,' wrote Bondarenko,

> a servant hung the blue general's uniform on a rack and carried it outside on the balcony, where he carefully brushed it in full view of passers-by. From time to time, Petr himself was spied walking through the covered market at Kitai-Gorod dressed as a general, smiling and nodding at the easy-going ladies with the greatest good humour.[8]

In Moscow, Petr's eccentricities caused much hilarity. He was said to have visited the baths in full uniform, complete with medals, and to have greeted visitors to his museum wearing an astrakhan cap decorated with a military cross. Thus, malicious rumour transformed a good and humble figure into an eccentric, ambitious merchant who had spent twenty-five years accumulating antiques in the hope that one day he would be addressed as 'Your Excellency'.

In the last years of his life, General Shchukin continued to surprise the populace and set tongues wagging. In 1907, after almost sixty years of celibacy, he took a wife. The chosen woman was Maria Ponomareva, *née* Wagner, a widow from Nizhny Novgorod, with a grown-up son serving in the Cadet Corps and a small boy named Grigory, whom Petr immediately adopted.

Petr Shchukin's new family was not admitted into the private apartments of the museum. Instead, Petr installed his household in a twenty-room apartment in the Prechistenka district, which had become increasingly desirable since the completion of the colossal Cathedral of Christ the Saviour. The residence had every possible creature comfort and was decorated with Petr's customary perfect taste. On this occasion, Petr set aside his legendary avarice, though the spectacular Madame Shchukin probably left him little choice in the matter. Maria Ponomareva's ample physique and alluring smile were reminiscent of Anna, the model for Renoir's seductive *Jeune Femme Nue*, a painting which hung in Petr Shchukin's bachelor bedroom.

The canvas did not remain there for long. Moscow was once again agog following the revelation of salacious details of the life of General Shchukin. It was discovered shortly after Petr's wedding that a certain Mademoiselle

Jeanne Bourgeois, a young and attractive woman from Bordeaux, had been sweetening his bachelor existence for some years past. Mademoiselle Bourgeois had accompanied Petr on his travels and he had passed her off as his granddaughter, but how was it that she had lived for several years with him in Moscow, entirely incognito? Nobody could understand. Apparently the girl had even installed her mother . . .

In any event, the scene was set for the rich merchant to make some financial reparation, and sure enough the young governess was offered a generous payoff. Mademoiselle Bourgeois, however, decided that in her case, her lost youth and reputation being irreplaceable, the immensely wealthy man who had taken advantage of the former and ruined the latter should not be allowed to dismiss her for a pittance. Her highly delicate and sensitive petition inevitably went before a court of justice and took several years to resolve.

It was impossible to hide all this for long. Vishnyakov, the famous Moscow gadfly, wrote in his private diary: 'I have learned by pure chance the real reason for all the discussion about Petr Shchukin's millions. His French ex-mistress has taken him to court . . . I was told this by Petr himself, who makes no secret of it.'

We can only guess how the irreproachable widow from Nizhny Novgorod took all this, and it is more than probable that the life of her new husband was not as calm and happy as he might have expected. Yet Petr made no change to his daily habits, and continued every morning to go from Prechistenka Street to the museum and thence to his office; he would often spend his evenings at the English Club.

In May 1912, Petr Shchukin lost the court case and was obliged to pay Jeanne Bourgeois compensation totalling 100,000 francs – a gigantic sum of money. At this point, he asked his brother Sergei to sell the small but marvellous collection of impressionist paintings that he had assembled between 1898 and 1899, when he had accompanied Sergei – who was then starting his own collection.

Petr's other masterpieces, which included Monet's *Dame dans un Jardin*, were displayed in the mezzanine gallery of the 'new museum', the banisters of which were covered with Persian carpets overhanging a collection of Japanese screens and fabrics. This created a very striking effect, with a

wonderful assortment of colours. Unquestionably, these superb pieces had very little to do with the concept of a museum of Russian antiquities; rather, they were part of the jumble of unclassifiable items that made Petr Shchukin's improbable Xanadu so uniquely charming.

Sergei, whose collection of modern art had been the subject of vigorous debate in Moscow for some years, was well aware of the quality of his brother's French paintings. He resolved to buy the best works (under conditions that we will discuss later) and help Petr out of the embarrassing fix in which he found himself.

Petr Shchukin's sudden death from appendicitis almost immediately after this transaction had been concluded, on 12 October 1912, was a final dreadful shock. Sergei now found himself bereft not only of his brother, but also of a faithful and trustworthy co-director of his firm.

Though Petr Shchukin quit the scene fairly young, at the age of just fifty-nine, the final photographs of him show a man who was prematurely aged and clearly disillusioned. He was engaged full time in two tasks that signalled a kind of end: the cataloguing of his museum and the writing of his memoirs. In taking a wife (and a child as well), Petr had decided to retire in every sense of the word. Yet he had shown what was dearest to his heart by each day putting on a uniform which testified to all and sundry (including the streetwalkers of the shopping mall) that Holy Russia had given her official recognition to his museum – a museum that was totally unclassifiable, because it was unique and entirely personal.

Petr Shchukin, thwarted in his sensibilities by a mother who gave him no tenderness and by a father who asked too much, had nevertheless been an indispensable lieutenant to Sergei Shchukin throughout his life. He had created a museum that reflected his passion for the activities of human beings, from the elegant letterheads of Sergei's wife Lydia Shchukina to the sublime thirteenth-century icons illuminated with glittering gold, and a place of wonder where anybody could go where they wanted and find what they had come to find, whether it was a box of earrings, or a painting by Tiepolo, or a Chinese screen on which monkeys gazed at the moon's reflection across the surface of the Han River.

The museum was the magnificent idea of a great collector. After the death of its founder, it was closed and, contrary to the terms of Petr's will,

all its collections were merged with those of the State Historical Museum on Red Square. In 1934, the majestic Russian palace on Gruzinskaya Street was home to the 'Museum of Biology and Atheism'. Today it can still be found under the same green roof slates in its new incarnation as the Biological Museum, and it is still possible to walk from one building to the other along Petr's tunnel.

Dmitry Shchukin
'The Dutchman'

The fourth Shchukin son, Dmitry, was born in 1855. If Ekaterina Botkina preferred the sickly Sergei to all her other children, Dmitry was his father's favourite. According to Petr's account, this emotional preference did not – to begin with – give him any advantage, and he duly did his time in the north under the hard German rule of the Behm School. But everything changed in 1874, when Petr left Berlin for Lyon: Ivan Vasilevich recalled Dmitry to Moscow, bypassing St Petersburg.

That was also the year in which the family moved to its new and far more sumptuous residence on Prechistenka Street. Ivan Vasilevich Shchukin, founder member of the Moscow Bank, vice president of the Kupets Society and judge of the Commercial Court, was moving up in the world. His new obligation to compete with the aristocracy in terms of wealth, power and gentility called into question his usual habits, including those concerning the harsh education of his children. No doubt his wife Ekaterina, who was proud of her own European-educated family's reputation, had a lot to do with this.

In consequence, Dmitry was sent to the Polivanov Gymnasium, a private boys' college a few blocks away from the family home. Founded in 1868, the *gymnasium* occupied a large building with an eight-columned Tuscan portico. Its headmaster, Leon Polivanov, was a liberal teacher who was very well respected in Moscow. It was not so much his innovative

teaching techniques or his pioneering pedagogical experiments that had made his name, as his insistence on the arts of language, writing and literature. This quickly won his school a reputation for excellence.

It became traditional for people in the avant-garde liberal intellectual milieu – university professors, prominent lawyers, journalists and men of letters – to send their offspring to Polivanov. Among his former pupils were the children of Leo Tolstoy and of the dramatist Alexander Ostrovsky, as well as the writer Andrei Bely,[1] the philosopher Vladimir Solovev and the chess champion Alexander Alekhine. No other school in Moscow laid such emphasis on the history of art, a discipline which aroused Dmitry's enthusiasm.

Pursuing his study of the humanities in this elite Enlightenment atmosphere, light years away from the miseries he had endured in the Grand Duchy of Finland, Dmitry quickly found his way to the Pashkov House, fifteen minutes' walk from the *gymnasium* past the cathedral. The Pashkov House, a spectacular private property overlooking the Kremlin and the river, was the home of the Rumyantsev Museum. The Rumyantsev collections, assembled by Count Nikolai Rumyantsev at the end of the eighteenth and beginning of the nineteenth centuries, had been transferred from St Petersburg to Moscow in 1861. The museum consisted of a huge library, a collection of manuscripts, coins and medals, and sections on mineralogy, zoology and the fine arts.

Count Rumyantsev himself was not a collector of paintings. He had created his museum along eighteenth-century lines – out of 'concern for education and the improvement of mankind'. After it was moved to Moscow, the museum changed radically. Because the city lacked a significant artistic collection that was open to the public, 201 European paintings were donated to it by the Imperial Hermitage, with infinite care and no doubt plenty of debate over its choices. Shortly afterwards, the Rumyantsev Museum received a precious gift from Tsar Alexander II: an enormous painting by Alexander Ivanov entitled *The Appearance of Christ Before the People*, in which recently baptized people in various states of undress are seen milling around the figure of St John the Baptist, their heads raised in rapture at a distant apparition of Christ on the road ahead. One can only imagine the impression made by this monumental work on

the nineteen-year-old Dmitry, whose own life had just undergone a transformation.

The museum's fine art gallery was the only place in Moscow where old masters could be viewed. Dmitry Shchukin could not believe his luck: as if by magic, he had been spirited away from his Teutonic prison to engage in studies where education of the mind replaced iron discipline. Moreover, here was a brand-new museum full of marvels that seemed to have been built especially for him. The groundwork was quickly laid for his passion as a future collector.

Nevertheless, the magic wand was still in the hands of his father. Ivan Vasilevich Shchukin was a self-made man moulded by the Taganka, and he was the one who maintained the flow of roubles. He refused to spoil his sons, especially his favourite. Ivan quickly realized that Dmitry had little appetite for mathematics, practical science or accounting. Nevertheless, he considered that the interests of the family took precedence over Dmitry's enthusiasms. After two years at the *gymnasium*, the budding aesthete was packed off to the Dresden Institute of Commerce in Saxony, where he was expected to perfect the German he had learned at Vyborg and acquire the basic skills for his future role in the family business.

Dmitry had a somewhat feminine nature. Though outwardly obedient, at the same time he possessed considerable reserves of passive resistance. As far as art and culture were concerned, there were worse places for him to be than Dresden. The 'Florence of the Elbe' at that time had a gallery of old masters collected by the great electors of Saxony, containing many famous pictures by Rembrandt, Vermeer, Dürer, Holbein, Breughel, Jacob van Ruisdael and others. Better still, there was in Dresden a young and brilliant art historian from Berlin named Wilhelm Bode, who had come to give a series of very popular courses on Flemish and Dutch painting. Dmitry attended them, and Bode soon noticed the young man sitting spellbound in the front row.

Everything was in place to completely enthral Dmitry and nourish his growing passion for the old masters of European art. Again, as in a Russian fairy tale, it was as if a mischievous spirit had conspired to pervert the designs of his father and replace them with a meticulous programme of education that would create yet another collector son, this time one specializing in classical works.

But Dmitry had to wait another twelve years for this education to bear fruit.

The grand duke's grenadier

In 1878, after two years of commercial training in Dresden, Dmitry had to don the grey and red cap of the 8th Moscow Grenadier Regiment of the Grand Duke Friedrich of Mecklenburg-Schwerin. The 8th Grenadiers, the result of a favour granted by a tsar to a princely German dynasty, were in fact the traditional regiment of Moscow and had their barracks on the outskirts of the city. In its reserve battalion, Muscovite conscripts, officers born into the nobility and regular soldiers from both the common people and a few families of the *kupechestvo* were initiated into the delights of Alexander II's national service programme. Exactly who was conscripted was something of a lottery, and as usual there was a degree of corruption involved. Nikolai Shchukin had escaped conscription because he was the eldest son and so was the support of his family; Petr resided abroad; and Sergei was eliminated because his stutter was incompatible with the need to give orders clearly. Therefore Dmitry had to carry the can for the whole family; one suspects that his father may have thought privately that he needed a dose of reality.

Whatever the cause, the dose was very painful to Dmitry, who found himself ejected from the artistic university atmosphere of Dresden into a rough community of poor, illiterate, superstitious, heavy-drinking young men capable of immense violence. Poor Dmitry, a plump *petit-bourgeois* with soft white hands, had to learn how to handle promiscuity, mockery and – worst of all for a Shchukin – persistent humiliation. Petr relates the story of how Dmitry went to a barber to be shaved, as was his habit, only to find himself turned away by the doorman with the words: 'Move along there – we don't want any dirty soldiers here!'[2]

Dmitry's period of conscription was only one year. In 1878 he returned to civilian life. His father felt that his training programme was not yet complete, however, especially given that the time was rapidly approaching when the firm would have to make some major strategic decisions. Nikolai came back from Leipzig and was soon joined by Sergei; Petr arrived from

Lyon after six years away from Russia. Their father proceeded to found his new trading firm of I.V. Shchukin & Sons with his three eldest sons as partners. As for Dmitry, he was sent as a 'volunteer' to Riga in Latvia, which was then a province of the Russian Empire. He spent another four years on the shores of the Baltic, no longer in the textile business like his brothers, but in the offices of a company called Schmidt, which was a local industrial conglomerate that manufactured cement and butter. After years of working for nothing, he now received an annual salary of 900 roubles – scarcely more than the 2,000 francs that Petr had earned while working for Warburg & Co.

Dmitry finally returned to his family in 1882, when the decisions had all been made: Sergei, displaying intrepid energy and anticipation, had installed himself as his father's right-hand man. Ivan was delighted to discover a pupil so receptive, so motivated and so gifted to whom he could pass on all the finest secrets of his profession, as well as his irreplaceable knowledge of the storehouse and of the strategic Nizhny Novgorod annual fair.

The partnership was already doing very well, and business had taken off in earnest. I.V. Shchukin & Sons was dressing elegant women and filling their houses with sumptuous hangings and beautifully designed art nouveau curtains, all based on the textiles of India, Central Asia, China, Japan and France. At the same time, the company was mass-producing all manner of other items with dizzying rapidity in the three factories it controlled. Orders were immediately processed by the Bank of Moscow, which was funded by Ivan Vasilevich and his friends. When Dmitry finally took his place as a partner at the top table of I.V. Shchukin & Sons, he did so as a replacement for his elder brother Nikolai, who, as we have seen, had left the firm to become one of the four directors of Danilovsky, the biggest textile manufacturer in Moscow. In this way, Danilovsky became tied to the Shchukin empire, which centralized profits and decentralized difficulties by 'having everything made by others'.

Resigned to this state of affairs, Dmitry did his best to carry out what was asked of him by his father. But he found himself swept up in the mad rush of triumphant capitalism: he simply didn't know how to say no. Nor was he particularly charming: in fact, he was arrogant and haughty when

he should have been cordial; hesitant and ill at ease when the situation called for decisive action. The timidity he had developed during his spell in the rough masculine communities of school and the military served him ill in the harsh reality of Moscow commerce; for the genteel *kupets* merchants who expressed themselves in French in the fashionable salons of the capital could quickly revert to their true horse-trading natures. During this period, the management of I.V. Shchukin & Sons was completely reorganized; with Nikolai gone, Sergei, now the undisputed heir, was openly preparing to take his father's place. Petr had assumed the role of faithful deputy, bringing with him all the experience he had acquired in Berlin and Lyon. What role could Dmitry play in this family alliance of commercial barons, bent on mapping the industrial future of a great enterprise?

His response was to do as he was told as modestly and as well as he could. No doubt he was often to be found 'sitting in the storehouse', maintaining a silent, somewhat idle presence that nonetheless made it clear that the Shchukins were keeping a close eye on things.

In the spring of 1890, Ivan Vasilevich Shchukin decided to restore the family vault in the cemetery of the Pokrovsky monastery, and renovated the tomb of his father, Vasily Petrovich, the founder of the Shchukin line in Moscow.

That autumn he himself felt unwell and from time to time was seen to limp. During a Sunday lunch on 2 December, he had a seizure and was taken upstairs to lie down in his office. Petr narrates the story:

> It all happened very quickly. Our good father died of a heart attack at 72 years of age, in the presence of our mother, Sergei and his wife, Dmitry, Vladimir, Ivan, myself, our sister Antonina and her husband. Our brother Nikolai arrived later that night, too late to see him again alive. Later we were joined by our sisters Nadezhda, who arrived from Tula, and Olga, who came from Novo-Tavolozhanka, with their respective husbands. [The eldest sister Alexandra was living in Leipzig with her husband].[3]

Ivan's funeral was held on 5 December at the Parish Church of the Resurrection of Christ on Ostozhenka Street. Among those who attended

were members of the Kupets Society, members of the municipal Duma, a full complement of relatives, and a large crowd of friends, acquaintances, admirers and bystanders. Flowers festooned the coffin. Particularly noticeable was a handsome wreath contributed by Ivan's long-time best friend, Kuzma Soldatenkov, bearing the words: 'In Memory of 52 Years of Friendship.' The coffin was carried on the shoulders of Ivan's workers, who had requested this honour, from the church to the Shchukin vault at the Pokrovsky monastery on the other side of the city.

Ivan Vasilevich deserved his eternal repose. Having begun in a two-room Taganka workshop with nothing but a weaver's loom, he was carried to his final resting place by a crowd of his own workers. He knew that his succession was safe, even though the unexpected winner was a stuttering outsider, who just happened to be extraordinarily gifted. This was yet another classic lesson of the *kupechestvo*: have plenty of sons, and life will choose between them. Sergei had already presented him with three grandsons.

Ivan did not live to know that his ambitious plans would be thwarted by the approaching twentieth century and that the *kupechestvo* would be obliterated for nearly a hundred years. And he could hardly have guessed either that his disciplinarian educational programme would have surprising consequences or that his sons would raise the act of collecting to an art form in itself.

It was Sergei, Ivan's chosen heir, who would assemble the most beautiful collection of modern art of the twentieth century; but the tenacious Petr deserves credit for building his own palace of marvels, as does the gentle and modest Dmitry, who put together a remarkable collection of his own. It was perhaps less dazzling than those of his brothers, but it was exquisitely balanced, discreet and in flawless taste – in the image of Dmitry himself.

The Allegory of Faith

Dmitry Shchukin – whom the art historian Igor Grabar was to call 'God's creature' – inherited part of his father's fortune, along with a comfortable income from his shares in the family business. Above all, at thirty-five years of age, he was free of Ivan's constant vigilance.

He lost no time in building the life of which he had always dreamed. Every autumn he went to Germany, returning to Moscow only at the end of January, and with the coming of spring Dmitry would again leave Russia bound for Italy. But he did not abandon his comfortable Moscow home for the pure air and luxury hotels of Europe. His existence appeared to be carefully regulated and not particularly exciting; but in reality – like all the Shchukin brothers – he allowed his passions full rein. His greatest and most authentic passion was for Dutch classical painting, which had never ceased to haunt him since the day he left Dresden and the lecture hall of Professor Bode.

'It was the Dutch – of whose canvasses he would eventually own about sixty – which gave the collection a feeling of proximity, intimacy and exclusive harmony, which one so rarely saw in the colourful collections of Moscow,' commented the review *Chez les Collectionneurs*, highlighting the consistency of the Dmitry Shchukin collection. 'It contained no master-pieces, but at the same time not a single dubious picture.'[4]

Dmitry's early forays into collecting were modest. He started with porcelain, small silver objects, a miniature on ivory, a gold snuffbox, whose ornamentation he would scrutinize with a magnifying glass. He then ventured into paintings with the obsessive prudence he had learned from the trials of his youth, starting in Berlin.

In the nineteenth century, Berlin was considered to have the best museums of any capital city in Europe. German art historians had un-rivalled expertise in old paintings. And among them was Wilhelm Bode, who had become one of the most respected authorities in the field and an expert on Flemish and Dutch painting. Dmitry had never forgotten his early teacher; now, ten years on, Bode had become the director-general of museums in Berlin and had acquired a reputation as the 'Bismarck of the museums'. Reunited with his enthusiastic former pupil, he guided Dmitry's first steps as a collector.

It would seem that Dmitry bought his first painting in 1893, on Bode's recommendation: *Ice Skating*, a small canvas by the seventeenth-century painter Hendrick Avercamp of Amsterdam, who painted scenes of daily life in the towns and countryside of Holland. His next purchase was *The Music Lesson* by the Dutch portraitist and genre painter Gerard ter Borch,

also from the seventeenth century. Today these two pieces are the pride and joy of the Pushkin Museum's rooms of minor Dutch masters.

Although his early acquisitions were made in Europe, Dmitry bought most of his subsequent paintings in Russia, principally Moscow. At the end of the nineteenth century, the magnificent remnants of the famous aristocratic collections of the past could still be bought at auction in Russia. When the heirs of Alexander Vlasov, an eighteenth-century collector married to an extraordinarily rich countess who had plundered Europe, decided to disperse his collection, Dmitry was able to secure two major works by David Teniers the Younger – *The Jester* and *The Cabaret*.

Mikhail Savostin of St Petersburg, who was at the time the most important antiques dealer in Russia, counted Petr and Dmitry Shchukin among his principal clients. He had this to say about Dmitry: 'He was a confirmed bachelor, and so could devote all his time to art. By day he visited the museums and the dealers; in the evening he consulted books, catalogues and prices at auction. I am quite sure that there is no other collection in existence that has been constituted with as much knowledge and hard work as his.'[5] Savostin also remarked that Dmitry Shchukin was only interested in pieces with indisputable provenance. He paid very close attention to certificates of attribution and never bought anything on impulse or without due diligence.

He regularly brought his latest acquisitions to Berlin, where their authenticity could be checked. He dreaded the idea of possessing an ordinary work or a forgery – this at a time when there were quantities of fake Flemish and Dutch pictures on the market. Indeed it was his extreme prudence that led him to overlook *The Allegory of Faith*. This was perhaps his worst moment as a collector.

The Allegory of Faith was a large canvas. Its allegorical subject matter against a realist Flemish background cast doubt on the somewhat clumsy signature of Gerard ter Borch the Younger. Ilya Ostroukhov,[6] a painter, collector, cousin and friend of the Shchukins, had sold the picture on to Dmitry Shchukin in 1898, not concealing his scepticism about its authenticity.

A year later, in 1899, Dmitry, at the instigation of Ostroukhov himself, decided he would get rid of the picture, because it detracted from the

rigorous authenticity of the rest of his collection. He took it to Berlin, where he was happily surprised when an antiques dealer, satisfied with the technique of the painter, agreed to buy it from him for 700 marks. A few months later, Dmitry read in a specialist magazine that Dr Bredius, director of the Mauritshuis in The Hague, had just bought a canvas entitled *The Allegory of Faith* from a Berlin dealer, having identified it as a painting by the great Vermeer of Delft.[7] The value of the picture was estimated at 400,000 marks! Dmitry used to tell the story of his disappointment with good grace, taking consolation from the fact that two of the finest Russian connoisseurs of art had got it hopelessly wrong and had allowed the only Vermeer in Russia to slip through their fingers.

However, this misadventure did not cloud his fame as a collector. Very few people in Russia had any idea of his reputation among the curators of Berlin. Savostin, who at one point happened to find himself in Berlin at the same time as Dmitry, was bowled over:

> During my stay, I realized the attention and respect that were afforded to Dmitry Shchukin. At the Kaiser Friedrich Museum, the porter was so reverential that he carefully placed our galoshes on the table when we arrived. Inside the museum, Dmitry Ivanovich seemed to be completely at home; he had barely to indicate that he wanted to see something more closely for all the display cases to be thrown open.[8]

Savostin was among the very few people who knew of Dmitry's extreme generosity: if a tiny detail in a canvas that he had just bought displeased him, he would immediately offer the picture as a gift to one of the museums he so regularly visited. It's hardly surprising that restorers rushed to execute any work commissioned by him, putting all their other tasks on hold.

Dmitry Shchukin remained a bachelor to his dying day. Nothing is known of his private life; if there was some Mademoiselle Bourgeois in the background, she (or he) remains a secret. His privacy remained impenetrable. He was addicted to his paintings and his miniatures and kept them well out of sight. In contrast to his brother Petr, Dmitry never dreamed of building a great storehouse for his collections; nor did he allow the public to see them, as his brother Sergei did.

Between them, the Shchukin brothers possessed every facet of the collector's passion. Petr exemplified relentless accumulation of things and palaces to fill the void within himself. The vision of the art of the future, imposed through a series of astonishing battles, would be Sergei's. But Dmitry was the incarnation of patient search. According to circumstance, he could be a fisherman waiting for a big fish, or a hawk stooping to snatch its prey. The result in both cases was the same; but if the piece lost its attraction, it was given away without a flicker of regret. He was a Don Juan of objects, and perhaps this explains the opacity of his private life.

As for the works that were dearest to him, they had their place in the collector's secret cocoon. In 1922, there were 127 pictures there – relatively few to show for twenty years of assiduous collecting, yet quite enough. These were the pictures that had chosen him more than he had chosen them. The others, whose promise faded, had to take their chances in any museum that would take them. And this was probably why Dmitry had so little regret for the loss of the Vermeer. Who cared about the signature of a master? More important was the fact that the painting and the collector had failed to bond.

Faithful to his teenage passion, Dmitry Shchukin chose the Rumyantsev Museum to receive his principal gift. In 1897, only four years after starting his collection, he made a first donation of thirty-two pictures. The museum counted on generous donors to enrich its collections, and given that he had been an honorary member of the museum since 1903, its administrators probably suspected that Dmitry Shchukin intended to bequeath his collection, even though he kept his decision secret.

The secret actually emerged by chance, through an error in the magazine *Starye Godi* (*Years of Old*), which described the liquidation in 1908 of 'a Shchukin collection' in Paris. The author of the article confused Dmitry with his brother Ivan, whose classical Spanish paintings, furniture and objects were dispersed after his tragic death to cover his debts (to which we will turn in the next chapter). But even so, Dmitry bided his time and did not publish any kind of denial until 1914, when he wrote to the same magazine: 'I have not sold my collection of paintings abroad. The entire collection remains in Moscow, and I would add that from time to time new acquisitions for it are being made.'[9] He went on to clarify that he planned to leave the collection to the Rumyantsev Museum in Moscow on his death.

Dmitry Shchukin and Soviet Russia

This generous gesture was quickly forgotten. The war and the revolution shattered the lives of millions of individuals, including Dmitry Shchukin. He could not contemplate leaving Russia – his treasures were so much a part of his life that he could not conceive of living without them.

The revolutionary authorities did not ignore culture and were careful to facilitate the people's access to art. The D.I. Shchukin collection was renamed the Museum of Old Western Painting No. 1 and opened in Dmitry's house off Arbat Street. Dmitry himself was appointed assistant curator and allowed to live quietly in his own home.

The museum in Dmitry's former townhouse subsisted for two years before suddenly being replaced by an American association for the assistance of famine victims, which took priority at that time over Dutch paintings. Everything had to be wrapped up and removed. At the same time, the Museum Affairs Committee began to share out artworks according to the modern scientific criteria adopted by the Soviet system.[10]

As for Dmitry Shchukin, the People's Commissariat for Education (Narkompros) did not ignore the merits of this 'capitalist': he was named a member of the Scientific Council of the Fine Arts Museum and chief curator of the Italian Section. The Committee for Museum Affairs provided him with a room on the ground floor of the Museum of Modern Western Painting No. 1 – the new name given by the revolutionaries to his brother Sergei's former collection. Thus Dmitry was lodged in the Trubetskoy Palace at 8, Znamensky Lane, in the ground-floor servants' quarters of the former home of his brother Sergei, who had by then emigrated to France.[11]

Who would ever have recognized in the blind old man, tapping his way down the long corridors of the palace, the celebrated collector Dmitry Shchukin? He died in 1932 at the age of seventy-eight, and was buried in the Miusskoye cemetery. Nobody knows exactly where his grave is located.

CHAPTER V

Ivan Shchukin
Portrait of the Younger Brother as a Parisian Dandy

Ivan Ivanovich, the youngest of the Shchukin brothers, believed that Paris was the best place in the world, the only city a civilized man could inhabit. Indeed, he lived in the French capital all his adult life.

Petr built a palace full of marvels; Dmitry created an intimate harmony of lesser masterpieces; Sergei revealed modern art to the world; and Ivan . . . Ivan was to be a Parisian of the first water: an exemplary Paris dandy through and through, just like Stendhal was a Milanese. He dazzled, and then was abruptly extinguished.

Nearly fifteen years separated Ivan, who was born in 1869, from his four elder brothers. In that intervening period, his parents conceived several daughters plus Vladimir, who was two years Ivan's senior.

Ivan turned twenty in 1889. His elder brothers had passed this landmark back in the 1870s. Everything had changed in the interval: the night-watchmen no longer carried halberds and tallow candles had vanished for good. Ivan's life was illuminated by electricity. He used hot and cold running water, and before long he was using a telephone. Having grown up in the enlightened Muscovite *kupechestvo* milieu of the 1880s, he inherited from his mother the Botkin predisposition for an aristocratic and westernized way of life.

He belonged to a new generation – that of the 'Silver Age', as the Russians call the *fin de siècle*. It was a time that belonged to him and his

Petersburg contemporaries, the future founders of the Mir Iskusstva (World of Art) group.

Ivan Ivanovich found the absence of taste that prevailed in Russia very hard to bear and the Asiatic soul of Moscow got on his nerves. He hastened to Europe, towards the 'west and its running waters'. He immediately fell in love with Paris and, as he himself explained, he quickly and easily became accustomed to the 'heady wine – or is it an insidious poison? – of the European way of life'.[1]

The education he received, with the blessing of his parents, played a decisive role in his transformation into a westerner. When he was born in 1869 his mother was forty-five years old. Her youngest son, her 'Vanya',[2] was lucky like his brother Sergei: she adored him. There was no question of German boarding schools in Finland or St Petersburg. Up to the age of fifteen, Vanya would study with Vladimir and his sisters at home, with his father's battalion of governesses and instructors.

Rich, privileged Muscovites had a choice of two establishments for the secondary education of their children: fifteen years earlier, Dmitry had been enrolled at the Polivanov Gymnasium, but Ivan and Vladimir attended the ultra-chic Tsarevich Nikolai College on Ostozhenka Street, close to Prechistenka Street. Nobody would have guessed that Ivan Shchukin was the son of a *kupets*. Like his elder brother Nikolai, his tall, refined and elegant figure spoke of his Botkin antecedents. There was no hint of the stocky peasant looks and small Asiatic eyes of his other brothers. 'He had intelligence, wit, and talent, but no depth,' wrote Igor Grabar, with the hindsight of age and communism in the 1930s.[3] In the mid-1880s, however, when they were together at college and then at the law faculty, Grabar felt more admiration for his schoolmate: 'He amazed me with the extent of his knowledge. His memory was phenomenal and he read ceaselessly in Russian, French and German. Ivan Shchukin not only knew all the Russian painters, but also the French, German, Spanish and English ones. He could reel off details about them that I was ready to listen to all day long.'

It was at the law faculty of the University of Moscow that Ivan developed his judgement and interest in Russian history and the history of religion, in which he became a specialist, just as he was a specialist in art.

While he was still a student, from 1890 onwards he collaborated with different newspapers. 'Wrote relentlessly in the Russian press for 5 kopecks a line.'[4] The wretched wage and the mercenary work this involved didn't put him off. He knew how to express his thoughts with concision and brio, and he had a sharp wit and a direct style. He wrote essentially about art, but he never lost the laconic precision he had learned in the world of journalism.

Philosophy, literature and art all came easily to him: western and Russian, ancient and modern. In 1893, at the age of twenty-four, he published his first paper: 'Biron in an engraving by Ivan Sokolov: a page in the history of Russian iconography'.[5]

Aquarelles Parisiennes

That same year, Ivan Shchukin moved to Paris.

Everything happened as if foreordained: with the death of his father in December 1890, and the sale of the big house, the two younger brothers and their elderly governess Emma took an apartment close to Tverskaya Street, close to the English Club, while they completed their university studies. Two years later, the health of Vladimir, who had been delicate and hunchbacked from birth, deteriorated even further and Ivan took his brother to Paris to consult the best French doctors. With this journey, Ivan's personal dream came true, but for Vladimir the outcome was not so happy. He barely had time to fall in love with Cécile Sorel before he died, on 30 August 1895, of tuberculous meningitis. Ivan had lost the one human being he loved the most. He accompanied his brother's body back to Moscow and was present at his funeral.

Afterwards, Ivan returned to Paris with a 'selfish feeling of relief': his last tie to Russia was broken. He was twenty-six years old and, in conformity with his father's will, he now had full control of his inheritance and was receiving dividends from the family firm, punctually remitted by his brother Petr. His total income amounted to around 2,200 roubles per year.

A master of seduction, he quickly became a well-known Parisian man-about-town and a familiar figure in the city's artistic and intellectual milieux. He had no ambition to conquer the town in business or politics, so the next

best thing was to secure a position in the sphere of thought. He took the shortest route, which for him – given that he already had Moscow credentials as a writer – was journalism. He became the Paris correspondent for various St Petersburg newspapers – *Novoe Vremya* (*The New Era*) and *Peterburgskie Vedomosti* (*St Petersburg News*) – and then for art reviews such as *Vesy* (*Scales*), which took over from Diaghilev's *Mir Iskusstva* (*World of Art*). As a connoisseur of the media, he wrote under the transparent pseudonym of 'Jean Brochet' (Jean is the Russian equivalent of Ivan, and Shchukin comes from the Russian word *shchuka*, meaning 'pike' (as in the fish), or *brochet* in French). After a while, he compiled his Paris reports into a single volume under the title *Aquarelles Parisiennes*. It was done quickly and well. Now he had a book under his belt, even though it was self-published.

Publishing one's own books may have been perfectly acceptable in good French society, but journalism was less so. Newcomers to the intellectual circles of Paris were expected to show depth. Well aware of this, Ivan Shchukin constructed for himself an irreproachable academic framework, leaning towards the progressive, as was expected in Russian expatriate society. Between 1901 and 1902, he taught in the Russian École Supérieure des Sciences Sociales, a private university institution founded by the leader of the Democratic Reform Party, Maxim Kovalevsky. For a token school fee of twenty francs a year and with the support of liberal donors, the school offered three years of political and social studies, open to all and entirely free of imperial censorship. Among the teachers were a number of more or less revolutionary émigrés: between 1902 and 1903, Lenin himself was a teacher there. Ivan was in good company.

'The entire history of religion rests on my shoulders,' wrote Ivan to the philosopher, university professor and symbolist poet Vyacheslav Ivanov, whom he recruited as a reader.

> The job is overwhelming: I have to teach the history of the first three centuries of Christianity. The central feature of my course is the influence of Greek elements within the Jewish faith, in other words the Hellenization of eastern doctrines. At the moment I'm still working on Judaism before the birth of Christ and naturally I won't have time to complete the programme this year.[6]

Even today, university academics seldom complete their courses, and so there was nothing odd about this – except, perhaps, the yawning gulf between Ivan's Old Believer convert father, who never missed a mass in the Orthodox cathedral on rue Daru when he was in Paris, and his youngest son, who was now busy teaching religion from a scientific standpoint.

Ivan was to find his niche at the École Nationale des Langues Orientales, where he taught Russian history. Later he donated to this school part of the magnificent library of philosophy and art which he had put together over the years. The remarkable value of this donation earned him the title of Chevalier de la légion d'honneur, quite something for such a recent arrival.

Nevertheless the real and undeniable success of Ivan Shchukin lay in the artistic, political and thoroughly urbane group of people that he managed to assemble around him in his spacious apartment at 91, Avenue de Wagram, near the Place des Ternes and the Orthodox cathedral. The apartment was in a fine corner building in one of the affluent bourgeois quarters of west Paris. It had high ceilings with plaster mouldings, marble fireplaces and a series of salons separated by double glass doors.

'Jean de Wagram's Tuesdays', as Ivan's former schoolmate Igor Grabar – now the Paris correspondent of the illustrated magazine *Niva* (*Grainfield*) – called them, were frequented by philosophers, historians, publishers, journalists, writers, artists and painters of all schools, both social and political. At various times they were attended by Dmitry Merezhkovsky, Petr Boborykin, Alexei Suvorin, Anton Chekhov, Vasily Nemirovich-Danchenko, Maximilian Voloshin, Alexandre Benois, Sergei Diaghilev and Konstantin Balmont, among many others. The talk went on late into the night, with Ivan's inner circle of friends: the Pushkin admirer and collector Alexander Onegin-Otto, the Polish historian Kazimierz Waliszewski, Ivan's painter cousin Fedor Botkin, the poet philosopher Vyacheslav Ivanov, and Igor Grabar himself. Very quickly (as always among émigré communities whose members are briefly or permanently exiled) news spread of the existence of a marvellous oasis near the rue Daru, and it was felt to be a great honour to belong to that circle. Moreover, no recommendation was necessary: Ivan's salon was open to all artists and intellectuals.

There had been a Russian colony in Paris for more than half a century, but few of its members, apart from Turgenev, had been able to penetrate the French intellectual élite. Most Russians in Paris were limited socially to groups of their own compatriots. But Ivan Shchukin, who belonged to a family of Muscovite traders unknown in Paris, managed to achieve a celebrity that extended well beyond his fellow Russians. One wonders today what form of magnetism attracted such differing personalities as the artists Rodin, Degas, Renoir and Zuloaga, the art dealer Paul Durand-Ruel and the writer Joris-Karl Huysmans to his salon.

Andrei Bely was there too, naturally:

> I remember Shchukin, our host; he was pale, somewhat distracted, his head hanging sulkily, hiding his blue eyes behind his spectacles as if he were sucking a lemon. He had a high forehead with lines of wrinkles across it.[7]

Ivan delighted the people who flocked to his house. He always made sure that there was plenty of champagne and brandy on offer. His extravagance, his knack of unexpected irony and his *kupechestvo* hospitality and munificence delighted everyone. At the same time, he had to pay the price of all Parisian success, as a target of petty gossip and mockery:

> Read some of Shchukin's *Aquarelles Parisiennes*. Not entirely devoid of talent, but his hostility to the émigré Russians is rather coarse . . . lunch at Shchukin's – bile and cynicism . . . Dinner with Serge at Shchukin's mistress's house – a strange crowd – salacious conversation – Shchukin very much out of place, easy cynicism, gossip.[8]

Benois may have sniped privately, but he would never have refused a dinner or an exhibition in the company of Ivan Shchukin. When you were with him, every door opened as if by magic. You might suddenly find yourself at the chicest, most inaccessible party of the moment, at the summit of Paris society or at its lowest depths. People were jealous of Ivan, disparaging his arrogance and cynicism; but they all helped themselves to his contacts, his knowledge and his money.

Of course, he was aware of the spiteful epigrams that swirled around the Parisian village (then as now). With few exceptions, memoirists and chroniclers stressed his disdain for Russia and the Russians, and well before his arrival in Paris he had shown a propensity for wit that could be immediately circulated with devastating results. Nor was he any gentler, as Benois reports, with the Russian émigrés he found himself among in Paris. The Russian roots (which he himself openly acknowledged) went unmentioned, as did his work and his teaching on the subject of Russia. Paradoxically, in spirit he could never leave the country to which he would never allow himself to return.

'When one lives abroad, one sees Russia in a better light and one idealizes it unconsciously,' he wrote three years after moving to France. 'The pitiless critic of the society of his own country is transformed, when he is far away, into an ardent defender of the motherland.' Ivan did not suffer from the nostalgia for Russia which was – and is – so frequent among his compatriots; but still his ties to it were very strong. Distant Moscow, as it grew more and more foreign to him, had left in his heart 'many memories that are very sweet, though tinged with sadness'.[9]

Portrait of the Minister for the Arts

Behind the gleaming facade of Jean de Wagram, the constant parties and the short-lived love affairs, doubt began to gnaw at Ivan Shchukin. His intelligence obliged him to view himself objectively. He was blessed by nature with a good memory, talent and a lively wit, but he wondered if his broad erudition did not betray a culture that was superficial overall. He could improvise a brilliant off-the-cuff lecture on the influence of Jewish Christians in the devising of the Koran, or silence a foolish Marxist; but what really had Jean Brochet achieved, now that he was well over thirty?

He was a luxury host. Everyone of note in the spheres of art and Russian intellectual controversy flocked to him, all the more enthusiastically given that his bar was open and well stocked, and the drinks were free. He was a motionless agitator: the best he had to offer was neutral ground at a time when the revolutionary struggle was pitiless, warning his guests in advance

when people of violently opposed views would be at table that night. Russians abroad had to have somewhere to meet and talk.

'You tell me that my country needs me,' he wrote to his cousin's husband, Ilya Ostroukhov, 'but in my country I would have to abandon the work I do at the moment, or risk being attacked because of my ideas. As for other occupations, no one has proposed any other occupations to me in Russia. Listen, Benois became editor of a new review, *World of Art*. He knows me well, in Paris he comes to my house; but in Russia he didn't even bother to send me his book on painting.'[10]

Furthermore, Ivan's brothers regularly visited Paris. They knew exactly where he was financially and they knew that to live life on the scale he did with an annual dividend of 2,000 to 2,500 roubles (depending on the year), he would have to be dipping into the money he had inherited. Anyone who lives on capital goes to the wall sooner or later. Ivan's brothers saw the way he was living; it worried them – and they were right to worry.

Ivan Shchukin had many faults, one of which was a temperament slightly divorced from reality. Nevertheless, in this case he understood what was going on and he had a plan. His interests may have been eclectic, but he had acquired unique professionalism and a basic culture in one specific domain – that of art.

That Ivan Shchukin should, like his brothers, have been a collector is scarcely surprising. Indeed, given his context and precedents it could hardly have been otherwise. Unlike his brothers, though, Ivan actually *began* his adult life in the sphere of art. While at school he had fascinated the future painter and art historian Igor Grabar with his knowledge of painters and painting. With his monograph about an eighteenth-century engraving Ivan was already an established expert at the age of twenty-four. What use was that to him in Moscow in the 1890s? Not much: the city was in the early throes of a new symbolist western art movement, World of Art. The assimilation of art nouveau and the incorporation of the decorative arts into art proper was led by the Petersburg group of Serge Diaghilev, Alexandre Benois, Leon Bakst and a few others. Ivan meanwhile complained that he had not been invited to take part.

On the other hand, having invented for himself the personage of Jean de Wagram, he had constructed a remarkable network in the most promising

territory of his time: the Parisian art scene. Most of the protagonists, artists, galleries and collectors on that scene came to his house. Ivan Shchukin, a collector who was as obsessed with collecting as any of his brothers, could expect a reasonable return on his investment, without having to spend years sitting in the storehouse of I.V. Shchukin & Sons.

His collector's temperament was different again from any of his brothers: he was a collector-dealer, buying and reselling and gradually perfecting his collection, while financing it through sales that were as adroit as his purchases: he mixed drawings and pastels (which could be moved on quickly, for low prices) with the opportunities offered by more expensive oil paintings.

His expertise in the market, his friendships with gallery owners and the taste for collecting that was common to all his family soon bore fruit. Ivan began by buying contemporary impressionist French paintings. After 1896, the name of 'Stchoukine' (diabolically awkward to transcribe into French!) had begun to appear regularly in the registers of Paul Durand-Ruel and, soon after, in those of Ambroise Vollard; Vollard opened his gallery on the rue Laffitte in 1893, the year Ivan arrived in Paris. Petr and Sergei were known to the Paris dealers by their first names, but in the trade, 'Stchoukine' always meant Ivan. The back of Degas's pastel *Après le Bain*, now in the Neue Pinakothek in Munich, is inscribed by the artist with the words '*A Monsieur I. Schoukine*'. As for Édouard Manet's *Portrait d'Antonin Proust* (Manet painted several portraits of his great friend, the first Minister for the Arts of the French Republic in 1881), Ivan sold it to Ilya Ostroukhov, which is why it is to be seen today in the Pushkin Museum in Moscow. 'Paris Minister for the Arts'! For Ivan, this was irresistible – after all, his brother Sergei was known as the 'Moscow Minister of Commerce'.

The catalogue of artworks that Ivan sold at auction at Drouot in March 1900, when he decided to change the direction of his collection, was entitled 'The Collection of an Amateur'.[11] The sale included twenty-three canvasses and nineteen drawings and pastels, and included two very fine Cézannes which he had bought from Vollard: *Nature Morte, Pot vert et Bouilloire d'Étain* and *La Maison Rondest, Quartier de l'Ermitage à Pontoise* (the title in Ivan Shchukin's collection was *Maison à la Campagne*). Ivan was the first Russian – well before Sergei Shchukin and Ivan Morozov – to believe in the man who was destined to be known in the future as the 'painter's painter'.

The sale also included works by Carrière, Daumier (*Don Quichotte*), Degas, Fantin-Latour, Forain, Guillaumin, Manet, Moret, Puvis, Raffaëlli, Renoir (*Portrait d'Alfred Sisley*), Sisley himself, Vallotton, Whistler, and a painting by Van Gogh (*La Maison de Campagne*) which later appeared in the reception room of the great French collector Gustave Fayet. These were the first artists chosen by Sergei Shchukin, Petr Shchukin and Mikhail Morozov when, in 1898, they began their own collections of French impressionists.

All three had the active assistance of Ivan, who on this occasion played the role of intermediary and bringer of bargains. Here he had a real source of revenue, in the clients who came to his house on the Avenue de Wagram. It was thanks to Ivan and his personal relationship with Durand-Ruel that Petr was able to acquire his fetish painting – the great Renoir nude that the dealer had thought to keep for his own personal collection.

All this shows that Ivan set out to occupy a prominent place in the Paris art market, to acquire a reputation and to earn a living thereby. When we examine his choices and his modus operandi, we see that every opportunity was presented to him, but he was still unable to satisfy his own need for money. This perhaps explains his attempt to move a step higher on the scale and his change of direction towards the great Spanish masters – and the disaster that followed.

In 1900, Ivan sold his paintings by Degas, Carrière, Cézanne, Monet, Renoir, Van Gogh, Forain and Whistler, after guiding Sergei's first steps in the direction of these artists. 'The modern artists are giving way to old masters,' he explained to Ostroukhov, who would go on to become the rediscoverer of the classic Russian icon.[12] Ivan was much influenced by the fashionable Spanish painter Ignacio Zuloaga, who saw himself as heir to the classical Spanish artists. Canvasses by El Greco, Zurbarán, Murillo and Velázquez began to throng the walls of the apartment on Avenue de Wagram.

They reflected Ivan's conviction that he could become a great art dealer and thus pay for his costly investment in the personage of Jean de Wagram, which he no longer had the means to cover. To do this, he launched himself into collecting and dealing in paintings by classical masters, notably Spanish ones, leaning heavily on Zuloaga's experience. In 1905, he organized a trip to Spain with Zuloaga, in the company of no less a figure than the elderly Auguste Rodin.

From the start, this expedition was beset by controversy. Of the nine El Greccos that the trio brought back to France, seven were shown to be forgeries and an eighth was of dubious provenance; the ninth, *The Opening of the Fifth Seal*, was an authentic masterpiece.[13] Zuloaga had reserved this painting for himself, and it became the pride of his studio in Montmartre. Picasso saw it when the two men were neighbours in 1906–7, and subsequently it became the inspiration for his own *Demoiselles d'Avignon*, for which he exactly reproduced its format.[14]

We can only conclude that Ivan Shchukin had an exceptional gift for fruitful contacts, prophetic intuitions and grand ideas that made him no money whatsoever. Today, just as it has always been, old master collecting is a high-risk enterprise (one thinks of the elaborate precautions and top-class expert opinions deployed by Dmitry Shchukin before he bought anything). Rumours of counterfeit pictures circulated like wildfire. Alexander Onegin-Otto, Ivan's close friend and an avid collector of artefacts and documents relating to Pushkin, summed it up as follows:

> I know for certain that he was comprehensively swindled. Somebody did a copy of a Velázquez and sent it to a remote village in Spain, or better still, to a monastery in the mountains. The local priest or the prior were duly bribed to hint to Ivan Shchukin that this was an authentic Velázquez which could be bought for a song and replaced with a copy.[15]

Onegin-Otto tried to warn Ivan of this ploy. But Ivan would listen to no one. He desperately wanted to believe in his own talent as a great dealer, and he needed, like his brother Sergei, to feel that he was better than anyone else at whatever he did.

His affairs swiftly became more complicated. Pursued by his debtors, he chased sales and clients. As Kovalevsky remarked:

> These paintings were not just sold to Russians and Americans who were unable to spot a fake. Matters took a tragic turn when a buyer from Berlin threatened to take Ivan to court; whereupon his status as a self-proclaimed expert collector of classical paintings began to turn

distinctly sour. He could not face the damage that had been done and was unable to repair it.[16]

Ivan's brothers were well aware that for him the only way out was to pay his debts by selling his entire collection. They had got wind several years earlier of 'Vanya's' fruitless efforts to do just that.

In a letter from Berlin to Petr, dated March 1905, Dmitry Shchukin wrote:

Professor Hauser[17] tells me that our dear Ivan recently contacted the Berlin Museum offering for sale his paintings of the Spanish school: 22 El Grecos and 32 Goyas. I am afraid he is in serious trouble. It appears that he has bought a mass of Spanish pictures through an intermediary, the painter Zuloaga . . . Hauser told me that authentic pictures by these masters are worth a great deal of money and that one has to be very careful of fakes, which are abundant in Spain. What a pity that poor Ivan has got himself interested in these painters . . .[18]

The Berlin Museum, which was already sceptical on the basis of the photographs sent to them, turned down Ivan's proposal. Nevertheless, Ivan managed to fix it for an auction to be organized. On 9 April 1907, the celebrated auction house Rainer and Keller offered ninety-three lots, mostly English and Dutch landscapes and still lifes, with some Italian and English portraits. Most of the Spanish pictures were unauthenticated and did not sell – though El Greco's *The Penitent Mary Magdalene* did, and is now in the Budapest Museum of Fine Arts.

The return from this auction fell far short of covering Ivan's debts. His precarious financial position threatened the affluent lifestyle to which he had grown accustomed, as well as his ambition of becoming a key figure in the art market. However, 'Jean de Wagram' provided his older brother Sergei with the perfect springboard to launch his own collection of French modern art, and his death would be an integral part of the tragic sequence which so afflicted the life and collecting activity of Sergei Shchukin – to whom we now turn.

Sergei Shchukin

An Oligarch in Moscow

'Sergei Shchukin was a dry man with black hair and a pepper-and-salt beard; his lips were plump and red. He appeared friendly and talkative; his intelligence was immediately plain to see . . . he was lively and constantly alert.' That was the verdict of Andrei Bely.[1] Others said that the scarlet of Sergei's lips came from the blood of his competitors. According to his eldest son, Ivan Sergeevich, his hardness in business earned him the nickname 'Porcupine'.[2] In town, he was irresistibly attractive. Alexandre Benois marvelled at his 'sparkling' temperament, and his 'highly coloured, brilliant, impassioned' manner. And Prince Shcherbatov joined the chorus: 'Shchukin knows no limits. He overflows with fire and zeal.'

The head of I.V. Shchukin & Sons bore no similarity at all to the sickly, stuttering child apparently destined for a short and painful life; nor even to the young man who had cured himself through physical exercise and speech practice. Indeed, Sergei had turned all these former handicaps to his advantage. First of all, he returned to work in the family firm earlier than Petr and Dmitry, who were absent for years. Otherwise only Nikolai was at home, the brother whose dream was to break free of the family.

Sergei, for his part, loved large-scale commerce and saw it as a fresh challenge. Through determination and talent, he managed to persuade his

father that he had been wrong about him. And Ivan Vasilevich duly chose him as his successor. Sergei ran the firm alongside his father before becoming its sole boss when Ivan died in December 1890. At no point was his accession disputed by his brothers.

In 1894, a decision was made by the Ministry of Finance and published in the commercial newspapers of Moscow:

> For distinguished service to national trade and industry, the title of Councillor of Commerce is awarded to Sergei Ivanovich Shchukin, an honourable citizen from a well-known family, vice-doyen of the Moscow Kupets Society and member of the Moscow section of the Council of Commerce and Manufacture.

This honorific title of Councillor of Commerce was hardly unusual: all the merchants of the First Guild received it. Meanwhile, 'honourable citizen' was a distinction invented by the ever-imaginative tsarist bureaucracy to reward non-nobles. But it was clear that Sergei had moved very fast. At the age of forty, just four years after taking over management of the Shchukin enterprise, his capacity to anticipate the movements of the market was legendary. His competitors tended now to align themselves with what he had decided to do, and this in turn made the market work as he had predicted. Thus the validity of Keynesian theory was proved in Russia, forty years before Keynes. Before long, people in Moscow were calling Sergei Shchukin the 'Minister of Commerce', a serious acknowledgement of his gifts. He had woven a vast spider's web of power, money and influence around them, not unlike the oligarchs of today's Russia.

Sergei Shchukin reigned over I.V. Shchukin & Sons, a textile empire stimulated by the rapid development of the middle classes in Russia and the headlong diversification of Russian industry. The Shchukins sold cotton, linen, wool and silk fabrics, scarves, household linen and clothes. They themselves manufactured nothing and made nothing. They merely controlled the production of most of the workshops and factories in Moscow and its surrounding region, by ensuring most of its distribution.

The business model inherited from old Ivan Shchukin and his long-time accomplice Kuzma Soldatenkov has not changed and still

serves as an example today. There was a firm employing a small number of workers, its capital controlled completely by a close-knit family and its creative executive (Sergei) directed by a skilfully organized management (Petr). This company controlled or influenced a network of client firms and subcontractors, who were kept in line by a system of cross-participation and seats on the boards of textile manufacturing companies, banks and insurance companies. There was also the beer concern that Ivan Vasilevich and Kuzma Soldatenkov so cherished: the Trekhgornaya brewery continued to prosper under the direction of Nikolai Shchukin, Sergei's elder brother.

The visiting card of Sergei the oligarch speaks for itself: he was a *kupets* of the First Guild, a councillor of commerce, a member of the Commercial and Manufacturing Council, an Elected Member of the Moscow Stock Exchange, a director of the Anchor insurance company, an administrator of the Moscow Discount Bank and the Moscow Kupechestvo Credit Company, and a board member of the Emil Zindel cotton mill. He even held a brief political mandate as a Duma deputy for the Moscow municipality, between 1897 and 1900.

The siren of the Dnepr

Any self-respecting *kupets* needed a family and as many children as possible, so that natural selection would produce a worthy successor. This had already been the case for two previous generations of Shchukins in Moscow. Sergei required a wife. But this was an extremely delicate manoeuvre for an oligarch of his stripe: he had to find the richest and most beautiful woman available. Among Old Believer *kuptsy*, divorce meant chaos, and impropriety was out of the question.

A suitable match was found. At nineteen years of age, Lydia Grigorevna Koreneva was considered one of the most beautiful girls in Moscow. She came from a family of landowners in Ekaterinoslav, Ukraine, who had made a fortune from the coal mines of the Donbass. She was a magnetic, inaccessible beauty, mysterious and melancholy. Her big, sad eyes and graceful figure made her an ideal model for the nymphs and naiads so beloved of art nouveau painters. Furthermore, her musical,

provincial country accent added an exquisite counterpoint to her bound-less charm.

For both parties, the match was perfect. An alliance with the fortune and prestige of the Moscow Shchukins could only delight the wealthy Ukrainian coal barons. The families had come together and Lydia was already betrothed to Petr. Poor Petr – in his memoirs he recorded what happened in exactly nine words: 'In 1884, my brother Sergei married Lydia Grigorevna Koreneva.' There was no further comment.

In a photographed *tableau vivant* – a highly popular thing in good society at that time – Lydia posed as Helen of Troy, wearing a diadem, pearls and diamonds. Petr courted the beautiful Helen, but it was Sergei who carried her off.

Did she think that this firebrand could bring her what she wanted from life? Behind her languid air of discontent, so typically *fin de siècle*, there was a mute appeal. Sergei was completely captivated. He responded by reinventing her according to his own way of looking at things, perhaps experimenting for the first time with the eye of a collector. Lydia was a beautiful young girl who had only recently emerged from adolescence. Now he turned her into a fairy queen. From the first summer that the couple spent together at Kuntsevo, the dacha community where the Shchukins, the Botkins, the Soldatenkovs and other families assembled was mesmerized by her elegance. Vera Botkina, one of the cousins, recalled the first visit made by Sergei and his wife to her family:

> Lydia Grigorevna was wearing such lovely clothes that Mama immedi-ately thought, *My God, I'm in rags!* Meanwhile I was glad I had taken off my awful shoes. Her dress was from Paris . . . she had a tall hat with a very long feather; her gloves, her shoes and the purse she carried for her visiting cards matched the shade of her gold-trimmed dress, which was the colour of autumn leaves.[3]

We know very little about the young couple's first years of married life. Lydia sang beautifully and loved fancy-dress balls and *tableaux vivants*. Sergei spoiled her and she wanted for nothing: furs, jewels and clothes from Paris made by the great couturier Worth.[4] She had a passion for

ancient history, and after one of several voyages around Greece with her husband, she published an essay entitled 'Sparte: Scènes de la vie antique'. Sadly, no copy of this essay has survived.

After his marriage, Sergei maintained the rigorous way of life to which he was accustomed. He would never change his habit of sleeping with the window wide open, whatever the weather. Some winter mornings, he was to be found beneath a thick, snow-covered fur blanket, with icicles hanging from his moustache. His strict vegetarian diet and daily regime of gymnastics was an open challenge to the habits of his fellow *kuptsy*, who ascribed little importance to physical health but plenty to good food, and for whom corpulence (or even obesity) was viewed as a sign that business was good. Sergei continued to counter with sheer effort the gloomy forecasts that had been made about his health during his childhood. While people around him dropped in their prime, thanks to iron will and discipline he succeeded in preserving his personal vitality until the eighty-second year of his life.

Madame Shchukin can hardly have appreciated such eccentricities as Sergei's refusal to maintain his own team of horses – or later on, to acquire an automobile. Andrei Bely remembers that Sergei liked to keep his transport simple, cantering along in his 'Ivan' with his bowler hat jammed on the back of his head.[5] Nevertheless, in general, relations between the two seemed harmonious enough. Sergei concentrated on running the firm with his father, while Lydia did her dynastic duty by producing a child practically every year. They were lucky: the firstborn, who arrived in January 1886, was a boy, baptized Ivan in honour of Ivan Vasilevich. Grigory came along in 1887, followed by Sergei in 1889. A girl, Ekaterina, was the last, in 1890. She was the final delight of Ivan Vasilevich, her grandfather, who died that same year. None of his other sons produced any grandchildren for him – only his daughters: Nikolai and Petr married late and had no children, while Dmitry and Ivan remained lifelong bachelors. When, on the occasion of the birth of his first grandson, Ivan Vasilevich gave Sergei and his wife the palace that he had bought from the old Princess Trubetskaya, he intended not only to display his affection for the couple but also to proffer an unspoken apology for not having immediately recognized his true heir. Sergei hadn't put a foot wrong.

A different world

After Ivan Vasilevich's death, Sergei, the future 'Minister of Commerce', was solidly established at the head of his firm. By the official and happy consensus of a united, confident family, he had taken a business from one brother, a wife from the other, and a palace from all the rest. Now he could combine utility with pleasure. The children were born and safely consigned to nurses and teachers. Their parents were free to travel.

The family firm's operations were still expanding south and east, covering the Caucasus, Asia Minor and Persia. A taste for risk-taking and a need to find new sources of supply spurred Sergei to explore new markets for Russian manufactured products and new sources of raw materials that were not only original, but also inexpensive. 'I write to you from Bursa, the former capital of the Turks of Asia Minor. It is remarkably warm, a radiant spring, everything in bloom: lilacs, jasmine and many other flowers. The weather is fine and soft. We are in the womb of nature at her most luxuriant.'[6]

In 1891, just a year after his father's death, a first trip combining business with pleasure took Sergei and Lydia to a world that was little known to Russians, beginning with the celebrated silk artisans of Bursa, close to the Sea of Marmara. They passed the Hellespont, ancient Propontis, and Greece with its majestic ruins and landscapes of the gods. They loved the markets of Asia Minor and often returned to them in later years: 'When he wore a fez, everybody took Shchukin for a Turk.'

Four years later, the couple did something even more daring – travelling to India by way of Egypt. The voyage was a thrilling one: excitement was as essential to Sergei as the air he breathed. He knew no better way of setting aside his anxiety and affirming his ability to outclass others.

The postcards he sent to Petr – who kept all of them – make it possible to reconstruct his itinerary:

Since we left the Suez Canal, the sea has been calm and the weather splendid. Nevertheless it is very hot. What extraordinary, luminous intensity! Yesterday we saw the most staggering sunset. The colours were vivid and intense. The coast of Africa was particularly beautiful.

Our ship, the *Caledonia*, is like a small town. She carries more than 500 passengers and almost as many servants and staff. All the sailors are Malays. Apart from ourselves, all the passengers are English and we are living according to English hours . . . For dinner, dinner jackets or tails are obligatory.[7]

The Shchukins landed at Bombay, then the 'Gateway to India', and travelled throughout the north-west of the country. They visited Jaipur, the Taj Mahal, Lahore and Delhi. Sergei rode a horse, while Lydia was carried aloft by coolies. As Sergei wrote to Petr (who, though a passionate orientalist, had never ventured further than Tunisia):

We are in a different world. The vivid colours, the variety of costumes and ethnic types, are all marvellous. Everything is new, interesting, beautiful and picturesque. The simplicity and extraordinary hand-someness of some of the buildings remind me of our own Russian churches in the style of Basil the Blessed . . .[8]

We loved Bombay. The new European quarter is remarkable for its admirable, majestic buildings with fretwork balconies surrounded by columns; some of them are reminiscent of Venice. But the most curious streets are those of the indigenous quarter, where every house is elegant and picturesque. All the balconies are brightly coloured, with red brick roof awnings. There are multitudes of domes and cupolas of every hue.[9]

Hindus in coloured robes walk through the broad streets of Jaipur. One regularly meets with caravans of camels, maharajahs' huge black elephants, two-wheeled wagons decorated with coloured stripes and drawn by buffaloes with painted horns and tails. Everything is decorated and resplendent.[10]

The couple had themselves photographed on an elephant. The eyes of the young Sergei shone with happiness; but even in India, Lydia retained her distant, dreamy expression.

Before long, they were back in the Trubetskoy Palace, which was much more than a house where people lived and children were brought up. It was indeed a palace – and a showroom, too. Sergei intended to perpetuate

the old traditions of Prechistenka Street, of the time of Ivan Vasilevich and his pious cook, while showing off the power and energy of the new boss of I.V. Shchukin & Sons, the fairy-tale beauty of his wife, her diamonds, her furs and her Parisian clothes made by Worth and the rising star of *haute couture* in Moscow, Nadezhda Lamanova.[11]

Ivan Vasilevich's Old Believer heritage, passed on to his son Sergei, stipulated luxury in the best of taste, *without ostentation*. From that point of view, the gift of the Trubetskoy Palace (8, Znamensky Lane) was perfectly in line. The main house was on two levels, each of about 500 square metres. A broad revolving door at the main entrance ensured that heat was kept in and winter was kept out. On the ground floor were the hall and cloakroom – a cloakroom was vital in the entrances of Russian houses, it being thought the height of bad manners to go into somebody's home without taking off one's overcoat – along with the kitchen, the stores, the servants' quarters and the other utility rooms.

The main staircase led to a broad first-floor landing. The first floor, or *bel étage*, was the abode of the *barin* and the *barynya*, the master and mistress of the house, who lived in rooms with high, vaulted ceilings. A series of reception rooms occupied the entire facade on the street side of the palace, while a big, square drawing room, its ceiling decorated with coats of arms, occupied the centre. On either side of the drawing room were long galleries: the dining room was on the left as you faced the building, and the music room – or ballroom – was on the right. Behind these galleries were smaller sitting rooms and studies.

According to a protocol that would never change, the main drawing room was furnished in the style of Louis XV and the dining room was neo-Gothic, as in all the *haut-bourgeois* houses of Europe in the mid-nineteenth century. Inevitably the question arose: what pictures would be hung on the walls? This was no small matter in the household of a family that was dominated by the credo of collecting.

Princess Trubetskaya had sold her palace to Ivan Vasilevich in the customary Russian manner – complete with furniture, decorations and paintings. Rare photos from the time show that there wasn't much of worth in this jumble of stucco garlands and family portraits, one of which was of the princess herself. (According to the provisions of sale, Princess

Nadezhda Borisovna Trubetskaya, founder of the Russian Red Cross and a former lady-in-waiting to Tsarina Alexandra Fedorovna, was granted a flat on the ground floor of the palace's left wing for life.) No inventory or reproduction survives of the Russian works bought by Sergei Shchukin post-1886, when he and his wife moved in. Nor is there any record dating from the decade of expansion of the family firm (and of the family itself) that followed.

The painter Leonid Pasternak, father of the author of *Doctor Zhivago* and illustrator of a series of Tolstoy's works, remembered noticing one of his own charcoal drawings at the Trubetskoy Palace.[12] It was hanging beside some studies by the fashionable Siberian painter Vasily Surikov,[13] of Feodosiya Prokopevna Morozova, the heroine of the Old Faith. Someone else remembered a seascape by Rufin Sudkovsky; there was also *The Garden* by Ivan Pokhitonov,[14] from whom Petr Shchukin later ordered a portrait of his father, Ivan Vasilevich. Lastly, the taste of Lydia Shchukina for classical antiquities was reflected in a painting with a Graeco-Roman theme by Fedor Bronnikov, which hung in the bedroom.[15]

In general, however, the random memories of contemporaries offer little information about the art owned by Sergei prior to the Shchukin collection. No analysis or conclusion can be drawn from them. Clearly his choices were in the prevailing good taste of the 1890s, at which time they ceased to interest anyone and were not replaced. Today they seem dull and academic. Ivan Sergeevich, Sergei's eldest son, used to say that his father had difficulty hiding his irritation when confronted with Russian genre paintings.

By 1898, Sergei was forty-four years old. He had been married for fourteen years and had lived in the Trubetskoy Palace for twelve. Two years earlier, his brother Petr had opened the museum of Russian and oriental antiquities that bore his name, and his brother Dmitry had for five years been assembling his own collection of minor Dutch masters from all over Europe. Ivan, the youngest, had been orchestrating his artistic and cultural salon in Paris for five years and was actively courting French impressionists and their dealers.

Who would have thought, surveying this family with its activities so neatly apportioned according to talent and affinity, that it would be Sergei who was to become one of the greatest collectors in the history of art? So

far, he had not initiated anything in that field; on the contrary, he had poured all his flair, audacity and talent into his textile business empire. He had no irresistible vocation to collect. He reacted only to the impulse of historical, social and worldly determinism; and, perhaps more fundamentally, to the deep wound to his pride caused by the doubt he saw in the eyes of the woman he loved.

Strangers on a Train

The owner pressed the switch, the room was flooded with light and the paintings emerged from shadow.

'Here's a Monet . . . see how alive it is,' said Sergei Shchukin.

From a distance, under the lights, it was impossible to see the paint strokes and touches. One had the impression of being somewhere in Normandy in the morning, looking out of a window. The dew had not yet dissipated and the day ahead promised to be hot.

'Look at Pokhitonov: he's completely overshadowed by Monet, we have to move him away from there. Here's Degas with his jockeys and dancers, and here's Simon . . . Let's go through to the dining room, that's where I have Puvis de Chavannes. And here is one of the Bande Noire, as they say of Cottet. An evening by the sea, just before a storm, with people walking along the quayside. This one is by Brangwyn. And here's Whistler . . .'

Sergei Shchukin has assembled a collection of the youngest painters belonging to the most innovative movements now under way in Europe. He has plenty of taste and a special artistic sensibility; the *dernier cri* of contemporary painting is to be found at his house.

Thus the painter Vasily Perepletchikov described an evening spent at the house on Znamensky Lane in 1900.

> There are quantities of Russian and foreign newspapers in the library. Over tea, we spoke of Diaghilev and his review *World of Art*, of Turner and of Vladimir Solovev.[1] Sergei Ivanovich is abreast of everything, he spends a lot of time in Europe. The children came to say goodnight: nice boys with black eyes, accompanied by their French tutor. They paint, too. In their bedroom there is an easel; across the table are spread a number of studies in which you can already identify the modern style.
>
> It's time to go home. The master of the house accompanies his guests to the bottom of the main staircase as far as the hallway. On the steps of the old palace, which has seen so many people coming and going over the last century, he is still talking, even though we have already put on our fur coats: 'Durand-Ruel is sending me a Maxence any time now,[2] come and see it when it arrives . . .'[3]

Any young painter visiting Shchukin could expect a similar culture shock.

It always began with the impressionists: 'There, right against the glass, grew a tuft of moss delicately adorned with terms of orange, lilac, yellow; one had the impression – and in fact it was true – that the filaments of colour actually had *roots* and were growing out of the canvas in a scented cloud.' So wrote the future avant-garde painter David Burlyuk, who was rendered ecstatic by the texture of Monet's pictures, with their 'tender interlaced plants, divine and strange'.[4]

Adds Perepletchikov: 'The wealthy merchant Sergei Ivanovich Shchukin has recently joined the élite of collectors. No one can doubt that he will soon emerge as one of the greatest of his time.'[5]

So Sergei had already won a reputation in Moscow – and he had only been collecting for two years. If the extraordinary discernment of his eye remains mysterious, we may at least venture that some of the business secrets of the industrial baron Sergei Shchukin were being methodically applied to art.

Challenged as he was by his own love of a challenge, by the society of collectors in which he lived, by the collecting passion of his three brothers, and by a burning desire to offer his wife a realm worthy of a queen, Sergei Shchukin, without having the smallest idea of what the choice of a work of art might mean, had to do better than anyone else.

Legend has it that in May 1898, three Russians entered 16, rue Laffitte in Paris, the gallery of the impressionist dealer Paul Durand-Ruel. They were the brothers Sergei and Petr Shchukin and their cousin, the painter Fedor Vladimirovich Botkin. The latter had moved to Paris shortly before his cousin Ivan Shchukin, and was an admirer of Maurice Denis and the Nabis.[6] His own country may have forgotten him, but he had become a regular exhibitor in the Parisian salons.[7]

Inside the gallery, the Shchukin brothers lingered before a series of views of the Avenue de l'Opéra that Camille Pissarro had just delivered to Durand-Ruel. Petr picked out *Place du Théâtre-Français*, a summer city-scape in which the green foliage of horse-chestnut trees was beautifully rendered. He bought it for 4,000 francs. A year later, on 28 April 1899, Sergei Shchukin paid 1,000 francs more for *L'Avenue de l'Opéra, effet de Neige le Matin*. These wealthy Russians, staying at the Grand Hôtel on the Place de l'Opéra, seemed to be buying landscapes like upmarket postcards. The only difference was that they had been painted by Pissarro in his room at the Hôtel du Louvre, way down at the far end of the avenue.

In November, Sergei returned to the rue Laffitte, and this time he bought his first Monet, *Rochers à Belle-Ile*, typical of the imperceptible shifts of nature so dear to the master. This first Monet cost him 10,000 francs. The following year, Shchukin paid 9,000 francs for *Champs à Giverny*, and his Parisian brother Ivan bought the superb early study *Lilas au Soleil* for 8,000 francs on Sergei's behalf. In late 1900, Sergei went in person to visit Claude Monet and bought one of his iconic *Nympheas Blancs*: a glorious summer day, a garden of luxuriant vegetation and a pool covered with water lilies spanned by a Japanese bridge. The following year, he went back to buy *La Cathédrale de Rouen, le Soir*, which the artist had set aside for him. (The same year, he was to buy another cathedral, *Le Midi*, from Durand-Ruel.)[8]

Petr accompanied Sergei when he made his purchases, lending his experience as a bargain hunter. So Sergei had at his disposal both the

experienced eye of Petr and the culture, Paris contacts and *savoir-faire* of Ivan. Now they were joined by their friend Mikhail Abramovich Morozov, the eldest of the three Morozov brothers, textile industrialists from Tver. Mikhail was a physical colossus as well as a major figure on the Russian stock exchange. He was just as passionate about impressionism as the Shchukins. Nobody put together anybody else's collection: there were too many connoisseurs in the group who were determined to show that their collections reflected their own special taste for that to happen.

In November 1904, Sergei's tenth and eleventh Monet acquisitions were delivered to the Trubetskoy Palace. One was a canvas freshly painted that year in the master's latest manner: *Le Parlement de Londres, les Mouettes*, in which Monet reinterpreted Turner using the mistiest, most extreme canons of impressionism. The other was already a cult classic, *Le Déjeuner sur l'Herbe*, a reduced version of Monet's grand canvas. The unknown price of this acquisition – from the German dealer Paul Cassirer – was constantly exaggerated by Moscow's rumour-mongers.[9] Whether deliberately or not, the collector also responded practically to a 1900 article by Alexandre Benois in *World of Art*, in which the critic described this painting as one of the most beautiful pieces of art of the past century. 'We dare not dream that a painting like this Monet will ever be brought to St Petersburg or Moscow,' complained Benois. 'Nevertheless, the day will come when history, which always lags behind life, will view such works as great masterpieces.'[10] Within four years, Sergei had resoundingly proved the critic wrong about the timidity of Russian collectors.

By 1904, the first cycle of the Shchukin collection – that of the impressionists and their greatest star Claude Monet – had come to an end. Nevertheless, it had given birth to the legend of the godlike collector Shchukin and his eleven Monets, plus the two Monets belonging to Petr and the collection of paintings by Renoir, Degas and Maurice Denis owned by the three Shchukin brothers. Already the truth was being distorted. Certain outstanding pictures by painters who were still not understood by the vast majority of people – even though they were worshipped by real connoisseurs – were bought by the Shchukins, along with about fifty other works by other, lesser artists, only some of whom became famous later. Never again after the period 1898–1904 would Sergei himself buy works by so many different painters. At the time, he was learning to understand

art as someone tries out a mattress, with the loyal and excellent Petr working beside him throughout the first years.

This first 'experimental' Shchukin collection still awaits an art historian capable of placing the works and their authors in perspective. Even so, we can discern in the early choices made by Sergei a feature that was later to become his hallmark: that of *selecting artists without operating within any kind of system*. Whether they were famous or unknown, he went straight for their best work. What follows is a list of works, with the number of these that he bought:

* women in soft crinolines by Charles Guérin (2);
* polished interiors of Versailles by Maurice Lobre, whose beautiful renderings of crystal chandeliers, mirrors and marbles earned the painter the sobriquet the 'French Vermeer' (3);
* *Tête d'Ouvrier* by the 'people's painter', Constantin Meunier (1);
* views of the Seine valley by the self-taught railwayman Albert Guillaumin (2);
* *Demi-Mondaines* by Jean-Louis Forain (3) and Toulouse-Lautrec (1);
* *Marché à Brest* by Fernand Piet (1);
* *Relais de Poste* by Édouard Vuillard (1);
* *Breton Landscape* by Henry Moret, a former companion of Gauguin at Pont-Aven (1).

Three polar opposites of the Pont-Aven group, members of the Bande Noire, foreshadow the debate over the role of colour:

* Charles Cottet (3);
* a *Femme Assise* whose bright dress stands out from surrounding shadow, by Maxime Dethomas (1);
* a romantic evening landscape by Émile-René Ménard (1).

In addition, there were works by Henri Fantin-Latour (1), Charles Guilloux (1), Fernand Maglin (3), Gaston La Touche (1), Émile Giran (1), Lucien Simon (1), Charles Milcendeau, known as the 'Vendée Wanderer'

(1), and even a *Chalet dans la Montagne* by the great Courbet, then living in exile in Switzerland, the doyen of the artists in the Shchukin collection (1).

Shchukin was also interested by northern impressionists: the master of German impressionism, founder and president of the German secession movement Max Liebermann (2), and the Norwegian Frits Thaulow (3). Thaulow's romantic corner of Venice, his Norwegian landscape buried in the snow and the panorama of the Boulevard de la Madeleine in the rain are all in the vein of Pissarro or Monet. There are also a few British artists: a big landscape by the Scottish romantic James Paterson (1), two pieces by the prodigious Pre-Raphaelite painter, engraver, tapestry and stained-glass maker Frank Brangwyn (2), three elegant miniatures in oils by the revered Anglo-American James Abbott McNeill Whistler (3) and a landscape by Robert Alan Mowbray Stevenson (1).

All these contributed to a superb cross-section of *fin de siècle* European painting. There were eleven Monets in all, forming a full overview that Sergei would never repeat for any other artist: two seascapes, two cathedrals, two fields at Giverny, one *nymphéas*, one Turneresque London fog, and so on. These were joined later by Petr's two Monets, one of which was the stunning *Dame dans un Jardin*, a model of restraint and elegance beside the other, more fulsome ladies that Petr seems to have preferred. Nor did Maurice Denis's nymphs in his *Bois Sacré* escape Petr's eye; Sergei followed this lead with two of Denis's religious subjects and his sumptuously Nabi *Portrait de la Femme du Peintre*, making three in all. Then there were the ballet paintings by Degas (5); aside from Petr's *La Toilette*, these included Sergei's *Les Danseuses en Bleu* and *La Danseuse chez le Photographe*, bought for the vast sum of 35,000 francs each. This was a record, which he never surpassed.

There were Renoirs (3): the *Jeunes Filles en Noir*, the strict and serene *Dame en Noir*, and the *Jeune Femme Nue*, depicting the same Anna who could be seen magnificently naked in Petr's bedroom. And there were four nebulous figures by Eugène Carrière (4), who was Henri Matisse's teacher at the time, in addition to Puvis de Chavannes (2) – *Le Pauvre Pêcheur* and *La Miséricorde*.

It was all rich, brilliant and insolent in its impressionist confidence – the next stage, in effect, beyond the Parisian feathers and *haute couture* of Lydia Grigorevna. Avant-garde visitors to the Trubetskoy Palace were

enchanted, while the owners of conventional paintings were smitten by despair, and malicious tongues condemned the expenditure of so much money 'just for show'.

Yet it is worth pointing out that neither the avant-garde so dear to dandified Ivan (Manet, Pissarro, Monet, Degas, Renoir), nor the northern impressionists, nor the Pre-Raphaelites, nor the World of Art decorative painters, nor even the Nabis championed by Fedor Botkin showed the true character of Sergei. His intention as a collector was still coloured by snobbery and fashion. It did not, as yet, reflect a genuinely personal vision.

If we are to understand the true workings of his process of collection and the influences which came to bear upon it, we need to turn away from the man trying out the mattress and concentrate on another side of Sergei Shchukin.

Strangers on a train

It all began as in a Russian novel: three travellers met on the Paris–St Petersburg *Nord-Express* in 1901. Prince Sergei Shcherbatov (1875–1962), a collector and patron of the arts from a great family in the service of the empire, was returning from Paris with the young painter and art historian Igor Grabar, who was himself on his way back to Moscow to re-join the magazine *World of Art*. The prince introduced Grabar to a third passenger – an older man of around fifty, with prematurely white hair and a black beard. This was Sergei Ivanovich Shchukin.

Igor Grabar knew most of the Shchukin brothers. He had been at college with Ivan Shchukin, and indeed it was he who had suggested Ivan's nickname in Paris, 'Jean de Wagram'. Grabar told this story in his 'auto-monograph', published in 1937, at a time when he could interpret the facts as he liked, without contradiction. A highly placed *apparatchik* in the museum system of Soviet Russia during the 1920s, Grabar foresaw the purges of the 1930s and managed to abandon all his official functions just in time, afterwards devoting himself entirely to painting and to writing his memoirs. After 1945, he resurfaced as an official covered in honours, an academician and winner of the Stalin Prize. In short, he triumphantly succeeded in slipping between the fire and the ice of those terrible years.

Grabar claimed that he was startled to learn from Shchukin himself, aboard the *Nord-Express* in 1901, that he had begun to collect modern art thanks to him, Grabar. The conversation apparently focused on Grabar's essay 'Decadence or Renaissance?', which had appeared in the literary supplement of *Niva* in February 1897. This magazine, edited by Adolf Marx, covered political, social and literary life, and had hit the jackpot: *Niva* attracted members of the nascent middle class in Russia and achieved a circulation of 250,000 in 1905, in a country that was still only semi-literate.

Grabar explained to his travelling companions that to interest a bourgeois readership, there needed to be articles on the painters in vogue in bourgeois salons:

> No matter what efforts I made to steer *Niva* towards a more innovative form of art, my dreams and schemes came up against the taste of Marx, which was perfectly in step with that of his readers . . . nevertheless, working discreetly to undermine him, I managed – by dint of homoeopathic doses – to open *Niva* to a flow of refreshing images diverted from foreign newspapers and Russian exhibitions. Gradually the strait-laced pages of *Niva* began to feature painters who, only two or three years earlier, would never have imagined such a consecration; to such a degree that in the mid-1890s, the celebrated critic Vasily Stasov (a giant with a huge beard), encountering Adolf Marx at the exhibition of his beloved 'Wanderers' (whom poor Vasily had been defending for the last 25 years), bellowed across the room: 'You've no business coming here, Adolf Fedorovich, there are no decadent paintings in this exhibition. The decadents have all feathered their nests in *Niva*!'[11]

Describing the evolution of painting in the nineteenth century, Grabar justified the abandonment of academism and naturalism by declaring that art was not limited to the representation of the truth of life; it had also to reveal the truth of the artist himself. Beyond what the eye perceived, what really counted was the impression felt by the artist, which was exactly what the impressionists were saying. He gave as his examples the painters of the second half of the century who had made Paris the centre of European artistic life: Édouard Manet, Edgar Degas and Claude Monet.

'Our time is not decadent, nor is it properly represented by the current mediocrity of its art,' Grabar concluded.

> On the contrary, a time of splendour and rebirth is at hand, a time of hope and expectation. We who are lucky enough to be alive and witnessing this renaissance, when the brothers of the great masters of the past are rising up before our eyes, will soon see artists who can outstrip the old masters themselves. Who will these longed-for emissaries be? What direction will they take? Who can tell? It is impossible to predict.[12]

According to its author, this essay had the effect of a bomb on its readers, among them Sergei Shchukin, whose character and temperament had compelled him 'to collect the living, active, shifting art of today – or more exactly the art of tomorrow – but never the art of yesterday'.[13]

At the dawn of the twentieth century, Grabar, Prince Shcherbatov and Shchukin were on the same train, steaming headlong into a maelstrom for which not even the more enlightened people in Russia – the 250,000 contributors to the magazine *Niva*, for example – were remotely prepared.

The 'Cour des Miracles'

Alexandre Benois has left a description of the origins of *World of Art* – the review and the aesthetic movement – which he launched with Serge Diaghilev shortly after the appearance of Grabar's article:

> Russian society at the time was generally provincial and backward. Where music and literature were concerned the Russians were on an equal footing with Germany, France and England; they even surpassed them at times, taking the lead in new movements. But in painting and in the plastic arts generally they were so far behind that even Russia's most avant-garde artists had to make tremendous efforts just to catch up with their counterparts' 'rearguards'. Russian society . . . had become immobilized around 1870, amidst a total indifference to the purely artistic intent in art. This indifference obviously had its effect on the world of collectors.[14]

The Russians were largely fixated on the 'Wanderers' movement, which had imposed itself in 1870 as the progressive artistic trend of the times. It all began in 1863, with a revolt by the St Petersburg Academy of Art's fourteen star students, who refused to compete for gold medals of excellence that would secure them a two-year grant to continue their art training in Rome. (Here it should be remembered that the entire course of the academy had been copied in the eighteenth century from European institutions.) The fourteen students rejected the compulsory topic of the competition, 'Odin's Banquet in Valhalla', demanding not so much aesthetic freedom as the freedom to choose the subjects they wanted to paint. The Wanderers (as these rebels called themselves) formed a group in 1870, which for the first time brought together the artists of St Petersburg and Moscow to organize itinerant exhibitions in the provinces of Russia. Until that time, the provinces had been devoid of works of art, which only existed for them in the all-but-inaccessible collections of great landowners. The Wanderers completely abandoned antique, mythological and biblical subject matter, and instead used the academic realism they had been taught to highlight the beauty of the landscapes of Russia, the tragedies of her history and the sufferings of her people.

The Wanderers' approach was similar to that of the Russian literary giants who were their contemporaries – Tolstoy and Dostoevsky. They too would soon have their own emblematic work of art, *Barge Haulers on the Volga*, and their leader was the man who painted it, Ilya Repin. The alliance of progress and classicism embodied by the Wanderers presented a peculiarly Russian obstacle to the acceptance of new trends in painting. The Russian public, while fiercely debating the content of the stories that painters should tell in their pictures, remained completely incapable of freeing itself from the tyranny of realism.

Ilya Repin himself could not even begin to appreciate the impressionists; nor could he contain his fury when he saw the works of Matisse and Picasso on the walls of the Trubetskoy Palace a few years later. On the other hand, Ivan Kramskoi, a leader of the 1863 dissidents and the founder and director of the Wanderers group, was open-minded and curious to understand the impressionist approach, which was so different from his own:

[In these artists' work], which is funny and impudent, there is the affirmation that everything in art is a lie, everything is false, in painting and drawing alike ... there is ... something in it that deserves thought, quite a lot of thought. It speaks of the ferment, the indeterminable, immaterial, elusive metamorphosis of nature, when you see and experience everything as a gleaming, moving, living substance.[15]

The Moscow public had its first chance to discover the impressionists in 1891.[16] Monet's *Meule de Foin*, which was destined to play such a decisive part in the future of abstract art, was among the paintings on display. The young Vasily Kandinsky was changed forever when he saw this picture, which was completely revolutionary in its absence of subject matter. Indeed, it turned the Russian aesthetic debate on its head:

The catalogue told me that this was a picture of a haystack. I didn't recognize it as such to begin with, and my failure to understand it disturbed and irritated me. I thought that nobody had any business painting something so vague. I sensed in some dull way that the work lacked a clear subject, but I also noticed that it exuded astonishing power, a power previously unknown to me, as well as a range of colour that exceeded my wildest dreams. I suddenly realized that *subject matter was not an indispensable element* of this picture.[17]

Next, an exhibition of French art featuring works by Degas, Monet, Renoir, Sisley and Puvis was organized in St Petersburg and it travelled to Moscow in December 1896. The paintings in the impressionist section all came from the Bernheim Frères gallery. *Niva* reproduced a certain number of them, and Grabar's essay 'Decadence or Renaissance?' appeared in the monthly literary supplement.

Another shockwave hit St Petersburg with the arrival two years later, on 1 January 1899, of the *First International Exhibition of Paintings*, organized by *World of Art* in the rooms of the Central Technical Drawing School founded by Baron Alexander von Stieglitz.[18] The main organizer, Serge Diaghilev, played the role of intermediary between a conservative public, which had been taught to revere the ideals of the Wanderers, and younger

Russian artists, such as Bakst, Benois, Somov, the already successful Serov,[19] the Parisian Fedor Botkin and others.

Diaghilev confronted his 'new Russian painters' with their foreign counterparts, who had shown work at the most important exhibitions in Paris, Munich and London. These included the Germans Lenbach and Liebermann, the American Whistler, the Finns Edelfelt and Gallen-Kallela and the Norwegian Thaulow. Nevertheless, the bulk of the work came from the French school. The Petersburg public was able to view the canvasses of Gustave Moreau, Puvis de Chavannes and Degas, as well as salon and genre paintings by Aman-Jean, Paul-Albert Besnard, Jacques-Émile Blanche,[20] Raffaëlli and Forain – all of whom were artists who were not violently offensive. Anyway, Diaghilev hoped they would win over the Russian public.

The pitfalls that awaited his attempt to conquer that public were made plain by the newspapers. Vasily Stasov led the charge in the *Novosti I birzhevaya gazeta* (*Stock Exchange News*), with an article over three columns entitled 'La Cour des Miracles' ('The Slums'). Denouncing the exhibition as an 'excretion of manners and viscous muck', he wondered: 'What gracious and pure Esmeralda will come to our aid, who will save us from this basket of crabs, monsters and degenerates, and who will deliver us from their disgusting claws?'

Alexandre Benois immediately responded in *World of Art*:

A perplexity bordering on horror seems to seize all those who see a painting of this school [impressionism] for the first time. Can it be that amid this senseless disorder of lines and colours, sincere and objective people can actually discover light, sunshine, life, the delicate wonder of colour, even poetry? . . . It is only by educating and developing our taste, and by entering more deeply into works that have so astonished us, that we will discover beneath what we at first take for ugliness, a divine spark that can set our hearts aflame . . .[21]

It went unremarked that the two pastels by Forain, *Les Courses* and *Le Foyer du Théâtre*, came from a collection that nobody had yet heard of, though it bore the name of a merchant known to everyone in Moscow. The note 'Sergei Shchukin Collection' had made its first tentative appearance.

Six weeks earlier, Sergei had acquired his first Monet.

The Storm

Moscow was changing. The tramway was under construction. Buildings were demolished, the first flowers from the Riviera appeared in the city and in the colonial stores exoticism reigned supreme. Piles of bananas, coconuts and pomegranates appeared as if by magic and Siberian fish of all kinds lay on the fishmongers' slabs. The population doubled, its accents grew more colourful and one began to hear the speech of Kiev, Kharkov, Ekaterinoslav and Odessa . . .

The static partitioning of the city's different districts gave way to a surge of exchange and movement. The centre of Moscow absorbed the inner suburbs, the rumble of carriages grew deafening and the pavements clattered with the heels of pedestrians. The signboards of the cafés glittered and shone and soon enough the lights of cinemas, restaurants and bars bathed Kuznetsky Most Street, Petrovka Street and Stoleshnikov Lane.

Within five years, automobiles were coughing and banging and trams screeching around the streets of Moscow. The horse-drawn omnibuses on their rails vanished to the suburbs.[1]

The modern Moscow celebrated by Andrei Bely was entirely at home in the palaces of the wealthy merchants. In November 1904, with the

arrival at Znamensky Lane of the two latest Monets – the oldest, *Le Déjeuner sur l'Herbe* (1866) and the most recent, *Le Parlement de Londres, les Mouettes* (1904) – Sergei Shchukin had completed his project. He had hung his salons with an insolent collection of nearly seventy paintings, mostly of the French school.

The admiring comments of snobbish visitors, just like the incredulity of the basic *kupechestvo*, must have pleased the vengeful side of Sergei, who had once been a fragile, stuttering child. The painter Boris Kustodiev[2] wrote:

> Yesterday evening, I attended a very interesting concert at the house of Shchukin, the famous and extremely rich collector. Wanda Landowska[3] played the harpsichord, and plenty of high society, all the chicest people in Moscow, were there. The walls were hung with glorious paintings by Manet [*sic*],[4] Monet, Degas and Renoir . . . Cottet and others. A marvellous collection.
>
> There were gigantic tables laden with flowers. The food was refined and there was only champagne to drink. A proper old-fashioned Moscow party, in fact. The interesting thing was that everyone was free to do as they liked, there was no obligation to talk to people or get to know them if you didn't feel like it.[5]

Lydia Grigorevna, in her jewels and Paris dresses, was magnificent at these musical evenings organized by her husband. During the interval, Shchukin showed his collection and his female guests were presented with red roses. His patrician eighteenth-century palace was ablaze with lights, revealing the deeper significance of Sergei's father's gift to his son. What better showpiece to consolidate his company's reputation could there have been than this great house, decorated by Sergei in the most modern taste at the turn of the twentieth century?

Nevertheless, such successes were not enough for Sergei Shchukin; nor, doubtless, for his wife Lydia, who still lacked something to complete her happiness. So her husband went on searching.

Just as the impressionist cycle was drawing to a close, in November 1904 two gems arrived at the Trubetskoy Palace and were unpacked simultane-

ously. They represented both the past and the future of the Shchukin collection. The first was *Le Déjeuner sur l'Herbe*, a glorious climax to the art of the nineteenth century (see above). The second was Cézanne's *Mardi Gras*, which struck the blow that began the era of modern art. It consisted of the images of Pierrot and Harlequin, dehumanized and transformed into still lifes by endless hours of posing. Fittingly, Cézanne's two models for this revolutionary painting were the painter's son and one of his schoolmates.

A year earlier, Shchukin had risked the purchase of a Cézanne from Durand-Ruel, entitled *Nature Morte aux Pommes*. Now, Durand-Ruel had sent two more canvasses – pictures that he himself had bought in 1899, when Victor Chocquet's magnificent collection was dispersed. As well as *Mardi Gras*, from the crate emerged *Bouquet de Fleurs dans une Vase*, which was to become Lydia's favourite painting. Between them, they cost Shchukin 20,000 francs. Just a few years earlier, his Parisian brother Ivan had bought two magnificent Cézannes from Vollard for much less. But the master of Aix was beginning to be lionized. He had only two years to live.

There was more to come as the household gathered around the two crates on the ground floor. From the boxes emerged Gauguin's *Femme au Bord de la Mer (Maternité)* and *Paysage* – two pictures that lit up the dark November day in Moscow. The Cézanne revolution had scarcely reached the palace before it was overtaken by Gauguin's flood of Tahitian colours, even more radically incomprehensible.

The painter Perepletchikov, who had become a great admirer of Shchukin's collection, described what happened: 'Yesterday, Friday, we were at Shchukin's house. He had received a couple of paintings by Gauguin. His other guests were a bunch of doctors and lawyers: in a word, the card-playing Russian intelligentsia. They couldn't stop laughing at the pictures.'[6]

Something had changed in the six years since the Shchukin brothers had gone shopping for art together, when the time was one of exploration and intersecting influences. The men had since gone their separate ways. Petr had returned to his museum of antiquities, after the gracious interlude when he bought a score of sensational French paintings. Ivan had dispersed his French collection in 1900, to concentrate on the wider market for old masters. Fedor Botkin, having finally been exhibited in Russia thanks to *World of Art*, was already a hopeless invalid: he was to die in 1905.

The only real rival that Sergei had had in the early years of the century was his friend Mikhail Abramovich Morozov, the other promising collector who had begun visiting Paris art dealers during the same period. Like Shchukin, he and his brothers had inherited an enormous fortune; also like Shchukin, he had acquired and decorated a magnificent palace and was married to a famous Moscow beauty, Margarita Kirillovna Morozova, a rival of Lydia's. But Mikhail Morozov was a larger-than-life figure, much given to excess and far removed from Shchukin's asceticism. His appetite, though, did not bring him luck: he died of acute kidney disease, aged just thirty-three, in October 1903.

Mikhail was brilliantly replaced as a collector by his younger brother, Ivan Abramovich Morozov, who had begun by collecting Russian art and came relatively late to the French school – later than Shchukin, in any event. He had to pay high prices for his magnificent Monets, Cézannes and Van Goghs, but within a few years Ivan had become the 'other Shchukin' – a notch below him, some would say, but in fact profoundly different. His brilliant family will re-enter the narrative later.

For the time being, Sergei Shchukin was alone in the field. He had learned about art from the best in the business, but thereafter, to judge by his choices, he needed no further help. Cézanne and Gauguin promised a clean break; Shchukin knew very well that good Moscow society would laugh at him, and in a way, what he did was a credit to the memory of Mikhail, who had been the first to buy two Gauguins, the first to bring Van Gogh to Russia, and the first to buy a painting by Edvard Munch.

These days Shchukin would only very rarely cherry-pick a single work by an artist. So what was it that Shchukin had grasped after six years of experimentation? As he himself liked to say, the process of collection turns on two key moments. The first is the impulse to buy, which strikes like a bolt from the blue. At such times you must not waste time thinking things over: you must open yourself up completely to your emotions, like a plant opening up to the light. You don't choose the painting: the painting chooses you.

Dmitry Shchukin summed this up in the 1920s:

Every collector must have an eye. But we Shchukin brothers have something extra: we have noses. We look at any drawing, painting or artefact without being able to make up our minds, but all our senses are alert. In my own case, this faculty was focused on old masters. My brother Sergei concentrated on modernity, whereas Petr targeted antiquities.[7]

Recognizing this family trait of inner trembling before a piece of art, Sergei bought his pictures without the slightest hesitation. Then came the second phase, which was accomplished in a *tête-à-tête* with the piece: he forced himself to track down the hidden reasoning behind the apparently irrational impulse that had made him buy:

You have to live with a picture for at least a year to understand it fully. It has happened to me that a given painter's art has escaped me for several years. And then one day my eyes were opened . . . You must involve yourself in the work to the point where you are actually a part of it. Very often the first time you see a picture you don't like it, but even so you find yourself going back to see it again and again. And eventually it opens up to you. Suddenly you understand it and you find you love it.[8]

This is the utterly simple, but also utterly mysterious answer. Look at paintings carefully and be alert to the 'shiver' of emotion. This is the signal. The glittering sea spray lashing across the blue *Rochers de Belle-Ile,* which was the first Monet Shchukin ever bought, provoked in him this special, quivering reaction. It was followed by ten more Monet canvasses which had the same effect. It was a carefree process with Monet, in stark contrast to Shchukin's more methodical investigations of other painters' work.

The year 1905 began with a consecration. The new review *Iskusstvo* (*Art*) published reproductions of ten canvases hanging on the walls of the Trubetskoy Palace. This was by no means a minor event. Nobody up until that time had seen a Russian publication attempt to make the public aware of European modern art from the standpoint of a private Muscovite collection, rather than by drawing examples from foreign collections. After less

than seven years of collecting, Sergei Shchukin suddenly found himself recognized as a truly innovative local collector, whose pictures were being reproduced in the newspapers.

Meanwhile in 1905, in the outside world, the Russian army was bogged down in trench warfare in Manchuria. Throughout that year, Sergei Shchukin refrained from buying a single painting.

Brave little soldiers

In February 1904, Japan had attacked the Port Arthur concession in the Yellow Sea, blocking Russian expansion to the Pacific seaboard. By 1905, patriotic outrage at this aggression had died down somewhat. Reinforcements for the army had difficulty reaching the war zone along the 9,000 miles of the Trans-Siberian railway, and consequently the tsar's ground forces were on the defensive. As for reinforcing the Russian Navy's Pacific squadron, which was greatly inferior in numbers and outclassed by the Japanese battle fleet, this could only be achieved by sending the Russian Baltic Fleet literally right around the globe. Forty-five capital ships sailed from St Petersburg on 12 October 1904; all Russia followed their eight-month odyssey round Africa, India and China.

By autumn 1904, the nation had reached boiling point. The liberals wanted social reform and the curtailment of the rights of the monarchy. The socialists wanted a social revolution and the installation of a republic. Everyone demanded representation for the people and individual freedom of conscience and speech; freedom pure and simple was the goal of the Bolsheviks and the Socialist Revolutionaries. As for the anarchists, they spread their subversive message of a war on war and the expropriation of property. In this climate of disorder and wait-and-see, censorship was relaxed and society was filled with new optimism, sensing a political spring but heedless of the explosive power within a volcano of contradictions that was ready to erupt.

On Sunday, 9 January 1905, the army opened fire on a huge, unarmed crowd of striking workers in St Petersburg. Accompanied by their wives, children and thousands of bystanders, the workers were converging on the Winter Palace to deliver a petition to the tsar calling for a Russian constitution.[9]

On Vasilevsky Island, the crowd marched past the Imperial Fine Arts Academy, which had taught so many painters of the Wanderers group. The masters and students who were present on that day, watching from their studio balconies, were to witness one of the most tragic events in Russian history. Among them was the celebrated portraitist Valentin Serov, who had once profited from a sitting with Tsar Nicholas II to obtain a subsidy to save *World of Art*. Now, before his very eyes, a regiment of mounted Cossacks with swords aloft charged straight into the crowd along the quayside.

'I shall never forget what I saw from the windows of the Academy of Arts on 9 January,' he wrote to his old professor, Ilya Repin. 'A majestic, unarmed crowd, marching forward to meet charging cavalry and volleys of gunfire. It was a horrifying spectacle . . .'[10] True to the ethic of the Wanderer painter-reporter, Serov dashed off a series of drawings that would later serve as the basis for his painting of the Cossacks charging in front of the academy, entitled *Little Soldiers, Brave Little Fellows, Where is Your Glory Now?*

The salons of the Moscow intelligentsia were appalled by this tragedy, and donations for the victims poured in.

'We are witnessing an earthquake. This is a colossal, historic moment whose results and consequences will produce a new culture of which we have as yet no inkling, except that it will come from us and that we will be fully a part of it,' declared Serge Diaghilev, speaking at a banquet organized in his honour at the Hotel Metropol by the artists, writers and collectors of Moscow, including Sergei Shchukin. Diaghilev concluded: 'I raise my glass to the collapse of all the palaces, and to a new alliance of the new aesthetic.'[11]

Perhaps the Moscow intelligentsia overestimated the importance of their aesthetic debate. By then the palaces, the people and the *kupechestvo* had much more serious things to worry about.

The decisive battle of Mukden, in Manchuria, was fought between 28 February and 10 March 1905. Japanese forces threatened to cut the Trans-Siberian railway, forcing the Russian army into a hasty retreat to the Siberian frontier. The resulting clash, in which 350,000 Russians faced 320,000 Japanese, was one of the largest land battles to be fought before

the First World War. By the end of it the two armies had reached a stand-still and were unable to move from their entrenched positions.

On 15 May, the forty-five ships of the Imperial Baltic Fleet finally reached the Tsushima Strait between Korea and Japan, where the entire Japanese fleet had been preparing to receive them for eight months. Exhausted by its long voyage, the Russian fleet was completely routed – sunk, sabotaged or captured. The only Russian ships to survive were two escort vessels and a light cruiser, which managed to reach Vladivostok. They brought the news, close on the heels of the army's defeat, of the greatest naval disaster in Russian history.

The tsar's finance minister, Sergei Witte, signed the Portsmouth Peace Treaty, whereby Manchuria was abandoned along with all Russian preten-sions to a naval presence in the area. Not only had the regime abjectly lost a war against a much smaller adversary, but its autocratic system had sustained a mortal blow.

A wave of strikes and political protests swept the empire. In the autumn, factory workers downed tools *en masse*, the railways shut down, newspa-pers went unprinted and water and electricity supplies were cut off. The tsar's government was forced to make concessions – a lot more of them than would have sufficed the previous January. The Imperial Manifesto of 17 October granted the peoples of Russia freedom of conscience, freedom of speech, the right to belong to a trade union, and an Imperial Duma elected by universal suffrage. Most of the nation exulted, but the left rejected all these concessions as too little, too late. Their aim was to be rid of the autocracy once and for all.

Gone missing

Inevitably, Moscow became a hotbed of revolution. The first issue of the newspaper *Borba* (*Struggle*), the now-legal organ of the Bolshevik party, appeared on 27 November 1905. It called for a general strike. The lecture halls were emptied of students. There was a steady exodus of white-collar workers: teachers, medical doctors, lawyers and musicians fled abroad with their families. From Nikolaevsky station, trains departed for St Petersburg; the only ones still running were under military management.

'I was walking along the lane that comes out on Znamenka Street. Beside the house of the famous millionaire Sergei Ivanovich Shchukin, who not long ago was reckoned a liberal, I came upon a picturesque spectacle,' recounts Andrei Bely (this was around 20 November).

In front of the building stood a mob of people in sheepskin coats, of the kind who in recent days had forced me to the other side of the road, clutching my little Bulldog revolver tight in my pocket. This time, the big red-faced, slab-handed men, yelping with joy, were listening to a figure who had his back turned to me. I immediately recognized the bassoon-like voice and the famous stutter.

'But what are you thinking? Eh? Th . . . those people are f . . . foreigners!'

I turned on my heel and walked back to see what was going on. Of course, it was Shchukin himself, his lips working furiously behind his greying black beard. He was haranguing a crowd of riff-raff in front of his house.

'We must organize a guard fff . . . f . . . for Znamensky Lane!'[12]

Sergei was not just holding impromptu meetings in his street. Elsewhere he was struggling with a desperate situation: his Zindel factory was on strike, armed militias were roaming the streets, and soon there would be barricades. The Presnya district, where his other plants were located – the Prokhorov workshops and the brewery – was particularly restive. The entire Shchukin empire was under threat.

The P.I. Shchukin Museum was close by, a stone's throw from Tverskaya. It was soon to be taken over by the revolutionaries, but Sergei's brother had taken precautions. Since May, the enormous antiquities museum and its two Old-Russian palaces had legally become the property of the City of Moscow – in other words, the property of the people. Petr's work, his monument to centuries past, was theoretically untouchable.

So Petr was more or less secure. He was a bachelor and had no family responsibilities; he could take care of the store. Sergei would have to leave with his family and lodge them in a place of safety, taking the train to St Petersburg and beyond with Lydia and the children. In the coming days, in

early December at the latest, the insurrection would break out. It was now or never for the revolution, before the strike ran out of steam and before St Petersburg could send adequate reinforcements to patrol the city effectively. The end game was focused on the paralysed economic capital of Russia.

Sergei Shchukin had to leave, but at the same time he had to do his utmost to save the family fortune and the legacy of his father, which was the company. The Shchukins were entrepreneurs. They had placed all their assets in I.V. Shchukin & Sons. The destiny of the firm was inseparable from their own. When Shchukin decided to become a permanent client of Ambroise Vollard, he paid him a monthly fee of 300 francs, settling accounts with him at the end of the year, according to the number of pictures acquired, as soon as Sergei received his only income – the dividends from his shares. He was a true nineteenth-century capitalist.

As the head of the firm, he did not wait for the threat of revolution to become reality before analysing the situation under three headings.

1. The imperial government had lost its war, but had been wise enough to bring that war to a close.
2. The imperial government had waited too long to liberalize the regime. Nevertheless, it had done so now, creating an expectation that was daily eating away at the determination of the insurgents. How long could a leader stand on a barricade when he had serious hopes of being elected to parliament?
3. That which begins in the street must end in the street. The bloodshed in St Petersburg on 9 January would have to be repeated in Moscow, if the insurgents were to be forced by the cruelty of the tsar's repression to bring their movement to an end without betraying the revolutionary cause.

Shchukin's way, as a *kupets*, was clear. His duty was not so much to save the family firm as to do his job, which was to make as much money as possible by betting on the near-certainty that things would return to normal and business would resume as before. The textile market was at a standstill, production was in free fall and stocks were unsold. I.V. Shchukin & Sons chose this moment to buy – and they bought everything, for weeks on end,

under the best conditions of price, payment and credit that the sellers could offer. The entire stock of textiles in the Russian Empire was cornered by I.V. Shchukin & Sons, and the former *kupechestvo* oligarchy metamorphosed into a Shchukin monopoly. As soon as the market resumed – and that was only a matter of time – Petr would re-emerge from his 'museum of the people' and sell the merchandise before he had even paid for it, on his own terms.

Everything was ready. It was time to take shelter before the final confrontation in the streets. Sleeping carriages to St Petersburg were booked for the Shchukin family and their English governess. But one child was missing. Sergei Sergeevich, the youngest son, had not returned home. He was seventeen years old.

Nobody knew where he was. The schools and universities were all closed, and some had been occupied by the insurgents. Many students were in the streets alongside the strikers. The police were barricaded at strategic points around the city, while at Nikolaevsky station the army was packing off bourgeois refugees and disembarking reinforcements. To go out in search of a wayward adolescent in this bubbling cauldron was unthinkable ... The street lights were dead and the night was lit by nothing but white snow. The revolutionary committee had ordered coachmen to stop carrying people at 6 p.m., though they could work until then to feed their families. The Shchukins were trapped in their palace.

It was an impossible quandary. Still the boy failed to return, and perhaps the family knew more than they were prepared to say. Appeals were lodged in the newspapers and a substantial reward was offered to anyone who could provide information as to young Sergei's whereabouts. It wasn't easy to deal with the police, who were themselves preparing to suppress the coming uprising with every means at their disposal. There were hundreds of young people among the insurgents, all of them caught up in the thrill of revolution.

On 7 December, a revolutionary committee meeting in the Fidler Technical School called for a 'pan-Russian' general strike, which would lead to an armed uprising. 'It was like a great party. People massed everywhere in joyful crowds of marching workers waving red banners,' wrote Countess Ekaterina Kamarovska in her diary.

Everywhere the call was heard: '*Comrades! General Strike!*', as people mutually congratulated one another in a fever of joy and celebration. Palace gates were closed and padlocked and ground-floor windows were nailed up with planks. The city's buildings were silent as tombs, but in the street everything was animated, busy and effervescent.[13]

On 25 November 1905 (Old Style), Sergei Shchukin's sister Olga wrote to her cousin Nadezhda Botkina, the wife of Ilya Ostroukhov: 'It may be just as well for the Shchukins to leave now. It will calm them down. In my heart of hearts, I believe that Serezha[14] will turn up eventually, as soon as the situation gets back to normal. If there's one thing I'm sure of, it's that.'[15]

The oligarch took his decision: overruling all objections, he declared that he would not risk the fate of his entire and very exposed family – including three other children aged nineteen, eighteen and fifteen – because one son was missing.

On the night of 9–10 December, the army and police stormed the revolutionary headquarters at the Fidler School; those insurgents who surrendered, mainly students, were put to the sword. The following day, all Moscow was barricaded. The Moscow uprising lasted for ten days in all – from 10 to 19 December 1905. It was crushed by the police and the army, whose elite regiments were brought in from St Petersburg. After a year in the trenches of Manchuria, they had no sympathy whatever for people whom they saw as the agitators and backstabbers of Moscow. They dispersed the young militias of workers, students and revolutionaries with artillery and machine guns. The principal outpost of the militias, the Schmidt furniture factory, was taken and torched on 30 December. At the same time, the neighbouring Prokhorov factory, in which the Shchukins were the principal shareholders, was liberated. The Shchukin workers, though threatened with repression by the revolutionaries, had refused to join them.

The disorder engendered by the 1905 revolution had a powerful effect on the *kupets* and the intellectuals surrounding Sergei Shchukin. Some went to ground, like Dmitry, who sat quietly with his Dutch minor masters, protected from the outside world by the walls of his house. Others

fled abroad, to Germany, Switzerland, France or England, as did the 'politicians'. Still others did not have the moral strength to cope with the fires, the bloodshed, the hundreds of dead and wounded. A wave of suicides was to sweep Moscow that spring and summer.

Yet when the time came, the bells for Orthodox Christmas (celebrated on 7 January, according to the New Style) rang out across the city of a thousand churches. Order had been restored; everywhere people returned to work.

The Debacle

There exists an old photograph of the Shchukin family beside the Sphinx and the pyramids of Egypt. In the centre is Shchukin himself, drooping like a deposed pharaoh on a donkey, looking to this biographer as if he can't quite believe he was so foolish as to organize this lunatic expedition. Ivan and Grigory, like knights errant on their camels, can barely contain their emotion. Ekaterina, on the middle camel behind her father, plays the aristocrat bored to the brink of tears. Lydia, on a donkey beside her husband, is painful to look upon: she is the picture of a grieving mother, her eyes cast down, looking inward. Outside the frame lingers the ghost of Sergei Sergeevich, still missing.

Of course, it is all too easy for anyone aware of the context to read all this into the photograph. Nevertheless, in this particular pyramid snapshot, nobody is smiling – not even the *fellahin* holding the camels, who seem mesmerized.

The Shchukins fled Moscow, like thousands of other wealthy Muscovites, but their destination seems crack-brained. On 20 January, Petr received the first news of them, in the form of a postcard from the Sudan, then part of British Egypt. The journey there was by no means as dangerous at that time as it is now: a railway linked Cairo and Khartoum with all the precision of the British colonial system. The manicured lawns of the great luxury hotels

and *The Times* delivered daily (and only three weeks old) bore witness to the security and comfort of the British Empire at both ends of the line. This was an expedition to the source of the Nile.

All the *sang-froid* of the experienced *kupets* came to the fore in this episode, when Sergei, faced with the fruitlessness of further search, abandoned his seventeen-year-old son for the good of the clan. The subsequent solidarity of his remaining family, whatever may have taken place when the decision was made, is equally remarkable. On 30 January 1906, on their return from Egypt, Lydia sent news from Rome to Petr, ever her favourite confidant:

> My dear Petya . . . Thank God! The voyage has fully occupied Serezha and has prevented him from being too sad. He thinks he should be back in Moscow by 20 February [New Style]. I'm worried that once he is home, alone in the empty house, he will get depressed again. I believe I shall stay on in Rome for another month, and then perhaps move on to Berlin with the boys. They need to get on with their studies.[1]

Sergei returned to Moscow to complete the audacious speculative coup he had pulled off during the troubles. This operation, which involved perfect financial timing, paralleled the intuition he demonstrated when he was spotting painters of talent. Demand for textiles soared all over Russia as business picked up; factory production had been stalled for a year and all stocks had been appropriated by I.V. Shchukin & Sons. As a result, prices were dictated by Petr and Sergei and the market went mad; it was a perfect example of the *kupets* 'sitting in his storehouse'.

Lydia and her three children stayed in Rome. What was she waiting for? More than three months had passed without word of her missing son. Lydia wrote that the children needed to go to school – the boys at least. Ekaterina could continue to learn English with the governess, Miss Holman (she, too, had gone with the family to Egypt; in the group photograph she is seen mounted on a donkey with an expression of deep gloom). It was agreed that Ivan, a brilliant student of philosophy, should be withdrawn from Moscow University, which was deemed too restive. As for Grigory, he had a painful handicap: a tumour in his skull had made him deaf and caused agonizing

migraines, which only his mother could allay. Hence the suggestion that Lydia and the children should move to Berlin. It was as if Moscow, where young Sergei had vanished in such mysterious circumstances, was driving the family out, just when their business had reached its zenith.

Sergei Senior would have to leave Moscow again promptly if he was to enrol Ivan in a German university, where the second academic semester began on 1 April. It was hard to decide what to do, with so few clues as to what had happened to the lost son.

But suddenly, the wait was over.

A short article in *Moskovsky Listok* (*Moscow Broadsheet*), Moscow's main mass-circulation daily, appeared on 27 March 1906:

> Yesterday, the body of an unknown young man was found in the Moskva River near the village of Khoroshevo. It was immediately thought likely that this was the younger Shchukin, and the Shchukin family, now abroad, was duly informed. Their housekeeper was able to identify the body as that of Sergei Sergeevich Shchukin. The investigation continues.[2]

On Wednesday, 29 March, a black-edged funeral announcement was placed in several local papers:

> It is with deep sadness that his parents, brothers and sister announce the death of Sergei Sergeevich Shchukin. Funeral masses will be said daily at the house of S.I. Shchukin on Bolshoy Znamensky Lane, at 1.15 p.m. and 8 p.m. The funeral will be held at the Znamenka Church, Znamenka Street, on Thursday, 30 March [Old Style], at 10 a.m. The burial will take place at the Pokrovsky Monastery.[3]

Sergei's body was found on 25 or 26 March and matters swung smoothly into action: the parents and siblings were immediately called home; the Trubetskoy Palace was placed in mourning; permission to bury the body was immediately obtained, despite the ongoing official investigation; and the traditional Orthodox funeral masses were arranged punctually. The funeral service itself took place on 30 March, with the entire family ranked beside the coffin. The Moscow firm's logistical base was nothing if not reli-

able, and behind this meticulous professionalism we see the devoted hand and organizational skill of Petr Shchukin.

The black silhouettes beside the grave were scrutinized by the Moscow public, who were by now aware of the phenomenal profits made by Sergei Shchukin's speculation on the crash caused by the revolution. It was rumoured that I.V. Shchukin & Sons had made several million roubles in profit. Now its owner seemed to be paying a terrible toll.

Rumours were rife. The younger Sergei was said to have left a suicide note, but it was hardly likely that any such note had been retrieved from the Moskva River with his body. So it would have had to have been a message left at (or sent to) the palace. But why on earth would a young, seventeen-year-old man want to kill himself, just when the revolution was dawning? It was a mystery and his relatives reacted as well as they could.

Thus ended the first phase of the Shchukin collection. For the collector himself, the collection became a passion – in every sense of the word – now that he had been forever separated from his palace of happiness by the black waters of the Moskva.

Le Bonheur de Vivre

After the funeral, the nine days of strict mourning and the first memorial mass, the family again separated. Lydia took Grigory and Ekaterina back to Italy, far from the scene of all the drama. Sergei had to prepare for that summer's Nizhny Novgorod trade fair; but first he had to deal with the matter of Ivan's future studies. The project of installing the family in Berlin had been dropped. Instead, Shchukin had chosen for his son the University of Marburg, in Hesse, which was renowned for its excellence in the study of the humanities. The photographs show buildings in pure Gothic style.

Imagine, then, the stupefaction of Lydia in Italy, when she learned from Petr that her husband and eldest son had made a detour to Paris on their way to Marburg. What had happened? Ivan's first semester at Marburg was supposed to have started on 1 April. Had Sergei set aside his collecting for too long? Did he simply want to keep his son close? As a father, Sergei had neglected his children, entrusting them to governesses and private tutors. Now one of his children was gone forever. It was time to make amends.

On one of the last days before the closure, on 30 April (European calendar), of the annual Salon des Indépendants exhibition, Sergei Shchukin and his son Ivan entered the monumental glass hall of the Cours-la-Reine, one of the now-vanished centrepieces of the 1900 Paris exhibition. The place was in uproar: a crowd had gathered to mock the ardent vision of happiness of a painter with whose work Sergei was unfamiliar.[4]

He saw an idyllic landscape, figures dancing, embracing one another and playing musical instruments, in a classic pastoral reinterpreted in the fauvist style. This was the only painting by Henri Matisse at the salon. It was entitled *Le Bonheur de Vivre*.

Sergei stood transfixed amid the scoffing mob, paying not the slightest heed to what they were saying. He was trembling, gripped by the sudden wave of emotion that always seized him the moment he recognized a work as his own. As he always said: 'I don't choose paintings; paintings choose me.' And this painting had chosen him right enough.

Shortly afterwards, a *commissionaire* of the salon elbowed his way through the crowd and on the picture stuck a label bearing the single word 'Vendu'. There was much hissing, shrugging and shaking of heads, gradually fading to an embarrassed silence. Money always has that effect. Then, as they say of sudden silences in France, 'an angel passed'. Or rather, if young Ivan's memory is to be trusted, a very tall, bald, stocky, brown-skinned man with large, sad eyes happened by. This was Ambroise Vollard, come to greet his loyal client 'Monsieur Stchoukine'.

'The Steins just bought it,' he said. 'A bold move, I'd say.'

These were four Americans: Leo Stein, who lived with his sister Gertrude in a big artist's studio on the rue de Fleurus, close to the Luxembourg Gardens, and their elder brother Michael and his wife Sarah, who lived on the rue Madame close by. They had inherited from their father and owned shares in the San Francisco cable car company. They were rich, but not rich enough to buy paintings by established artists, and so they trusted their instincts with unknown ones. Leo had been at the last Salon d'Automne, which Shchukin had missed, and had bought the most controversial picture there: Matisse's *La Femme au Chapeau*. This was the famous Salon at which the painters grouped in Room 7 of the Grand Palais (Matisse, Derain, Marquet, Manguin, Camoin and Girieud) flooded

both line and perspective with bright colour, as if to devour the sculpture of a child in the centre of the room. The critic Louis Vauxcelles described the effect as 'Donatello among the wild beasts [*fauves*]'.

'Well,' Vollard concluded, 'Leo's been dithering for the last few weeks, but now he's made up his mind. He and Gertrude have just bought *Bonheur*!'

The Russian couldn't take his eyes off the canvas. He had just lost a son and now he was contemplating a strange painting that moved him very deeply. Matisse had used the deformation of his motif in just the same way as dissonance is used in the composition of music. This was *dissonant* painterly harmony, captured in a scene of absolute peace, with an absolute insolence that confirmed within him the conviction that all was still well. Somehow this painting defied the icy river that had swallowed his son, inviting him to enjoy life once again.

There was satisfaction to be found in making fun of the real world. The world reacted violently to provocations like this, its rage and sarcasm creating a dissonant accompaniment that was nevertheless perfectly pitched for the moment.

There was one detail above all that fascinated Sergei Shchukin, around which Matisse's entire composition seemed to be arranged. At the top of the canvas, towards the line of the sea along the bright yellow sand, were six naked figures outlined heavily in black or orange, capering furiously in a ring. These figures contrasted starkly with the languid poses of the creatures all around, seeming to invite them to partake in the very joy of living that Sergei believed he had lost.

'Can you give me the address of Matisse's studio? I'd like to meet him.'

'19, Quai Saint-Michel,' replied Vollard. He was surprised. As far as he knew, this Russian collector was not in the habit of meeting painters in person.

Le Pêcheur de Collioure

In early May 1906, Sergei Shchukin climbed five flights of stairs to a small apartment-studio whose windows offered a view of the Seine, the Louvre, the Pont-Neuf and Nôtre-Dame.

Henri Matisse had no idea of the extent to which his painting at the salon had bewitched the rich Russian industrialist at a crucial moment of

his life, though he himself had reached an important crossroads in his own career. Born into an upright French bourgeois family in the textile-producing north of France, he had been trying unsuccessfully to make a living with his art ever since his arrival in Paris in 1891. He had studied with Gustave Moreau to prepare for the Beaux-Arts and Moreau had told him: 'One day, you will revolutionize painting.'

Matisse had spent the last seventeen years trying to fulfil this prophecy. He was estranged from his father, a grain merchant from Bohain in the Aisne department, who as long as he lived viewed his son as a failure. At the same time, Henri provoked the bitter hostility of the Paris artistic and academic establishment. The continual rejection of his work had effectively made him a failure: to survive, he sold copies of paintings in the Louvre and lived on his wife's money, with occasional help from friends. Nevertheless, he was an illustrious failure, the leader of the failures, constantly sounding the death knell of old-style painting and capable of inspiring blind devotion within the small circle of companions, admirers, artists and lovers of art who were bewitched by his talent. At the forefront of these was Amélie, his wife, his model, the soothing, intimate light of his life, who supported him by toiling as a hat maker and served as his bulwark against the trials of daily existence.

In the summer of 1905, Henri Matisse travelled to Collioure in southern France, where he immersed himself in colour in the company of his colleague André Derain. After the resounding success of the fauvists at the Salon d'Automne Matisse became the leader of the group, and his *Femme au Chapeau*, bought by Leo Stein, became one of the movement's most celebrated and controversial works. Matisse, Derain, Vlaminck, Marquet, Othon-Friesz, Manguin and Rouault shared an unusual way of using bright colours; their brushwork was free and their exploration of the language of painting totally uninhibited. As Matisse succinctly explained: 'We used blue, red and green, and combined them in an expressive and structured way. Nor was this at all intended; it was just something that arose from an inner need.'

Le Bonheur de Vivre at the Salon des Indépendants had once again riled up swarms of detractors, even more numerous and virulent than before. The fuss attracted the attention of gallery owners and collectors, especially those at the cutting edge of artistic renewal; for a while now they had been

interested in the original and unclassifiable talent of Matisse, so gifted in the art of false *maladresse* and of conveying intense emotion through what on the surface seemed to be mere daubs. Guillaume Apollinaire, one of Matisse's greatest admirers, was soon to write that the Paris establishment was ready to stone to death one of the most seductive contemporary masters of the plastic arts. At the end of 1905, the socialist parliamentary deputy and Matisse supporter Marcel Sembat was struggling to raise a subsidy of 200 francs that would see the Matisse family through the winter; but by spring 1906, the purchases of Vollard, Druet (who on 23 March showed sixty Matisses at his gallery), the Steins and the collector Gustave Fayet had finally extracted the artist from the difficulties into which his innovative intransigence had plunged him ever since he started out.

When Sergei Shchukin first met Matisse, it was at a moment when he was ready to raise his collection to an altogether higher level. Henri Matisse described the meeting in a number of subsequent interviews and in a letter written to Henri Manguin in June 1906:[5]

> Shchukin, a Moscow importer of Eastern textiles, was about fifty years old, a vegetarian, extremely sober. He spent four months of each year in Europe, travelling just about everywhere. He loved the profound and tranquil pleasures . . . One day he dropped by at the Quai Saint-Michel to see my pictures. He noticed a still-life hanging on the wall and said: 'I buy it [*sic*], but I'll have to keep it at home for several days, and if I can bear it, and keep interested in it, I'll keep it.' I was lucky enough that he was able to bear this first ordeal easily, and that my still-life didn't fatigue him too much.[6]

In reality, Shchukin did not actually purchase the big still life *Cafetière, Soupière sur une Table*, or *Vaisselle sur une Table*, dating from 1900; we now know Vollard bought it from Matisse at that time for 150 francs, and it was inventoried among other works on his register for 1906. But during this first exploratory visit, Shchukin did pay Matisse 100 francs for a drawing and two lithographs, both of which are mentioned in the letter to Manguin; it is as if this otherwise ruthless businessman dared not leave a painter's studio without buying something.

Actually, the episode had all the hallmarks of a diplomatic interview: the two men talked about a hypothetical project for the future and exchanged small gifts. The future was to show that they were made for each other. This was only the first meeting of many.

As it happened, both were about to depart on long journeys. Matisse left Paris a couple of days later; he was scheduled to embark for Algiers at Port-Vendres on 10 May, on what he described as an 'exploratory trip' that his new-found wealth had made possible. As for Shchukin, on 7 May he was writing a postcard to his brother Petr from Germany, telling him how much he liked the beautiful city of Marburg, where his son Ivan had at last begun his first university semester.

For the time being, there was little else for the two men to discuss. *Le Bonheur de Vivre*, which had so mesmerized Shchukin, had been moved to Leo and Gertrude Stein's house on rue de Fleurus after the salon closed down on 30 April. Sergei had to swallow his regret. The situation being what it was, it would have been unimaginable to buy what would have represented the most wonderful homage, the dream of a father that his son might rest in peace among the ecstatic figures of *Le Bonheur*. It was almost as if he were paying Matisse a visit of condolence for the painting he had missed, while opening the door to future collaboration.

The little pen drawing *Le Pêcheur de Collioure* was thus the first Matisse to enter the Shchukin collection. It depicts a fisherman casting his line across a calm sea from a rock overlooking the beach at Collioure. The figure wears a broad hat and probably represents Henri Matisse himself. One wonders what was in the artist's mind as Shchukin left the apartment with the drawing under his arm; can he have suspected that although he was not to hear from the millionaire for another two years, Shchukin was the catch of his life?

Before taking the express to Frankfurt and Marburg with his son on 5 or 6 May, Shchukin revisited Ambroise Vollard's gallery on the rue Laffitte to conclude the purchases he had initiated on 27 April. Returning to his collection at the exact stage where he had left it in November 1904, he bought two major Cézannes: *L'Aqueduc* and *L'Autoportrait* (considered by some to be the founding work of cubism). He also bought at least two Gauguins, *Les Tournesols* and *L'Homme Cueillant des Fruits*, the latter painted almost

entirely in bright yellow tones. In other words, in two visits to rue Laffitte, Shchukin bought over 30,000 francs' worth of paintings from the dealer. He was no longer the same man he had been between 1898 and 1904, a careful experimenter with impressionism and the romantic Nabis. He now knew exactly where he was going. He had understood the founding contribution of Cézanne and cannot have failed to see *Les Trois Baigneuses* hanging in Henri Matisse's studio on the Quai Saint-Michel. Matisse had bought the *Baigneuses* in 1899 from Vollard; Amélie had pawned her ring to raise the money. As for Gauguin's Tahiti series, they brought Shchukin a pleasure and a relief that were comparable to what he felt when he first saw *Le Bonheur*.

The master on the mountain

Shchukin bought three new Gauguins from Vollard's gallery on 5 November 1905. He was back in Paris with Lydia and the two younger children after two months' rest in Florence, Venice and Greece. It had been a family pilgrimage to places where they had been happy beforehand, and he was to remember it with wistfulness in later life.

Everywhere, in hotels and restaurants, they met Russian friends and acquaintances. Ivan's salon on the Avenue Wagram was constantly filled with people. They were all there: Alexandre Benois, Igor Grabar, Ilya Ostroukhov, Ivan Morozov, Prince Shcherbatov, in addition to the painters Pavel Kuznetsov, Mikhail Larionov and Kuzma Petrov-Vodkin.[7] There was also Count Dmitry Tolstoy with his little beard, round spectacles and decorations, who was soon to be made director of the Imperial Hermitage. Tolstoy was also the honorary president of the groundbreaking retrospective at the Salon d'Automne in 1906: *Two Centuries of Russian Painting and Sculpture*, an enormous exhibition of 750 pieces.

This was another triumph for Diaghilev and his group, who had provisionally closed down *World of Art* because they were too busy with grander projects. Leon Bakst had decorated no fewer than twelve rooms at the Grand Palais for the show. Diaghilev's triumph didn't interest Shchukin. Moreover, his brother Ivan's extravagant way of life was a source of deep foreboding: when Count Tolstoy and all the other hangers-on dined

at Ivan Shchukin's house, it was certainly not Diaghilev who was paying the bill.

Sergei kept returning to the other retrospective showing at the Salon d'Automne, where Gauguin was on display. This first important exhibition in Paris, which comprised some 195 works of art, was organized by Georges-Daniel de Monfreid and Gustave Fayet; at last it did full justice to the impoverished exile of the South Seas. Paul Gauguin was finally emerging from purgatory. Charles Morice, his future biographer, announced the fact in his preface to the exhibition's catalogue: 'Let us hasten to repair an injustice that has continued for much too long. Let us proclaim loudly and clearly that Gauguin was a great master and alert the younger generation to the fact that they will find in his work a wonderful source of guidance . . .'[8]

Sergei was consumed with excitement. He had hung his first two Gauguins of 1904 in his private office, scarcely daring to show them to anyone. Now he found that he had been well in advance of the pack, even in Paris. On 5 November, he added more paintings to those he had bought in the spring: *Tu es Jalouse?* (in which two naked Tahitian girls are depicted lying on a beach beside a tawny sea); *Nativité Tahitienne* (in which the Virgin Mary, enveloped in a yellow halo, lies in a stable exhausted by her labour, while in the foreground local midwives cradle the child Jesus); and the languid nobility of *Couple Assis dans une Chambre avec un Chat* (or *Ne Travaille Pas . . .*).

The very next day, Sergei went back to Vollard's to buy *On l'Appelle Vairamuti*: a naked woman in the centre, a half-naked man to one side, and symbolic figures telling the untellable history of Tahiti. This was the kind of painting that bewitched Shchukin, who loved to spend hours on end with a picture. The price had reached 25,000 francs – for a painter to whom Vollard had paid 250 francs per piece, plus the cost of canvasses, colours and brushes. And Shchukin grew more and more insatiable. On his arrival in Paris, he learned of the death of Cézanne on 22 October 1906. The painter had gone out at dawn, as he did every morning, to catch the light on the Montagne Sainte-Victoire. Soaked to the skin by a thunderstorm, he did not survive the pneumonia which followed.

Six works by the master were hanging at the salon. Fresh flowers were stacked beside his self-portrait, among them a wreath placed by 'Sergei

Shchukin, a Moscow collector'. Just as he was leaving after the salon closed, Shchukin bought a Sainte-Victoire, freshly painted that year, from Vollard. The maturing of his collector's eye was in unison with the artist in the act of painting: this is a unique Sainte-Victoire, hot on the plain, cold in the sky, with the mountain bizarrely sculpted, twisted and tormented, anticipating cubism and the shift towards abstraction.

Henri Matisse showed twelve still lifes at the salon, all of which had already been bought by Gustave Fayet. Shchukin then placed Matisse on the back burner until the end of October, when he bought a painting from Eugène Druet – a pre-fauvist piece, executed in 1901. What does this wooded and coloured landscape represent? The title is *Jardin du Luxembourg*, but it may be the garden at Vives-Eaux, in the Paris region, which the parents of Amélie Matisse managed. So the first oil on canvas by Henri Matisse recorded in the Shchukin collection escapes any precise identification, and no one can be sure of its origin. Decidedly, the beginnings of this, one of the most productive artistic associations of the twentieth century, are hard to track.

The tragic year 1906 drew to an end for Sergei Shchukin in a riot of exotic colours. It was as if, gripped by the fear of some new drama, he was looking for forgetfulness in the Eden that poured from the palette of Gauguin. For a Russian accustomed to ephemeral vegetation, with pale colours and fleeting aromas, the fairy-tale kingdom of the South Seas was a delicious revelation, with its multicoloured hummingbirds, emerald shores, sapphire skies and blinding sunshine. With Gauguin, Shchukin could walk in a dream that deadened the pain of his loss, his misery at his wife's unhappiness, and his anxiety over what recent events portended for Russia.

In the Footsteps of Moses

In Old Arabia, which today is known as Palestine, there is a vast desert, arid and desolate, where no plants grow. At its edge is Mount Sinai, looming above the rocky escarpments that rise from the sea-coast. On the flanks of this mountain live hermits whose lives are dedicated to preparing for death in the peaceful seclusion of the desert. This seclusion is dear to their hearts. They have made it their task to build upon earth the heavenly abode of the angels, serving God day and night through fasting and prayer.

Procopius of Caesarea, fourth century AD

On 3 January 1907, well before dawn, Sergei Shchukin knocked on the door of Valentin Serov. Lydia had died a few hours earlier and Sergei had come to beg his friend to paint a last likeness of his beloved wife.

The artist quickly wrapped himself in furs and gathered his materials together. Serov was the man whose pencil drawings had immortalized the image of Cossacks slaughtering protesters outside the Fine Arts Academy in St Petersburg. Now he was living in Moscow, on Volkhonka Street, close to Znamensky Lane.

The city was pitch dark and cloaked in snow as the two men made their way past the white, golden-domed Cathedral of Christ the Saviour, overlooking the frozen Moskva River.

In December, Lydia had returned to Moscow in a state of exhaustion. She took to her bed just before Christmas. A female ailment, the doctors said at first; but in fact she was riddled with cancer. She was forty-two years old.

The priest read the Gospel by Lydia's deathbed while his deacon responded in the deep, rumbling bass that only Russian Orthodox churchmen can achieve. The three motherless Shchukins, in the same mourning clothes they had so recently worn for their dead brother, stood by, holding each other close. At the door, an elderly lady greeted Sergei in the grand manner. Nadezhda Borisovna Trubetskaya was a princess of the old school, though for years past she had been reduced to living in an apartment in one wing of the palace that had formerly been her own.

Bright candles were brought and placed among the night lights beneath the icons, so that the painter Serov could see to work.

His charcoal drawing shows the thin, aquiline face of a very beautiful woman, with an Orthodox white cotton band laid over her brow. The head is cushioned by immaculately white pillows. There is a faint bitterness about the dark, regular line of the lips. In this, the great portraitist has somehow captured the elusive melancholy of Lydia.

That same night, Sergei wrote to Petr, 'Dear Petya, please send across a copy of my will . . .' It was an anguished request, scrawled on a black-trimmed card. Sergei had decided to bequeath his entire collection to the city of Moscow. He wished it to be held by the Tretyakov Gallery, whose museum of modern art it was to become. It was to be the first of its kind in the world.

Sergei commissioned a fashionable Moscow architect, Lev Kekushev, to oversee the changes required to turn the Trubetskoy Palace from a patrician home into an art gallery open to the public and then gradually a full-fledged museum. The project was carried out at characteristically breakneck speed. Even in his grief-stricken state, Sergei was able to draw upon deep reserves of determination and *sang-froid*; he knew that for him action was

the best antidote to grief. The plans were completed and sent to the municipal Duma by 19 January.

Kekushev, an eclectic architect locally nicknamed 'The Encyclopaedia', grasped his client's desire for a simple backdrop. He did not change any details of the building's interior, leaving the finely worked cornices and the ceilings adorned with purple and ermine armorial bearings. Instead he closed off two windows: one in the Gothic dining room, with its dark wooden panelling; the other in the music room, where the hangings were pale silk with silver edgings. In this way he gained space to hang more pictures. Next, a floor was skilfully added to the wing inhabited by the elderly princess, featuring three tall windows with art nouveau arabesques. As soon as this spacious new apartment was completed, Sergei moved his sons Ivan and Grigory into it, thereby freeing up the maximum of gallery space on the main floor of the palace.

Sergei continued to fend off his grief with new projects; but as the months dragged on, it caught up with him. We know nothing of his relations with his three remaining children, but we do know that his dream of a Muscovite temple of modern art was starting to falter.

Sergei Shchukin, suddenly a widower, failed to buy a single new painting in 1907.

Mosquitoes and flies

'Tomorrow I leave for Trieste,' wrote Shchukin to Petr from a spa in Semmering, Austria.[1] 'On 10 October a ship of the Österreichischer Lloyd Line, the *Habsburg*, sails for Alexandria, and I have succeeded, not without difficulty, in booking a cabin aboard her. This is high season for travelling to Egypt, so the vessel is packed. One of the servants aboard gave me his cabin, his kindness cost me 200 francs. I anticipate a long and difficult voyage . . .'

The next communication bore an Egyptian postage stamp:

Dear Petya, I have spent the last few days completing the arrangements for my caravan. I thought I would manage to organize everything fairly rapidly, but I find that everything in the Orient moves at a snail's pace. Now my caravan is ready at last; in an hour's time I shall cross the Suez

Canal in a sailing vessel and begin my journey across the Sinai desert to the monastery of St Catherine on the Mount. From there I plan to continue eastward to Akaba. The most awkward part will be crossing the Turkish frontier and closely skirting the territory of the Bedu, who are not subject to Ottoman rule. It is possible that we may have to travel by night and remain hidden by day. After this, I plan to visit the ruins of Petra in Arabia before returning to Jerusalem across the Jordanian desert. This promises to be an interesting journey, not entirely without danger. It should take about two months. So don't worry if you hear nothing from me for a while. There's no postal service here.[2]

The Sinai journal kept by Shchukin throughout these travels is the only personal text written by him that has survived. Parts of it are recorded below.[3]

Suez, 29 October 1907

Arrived in Cairo on 1 October [14 October according to the European calendar], expecting to stay four or five days only, since I planned to begin my expedition to the Sinai and the mountains of Arabia as soon as possible. I am in uncertain health; my heart is heavy and my nerves on end. Within a very short space of time I have had to endure great trials and irreparable losses. Any religious feelings I had were dormant. I plunged about blindly, trying to keep myself occupied in one way or another. At one point I threw all my energy into acts of charity, but probably because I lacked experience in these matters I encountered nothing but difficulty. Then I turned feverishly to my business, looking for new resources and new merchandise. This calmed me for a short while. Finally, after my wife's death, I realized that nothing could fill the void that had opened in my life, and so I determined to put that life behind me. To this end I resolved to undertake a real journey across a real desert, to live in a tent, to stay all day long in the open air, and to nourish myself as the real Bedouins do – with dates and flat bread, drinking nothing but water. In short, I would live as men have lived for thousands of years past; before there were telegraphs, telephones, railways, ocean liners, luxury hotels, automobiles, theatres and art galleries.

111

My aim was to abandon and forget all the outward conditioning of our lives, everything that we call our culture.

Once I had arrived in Cairo, I had to accept the fact that I was in the East, that time here has a completely different value to the one we westerners give to it.

On the 28th, I left Cairo by train for Suez, where my principal dragoman, Halil Harbour, a Syrian from Jaffa, awaited me. He declared that the camels and the Bedouins were already on the other side of the gulf, but they had been held up by a delay in the issuance of visas for our passports by the Pasha and the British governor . . . At last everything was in order and at three in the afternoon we were able to cross the strait. We set up camp by the sea on the far side.

My caravan is quite substantial: eighteen camels, fifteen Bedouins, two dragomen, a cook and my servant. In fact, it seems quite odd to me to be heading into the desert encumbered with such a train. But it is difficult to travel here in any other way. I don't speak Arabic, I need an interpreter and Arabs and camels are indispensable for safety and transportation. For my own part, I need no cook. I mean to feed myself on nothing more than bread, fruit and water; but a cook is very much required by everyone else, including my servant. As for the second dragoman, I hired him primarily to take care of the tents. Furthermore, he is a competent photographer.

My dragoman spent the whole evening opening the cases in preparation for our departure next day. The Bedouins took care of their camels and in general the camp was a hive of industry. I was the only one who had no idea what to do. To begin with I wandered by myself along the shore, breathing the delicious air. But alas, I can no longer innocently enjoy the prodigies of nature as I once did. The poison of memory kills the least moment of happiness. In that place I was reminded of the sublime beach at the Lido, of the wonderful days I spent there with my wife, of our delicious walks together. And I was stung by so sharp a grief that I had to return to camp and pretend to oversee the work of my people. Within myself, I felt a gnawing jealousy; they were busy, they had a goal; and that goal was to prepare everything on my behalf.

The wind gathered strength. Suddenly it was cold. I retreated to my tent where, for the first time in my life, I began to write a diary.

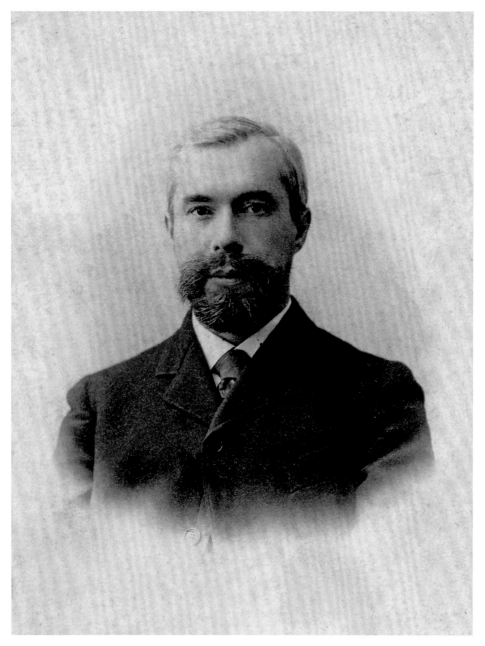

1. Sergei Shchukin, early 1890s. Known for his 'highly coloured, brilliant, impassioned' manner, Shchukin was an immensely successful textile merchant, awarded the honorary title of 'commercial councillor' in 1888. His tough-minded approach to business earned him the nickname 'Porcupine'. At the end of the decade he would visit Paris and begin to apply his talents to the acquisition of masterpieces, beginning with works by Monet and Pissarro.

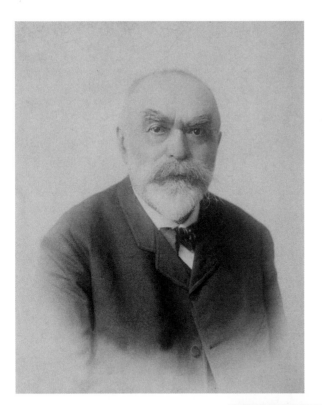

2. Ivan Vasilevich Shchukin, Sergei's father, 1880s. Famous for napping at the Bolshoy Theatre, this self-made man was the founder of the textile trading firm I.V. Shchukin & Sons. At his funeral his coffin would be borne by the firm's workers, followed by the great and good of Moscow society.

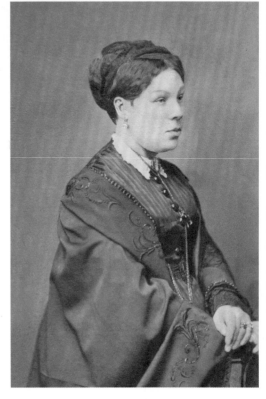

3. Ekaterina Petrovna Shchukina *née* Botkina, the mother, 1860s. Daughter of the 'Tea King' Petr Botkin and sister of a handful of powerful Muscovites, Ekaterina's marriage allied the Botkins with the Shchukins. She gave birth to eleven children, seven boys and four girls, four of whom would go on to become leading art collectors.

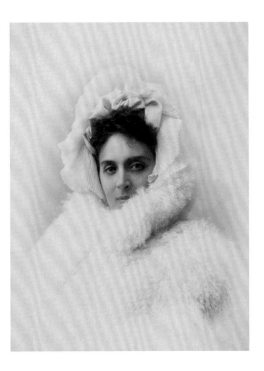

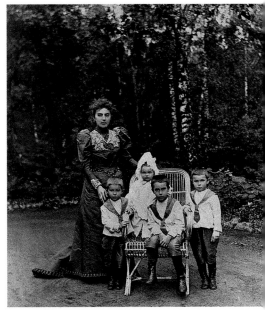

4. Lydia Shchukina, early 1890s. Lydia had married Sergei Shchukin in 1886. A member of the Korenev family, which ran the coal mines in Donbass, Ukraine, she was said to be one of the most attractive women in Moscow.

5. Lydia with her and Sergei's children, 1890s. From left to right: Sergei, Ekaterina, Ivan and Grigory.

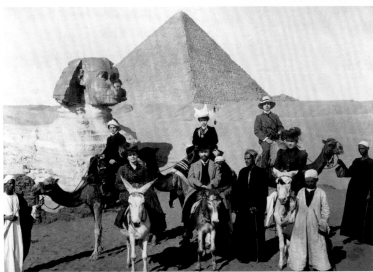

6. The Shchukin family in Egypt, January 1906. From left to right, on camels: Grigory, Ekaterina and Ivan; on donkeys: Lydia, Sergei and Miss Holman, the children's English governess. The family travelled to Egypt in order to flee the revolutionary riots in Moscow. Their son Sergei was not with them – he had been missing since November 1905. Tragically, his body would be recovered from the Moskva River in March 1906.

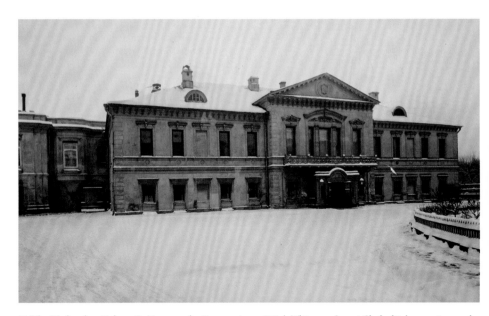

7. The Trubetskoy Palace, 8, Znamensky Lane, winter 1914. This was Sergei Shchukin's mansion and his showroom. The left wing was redesigned in 1907 in the modern style. The Gauguin dining room was in the left gallery, the Matisse pink salon was in the middle, and Monet's works were displayed in the music room in the gallery on the right.

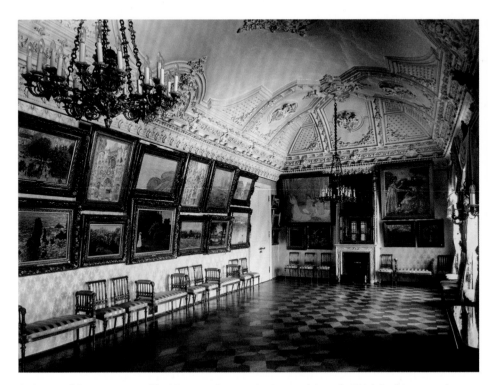

8. A view of the music room (the Monet and impressionist room) in early 1914. In this room, the impressionists with their green shades, pearly pinks and cold blues were hung against a pale, silvery tapestry. This room became legendary, displaying thirteen Monets, two Pissarros and one Sisley.

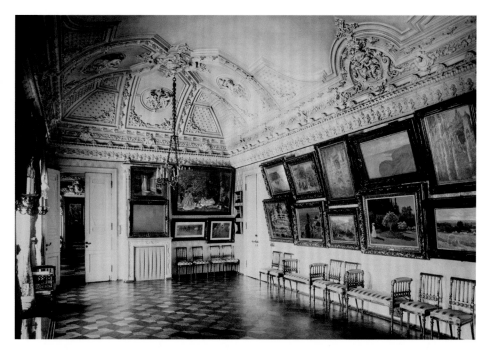

9. An alternate view of the music room with *Le Déjeuner sur l'Herbe* by Monet on the far wall, as well as paintings by Degas, Lobre and Guérin. The high price paid for Monet's painting was the talk of Moscow, but the critic Alexandre Benois predicted that 'the day will come when history, which always lags behind life, will view such works as great masterpieces'.

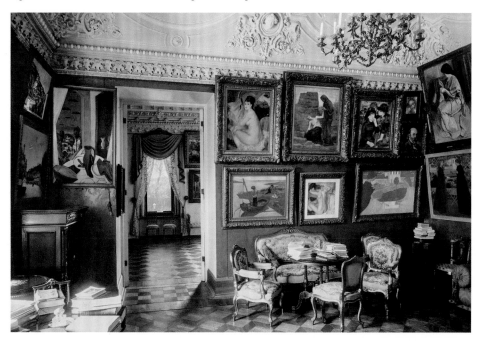

10. A view of the small salon, with paintings by Derain, Degas, Renoir, Puvis de Chavannes and Denis. By 1904, the first cycle of the Shchukin collection – the acquisition of works by the impressionists and their greatest star Claude Monet – had come to an end.

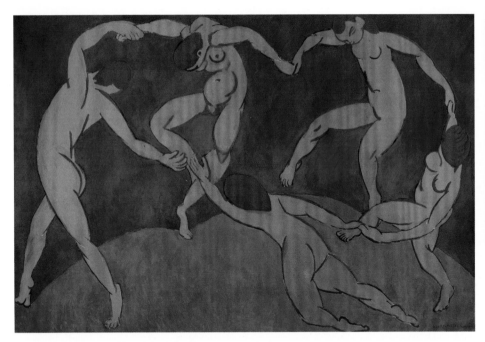

11. Henri Matisse, *La Danse*, 1910. 'But alas, I cannot hang nudes in my staircase' – this first piece of a twin panel was commissioned and then cancelled by an agonised Shchukin. Finally, though, he overcame his reservations, sending a telegram to Matisse: 'I find your panel *La Danse* to be of such nobility that I have resolved to defy Russian bourgeois opinion'.

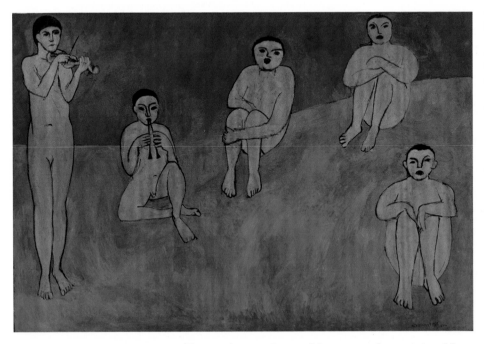

12. Henri Matisse, *La Musique*, 1910. This was the second piece of the twin panel commissioned for the central staircase. Shchukin was a passionate music lover: 'There is plenty of music played in my house; every winter we hold about a dozen concerts'.

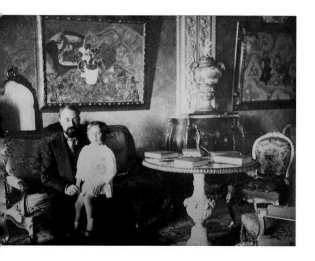

13. Henri Matisse in the pink salon (the Matisse room) during his stay with the Shchukins in Moscow, November 1911. Sitting on his lap is Ilya Khristoforov, Shchukin's grandson. Matisse's visit was a great success, and all the Moscow newspapers published interviews with him. He was deeply impressed by Russian icons: 'I have wasted a full ten years searching for what your artists discovered long ago, in the sixteenth century. You don't need to study in France. We French need to come and study here in Russia!'

14. A letter from Matisse, 1911. Matisse was given a royal welcome in Moscow and enjoyed every moment, not least an evening at the Chauve-Souris cabaret: the entirety of Moscow was there – artists, commercial painters, dandies, all mingling together in an animated throng. Matisse was given a caricature depicting him in the company of ladies of decadent aspect, scantily dressed and carrying a sign saying '*Adoration du grand Henri*'.

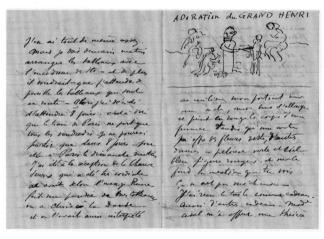

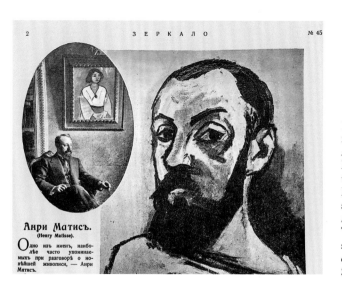

15. A page from the Moscow newspaper *Zerkalo* (*The Mirror*), 1911, celebrating Matisse's visit to the city that year. In the photograph, Matisse is sitting in the pink salon with his *Dame en Vert à l'Oeillet* hanging above him. The main image is the artist's self-portrait which was in the collection of Michael and Sarah Stein in Paris.

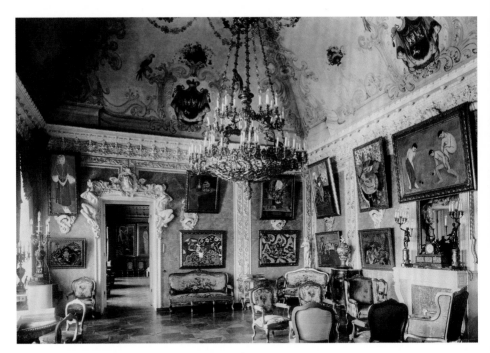

16. A view of the pink salon (the Matisse room). Vasily Kandinksy visited the Trubetskoy Palace and wrote to a friend, 'In the main salon, amid a mass of eighteenth-century furniture, there are thirty Matisses! The effect is simply stunning. That man has real flair.'

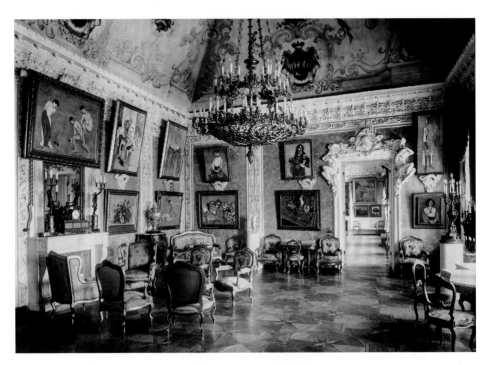

17. The pink salon was Shchukin's favourite room. He said that for him it was like a heavily scented orangery, sometimes toxic but always full of magnificent orchids.

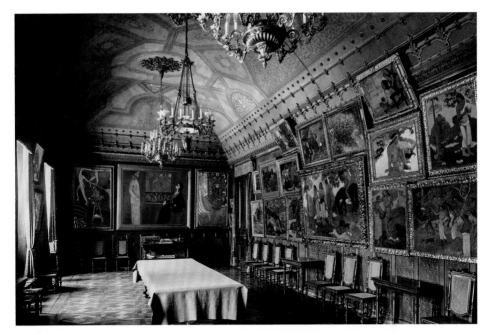

18. A view of the Gauguin dining room. Paintings by Gauguin and Van Gogh are flanked on the far wall by Matisse's paintings: *La Conversation* in the middle, *Les Capucines á 'La Danse II'* on the left, *Coin d'Atelier* on the right. 'The canvasses hang side by side, touching, and at first you don't see where one ends, and the other begins. You have the impression that you are standing before a fresco or an iconostasis,' wrote the critic Jakob Tugendhold.

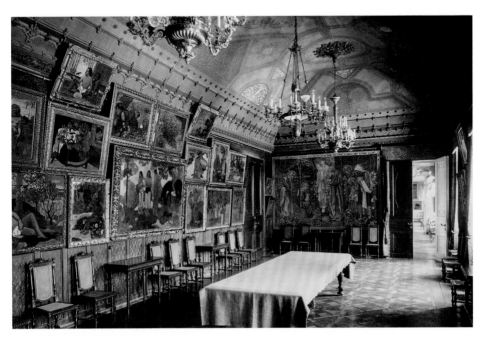

19. Another view of the Gauguin dining room with paintings by Gauguin and Van Gogh. On the opposite wall, sharply contrasting with the canvasses, is a tapestry of the Adoration of the Magi, woven after Edward Burne-Jones's design.

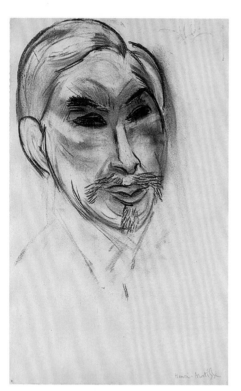

20. Henri Matisse's drawing of Sergei Shchukin, summer 1912, was for a portrait that was never completed.

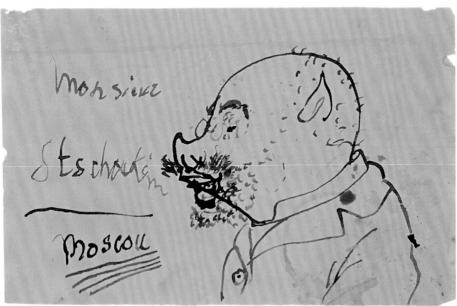

21. Pablo Picasso's caricature of Sergei Shchukin, 1908. According to Fernande Olivier's memoirs, Shchukin and Picasso met at the Bateau-Lavoir during the autumn of 1908. Olivier describes Shchukin as a heavily stuttering 'Russian Jew' with a large head resembling a pig – words that resonate with the caricature, strongly suggestive of the difficult beginnings of the relationship between artist and patron. Still uncertain as to the name of the Russian collector, Picasso entitled his piece *Monsieur Stschoukim Moscou*.

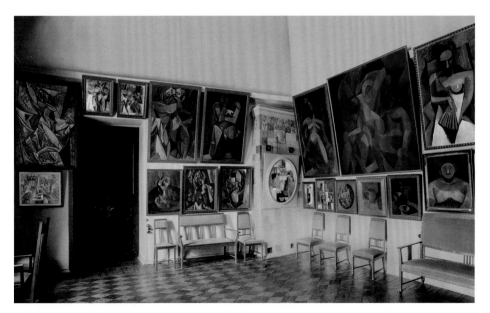

22. A view of the Picasso room with the proto-cubist and cubist period paintings. *Trois Femmes*, formerly of the collection of Leo and Gertrude Stein, is on the left. Visitors to the gallery were literally overwhelmed by the strange colours and frightening forms of Picasso's pictures. Shchukin said the artist took 'possession' of him.

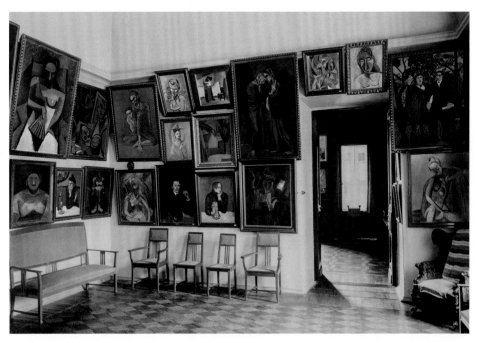

23. An alternative view of the Picasso room with the blue and proto-cubist period paintings. The small room with white walls and a domed ceiling was crowded with Picasso's work: incredibly, almost fifty paintings hung in the 25-square-metre space.

24. Shchukin's stepdaughter Anya Titova in the music room, 1916. Following family tragedy, Shchukin adopted two orphan girls, the daughters of peasants who had perished in the war against the Japanese. Anya was good at music and dancing. In later life she reminisced about her wonderful years in Shchukin's palace.

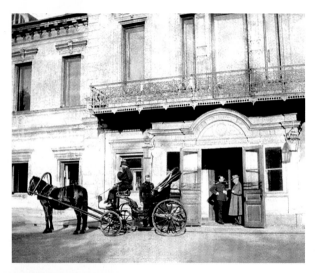

25. Sergei Shchukin speaking to his son Ivan in the doorway of the Trubetskoy Palace while his carriage waits, c. 1915. In later life Ivan would go on to become a leading academic in the field of oriental art.

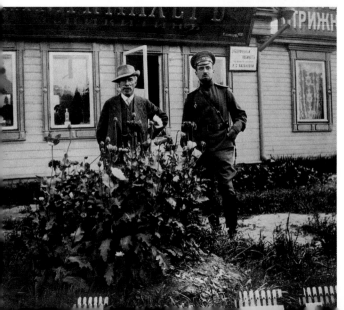

26. Shchukin and his son Ivan posing in front of a barbershop, c. 1915. Ivan is in Russian military uniform but was not drafted into the army because he worked for the organization which supplied it with food and ammunition.

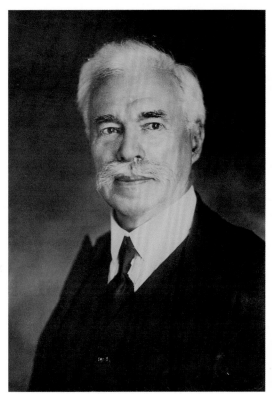

27. This is thought to be one of the photographs of Sergei Shchukin used by Xan Krohn for his portrait of the collector, *c.* 1915. Standing by his principle not to have any Russian work in his collection, Shchukin commissioned the Norwegian painter Krohn to paint his portrait in the simplest way possible.

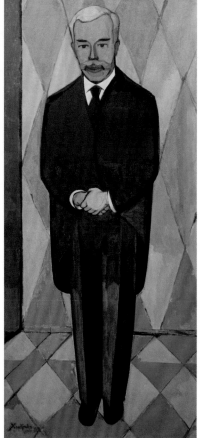

28. Xan (Christian Cornelius) Krohn, *Portrait of S.I. Shchukin*, 1916.

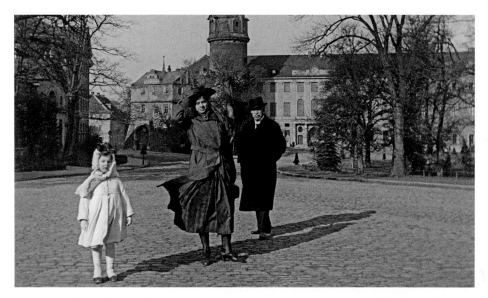

29. Having fled revolutionary Russia, Sergei Shchukin went to Weimar, and is seen here with his daughter Irina and her governess in autumn 1918. Following the end of the war, by June 1919 they were able to reach France through Switzerland.

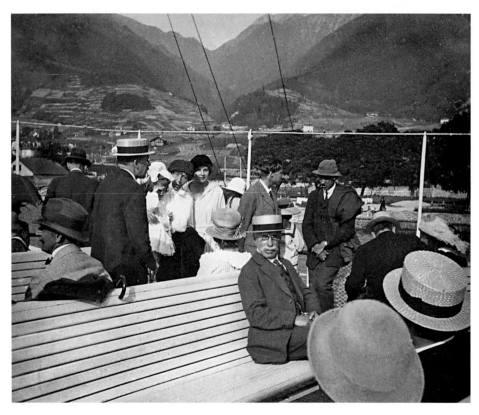

30. Sergei Shchukin onboard a steamboat on a Swiss lake, early 1920s.

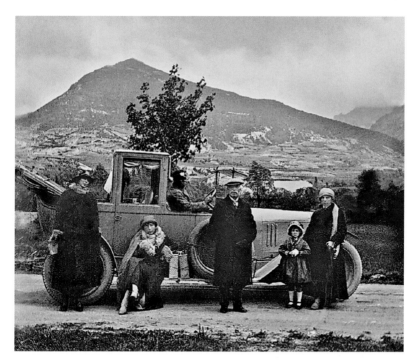

31. The Schchukin family beside a car in the French mountains, *c*. 1925. From left to right: Nadezhda Conus, Shchukin's stepdaughters' music teacher; his sister-in-law Vera Mirotvortseva; Sergei himself; his daughter Irina; and his second wife, Nadezhda Mirotvortseva-Shchukina.

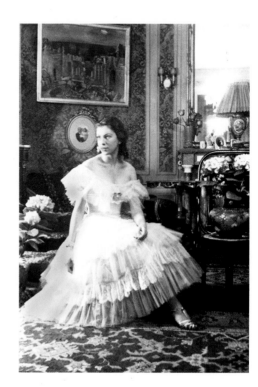

32. Irina Shchukina around the age of twenty, after a ball in the drawing room of her father's bourgeois Paris apartment in the sixteenth *arrondisement* during the early 1930s. On the wall behind her is *Le Théatre Antique de Taormina* by Raoul Dufy.

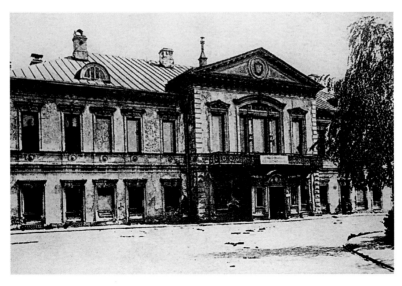

33. The Trubetskoy Palace in the late 1920s. It is hard to imagine the former beauty and prosperity of the grand Shchukin residence. In 1928, Shchukin's magnificent collection left this building forever.

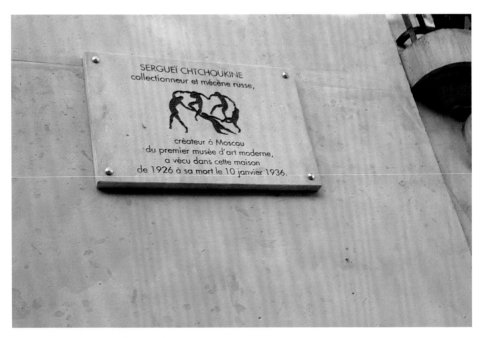

34. A plaque commemorating Shchukin's final Paris residence on rue Wilhelm, depicting Matisse's *La Danse*, was unveiled in June 2018.

I have neither the habit nor any experience of this. Nevertheless I will try to be absolutely sincere. Perhaps it will soothe my nerves, which are in a dreadful state. I long to have done with the memory of a happiness that is gone forever. I'm looking for a new reason for living. I still have reserves of strength, health, energy and motivation. I have no fear of the other side, but while I am still here, it is hard to tear myself away from real life.

This is my first night in the desert. Actually it isn't quite the desert, not yet; I can still see the lights of Suez shining over the water and hear the faraway barking of dogs. The quarantine building is only a hundred yards from our camp site. I am not yet detached from civilization. Tomorrow's stage is a short one; we don't need to get up too early. My Syrian dragoman, Harbour, is a happy, carefree fellow. He loves setting me riddles in English. After dark, I was reading the Bible when he came to say good night.

'You are reading Bible? So you know when was created Adam?'

'I don't know, only that it was before Eve.'

'Before sunset, then!'

Sinai desert, close to Ain Musa Oasis, 30 October

The camp came to life at 4 a.m. The eighteen camels were found to be insufficient: we needed to hire two more. The early morning was spent loading everything up and we were on the move before nine. We marched along a deep, flat-bottomed ravine, which was stony underfoot to begin with, then sandy, with no trace of vegetation. In the distance, to the east-ward, we spied the *jebel* (a chain of mountains), the colour of pink lilacs. To the west, we could still see the Gulf of Suez, with blue mountains beyond it.

Our caravan began to string out more and more. I had obviously been given the best camel and the two dragomen also had fine mounts. Soon we were well ahead of the others, for behind each camel except ours walked a Bedouin. About three hours later, around noon, we crossed the Ain Musa Oasis and stopped a mile further on.

Our appearance was quite an event. Children of all ages, large and small, came surging out of the oasis, surrounding us but afraid to come too close. With intense concentration they observed every move we made and

everything we did, how we unpacked the camels, how we raised our tents, how we settled down to eat. Clearly all this was most unusual for them, an important event. Gradually they screwed up their courage and came closer. I ordered one of the dragomen to pass out *baksheesh* and they scattered, running away happily.

At five in the evening came the solemn moment when certain essentials were distributed as gifts among the Bedouin. Each one received half a pound of Egyptian tobacco, a loaf of white bread and a handful of coffee beans. They seemed delighted with this and thanked me profusely.

Tomorrow the stage is longer, we must start before 6 a.m. at the very latest. The dragomen warned me that they would wake me early, between 4.15 and 4.45. I will dine at seven, so I can be asleep by eight. The Bedouins are already rolled in their blankets. Their asceticism is astonishing; sometimes they survive on three dates a day. They are lean, bony and tough, peaceably marching thirty to forty leagues a day in the heat. At present we are going at a good pace with our camels and they follow along. They can easily put up with the torrid heat and the cold nights. Only the women and children sleep in the tents.

31 October

This was a terribly difficult and long stage. We had to go from Ain Musa to Wadi Verdine, but a violent sandstorm forced us to halt: the *khamsin* blew from dawn onwards, the sky was like lead. My throat was dry and I was constantly thirsty. Towards noon I could stand it no more and called a halt for at least thirty minutes. We had been marching at a great pace since 6 a.m. The spectacle was lugubrious, to say the least. I think I have never in my life seen such a desperate expanse of arid landscape, with burning hot stones scattered everywhere. The torrid air blotted out the mountains on the horizon. Everything was flaming and burning, it was like being in a furnace.

But my Bedouins were brave as lions. They had walked forty leagues through this, without rest and without a sip of water. The struggle for life has made these people strong and reliable. The merest weakness in such conditions leads to disaster. Only the strongest survive: the Bedouins are a truly stoical people.

Wadi Garandel, 2 November

Yesterday, for the first time, I began to wonder if I was going to see this trial through to the end. I have the impression I am too old to put up with such adventures. I feel my strength is waning. I don't know how I managed to survive the last few hours with my head spinning and my body hurting all over. Impression of profound fatigue. The time went by desperately slowly. We were walking across the dry base of a vast crater. From time to time I looked at my watch, then forgot it, thought that a full hour had passed, looked again and saw that only ten minutes had gone by. It is hard to comprehend how, in such a monotonous environment, the passing of time can become so interminable. Only one's impressions change; perhaps that is why time seems infinite. Only now do I realize what a minute truly signifies, how long it can be, with all the things that one has time to sense in the passing of a minute. Yesterday was an eternity. In the evening I had to force myself to dismount from my camel, with the help of my dragoman. I was gripped by thirst.

I was unable to put pen to paper. I have no idea how I managed to undress and get to bed. But no sleep was possible. My head hurt too much and my heart was throbbing too hard. And the mosquitoes were whining all around me. I got up and slathered my face with eucalyptus oil, to no avail. The mosquitoes were ravenous. Well, it looks as if I'm going to get seriously ill in this place. I'll get malaria from the mosquitoes. My organism is much weakened, ripe for illness. I am ashamed of being afraid and I'm beginning to miss my cosy Moscow home. I think of my dear friends, my beloved relatives. At this moment, I dream that a magic carpet will suddenly appear and whisk me back to Russia. My head screeches, something large and heavy squeezes against the side of the tent, a nightmare, of course, or maybe a jackal?

The mosquitoes bite me, the flies enter my mouth, my nose and my ears, they crawl across my face, the heat is stifling, my whole body is on fire, infernal headache. No, expeditions like this are not for men of my age. I need Paris, art, music, painting, literature. Yet these conditions suit the Bedouins. They have covered forty leagues on foot without stopping, in temperatures of 50°C, and after that, have worked on for nearly two more hours. They say that when a Bedouin has nothing to eat, he places a heavy

stone on his stomach and the hunger leaves. I don't have that kind of stamina. My pleasures are of a different nature. *I listen with delight to the music of Skryabin, I read Valery Bryusov,*[4] *I gaze at the paintings of Maurice Denis. No, no, I must go back to Europe, to my pleasant world of refinement and culture* [italics added]. How culture conditions us! We have become a feeble race, physically and no doubt morally as well.

I have endured just two difficult days and already it is as if I were drowned in acid. For the Bedouins, this is all life has to offer. It is as if there is within them what the French call *joie de vivre*. My thoughts grow confused, I cannot sleep deeply, I have waking nightmares, all night.

There was a little freshness in the air this morning, I felt better.

Ras Abu Zanin, Red Sea Coast, 3 November

We set off at 6 a.m., as usual, having risen at four. Despite the heat, I felt far less fatigue. This was partly because I was beginning to get used to the swaying of my camel, and partly because the heat no longer had the same effect on me. At the same time, the desert was becoming more interesting. We reached the edge of the hellish crater at last and saw ahead of us defiles, steep rocky escarpments, volcanic mountains. In some places there were streams of bitter, salty water flowing from the hills; undrinkable, but around them grew pockets of vegetation; there were tamarinds, and sometimes even wild date palms.

I had a moment of ecstatic joy when, emerging from a defile, I saw the sea ahead of me. I understood at that moment the full meaning of the cry of Xenophon's 10,000 Greeks: *Thalassa! Thalassa!* It seemed such a marvellous thing.

As my journal makes clear, thus far the desert had brought me nothing but intense physical weariness. I remember nothing of it save painful, nightmarish marches. My wish to find forgetfulness had not been fulfilled, not for a single moment. On the contrary, never before had I remembered my former happiness, now utterly lost, with such agonizing sharpness; nor had my own responsibility for this disaster ever appeared to me so clearly . . . I have relived many grievous events; I have stood before a court wherein I was the sole judge of myself, and the past few days have seemed like years. I bear

the burden of guilt for everything that has happened. Even after the death of my wife, I persisted in the wrong path. My ego was my only guide. There was nothing else but my ego, the cause of my shipwreck.

Here I have assembled twenty-two people to serve me. I support them. They try to satisfy my every whim. Money presents no difficulty. But would I not have been a thousand times happier had I understood earlier that life's true wisdom does not reside in whims? Supreme wisdom, supreme happiness, is a love so true that it leads to the sacrifice of self. All the rest is a mirage. There is no such thing as one's own happiness, there is only the happiness one creates for others. I feel that I am growing confused and that I am beginning to write nonsense. The inexorable nightmare continues.

Wadi Djinn, 4 November

Today the march lasted not for eight hours, but for more than ten. We rose at four and moved off at six exactly. We travelled along the seashore, on the far side of the mountain, for two hours. It was a bright morning, very different from the ones that had gone before. Our lungs gulped in the marvellous sea air. The path here is nearly always highly interesting. There are volcanic steeps with a broad mix of colours, though red porphyry is the dominant hue; I fancy them from time to time to be ramparts guarded by cyclops. There are rocks of basalt and granite. The general impression is of a completely different world, another planet. The surface of the moon, with its dead craters, is not dissimilar. Nothing grows here.

We halted in the mountains of Wadi Djinn, where, under the dry bushes, are hidden the mineral veins which supplied the Egyptian pharaohs with turquoises 2,500 years before the birth of Christ. It is a beautiful but forbidding place. Tomorrow a very long march awaits us, no less than nineteen hours; we must reach the pearl of the Sinai, the Oasis of Pharaoh.

It has been a day of burning heat and in the close valleys the noon sunshine blazed atrociously. But now I am better accustomed to the conditions. Moreover, I have learned to cover my sun helmet with a broad Aleppo shawl, which means that when we are on the march my face is entirely covered, except for my eyes. Still, I have sand in my mouth and my dry lips are sometimes very painful. All the skin has burned off them and they bleed.

The Oasis of Pharaoh is beautiful. There is plenty of vegetation and there are fig trees. The local grape is elongated, blue and sweet, with a thick skin. A fallen pear seemed to me hard and dry. There were salads and courgettes here, too; so far I have eaten almost nothing but preserved foods and I am thoroughly fed up with them, which is why I search everywhere for fresh fruit and vegetables which are very hard to find in the desert. Dates and figs (my main source of nourishment) become extremely dry in the conditions and my teeth are not strong enough to chew them. But on the whole, I don't give much importance to food; a cup of water and a few olives suffice. Flies and mosquitoes torment me far more cruelly than hunger. I was right to think that organic life did not really exist in the desert, but I had not reckoned with the oases and the ships of the desert – the camels. Wherever there is an oasis there is water, and wherever there is water there are mosquitoes. Yesterday evening we had barely begun to drink our tea when we found ourselves besieged by the incessant whine of mosquitoes. What hell. Meanwhile the flies travel with us, riding on our camels!

5 November

Yesterday's march was so hard that I decided to call a halt today. I note that even the Bedouins sometimes rest, with their camels crouched in the sand. Everything and everyone is covered in flies all day long. In the desert there are flies and at the oases there are mosquitoes.

6 November

I feel that these last eight days have been more difficult and more violent than the eight months previous to them in Moscow.

I have never before recalled my past with such clarity; everything in my life boils up in my memory, from my earliest childhood on. And everything I wish to forget seems to be etched indelibly on my soul, even my most intimate thoughts. And I have reached a verdict on myself. Guilty.

How keenly have I pursued life's pleasures! It is as if I wanted to enjoy all and everything to the hilt. But what use are these assaults of conscience? The past will never come back . . . And how slowly time passes here.

Yesterday, the wind spoke to me of Ceylon, of a walk she and I took together one morning, when she suddenly began to speak of her life at boarding school, wondering what had become of her schoolmates since that time. The wind repeated the tale as she told it, almost word for word. And then the wind began to read me the letter she wrote to me in 1887, from our dacha at Kuntsevo. I was at Nizhny Novgorod and I had gone to Yurevets to view the eclipse of the sun. The family had stayed behind at the dacha. On the day of the eclipse, Lydia rose early for fear of missing the moment. She was full of excitement and she climbed the Hill of Salvation with her mother's companion. The weather was overcast and the eclipse was only partial seen from Moscow, but she saw it all, everything that happened, the terrified birds flying in all directions.

This letter was written twenty years ago. I had lost it and forgotten it long since, and now I found myself remembering practically every word of it. Clearly, then, nothing vanishes from our minds; everything is preserved entire, to reappear when the opportunity presents itself.

So where is the forgetting? I have utterly failed to find what I was looking for. Is it conceivable that I must live my whole life all over again?

Cloaked in mystery as it is, how is it that this different world has forced such a plunge into the depths of myself? This analysis of my life, my deeds and my thoughts – how is it that instead of living intensely in the real world, I am reviewing the whole of my past?

This burning air! This procession of nightmares!

Wadi Sahel, 7 November

Our progress is steady and I am beginning to take real pleasure in the expedition. On the morning that our caravan crossed the Oasis of Pharaoh, there was a breath of cool air, delicious and invigorating. There was also a charming little copse of tamarinds and lemon trees . . . I could breathe without difficulty and I felt somehow lighter. Finally, this see-saw camel-back existence seemed to be something exquisite. I can put up with the heat much better than before. Today we found ourselves on a mountain plateau, completely open, the sun beating down relentlessly, but I did not suffer. Of course, my whole face was covered. The desert air is beginning

to have its effect. I lunched most agreeably on cold potatoes, olives and onions with a glass of water. The plateau is fairly monotonous, but when we turned around we were enraptured by the magnificent view of Jebel Musa. This is the real Mount Sinai. It gives the impression of a powerful, majestic peak, looming large in the imagination of its people.

We halted on the plateau. The air here is cooler and very pleasant. There are no mosquitoes and it seems that the flies are having difficulty keeping up with us.

St Catherine's monastery, 8 November

This day was astonishing to me. The crossing from Wadi Sahel across the rocky mountainside was magnificent. The monastery itself stands in a narrow defile close to Jebel Musa. The monks greeted me with the greatest kindness and warmth and gave me a magnificent bedroom to sleep in. They showed me their church and the Burning Bush and revealed to me the relics of St Catherine (her head and one of her hands). I knelt before them. Here also are three Franciscan pilgrims, two Germans and an Arab. I made the acquaintance of one of them, Father Barnaby, and found him enchanting. What an amiable, intelligent and knowledgeable man! He has spent eight years at [*illegible*] and now he is spending another eight in Jerusalem. He showed me the route taken by the Israelites on a map of the Sinai Peninsula. Up to now, my own path has in nearly all respects co-incided with the path of the Exodus. As far as Mount Sinai is concerned, he shares my view that it is indeed Jebel Musa, the mountain of Moses.

Here at the monastery the air is truly celestial and the silence profound. It is a haven of calm and peace.

A note awaited us, from Cook's. The Mushir of Damascus has authorized us to cross into Turkey at El-Akaba.

9 November

This morning I rose at six and had a long talk with the Franciscan friar, Brother Barnaby. He told me a lot about Jerusalem. Afterwards, at nine o'clock, we ate with the assembled monks. The meal began with a prayer

and consisted entirely of a greasy lentil soup, laced with olive oil. It ended with another prayer. I begin to understand why I feel somewhat claustrophobic here. The monastery (a stone mausoleum) lies at the base of a narrow gorge, between two great overhanging rocks. So it is like a tomb, a sarcophagus of porphyry. You can only see the sky if you look above the building. Despite the good mountain air, it is all somewhat oppressive. I spent several hours in the garden, where a strange silence reigns. It is like a corner of an abandoned kingdom.

13 November

When a monk dies, he is buried for three years in the earth. Then his coffin is opened and his skeleton is placed in the church (the bones of the *higumenos* are given a separate tomb, those of the priests and deacons are all placed together, and those of the ordinary monks are all piled up together). I went to the monks' crypt and was duly depressed by the mountain of skeletons I saw there.

Yesterday evening I felt very morose and gloomy.

I recalled every aspect of Sergei's death and of our search for him. The unbearable minutes, hours and days of waiting that I and my darling Lidochka [diminutive of Lydia] had to endure! And now I have come away to forget it all . . . but instead, in this confined place, the memories swarm back all the more clearly and relentlessly. My goal was to forget the past and start a new life, but the desert and the monastery have forced me to relive everything with fresh force. All that had quieted is reawakened. This is not the peace of the soul; I must search for it in another way. How good it would be to banish all thought of what I have lived through and begin again, with new triumphs and new dreams! At the moment I do nothing but look back. I am reliving the memory of a broken happiness.

18 November

A long conversation with Father Grigory and Father Pakhom. Together we examined their restoration work on the icons of a painter-monk who lived in the Sinai desert in the early seventeenth century. A strong Italian

influence. Pakhom is partial to the mediocre paintings of Carlo Dolce.[5] He has heard of Viktor Vasnetsov[6] and Mikhail Nesterov.[7] I advised him to paint frescoes on the walls of the refectory. I promised to send him colours from Jerusalem.[8]

19 November

Our day of departure, accompanied by solemn blessings, ringing of bells, firing of cannon. The whole monastery turned out to escort me, accompanying the caravan for a full ten minutes. Then, after I had embraced every one of my hosts, we parted for good. In general, all these young people have brought me much comfort. Our evening talks in their cells will stay with me for many years to come.

Wadi Hubara, 20 November

Our usual schedule – rise at four, on the road by six – has resumed. This morning the sun was obscured by cloud cover for the first time. It looked like rain was coming, but only a few drops fell, then nothing. The clouds lingered nearly all day; it was hot, but not excessively so. The region through which we passed was very interesting. Although the crater formations persisted, the mountains were more diverse than before, the colours of the stones pretty and the light soft and pleasant. The outlines of the mountains, in particular, were prodigiously grand.

One crater particularly entranced me. We seemed to be wandering through a colossal ruined city. On the edges of the crater were half-demolished palaces, sanctuaries, porticoes and pyramids (especially fine were two of these side by side, one of red porphyry, the other of white limestone). It was a strange, mysterious world, as if life really had been present here once upon a time; as if a legendary city of castles and temples, all of a striking and enigmatic beauty, had once occupied this space. Enchanted, I looked everywhere, several times dismounting from my camel to examine things on foot. I felt in good fettle and in high spirits. I am beginning to take real pleasure in this nomadic life. The air is pure and invigorating; one lives without care or anxiety. From time to time I forget

the past, unawares. I am beginning to live in step with nature. The change in my surroundings and the open-air life of the camp offer great solace.

The Red Sea and the Gulf of Akaba, Ain Nuweiba military post, 22 November

A marvellous place on the Red Sea shore. Far away, on the Arabian coast, stand the blue-tinged mountains of Jebel Taurin. The colour of the sea is divinely beautiful.

There are green date palms, tamarinds and lemon trees, but few inhabitants. We are camped at the foot of a mountain. The view is one of great splendour. I slept very badly last night, probably because I walked too much yesterday. We rose early as usual; to begin with the trail led along a narrow defile (Wadi Tamil), then widened as we neared the sea.

Coastline north of Ain Nuweiba, 25 November

Yesterday at Nuweiba there was an extraordinary sunset, with sublime colours. I was reminded of the Bolshoy and some of Korovin's décors with their electric lighting.[9] On the Arabian side, the pink mountains of Jebel Taurin were illuminated by the setting sun. I felt an intense pleasure sitting by the sea, as I watched the subtly changing hues. It was like listening to silent music.

El-Akaba, 25 November

Late yesterday evening, a Turkish officer appeared riding a mule, accompanied by three soldiers on foot. Three weeks earlier, the Mushir of Damascus had given orders to the local commander to allow me to enter Turkey and give me all the assistance I required on my expedition. The officer and his men had been instructed to accompany me to the ruins of Petra, and thence back to Maan. So everything seems to have turned out for the best.

This morning, accompanied by the soldiers, we crossed the Turkish–Egyptian frontier and arrived at El-Akaba, a small military post on the northern coast of the Red Sea.

We have pitched camp by the sea, in a copse of date palms. It is hot. The first and most important leg of my expedition to the Sinai desert ends here. Next, we will tackle the second leg, rocky Arabia and the regions of Transjordan. Ahead of us is a four-day march to Maan, and thereafter two more days, from Maan to Petra, six days in all. The road is mountainous. The dragomen have warned everyone to take warm clothes, because we will be at higher, cooler altitudes.

El-Akaba, 27 November

Today was spent negotiating with the Bedouins. I hope my dragoman will reach an agreement with them and that tomorrow we can get started. Every day has its price at the moment. The sky has clouded over since this morning; the rainy season is approaching.

Sergei Shchukin's 'Journal' ends at Maan, in Transjordan, on 2 December 1907. He had enough time to join his children for Orthodox Christmas in Moscow. It is reasonable to suppose that in the interval he reached the cave tombs of Petra, which were two days by camel from Maan. Thereafter, as planned, he passed through Jerusalem and re-embarked from Jaffa, which at that time of year was crowded with ships ferrying pilgrims to the Holy Land for Christmas.

Oddly enough, no document or eyewitness account has come down to us concerning Shchukin's stay in Palestine; either because for some unknown reason he was forced to embark from Jaffa as soon as possible, or else because he had nothing further to record after his impressions of the Sinai desert. The latter is probably the correct explanation. At El-Akaba, the Thomas Cook agency doubtless recalled Sergei to the reality of tourism and to bottles of Vichy Célestins mineral water shared with Turkish effendis. Descriptions of visits to Petra and the Holy Sepulchre, Baedeker in hand, were out of place in the journal of a man who had come to the Middle East in search of his own personal truth.

The Price of a King's Wife

Paris, Avenue de Wagram, a Russian New Year's Eve party, 13 January 1908:

> Ivan Shchukin, as was his wont, was charming and agreeable as only a Muscovite can be. He appeared to be in good spirits, sparkling with wit and always attentive to the smallest wishes of his guests. After dinner he surprised them by offering to give away certain pieces from his collection for a token price. The guests remained till the night was well advanced. On New Year's Day, he did not answer from his bedroom. Next morning, the door was forced, and his lifeless body was found within. The autopsy determined that he had committed suicide by poisoning himself.[1]

The suicide of Jean de Wagram at the age of thirty-nine prompted plenty of rumours: some claimed that he had shot himself with a pistol; others that he had taken cyanide. Nobody knew for certain exactly what had happened.

The gazettes hinted at mountains of unpaid bills. Maxim Kovalevsky claimed that all the money had been spent on women and that one famous, not-so-young *demi-mondaine*, Mademoiselle Berthe, had completed Ivan's

ruin. But while the courtesans of Paris were no doubt part of his personal landscape, they were far from responsible for his downfall. Much more than his lifestyle, it was Ivan's passion for collecting and his fantasy of transforming the dandy Jean de Wagram into a fierce and mighty dealer that had led to his tragic end.

He had been in debt to the tune of 100,000 francs or more, and had been unable quickly to dispose of either his Spanish paintings of dubious authenticity or his huge collection of precious Russian books – they were all he had left.

Why had none of Ivan's brothers offered to help? Had they wished to inflict a lesson on their flamboyant and frivolous younger brother? Or was the austere, implacable morality of an Old Believer *kupechestvo* clan to blame?

Sergei Shchukin, who had just returned home from Palestine, did not make the journey to Paris that January. Instead Petr took care of everything, bringing Grigory, Sergei's younger son, along with him. Aged twenty-one, Grigory was embarking on his career as a member of the powerful family in hard times. He witnessed the spectacular shipwreck of Jean de Wagram and Petr's cold-blooded efforts to keep the family afloat.

Taking into account the forty-eight-hour journey from Moscow to Paris, Petr acted with his usual speed and efficiency. Uncle and nephew bought a perpetual concession of a four-person plot for 4,664 francs at the already pricey Montmartre cemetery. Jean de Wagram was buried there on Saturday, 18 January 1908, three days after his tragic death, without a church service. The Orthodox eparchy would have denied it to the renowned atheist who had died by his own hand.[2]

What of the Paris apartment, overflowing as it was with books, furniture and paintings, yet containing just 26 francs and 5 centimes in cash and with three months' rent unpaid? Petr left the Russian Embassy's consular agents, and an administrator appointed by the French court, to deal with the assets and debts of their Russian citizen in residence. So it was that Petr Shchukin, bric-à-brac expert extraordinaire, agreed for everything to be shipped to the Drouot auction house and sold under the hammer. Petr knew the debts would overcome the assets and did not want the family to be liable for any more costs accruing to his unfortunate

brother even after his death. Grigory, a bibliophile in the process of becoming an expert in antiquarian books, was about to witness the dispersal of one of the most prestigious Russian scholarly libraries, without being allowed to keep a single volume.[3]

'It cannot be denied that Ivan Shchukin knew the art world very well: we have seen this fact demonstrated beyond all doubt,' wrote the Paris correspondents of *Russkoe Slovo* (*Russian Word*), who were present at the posthumous dispersal of Ivan's paintings and sculptures at the Drouot auction house on 17 June 1908, and of his magnificent library on 18 November.[4] As a later report went on:

> Bookcases filled the apartment, from the workroom right through to the bedroom. There was no way one could grasp the sheer wealth of this library, assembled by an enlightened amateur. There was a vast selection of beautiful volumes on theology, philosophy, law, sociology, political economy, philology, natural science, history, literature and fine arts. So many editions, old and rare, dating from the fifteenth and sixteenth centuries . . .
>
> By the time these lines are read, this great library will have been scattered to the four winds. Poor Ivan! What a sad memorial to a Shchukin of Moscow, one of our country's most erudite men! He had assembled it in the so-called capital of the world, a corner of high culture; and he lost it, tragically, on account of his financial difficulties.[5]

According to the accounts registered by the liquidating administrator, the final value of Ivan's estate, after taking into account the almost 70,000 francs raised at auction, came to the grand total of 103,000 francs in unpaid debts, without costing the Shchukins one centime.

But while the great antiques expert Petr was teaching his nephew a hard business lesson, Grigory was proving his Shchukin collecting pedigree. Answering a request from the director of the École des Langues Orientales, young Grigory transferred 1,000 francs to him so that the school could purchase at the auction the remaining section of the academic Russian library that Ivan had not donated to them before his death. Sergei's elder son, Ivan Sergeevich, also bought at the auction six Spanish canvasses

which decorated his private apartment in the wing of the Trubetskoy Palace.[6]

Without a doubt it was Sergei's money that funded his children's purchases, but we know nothing of his own activities or state of mind that spring, when he did come to Paris. It is not hard, though, to imagine the feelings of Grigory, the young bibliophile, having lost both his mother and brother, struggling to save a handful of his late uncle's most faithful friends, his books.

A fateful clock had begun to tick.

The Tahitian iconostasis

Although we have no record of Sergei Shchukin's personal reaction to Ivan's death, we may read between the lines the emotional control that was the hallmark of the family. What we do know is that nothing deterred him from his collecting activities, which now progressed with the full power, breadth and certainty that were only beginning to emerge prior to the death of Lydia.

Whatever happened to him from now on, Shchukin held on tight to the lesson he had learned in the Sinai desert. He strove to recreate the ecstasy of the sun setting over the Red Sea; to find the true colours of the world and bring them back to Moscow, whatever the cost. As a collector, he never again lost sight of this goal. The provocative, extravagant snob was no more. His company's image and his position in the world of frivolous high society no longer mattered to him. He had found a new reason for living and perhaps new hope; he had heard it in the murmur of the desert wind and seen it in the eyes of the monks of St Catherine's monastery.

Like an artist reaching full maturity and turning to vast compositions laid on with furious brushstrokes, Sergei built up the Shchukin collection just as he had once built up the family firm. He had faced disaster and, in his darkest hour, planned his vision for a Moscow museum of modern art, the first institution of its kind in the world.

Through a series of subtle changes, he had reconstructed the old palace, adapting its function of housing people to that of housing artworks. He had set out to create a museum whose purpose was to construct a dialogue

between the old Russia (as symbolized by the Trubetskoy armorial bearings) and the ultimate expression of radical creativity, as symbolized by modern art. For Shchukin, any work of art was the expression of a dialogue with the world. In this he was completely modern, assimilating the lessons of art nouveau and its Russian offshoot, World of Art. In the midst of his grief for his son, his wife and his brother, he somehow managed to raise the bar of what a great collector and curator could achieve.

As he created his museum of modern art room by room, exploring the rich dialogues that might exist between one artist and the next, perhaps he thought from time to time of Father Pakhom, painting far away on his mountaintop. No sooner had he returned to civilization than he kept his promise and sent boxes of brushes, charcoals, colours, turpentine and everything else that Father Pakhom would need for his frescoes in the refectory of St Catherine's monastery. Sergei would never see those frescoes himself, but he had no doubt that Pakhom set to work to paint them and that he, Shchukin, had for the first time fulfilled his role as a midwife of painters.

The formal dining room of the Trubetskoy Palace had sombre wood panelling; its walls were hung with dark green silk and it was furnished in neo-Gothic style. The principal artists for this space had been chosen – or rather, fate had singled them out and they revealed themselves to be exactly in step with Shchukin's vision: a dinner in Moscow, transformed into a feast in an earthly paradise. 'An imbecile painted that . . . and another bought it,' Sergei Shchukin would say whenever he showed visitors his 'iconostasis' by Gauguin in this first room of his museum of modern art. This work aroused the indignation of Shchukin's detractors – men such as Nikolai Vishnyakov, a Moscow dealer and assiduous spreader of malicious gossip:[7]

They are grotesquely naïve imitations of childish representations of nature. They ignore the rules of perspective and anatomy and they are painted in flat tones, like street posters . . . these Tahitian landscapes are totally lacking in the most elementary harmony. Their titles are extravagant, incomprehensible and ridiculous. On one of the canvasses, covered in cadmium yellow, there are what appear to be human silhouettes; their arms are raised, so that they look like question marks . . . It is entitled the *Golden Age* . . . but why? Because everything is yellow,

and because the silhouettes reach toward vines . . . but what do vines have to do with the Golden Age? In another canvas, a monstrous idol with bared teeth sits amid a fantasy landscape of mountains, one painted pure cobalt blue and the other emerald green . . . In the third picture, a group of three brown natives look like dolls made of tanned leather stuffed with cotton, with not a single line to show they have muscles in their bodies . . . completely outlandish.

And Sergei Ivanovich explains: 'This is a painter who was ridiculed and mocked all his life, but after his death his paintings would be worth a king's ransom.' You'd think we were in a lunatic asylum . . .'[8]

The critic Jakob Tugendhold offered a contrasting view:

The canvasses hang side by side, touching, and at first you don't see where one ends, and the other begins. You have the impression that you are standing before a fresco or an iconostasis. You see luxuriant, vibrant colours and you seem to hear the ring of solemn music in your ears, like a hymn to the joy of life.[9]

Another critic, Sergei Makovsky, added:

Not only are the paintings of Gauguin rich with the decorative beauty of tapestry, they also possess a generous, monumental, quasi-religious quality. Through the sweetness and majesty of these Tahitian pastorals, the artist has unveiled an eternal truth, the very essence of love and death.[10]

Indeed, the fabulous, packed array of pictures in the dining room of the Trubetskoy Palace evoked the iconostases of Orthodox churches. It deliberately imitated the intricate icon puzzles of silver, red, brown and gold that adorned the screens separating the congregation from the choir, earth from heaven.

Though he had never himself learned to draw or paint, Shchukin was extraordinarily sensitive to colour. He perceived its nuances with the subtlety of a *parfumeur* and responded to them personally in the same way

that he selected the fabrics in which he traded. The textile stylists of I.V. Shchukin & Sons had for years developed patterns and ranges of fabrics, directed by Sergei. We have seen the father's plan for his sons' education, and we have seen how Sergei himself built up a professional eye for colour, form, design and decorative motif. As the head of a great textile empire, he was also uniquely prepared to absorb and comprehend the art of painting in its revolutionary new forms.

Sergei had settled on a method that remained unchanged for the rest of his collecting life. He knew the artists he needed – those he had chosen on impulse exactly when the moment was right. The talent to seize and act upon his instincts when he spotted the right artist at the right time was the fruit of his long years of apprenticeship as an 'art hunter' between 1898 and 1904.

He had his method; now all he needed to do was keep two appointments with two momentous craftsmen. On 28 April 1908, the names of Paul Gauguin and Henri Matisse appeared for the first time on a page of Ambroise Vollard's register, which recorded the sale of four paintings to Sergei Shchukin. Sergei bought two Gauguins for 8,000 francs apiece and two Matisses for 800 francs each. Gauguin was already in vogue; Matisse was still two years away from full acceptance. The first Gauguin was the mysterious elopement of two lovers on horseback, *Le Gué*; the second was a new metaphor for femininity in paradise, *Le Mois de Marie*. From Matisse came *Le Bois de Boulogne* (in the same spirit as *Le Jardin de Luxembourg*, Shchukin's first acquisition in the autumn of 1906) and *Nature Morte à la Soupière*, a piece he may have seen at the painter's studio when the two men met for the first time.

How his collection might be exhibited in the best possible light in his museum of modern art presented Shchukin with a pair of problems. First, Gauguin, a decorative artist at heart, who would have been more than able to fill the long blank space of wall which now stood before Shchukin, had nevertheless never painted a fresco – and in any case, now he was dead. Second, Matisse's *Le Bonheur de Vivre*, which would have been perfect for the purpose, had heretofore eluded Shchukin's grasp.

He made up for the deficiency with a typically 'Shchukin' move.

On the panel running lengthways down the Trubetskoy dining room, which during the day was lit by the tall windows of the palace's *piano*

nobile, Shchukin would fashion a Gauguinesque fresco from a multiplicity of the artist's works arranged as a kind of puzzle, strip cartoon or visual opera, each in a rich, gilded frame. On entering the dining room, with its dark background hues, you would be instantly dazzled by flaming orange-yellows, soft pinks and sumptuous deep blues. Light would irradiate the paintings, seeming to pour out of them, brightening and even scenting the entire room. Later, Jakob Tugendhold would write that 'Moscow and snowy Russia may flatter themselves that they have given refuge to the exotic colours of eternal summer, which their official homeland of France has failed to do'.[11]

Sergei thus required Tahitian Gauguins in sufficient numbers to cram the whole wall with his artistic iconostasis. When he first had this idea, in spring 1908, he owned eight Gauguins (his two 1904 purchases and six more acquired during the buying spree of 1906). Now the wall was to be populated at lightning speed: he immediately bought no fewer than eight more Gauguins (the last two were possibly acquired in 1909, but certainly no later). These were now rare items and a high price had to be paid for them. They included the painter's personal crowning glory, *La Femme du Roi* (or *Te Arii Vahine*), which he described to his friend Georges-Daniel de Monfreid thus:

> I have just painted a picture that I believe to be better than anything I have ever done before: a queen, naked, lying on a carpet of green; a servant gathers fruit; two old men are talking near a tall tree, the tree of knowledge; the sea shore is in the background. This sketchy outline will only give you a vague idea of it, but I think that in terms of colour I have never done anything with such deep resonance. The trees are in blossom, a dog stands guard, two doves murmur on the right-hand side . . .[12]

La Femme du Roi belonged to the French collector Gustave Fayet, who was something of a Renaissance man: a rich Languedoc wine producer, a gifted painter, a curator of the Béziers museum, an early supporter of Gauguin and Van Gogh and the future founder of a private museum housed in a former Cistercian abbey decorated by Odilon Redon. *La Femme du Roi* – which explicitly echoes Manet's great work *Olympia* – hung above the mantelpiece in Fayet's drawing room in Paris on the rue de Bellechasse.

The Frenchman had no desire whatever to part with it, and the price he extracted from Shchukin marked a turning point: thereafter, the value of Gauguin's paintings soared.

When Georges-Daniel de Monfreid, Gauguin's friend and first great admirer, and the co-organizer (with Fayet) of the 1906 Gauguin retrospective, noticed that the masterpiece was gone, Fayet explained:

> You have to understand, *I didn't want to sell it* . . . You know how much I loved it. But what can I say? Somebody came along and offered me 15,000 francs. Of course, I refused. (But 15,000 francs for *Te Arii Vahine*? Can you imagine it?)
> I said: 'We really don't want to sell it. But I suppose if you were to offer me a really extraordinary price, things might be different.'
> 'How much?'
> 'Well, 30,000 francs, for example.'
> '30,000 francs? Here you are.'

Monfreid was stunned. But Fayet's logic was unassailable: 'My dear friend, you know very well that the last thing I wanted to do was sell her, but think about it: she has paid for all the rest of my collection!'[13] Fayet had bought *La Femme du Roi* from Monfreid in 1903, just after Gauguin's death. At the time he had paid 1,100 francs (and that had included two other paintings by the master).

The same day in 1908 that Shchukin bought *La Femme du Roi* he also bought *Rupe Rupe: La Cueillette de Fruits* from Fayet. For this two-metre-wide canvas he paid 'only' 17,000 francs (which itself would have been a record for the artist had it not been for the *La Femme du Roi* extravagance). Shchukin would now be able to hang this huge picture, with its delicate pink hues, at the centre of an arrangement from which his other paintings could fan out.

Probably around this time Shchukin also bought *L'Idole*, a mysterious picture full of the warm, glittering, scented world of the South Seas.

The next thing Shchukin's iconostasis required was Gauguin's self-portrait. This Shchukin found at Vollard's gallery on 12 October 1908. He paid a more reasonable 2,000 francs for the canvas, which was painted by

the artist in earlier years and had been sent to Vollard a month before Gauguin's death. This was the last of Gauguin's pictures to take its place, to the left of the entrance, next to *L'Idole*. The effect was not unlike a screen from the Middle Ages, with the artist discreetly including a likeness of himself on the fringes of the main scene.

The oldest photographs of Shchukin's extraordinary iconostasis date from around 1910, at which time the composition, with all its scintillating colours, was arranged in three straight rows. Shchukin modified this, as is clear from the photographic overview taken in 1914 at a time when the palace was coming more and more to resemble a museum. Two paintings by Van Gogh were positioned above all the others, rendering the general form of the composition more asymmetrical. It became heavier and more crowded in the middle; lighter and sparser on the sides.

With the two uppermost paintings, Gauguin and Van Gogh's 1888 Arles companionship was subtly evoked. Above all, the two Provençal pieces appeared to hold the composition together – as if Van Gogh, at the top, was somehow marshalling the Gauguin canvasses beneath. This arrangement shows how Shchukin's talent as a decorator and stage designer had ripened. Though he bought the Van Goghs in 1908, while he was constructing his iconostasis, the keynote dialogue on his wall was not fully established until 1914.

A heavenly banquet

Shchukin's attraction to Van Gogh was fairly moderate: only four 'feverish and trembling' canvasses by the great Dutchman feature in his collection. By 1904, when *Les Arènes d'Arles* (which had also formerly belonged to Fayet) arrived in Znamensky Lane, collectors were already interested in Van Gogh. The next to arrive were the two paintings that were positioned at the top of the iconostasis: *Les Dames d'Arles* and *Le Buisson de Lilas*, with its quivering blues, yellows and greens. The poet Osip Mandelstam later remarked of the latter that 'the lilac in flower is done with such furious strokes of the brush that it truly seems to breathe of itself'.

The fourth and final Van Gogh was positioned on a panel facing the iconostasis, between the two windows. Thus it was among the first perma-

nent spectators of Gauguin (before being moved into another room a few years later). Bought by Sergei in 1908, this *Portrait du Docteur Rey* was completed the year before Van Gogh's death, when he was already in the psychiatric hospital.

The dining-room gallery contained two narrower panels: 1903 had seen the arrival of one of Shchukin's proudest acquisitions – a tapestry of the Adoration of the Magi woven by William Morris, father of British design and advocate of a return to traditional arts and crafts. Morris's workshops were at Merton Abbey, London. Petr and Sergei had noticed the piece at the 1900 Universal Exhibition in Paris; its original pattern was by Edward Burne-Jones, with tints of orange and blue predominating.

This Number 5 example of the tapestry shown in Paris was pledged to the Hamburg Museum of Decorative Arts. Number 1 had been woven specially for Exeter College, Oxford, and Number 4 for Eton College. Shchukin ordered Number 7 for the Trubetskoy Palace. The idea that his Moscow residence could belong in such an exclusive circle of owners was part of his strategy to showcase the firm of I. V. Shchukin & Sons. The tapestry took two years to manufacture and involved three masters hand-sewing it; that did not come cheap – Wilfrid Scawen Blunt, a breeder of English thoroughbreds, had paid £545 for Number 2 in 1894, the equivalent of 18,000 francs.[14]

The Morris tapestry occupied one end of the dining-room rectangle. The Magi in their orange robes and the Virgin and Child with their royal blue ones respond perfectly to the detached Tahitian men and the languid Tahitian women facing them.

Alexandre Benois chided Shchukin for this tapestry, describing it later as a 'youthful error'. Admittedly, there is a certain 'kitschness' about it, though in this instance it harmonized miraculously – almost comically – with the iconostasis, and definitely contributed to the 'heavenly banquet'.[15]

Wrote the painter Mikhail Nesterov to a friend:

A few days ago I went to Shchukin's and viewed his famous collection of decadent artists, old and new. Sergei Shchukin is one of two brothers who are well known for their art collections. Both are wealthy merchants; they manufacture and sell scarves by the million. Their substantial wealth allows them to live very well and buy art objects.

One collects magnificent antique pieces, such as manuscripts; the other interests himself in the decadent French painters, Puvis, Monet, Manet, Degas, Marquet, Denis, Cézanne, Matisse, Sisley and Pissarro . . . he also owns a Gauguin, which is better than all the rest, for which he paid several hundred thousand francs (he bought his last picture for 100,000 francs).

The exaggeration is flagrant: at that point, Gauguin's prices were nowhere near as high.[16] Yet Nesterov was not entirely mistaken: over 100,000 francs had been invested in the Gauguin iconostasis.

There still remained the panel at the end of the gallery – the one that guests saw first when they entered the dining room, having been summoned in French by Sergei's butler with the words: *'Monsieur est servi.'* This was a major lacuna in the first room of Shchukin's developing museum of modern art. But Shchukin knew how to fill it: he wanted a major still life to offset and lighten an ensemble that had such large numbers of figures in it. The still life would have to be predominantly blue, so as to soften the golds, purples and bright yellows on the other walls. To this end, he had decided to settle his first commission as a collector on an artist he had been quietly courting for years: Henri Matisse.

CHAPTER XII

Harmonie en Rouge

Sergei Shchukin made his appearance in Paris sometime in March 1908. If he visited *Le Bonheur de Vivre* at the Steins' atelier prior to meeting Matisse – which is quite likely – this, in Gertrude's own words, is the scene that would have greeted him:

> I have refreshed my memory by looking at some snapshots taken inside the atelier at that time. The chairs in the room were almost all Italian renaissance, not very comfortable for short-legged people and one got in the habit of sitting on one's legs. Miss Stein sat near the stove in a lovely high-backed one and she peacefully let her legs hang, which was a matter of habit, and when any one of the many visitors came to ask her a question she lifted herself up out of this chair and usually replied in French, 'not just now'. This usually referred to something they wished to see . . . But to return to the pictures. As I say they completely covered the white-washed walls right up to the top of the very high ceiling. The room was lit at this time by very high gas fixtures. Before that there had only been lamps and a stalwart guest held up the lamp while the others looked.[1]

This was how Gertrude Stein, in her self-penned *Autobiography of Alice B. Toklas*, imagined the first impressions of her future companion Alice

upon entering her studio on the rue de Fleurus one Saturday in March 1908.[2]

Le Bonheur, hanging high on the wall of the atelier in the warm, easy-going atmosphere Gertrude had created around herself, was doubtless shown to far better effect than it had been in the cold light of the cavernous, glass-roofed Salon des Indépendants a year earlier. If indeed he went there, what Shchukin would have seen at the Steins' – basically, Matisse along-side Gauguin, Cézanne and Picasso – marked the way forward for his own collection. Above all, the new century was only eight years old and the fertile rivalry, struggle, friendship and passion of the two future giants of modern art, Matisse and Picasso, were already well under way and visible on the walls of the spacious private studio in the rue de Fleurus.

To the right of *Le Bonheur* hung *Nu Bleu*, a painting inspired by Matisse's trip to Biskra, Algeria, which had added to the scandal of the previous year at the 1907 Salon des Indépendants, ending likewise with another resolute purchase by Leo Stein. Just beside it was a large canvas from Picasso's acrobat series, *L'Acrobate à la Boule*. And then two famous Picassos from his neo-classical period, *La Dame à l'Eventail* and *La Fillette à la Corbeille de Fleurs*.

Nearby was one of Matisse's star paintings, *La Femme au Chapeau*, which had been the principal target of the naysayers in the 'Salle des Fauves' at the Salon d'Automne, 1905. Just above it was a superstar – Gertrude Stein in all her majesty, portrayed by Picasso, gathered into a pose copied from Ingres, with eyes that prefigured those of the cubists and which were based on African statuary. After that, one only needed to turn around to see the huge *Meneur de Chevaux* by the same painter, and a number of other wonders.

Shchukin would have felt the familiar shiver or *frisson* – or for him personally an intense vibration of sound, a violin . . . Where was it coming from? There! A smaller canvas, just a sketch really, but a thing of uncommon power: there he was, the violinist standing naked, sexless, concentrated! At his feet, a naked boy sits listening; nearby a pair of young girls in diaphanous dresses dance in each other's arms; nervous brush-strokes of green and black summarize the earth and sky. Four children full of joy, playing, listening to music and dancing. They were enough to

reduce Shchukin to tears as he stood in front of the single painting belonging to the Steins that enveloped all the rest in its enchantment. 'Henri Matisse, *La Musique*,' Gertrude might have whispered in his ear, had she sensed the question '*Who painted this marvel, and what is it called?*' in the collector's silent emotion.

The planning and completion of Shchukin's museum of modern art was going to take a lot of work. If he visited the Steins at this time and saw their collection, Sergei Shchukin must have finally understood the magnitude of his task. And also comprehended that the prize was worth the effort.

Blue *toile de Jouy*, glimpsed from an omnibus

April 1908 witnessed an important moment in the history of twentieth-century art, when Henri Matisse met the great Russian collector Shchukin, accompanied by his friend, competitor and (almost) disciple, Ivan Abramovich Morozov. Ivan was about to become Russia's second major collector of modern art, thereby continuing the work of his brother Mikhail, who had earlier accompanied Shchukin when he visited the Parisian dealers before his death in 1903.

The Morozovs were an extraordinary family. Ivan Abramovich's branch operated a huge textile manufacturing concern in Tver, a town on the Volga north-west of Moscow. Their ancestors were serfs and Old Believers who in the space of three generations had built up an empire in industrial textiles.

Theirs was a different enterprise from that of the Shchukins, which was essentially a white-collar trading affair. The Morozovs owned factories that smoked and hummed, with shrieking sirens and belching steam, whose stewards and managers hired and laid off workers by the thousand. But their works were not the hellish places described by Karl Marx: indeed, the Morozov workforce consisted of former serfs who had joined the new proletariat and saw their employers as people not unlike themselves. And the Morozov family built houses for their workers and schools for their children, along with hospitals, orphanages and libraries.

Behind the well-swept alleys and neat flower beds was the strong and determined hand of Varvara Morozova, the widow of Abram Morozov and

heiress to the textile conglomerate – on the sole condition set out in the will of her husband that after he died in 1882 she should never remarry. She fulfilled this condition until the day of her death in 1917; instead, she installed her lover, an eminent Russian intellectual, in a large house next to her own.

This semi-comfortable situation left Varvara's three sons Mikhail, Ivan and Arseny with lots of leisure time and plenty of money, which they spent on extravagant residences in Moscow and works of art to decorate them. A tall, powerful, shy and hard-working figure, Ivan Abramovich Morozov (1871–1921) began by collecting the works of Russian artists. After the death of Mikhail, he expanded his collection to include European modern art, in a full, non-competitive friendship with Shchukin (though there was a touch of rivalry, as we shall see later).

Surrounded by a group of advisers led by the portraitist Valentin Serov, Morozov assembled a gentler, more balanced collection which was less coloured by avant-gardism than that of Shchukin and which had a delicate harmony that was all its own. Morozov was capable of waiting patiently for years to acquire a particular work by Cézanne, Van Gogh, Monet, Gauguin, Guérin, Bonnard, Valtat or Friesz that he had picked out (or of which he dreamed). Without creating any hierarchy of artists, Ivan Morozov tried to pull together a varied panorama of impressionist, post-impressionist and modern art, commissioning copious numbers of works from Maurice Denis, Bonnard and – later on – Matisse. In his townhouse on Prechistenka Street, close to Shchukin's palace, he methodically built up his own private museum of modern art, second only to Shchukin's. Indeed, it was designated 'Number 2' by the authorities at the start of the Soviet era in 1919.

But back to 1908.

The two Russians alighted from their cab at 33 Boulevard des Invalides – a chic, quiet area of Paris where dashing officers in madder-red pantaloons exercised their horses or took the air with their lady friends in the leafy *allées* of the Champ de Mars. The anti-clerical Third Republic had taken over a convent school in this district, driving out the nuns, and was now renting out sections of the huge premises very cheaply (because the leases were anything but secure) to artists like Henri Matisse. For Matisse in particular, who was always hard up, this arrangement was providential.

Trim in his velvet suit and spectacles, Matisse was steadily and tenaciously ascending through the art world, though his work was still plagued by controversy. He owed a great deal to the support of the four Steins – Gertrude and Leo (those eccentric high-society siblings and art hunters of genius), Michael and his wife Sarah (more discreet in their collecting) – who were assembling an extraordinary collection of Matisse's work that Shchukin would only surpass in 1914.

Shchukin took the field a few weeks after the closure of the Salon des Indépendants, a symbolic interlude spiced by a joke-schism, orchestrated by Gertrude, between the *Picassiens*, led by herself, and the *Matissiens*, whose champions were Michael and Sarah (especially Sarah, who was the principal artistic 'eye' of the group). Leo, himself a painter and art theorist, began to distance himself from his sister Gertrude when her relationship with Alice Toklas blossomed. That relationship was to last for the rest of the two women's lives.

Also in 1908, Leo and Sarah, both passionate painters, convinced Matisse to open an art school, to which they contributed money. The school, which lasted for four years, was set up along the lines of the academies of antiquity; in other words, it was the polar opposite of the official French Académie des Beaux-Arts. It brought together a cheerful, informal and enthusiastic group of about thirty people, most of them non-French, with a preponderance of Scandinavians and Germans. Among the students were Leo and Sarah Stein, Oskar and Greta Moll (artists of the Berlin Secession group), Hans Purrmann, who was to become Matisse's agent in Germany, and Olga Meerson, a striking Russian blonde who had learned her breathtaking techniques from the Moscow school of art and whose beauty caused much agitation in Matisse's private life. All these people painted together in the refectory of the former convent on the Boulevard des Invalides; on Saturdays they went to the Louvre to make copies of paintings there. They even made music, mostly German *Lieder*, accompanied by Matisse on his pianola.

Shchukin had a fresh shock when he clapped eyes on the big painting hanging in the painter's studio: three nude women gazing at the small brown outline of a turtle, on a green plain stretching to the line of the seashore; and beyond that the line of the horizon. There were thus three bands of colours, almost parallel to one another. No luck: the *Baigneuses à*

la Tortue had just been sold to the German collector Karl Ernst Osthaus.[3] Shchukin and Morozov did their best. Might there be a way to renegotiate the deal with Herr Osthaus? Or perhaps the artist would paint an identical copy for them? Waste of breath. Matisse had survived so far due to his intransigence. Yet the disappointment, even despair, of Sergei Shchukin touched him nonetheless.

They reached an alternative agreement. Matisse would paint a smaller picture in the same spirit: a few spare figures on the seashore. One can imagine the scene: in full view of Ivan Morozov (who on this occasion bought nothing, though he began to take an active interest in Matisse at the Salon d'Automne that followed), a dialogue began between the painter and his future patron. Over time this was to generate a number of major works of art.

After the deal had been concluded, Shchukin returned to the main purpose of his visit: he wanted to commission a panel for the end of his dining room, in a range of blues that would create a counterpoint to the overwhelming yellows and reds of his iconostasis of Gauguins. This idea appealed strongly to Matisse, inasmuch as he had always championed the notion that paintings should never be cut off from their surroundings (and vice versa). He dreamed, in short, of being an architect of paradise.

He hunted through the tapestries and odd pieces of fabric in the atelier, which he used as decorative accessories for his work. Finally, he unfolded a large remnant printed with dark blue garlands and baskets against a bright pale blue background.

'What about something based on this *toile de Jouy*?'

'It's not from Jouy,' objected Shchukin.

'I know that, for heaven's sake. It's from the part of France I come from, in the north, but still everybody calls it "Jouy". I was dreaming on the top deck of the bus, in the Boulevard Saint-Germain, when I spotted this blue. There's a second-hand clothes shop on the corner of the rue de Buci and this blue remnant was in the window. I jumped off the bus when the horses slowed down at the crossroads and dashed in and bought it. Since then I've often gone back to my "*toile de Jouy*". Here's a portrait of my student Greta Moll, for example; the background is copied from it.'[4]

142

Here were three people who had originated in, and belonged to, the world of textiles: an artist from the Cambrésis region, an oligarch from Moscow and a factory owner from Tver. They spoke the common language of fabrics and shared the same visual culture. As they talked, Shchukin's putative commission began to take shape: a broad panel based on *toile de Jouy* which would be entitled *Harmonie en Bleu*. There would also be a smaller still life. A price was agreed upon: 4,000 francs for the former and 2,000 francs for the latter. And Shchukin went further, insisting on having his own edition of Matisse's bathers. He was eventually promised a smaller painting of figures by the sea, to console him for missing out on *Baigneuses à la Tortue*. This would cost him another 1,500 francs.

For Matisse, this was beyond his wildest hopes. No sooner had he been bailed out of extreme poverty by the Steins and his handful of supporters among the Paris dealers, than somebody was offering him the chance to work in real freedom and affluence!

For the two Russians, the sums involved were modest. Modern art, as they knew, was still eminently affordable, provided one made the right choices. That said, the great forerunners (Cézanne, Gauguin and Van Gogh) were beginning to sell for dizzying prices: only a few days later, as we have seen, Shchukin would pay a staggering price for Gustave Fayet's remarkable Gauguin.

After this seminal meeting with Matisse, Shchukin zigzagged across Paris like a man drunk on love. He saw all the Matisses that were available to buy. In addition to the two in Vollard's possession, he found *Table avec Fruits et Bouteille* at Eugène Druet's gallery,[5] where Matisse had used the same blue *toile de Jouy* pattern, spied from the bus, to render a shimmering tablecloth. On 1 May, Shchukin bought *Nu en Noir et en Or* from the Bernheim brothers, a picture that would later serve as an illustration for Matisse's first theoretical text, *Notes d'un Peintre*, which was published in the Christmas issue of *La Grande Revue*.

Before long, Shchukin had to return to Moscow, where news of his buying spree had preceded him. On 11 May, Ostroukhov wrote to his cousin, the daughter of Pavel Tretyakov: 'Sergei Shchukin and Ivan Morozov are back from Paris. It seems they've bought a slew of Gauguins, Matisses and other painters.'[6]

Still life with figure

Other acquisitions were in the offing, but Shchukin had lost the Paris base formerly used by all the prominent Russian collectors – namely his own brother, Ivan, who had kept in touch with dealers and developments in the art world on his behalf. Shchukin's solution was to engage Matisse himself to buy his own works from the dealers who had them, while keeping him fully informed of any other commissions that came his way. This arrangement generated a fascinating correspondence between the two men which covered a full seven years of collecting and creating. Sadly for posterity, the extant correspondence is a one-way street: with a very few exceptions, all Matisse's letters have vanished without trace.

'I still think of your admirable *Mer*,' wrote Shchukin, obviously referring to *Baigneuses à la Tortue*. 'I see it in my mind's eye. I feel the freshness and vastness of the ocean, and the sense of sadness and melancholy permeating all!'[7] Finally, on 29 July 1908, he received his own version of the painting, though this time the bathers were male. Matisse sent a variation on the original which had so delighted him: against a background of horizontal bands – green for grass, light blue for sea and a darker blue for sky – he had placed the silhouettes of three young boys playing *bocce* (a form of *boules*). 'Yesterday I received your painting *Les Baigneurs*[8] and I am delighted with it . . . I love the freshness and nobility of your work . . . Perhaps you could send me a photograph of the big still life?'[9]

Here Sergei is worrying about his commission, *Harmonie en Bleu*.

In the meantime, Matisse had completed the picture, incorporating his *toile de Jouy* as a model for a tablecloth, and drawing inspiration from an earlier youthful impressionist picture of his (which today looks pretty tame, but which nevertheless provoked his first serious scandal when it was shown at the 1897 Salon National). This early work, *La Desserte*, depicts a lavishly set table in a simple room, with a bonneted servant girl arranging flowers as a finishing touch. Now Matisse had fashioned an astonishing work of art: the *toile de Jouy* overflows from the table, annexing the entire wall with its leaf patterns and enormous flowers. Beyond the window, which is framed like a painting, stretches the same stylized landscape that so fascinated Shchukin when he first saw it; below the window is a reas-

suring cane-bottomed chair, which seems to say 'one can sit here, drink from a jug and taste fruit from a table that has no distinct beginning and no end'. The final touch of fantasy is the little servant girl, imported from *La Desserte* of ten years earlier, and still peacefully focused on her work. At a stroke, her presence changes this great still life into a figurative painting (or, as one critic pointed out, into the portrait of an arranger of still lifes).[10]

Eugène Druet photographed the painting at the beginning of July, ostensibly so that Matisse could send the photo to Shchukin with the good news that it was finished.

But Matisse did not send it.

Shchukin wrote for news and fired off telegrams. A month passed with no word from Matisse.

On 6 August, the artist finally wrote him a reply, the draft of which has fortunately survived. The letter was accompanied by Druet's photograph – and it is the only trace of *Harmonie en Bleu* that remains to us, because by the time Shchukin received it, the painting no longer existed in that form.

> Dear Sir,
>
> I considered the G.N.M. [*Grande nature morte*] as finished a month ago and I hung it on the wall of my studio to review and judge it at my ease. Druet photographed it. But it looked to me to be insufficiently decorative and I couldn't do otherwise than go back to work on it and today I'm very glad I did . . . I am sending you the photo of its first state and I will try to give you an idea of its present coloration with a watercolour sketch. Its price is 4,000 francs.[11]

The watercolour Matisse refers to has also disappeared, but no doubt it would have stunned Shchukin. The blue invading the entire painting and proclaiming the title *Harmonie en Bleu* had been *completely repainted in red*. This is the story of *Harmonie en Rouge*, also known as *La Desserte Rouge*, which was and remains one of the absolute masterpieces of Matisse and of the Shchukin collection.

The reaction of the man who had commissioned it was brief and to the point:

I am very happy that the still life is finished. In two or three days I will be in Moscow, at which time I will send you the 6,000 francs (for the two commissioned paintings). I would ask you to send the big still life to Moscow as quickly as you can, and to insure it for 4,000 francs. The same with the smaller picture, as soon as you have finished it.[12]

Sergei did not receive his *Harmonie en Rouge* quite as quickly as he had hoped. He authorized Matisse to exhibit it at the Salon d'Automne, along with eleven other paintings, thirteen sculptures and seven drawings. Among these were *Panneau Décoratif pour une Salle à Manger* and *Nature Morte au Tapis d'Orient*, with the note: 'belonging to M.S.Stch'. The big red panel was the cornerstone of this personal quasi-exhibition of Matisse – and inevitably, it was the principal target for his most virulent detractors (though less so than in previous years). Louis Vauxcelles wrote of 'a large central decorative piece, *which I didn't like at all'*.[13] According to Charles Morice, 'M. Henri Matisse continues to stir up his enemies without reassuring his friends.'[14]

The work had quite the opposite effect on a more impartial observer – Isaac Grünewald,[15] the man who introduced modernism to Sweden. He immediately signed himself up for the Matisse Academy, writing at the time: 'Suddenly I stood in front of a wall that sang, no, screamed, colour and radiated light.'[16]

Canard au sang

In January 1909, Shchukin invited Matisse to lunch at Larue on the Place de la Madeleine, kept by the revered chef Édouard Nignon and at the time one of the great restaurants in Paris.

Ever since his visit to the Boulevard des Invalides the previous year, Shchukin had been steadily adding to his collection of Matisses, which was about to overtake his collection of Gauguins. Including the purchases he had made in the past few days, he now possessed fifteen. Among them was *Nature Morte au Camaïeu de Bleu*, in which Matisse elegantly returned to the theme of the room invaded by *toile de Jouy*, reprising the original blue

as if to beg pardon for the outrageous liberties he had taken with it the year before. There was also *La Nymphe et le Satyre*, another painting in the stripped-down manner of the *Baigneurs*, but more powerfully erotic. Matisse had painted it in two weeks. It clearly expresses his consuming sexual desire for his Russian pupil, Olga Meerson, and the ever more complicated relations between the two.

At the restaurant, Shchukin came straight to the point, as was his wont. An opportunity had presented itself. What did Matisse think of the seven panels by Maurice Denis on the theme of the Story of Psyche, which had been commissioned by Ivan Morozov and shown at the Salon d'Automne? Morozov had ordered them as decoration for the main drawing room of his townhouse in Moscow.

The question disconcerted Matisse. He was not indifferent to the hieratic, almost Byzantine approach of some of Maurice Denis's religious compositions, but he didn't care for the latter's recent, mannerist drift. Denis would soon become a sworn adversary of Henri Matisse, but for the moment they were still on polite painterly terms, as comrades-in-arms who had led the assault on the academics.

Shchukin got carried away and began to stammer while Matisse tucked into the main course. (Nignon's celebrated speciality of *canard au sang* – bloody duck – was put to one side by the vegetarian patron.) Sergei did not deny that Denis was a great talent – he himself owned three pictures by him. Nor did he doubt that the sexual union of a mortal virgin with the God of Love would thrill Moscow; yet the very essence of the project – a story from mythology illustrated on the walls of a house – completely deadened it as far as he was concerned. There was no sign in these panels either of Denis the progressive disciple of Gauguin at Pont-Aven, or of Denis the Nabi theorist. Locked as he was into his decorative project and eager to please his powerful Russian patron, Denis had yielded to his weakness for charming detail, pastel colours, plump *putti*, frothy garlands of flowers and white rotundas in pink lakes. Naturally the panels would charm people for a while, but the sight of them would quickly pall on the denizens of Morozov's grand salon, who would have to live with this ridiculous fairy tale.

Shchukin went on:

147

Nothing in common with your own *Chambre Rouge*. That's at the other end of the spectrum . . . the cloth overflowing the table and invading the walls, the landscape viewed through a window which turns into a painting, the blue harmony turned to blazing red. And . . . to sum it all up, I believe that's what a museum of modern art should be all about . . . and here you are being defied in my own city of Moscow, with a work that is utterly indefensible. We have a once-in-a-lifetime opportunity to do something . . .

Matisse smiled. The project appealed to him strongly. 'And where would you have me bleed them, your ducks?'
'On my staircase.'

The Two Orphans

I am to decorate a huge staircase with three flights of stairs. In my mind's eye, I see the visitor who comes in and spies the landing on the next floor. This must be given a sense of strength as well as light-ness. The first panel will be of a dance, a *ronde* on the top of a hill. By the time he reaches the second panel, he is already in a more silent area of the house, so I see there a music stage with an attentive audience. Finally, on the top floor, where there is absolute peace and quiet, I shall paint a scene of repose, with figures stretched out on grass, deep in reverie and contemplation.[1]

In the spring of 1909, Matisse described his work to the correspondent of *Les Nouvelles*, a French magazine. He was probably already aware that he couldn't carry out his project in this form, but still he enjoyed toying with the idea. The staircase to be decorated was in Moscow, and Russians liked to emphasize how different they were from Europeans: their calendar was thirteen days behind that of Europe, their railway tracks were wider and (as in America) what they called the 'first floor' was what others called the 'ground floor'. Actually, the main staircase at the Trubetskoy Palace had only one flight of steps and a single landing on the first floor (which of course the Russians would call the second).

On 4 March 1909 (European calendar), Shchukin, in excellent spirits, wrote to Matisse to say he had just received the two still lifes he had bought in Paris around the time he had issued Matisse's commissions, in April 1908: *Nature Morte au Camaïeu Bleu* and *Nature Morte, Vase avec Fruits et Bouteille*. He had also received the two other paintings he had bought from Druet – *La Chambre Rouge* and *Nature Morte en Rouge de Venise* – which had been borrowed, and thus delayed, for an exhibition in Berlin. Matisse's colours were literally streaming into Shchukin's palace. The collector was nonetheless anxious about his staircase panels, which he called *Le grand tableau*, and asked for a coloured sketch of what was intended.[2]

His wish was granted on 11 and 12 March, when he unpacked the artist's watercolours *Composition no. 1* and *Composition no. 2*. Number 1 was *La Danse*, still very much a sketch, with pale pink bodies. The arrival the following day of *Les Demoiselles à la Rivière* made Shchukin distinctly uncomfortable: all the figures in the painting, however refined they might be, were ostentatiously nude.

Moscow, 16 March 1909

Your sketches are very beautiful and very noble in both line and colour. But alas, I cannot hang nudes in my staircase. After the death of one of my relatives, I took into my house three young girls (of 8, 9 and 10 years of age),[3] and here in Russia (remember we Russians have one foot in the Orient) one cannot show pictures of nudes in the sight of young girls.[4]

And it was more than the décor that was changing in the Trubetskoy Palace. On 8 March 1909, Princess Nadezhda Trubetskaya, who had continued to occupy an apartment there, died at the age of ninety-seven. No details of her passing have come down to us: were there night vigils and flags at half-mast to accompany the princess, a Dame of the Order of St Catherine, to her grave, or was her funeral a quiet and private affair? In any case, the death of the founder of the Russian Red Cross could hardly have gone unnoticed in Moscow.

Meanwhile, Shchukin's son Ivan was back home from Marburg University: at the philosophy faculty in Moscow he had come upon the

new and abstruse subject of psychology. He was also sowing his wild oats with the rest of the *jeunesse dorée* of his time, and his doting father refused him nothing. He teamed up with Nikolai Ryabushinsky,[5] who organized the first major symbolist exhibition *La Rose Bleue* in 1907, followed by three exhibitions sponsored by *Zolotoe Runo* (*The Golden Fleece*), which filled the void left when *World of Art* folded and which moved the centre of gravity of Russian artistic debate from St Petersburg to Moscow. There were worse people around for Ivan to consort with, even though Ryabushinsky's wild parties attracted the most dissolute company possible.

Sergei's other son, Grigory, remained an elusive character, immured in a world that his father could not penetrate, wherein he saw himself as the principal mourner for his mother, Lydia. Grigory had studied, along with his brothers, at the Polivanov Gymnasium in Prechistenka Street; his schoolmates, from the best families in Moscow, belonged to a much more spoilt generation than that of his uncle Dmitry and his contemporaries when they attended the same establishment. Photographed at Uncle Petr's wedding in 1907, Grigory appears to be a serious young man. Now a passionate bibliophile (who was still young enough to be kept on a short financial leash), we have already seen his gallant efforts to prevent the dispersal of his uncle Ivan's magnificent library following the latter's suicide in Paris. One wonders how the tumour at the base of his skull might have affected his hearing; the growth was not cancerous, but when it flared up it completely floored him, despite his mother's loving care.

Finally, there was the younger sister Ekaterina, who was nineteen years old at the close of 1909, already married and the mother of a little boy, Ilya. If a film were to be made of the Shchukin story, she would unquestionably be cast as the heroine, with events unfolding from her viewpoint: life, love, war, revolution and finally the emergence of the Museum of Modern Western Painting, of which she became the first curator under the Soviet regime. Ekaterina possessed the charm and vivacity of Natasha Rostova in *War and Peace* and the determination of Scarlett O'Hara in *Gone with the Wind*. In 1909, she was about to enter the Shchukin drama, in which she was to play a leading role.

Dyadya Serezha and Baba Liza

The following brief digression is offered to explain the young children – war orphans – mentioned in Shchukin's letter to Matisse (above). Sergei Shchukin, active and energetic as he was, could not lay to rest the tragedy that his family had endured. It had erected an insuperable barrier between him and his surviving children. He responded to this by gathering together a replacement family in his palace, complete with peals of childish laughter and piano lessons – just as it had been before. The beneficiaries were two little orphan girls, the daughters of peasants who had perished in the war against the Japanese.

For the two newcomers, Shchukin was Dyadya Serezha.[6] He was like a magician in a fairy story . . . Still devastated by the loss of their fathers, the little girls found themselves whisked away to an enchanted palace, where a nice man with silver hair and a grey beard showed them round a kind of paradise that blossomed around them like a magical garden. There was a dining room where you could run and laugh in front of peculiar ladies watching from paintings on the walls; a big drawing room with parrots on the ceiling, white statues in the doorways and pictures of Pierrot and Harlequin strolling arm in arm; and a long gallery with a piano in it, a wall of flowers, strange cathedrals, a bridge across a pond with water lilies and gentlemen in beautiful clothes picnicking under trees.

Varya had an aptitude for drawing and Anya was good at music and dancing. They were taught foreign languages and deportment. Shchukin commandeered his sister-in-law, Elizaveta Myasnovo, to take care of them; Elizaveta was the widow of the brother of Alexander Myasnovo, the husband of Nadezhda Shchukina.

Very soon, the two shy country girls were transfigured, under the iron yoke of Baba Liza[7] and the keen eye of Dyadya Serezha, first into well-bred little girls, and then into elegant young Muscovite women, curtseying and speaking with the same faint French accent as Sergei himself.

Their early mastery of languages was to prove a life-saving investment. After the revolution, the girls were employed by the Narkomindel (People's Commissariat for Foreign Affairs) as polyglot typists. In 1922, Varya, whose full name was Varvara Vasina, was sent on a mission to Denmark,

where she got married. She never returned to the USSR. As for Anya (Anna Titova), she spent the rest of her days in Moscow, where she reminisced about her wonderful life in Znamensky Lane – and especially the wedding day of her adoptive brother Ivan Sergeevich Shchukin, when she and Varya, gloved and robed in white, were bridesmaids.[8]

This was the domestic situation of Sergei Shchukin when Matisse proposed to paint bold, huge, ostensibly naked figures on his main staircase. But the presence of two young girls in his house was not the only reason Shchukin had for being taken aback. He was hardly the type to hide away paintings of nudes in his bedroom, like his brother Petr. He had not hesitated to hang Matisse figures in an equally undressed state: *Les Baigneurs (Les Joueurs de Boules)*, *Nu en Noir et Or*, and the very suggestive and sexy *Nymphe et le Satyre* were visible to all in his house. What Shchukin dared not tell Matisse was that he had got cold feet: to install a riot of red nudity around the main staircase, in full view of everyone who used it, would have the effect of a violent and deliberate provocation.

Without expressing it directly, Sergei had commissioned from Matisse a veritable manifesto of modern art – one that would instantly transfix every visitor to the gallery at the top of the stairs. The artist's proposal so exactly answered the wish of the collector that Shchukin suddenly found himself terrified by the forces that the pair of them were about to unleash.

Shchukin struggled with the idea of offending Matisse with an outright refusal:

Moscow, 27 March 1908

For my staircase, I only need two decorative panels. As to the subject matter, I would prefer to avoid nudes . . .

I have another proposal to make to you. Your sketch *La Danse* pleased me immensely, its movement is so noble. Would you be able to produce a painting based on this study, the same size as *La Chambre Rouge*? . . . I would be glad to pay the same price of 15,000 francs, which I had agreed for the big four- or five-metre canvas. This painting would go in my bedroom.[9]

Shchukin sent this proposal in the morning. That very evening he received the final sketch for *La Danse*. Next day, he sent a telegram to the Boulevard des Invalides, telling Matisse to forget all his earlier reservations and to proceed with the commission.

The telegram was followed by a letter dated 31 March.

> Dear Sir,
>
> I find your panel *La Danse* to be of such nobility that I have resolved to defy Russian bourgeois opinion and install a painting with naked figures in my main staircase. I will also need another panel, the subject to be *La Musique*.[10]

The price of *La Danse* had been settled for some time at 15,000 francs. For *La Musique*, Shchukin proposed to pay 12,000 francs. 'There is plenty of music played in my house; every winter we hold about a dozen concerts of classical music (Bach, Beethoven and Mozart). The panel for *La Musique* should give some slight indication of the character of the house.'[11]

Shchukin was indeed a passionate music lover. After the death of his wife, he continued to organize concerts in his music salon, a room that was now mainly given over to his collection of Monets, which were hung in a long, bright line that formed not so much an iconostasis, as a little Giverny.[12]

Photographs have survived showing Anya posing in a tutu in this gallery. The piano there was played every day, its notes reaching Sergei in his adjoining office, perhaps reminding the widower of happier times. Nor did he ever miss a concert at the Aesthetic Society, whenever the pianist Vera Skryabina, wife of the composer Alexander Skryabin, played her husband's compositions. It wasn't just the music that appealed to him: the pianist herself occupied his thoughts to a considerable degree.

Women and angels

Sergei had considered remarrying, but after twenty years of an intensely close relationship with Lydia, he scarcely knew how to go about it. He appeared in public as a consistently charming and polite figure, but one

who had taken a step back from the world, a man who could effortlessly rebuff adventuresses, while simultaneously terrorizing prudes. And then, while he was waiting impatiently for news of the big still life he had commissioned from Matisse – and which wasn't even red yet – he fell in love. Not with a woman, but with a melody.

Vera Skryabina was much more than just the wife of the great composer Alexander Skryabin and the mother of his children. She was also a remarkable pianist, the greatest exponent of her husband's work and a frequent performer at the concerts given by Sergei Shchukin at the Trubetskoy Palace. She, like Shchukin, had had her share of troubles, and after many years of family life in Paris and Geneva she had returned to live by herself in Moscow.

Skryabin had left Vera four years earlier for one of his pupils, Tatyana Schloezer. The outcome was unusual: the composer's second wife remained with him until he died in 1915 and gave him four children, but their marriage was never made official. Vera Skryabina adamantly refused to divorce her husband, and since she was an abandoned wife there was no way of forcing her to do so. And so she kept Skryabin's famous name, and with her talent as a pianist continued to give hugely successful Skryabin concerts.

She was a brunette with a broad, typically Russian face; and was a little awkward, with the manners of Nizhny Novgorod, the province of her birth. She would have passed unnoticed had it not been for the extraordinary transformation that took place when her fingers touched the keys of a piano. When she played she radiated an energy so intense that she held audiences spellbound.

Shchukin, who for twenty years had never looked at a woman other than his darling Lydia, was completely enslaved by the music of Vera. He took several days off from the Nizhny Novgorod trade fair to stay in a monastery close to her dacha, where she allowed him to come and listen to her play the piano on a daily basis.

Vera was flattered by Shchukin's ardent attentions, calling him the *intélé-galant* on account of his intelligence, elegance and gallantry. Nevertheless, she turned down his offer of marriage as that would have meant giving up her status as Madame Skryabina – which was probably what had attracted

Shchukin in the first place. As Skryabin's wife, she was assured of a place in the world – and of perpetual revenge on the man who had betrayed her. Even after the composer's death in 1915, when she had become a teacher at the Petrograd[13] Conservatory, she again refused to marry – this time her suitor was the rector and composer Alexander Glazunov.

Nevertheless, she did not condemn Sergei to silence after having so bewitched him. Instead she recommended a lady professor of music for his two orphan girls. This was her friend and co-disciple ever since her Nizhny Novgorod days, Nadezhda Conus, wife of the pianist, composer and Moscow Conservatory professor Lev Conus.[14]

We do not know exactly when Nadezhda Conus first appeared at Znamensky Lane, but it was sometime between autumn 1908 and the beginning of 1909. To begin with, the two orphan girls were driven to Conus's private music school, but very soon Nadezhda began to teach them at the palace where they lived.

Nadezhda bore the surname Mirotvortseva, which could mean either 'creator of the world' or 'peacemaker'. In any event, she knew how to bring people together. Diminutive, brown-haired, with the full figure that was so appreciated at the time, this daughter of the headmaster of the Nizhny Novgorod school was lively, cheerful and hospitable. She had assimilated, above all, the unpretentious elegance of a true Muscovite. It seemed that she had been born to live at the heart of the Shchukin household; all she needed to do was sit in a chair and a queue of people would appear before her. One wonders what went through her head on her first day at the palace, when she found herself in the long white gallery hung with impressionist paintings, sitting alone at the great Steinway piano, whose high notes were so famously crystalline in quality.

Vera Skryabina was a sound; Nadezhda was a spectacle. Her technique at the piano was irreproachable, though it lacked the heavenly harmony that Vera could extract from the music of Skryabin. Nadezhda had a way of raising her wrist in the air and leaving it suspended for a fraction of a second, letting the note vibrate. Lydia had been a fairy; Vera was an angel; Nadezhda was a woman.

Her husband had given her a son, Adrian, who was now nine years old, and a daughter, Natalya, who was seven. It was rumoured that Lev Conus,

a brilliant teacher, had a weakness for his female students and that Nadezhda suffered much from this.

A horse in the desert

In the meantime, Sergei was alone. With the commissioning of his panels from Matisse there commenced a long period of gestation, which was to continue until the 1910 Salon d'Automne. Shchukin could have no inkling that in the space of a year (November 1909 to November 1910) his life would again change dramatically . . .

For his part, Matisse was made fully aware of the enormity of the challenge he had taken up on behalf of Shchukin. In May 1909, the latter told him of the expected success of Maurice Denis's huge compositions for Ivan Morozov's salon. Naturally, the loves of Psyche and Adonis delighted Moscow: here at last was modern painting that people could understand, and which told a beautiful and touching story. The contrast with the outlandish daubs hanging in the Trubetskoy Palace was all too clear.

Moscow, 30 May 1909

Here in Moscow everything is calm. Morozov has commissioned six new panels from Maurice Denis, in the wake of his success with the first decoration. People here are talking about them as a great masterpiece and they laugh at me a bit; but I always answer, he who laughs last, laughs longest.[15]

But Matisse certainly wasn't laughing. He was unable to begin work on the most important commission he had ever received until he could find a studio in which to work and a home for his family. He couldn't stay in the building on the Boulevard des Invalides, with its precarious leasehold. What he needed immediately was a place big enough for him to start painting the panels of Shchukin's staircase, which were to be 4 metres wide and 2.60 metres high.

Now that his finances were more or less on an even keel, he could make his dream come true: he could rent a house in Issy-les-Moulineaux, on the edge of Paris, move into it with his wife and three children and construct

a big prefabricated studio in the garden. But this involved extensive building work, and he would not be able to move there until September. He decided to make use of this hiatus to think, travel, make sketches and put behind him the constant anxiety of the past.

Shchukin returned to Paris in the autumn and bought a number of other works. He probably saw Matisse's newly completed studio and his first, as yet unpainted, staircase panel hanging in it. Its surface would soon be covered by an initial study of *La Danse*.[16] Like Matisse, Shchukin was ill at ease. He had made sure that the artist was talked about in Moscow as soon as possible. A special issue of *Golden Fleece* devoted to the painter had appeared in June with numerous reproductions; among them, Shchukin had managed to slip in his sketch of *La Danse*. The literary section of the magazine included a Russian translation of Matisse's *Notes d'un Peintre*, which had been published in Paris the year before.

In November, Shchukin returned to his beloved Egypt. Around the middle of the month he went riding alone in the desert, on the edge of the Sheykh Obeyd stud farm just outside Cairo, the cradle of Arabian thoroughbred horses.

Ostroukhov preserved the letter that Shchukin sent him from Cairo on 10 November. In it Sergei wrote of nothing but Matisse, announcing that Professor Hugo von Tschudi, the head of the new Munich Pinakothek, had commissioned a still life the same size as *La Chambre Rouge* for his own private collection, and himself viewed Matisse as one of the most important artists of the century. Shchukin added that Bernard Berenson, the great American historian of Renaissance art and a friend of the Steins, had been heard to say that Matisse was 'the painter of our epoch'.[17]

Ostroukhov's support was strategic: if the administrator of the Tretyakov Gallery, whose avant-garde opinions were well known, poured scorn on the panels that Matisse was painting, then Shchukin's bequest of his museum of modern art to the gallery would be seriously compromised. The decisive aesthetic battle that Shchukin had decided to join for the sake of these panels would turn into a disaster.

The collector was therefore worried and anxious, and the Arabian thoroughbred he was riding through the Saharan dunes may have felt it. For whatever reason, the horse suddenly burst into a full gallop and

Shchukin – though he was a fit man and an excellent rider – was unseated and thrown. He picked himself up unhurt, but found himself on foot with no horse, no hat, no veil and no sunglasses. Cairo and the pyramids were visible, but were many miles away. It took him several hours to get back to civilization, where it was discovered that his eyes were badly burned.

Letter to Petr Shchukin, Paris, 21 December 1909
 My eyes have been very seriously damaged. For a moment I thought I would lose my sight, but they're getting better now. The left eye is fully recovered and I can see well with it. The right one is gradually improving, but progress is slow. The doctor expects a complete recovery, but it is liable to take some time. I shall not be returning to Moscow before mid-January and even then I will have to continue the treatment at home . . .[18]

In his atelier at Issy, Matisse was moving forward with *La Danse 2*, the panel earmarked for Shchukin. He was already making sketches for *La Musique*, because soon enough he would be turning from one composition to the next. Meanwhile, his patron was close by, staying in the Grand Hôtel in Place de l'Opéra, with his eyes bandaged over.

In Moscow, Christmas was celebrated without Sergei Shchukin. No doubt Baba Liza arranged a Christmas tree and presents for the little girls. Ekaterina was probably with her own family and Ivan had gone out. Perhaps Varya and Anya caught sight of Grigory slipping past the strange, brightly coloured paintings like a silent Hamlet . . .

On 3 January 1910, Moscow awoke in winter darkness. Snow crunched underfoot and beneath the runners of the sleighs. At around 8 a.m., a single gunshot rang out, its echo quickly deadened by the snow.

Quo Vadis?

The 21-year-old son of S.I. Shchukin has ended his days with a gunshot to the heart. The wing of death has again passed over this great family of the Moscow *kupechestvo*.

Only a few years ago, the uncle of Grigory Shchukin also committed suicide: I.I. Shchukin, a passionate collector and savant, well-known to the Russian Parisian community and to all the great antique dealers of Europe . . .

In 1905, Grigory Shchukin's elder [*sic*] brother also perished, crushed by the disaster of the failed insurrection . . .

Today there is another death to announce . . . another misery for this ill-starred family.

It seems that during the mass to mark the third anniversary of the death of his mother, Grigory Shchukin prayed with special fervour. Afterwards he wandered through the Moscow darkness as if to make himself drunk with the sounds and scents of life. Early in the morning he returned to the Shchukin family home on Znamensky Lane and went to his room after sending his manservant to bed. His body was found with an open wound to the heart. Two revolvers lay by the bedside.

There was no note to explain the mystery of this young man's death at such an early age.

The father of the deceased is currently in Paris and will return for the funeral. His brother, P.I. Shchukin, the celebrated owner of a huge museum of art objects which he has bequeathed to the city of Moscow, will also be returning from Berlin.[1]

Sergei Shchukin arrived back from Paris the night before the funeral with a black bandage over his right eye. Ekaterina Khristoforova, his daughter, had arranged everything. A large crowd was crammed into the grand salon for the six-hour funeral mass.

The body of the deceased young man lay in a rich coffin of metal. At the daily masses all the great names of the *kupechestvo* were represented, along with numerous employees of their companies and many passers-by.

The Shchukin townhouse, which is normally such a hive of all the arts, has been plunged in recent days in the silence of death. In the centre of the grand salon stands the coffin covered with lilies, and red and white roses. The room looks not unlike a sunlit conservatory. The flowers, carnations and roses, are interlaced with red ribbons. Garlands hang from the ceiling and a great wreath of yellow daisies faces the coffin. On its broad yellow ribbons, traced in letters of gold, are the words '*Quo Vadis?*' expressing all the anguish of the young man's younger sister.[2]

Sergei Shchukin had the impression of being surrounded by all the other family members who had died, and felt that everybody present could see them too. It had all begun with the terrible end of the younger Sergei. But that had been at a time of revolution – it was as though he had lost a son in war; as if the grief had been thrust upon him by destiny. He had remained side by side with Lydia for a full year of mourning; but Lydia was a creature that nobody had ever taught to suffer and she was quickly carried off by her sadness. Though he couldn't accept this, at least Sergei understood it. And then there had been his brother Ivan, a figure so gifted, yet so defenceless. Ivan had been a gambler, much too weak to face the consequences of his ambition. He had lost his wager.

And now Grisha.[3] How could Grisha have brought himself to so hideous a choice? His own son had shut himself into the most desperate solitude, into an emptiness that Sergei himself knew very well from his own childhood as a stutterer, almost incapable of expressing himself in words. Sergei had never ceased trying to fill this void: running, dealing, buying, selling, persuading, testing, waiting, and beginning all over again – but never stopping. Instead of struggling to fill his own personal void, Grisha had let it suck him in, and that had been his downfall. His father could have – should have – explained to him what to do. Instead he had left him alone in the most beautiful museum in the world. What use was Gauguin's paradise if you had to walk there all alone? Grisha had not only turned his gun on himself, he had closed the book on his father's entire family. What could Shchukin say to Ivan now, or to Ekaterina? Five years ago, there had been six in the family; now there were only three. His last two children were not children at all; they were mere survivors.

The funeral ceremony came to an end, along with the psalms of the priests in their black headdresses. Incense spread through the room, the crowd dispersed towards the landing of the main staircase.

Shchukin suddenly heard music being played in the house – sad music that suited the circumstances. It was coming from the long gallery, sombre as it was and lit only from the outside by the streetlamps of Znamensky Lane. A wave of emotion swept over him when he realized who was playing. She was waiting for him at the piano, sweet, sovereign, at home everywhere in his house, the teacher of his little foster children: Nadezhda ('hope') Mirotvortseva ('bringer of peace').

Spirit-weariness

Russia post-1905 went through a period of 'spirit-weariness', as it was described at the time. There was an epidemic of suicides. Death became the preferred theme of novels and stories; people sang hymns to the beauty of it and celebrated its cult. There was even a secret society of candidates for suicide that met regularly in Moscow. People killed themselves alone, in twos, in threes . . . and ghoulish reporters wrote about their fate in sensational newspapers.

In the autumn of 1909, a few months before Grisha's death, Katya[4] Shchukina's close friend Olga Gribova killed herself. Her young lover followed her example shortly afterwards, as did the third member of the triangle, twenty-eight-year-old millionaire Nikolai Tarasov,[5] patron of the Moscow Art Theatre and creator of the fashionable Chauve-Souris cabaret. It was said that Olga Gribova, who was also the daughter of a wealthy merchant, had had time to make several other young men inconsolable, and that the rich art patron and editor of the *Golden Fleece,* Nikolai Ryabushinsky, was only alive because he had failed in his own attempt at suicide. There was even a rumour that Olga's influence had played a part in the death of Grigory Shchukin. Speculations of this kind were easy to make, of course, because most of the principals were no longer around to rebut them.

There was much worse to come: Nikolai Vishnyakov, the leading purveyor of malicious gossip among the *kuptsy*, revealed in his journal that all the Shchukin children were abnormal and that their father, with his obsession with 'decadent' paintings, was accumulating an incomprehensible 'bazaar'. His conclusion was that the awful pictures collected by their weird father had driven Shchukin's children stark raving mad.[6] Others pointed out that the Shchukins had converted the chapel of the Trubetskoy Palace into a playroom:

The holy images in the friezes and on the ceilings did not harmonize in any way with the extreme French paintings hanging on the walls . . . This room, formerly a sanctified chapel, was assigned to the Shchukin boys . . . they spent their carefree youth there and all Moscow may justly conclude that their fate was the evil consequence of being brought up in a converted chapel.[7]

Obviously, this was nonsense. The problem had nothing to do with the icon room, where the works in the collection only appeared after the palace had been entirely converted into a museum. On the other hand, the powerful energy emanating from the paintings might easily have had an effect. Not everybody can live surrounded by large numbers of paintings, especially adolescents who were no more than ten or eleven when

Shchukin's great paintings started to pour in. The collector's daughter vividly remembered the emotion which gripped her father, and his nervous trembling in the presence of the pictures he loved. The daily sight of strange or even frightening images may have had negative effects on the children (one is reminded of the syndrome that overcame Stendhal, who wilted when confronted by 'overmuch beauty' in a Florentine church).

That said, the little orphan girls from the country, who did not share the Shchukin blood, managed to live a carefree and happy life in their foster father's accursed palace of marvels. They occupied the children's room in the former chapel; they laughed about sleeping in a choir, loved the painted paradises contrived by Dyadya Serezha, and never, ever showed any ill effects of having spent their childhood in the company of Monet, Gauguin, Cézanne, Picasso and the rest of them.

What was it about the genes? The wealthy industrialist Savva Morozov, a cousin of the Morozov collectors and himself a protector and financier of Stanislavsky's Art Theatre, gathered meticulous statistics on the percentage of nervous and psychological illnesses in the third generations of great families, even extending his research to comparable American dynasties. This question worried Morozov personally; indeed, he was unable to complete his ambitious experiment, for he himself committed suicide in the spring of 1905, in Cannes, where his family had sent him for treatment of his mental difficulties.

Morozov's theory of the genetic exhaustion of the *kupechestvo* had a solid basis in fact. Repeated intermarriages within the same families, coupled with the ravages of syphilis (which few of the former generations had escaped), did indeed present a worrying picture of what was going on. The number of deaf and dumb babies, hunchbacks and lunatics was abnormally high in the large families of the Botkins, Shchukins, Morozovs and Tretyakovs. Annette Botkina, the sister of Nadezhda, Ostroukhov's wife, spent almost her entire life in a psychiatric clinic, while the painter Fedor Botkin, who lived in Paris, died prematurely from the effects of a hereditary psychiatric illness.

The start of the twentieth century coincided with the rise of psychiatry and the sensational discoveries of psychoanalysis, along with a surge of new interest in alternative doctrines that were more or less mystical or

esoteric. The beautiful Margarita Morozova, Mikhail's widow, orchestrated a theosophy group and supported Alexander Skryabin's increasingly mystical ideas about music viewed as an all-encompassing cosmic art.

Meanwhile Sergei Shchukin, deeply wounded though he was by all these events, reacted in his usual rational and constructive way. His own family's urgent need for a firm response to the grief that seemed to strike them again and again for a while took precedence over his passion for collecting. On 5 May 1910, five months after the death of Grigory, he made a donation of 100,000 roubles towards the construction of an institute of psychology, the first of its kind in Russia, which was to bear the name of Lydia Grigorevna Shchukina and be built on property belonging to the University of Moscow.

Professor Georgy Chelpanov, the father of the Russian school of psychology, developed a project for a scientific institution devoted to research into the origins of psychological illnesses, and most notably into the role played in such illnesses by heredity. In 1907, Sergei's older son Ivan Sergeevich, who had also taken an interest in experimental psychology, attended Chelpanov's first seminar, entitled 'The Brain and the Soul'.

The construction of the institute's new building began at the end of January 1911. Professor Chelpanov travelled all around Europe visiting comparable institutions, notably the psychology laboratory in Leipzig. He also crossed the Atlantic to review the equipment and operational dispositions of American university research institutions. When he came back with his findings, Shchukin added another 20,000 roubles to finance the technical installations that were required.

At that time, buildings were raised quickly, with rudimentary methods of construction. The Lydia Grigorevna Shchukina Institute of Psychology was able to open its doors on 1 September 1912.

In 1924, it was transformed into the State Institute for Experimental Psychology and the inscription on its pediment honouring Lydia's memory was erased. Nevertheless, this establishment, now known as the Psychological Institute of the Russian Academy of Education, is still very much alive in its original building. In 1993, a new plaque bearing the name of Lydia Shchukina was placed in the entrance hall. However, generosity and philanthropy could not shake the sense of tragedy and scandal that lingered

around Sergei. It was made worse by the fact that his two remaining children, both of whom were active and in good health, continued to interest the newspapers, and not always for the right reasons.

The gentleman from the land of the Scythians and the bibliophile count

We now return to the nineteen-year-old Ekaterina Shchukina, who, with just her brother Ivan, had faced the immediate consequences of Grigory's suicide.

Surviving photographs show an attractive woman with the bright eyes and round face of the Shchukins. She had an appetite for life, a sometimes wayward attitude and an unfettered imagination. It was said that she had two little diamonds set into her incisor teeth, which flashed agreeably when she smiled; and that the pearl collar her father had given to her rivalled that of Margarita Morozova.

There was also the story of the snake. According to her friend, the actress Sofiya Giatsintova, Ekaterina had brought back a live boa constrictor from her 1906 trip to Egypt, which she liked to drape around her neck. Sofiya added that the serpent's 'poisonous fangs' had been removed. Given that boa constrictors do not live on the African continent (and pythons, which do, can weigh dozens of kilos), and also that they are not venomous, this anecdote seems far-fetched. It was more likely that Ekaterina, who was not without fantasy, had selected the snake at the same curio shop that had supplied her with diamond-encrusted teeth. These shops were fashionable and successful in that time of charades, disguises, *tableaux vivants* and amateur theatricals.

Her marriage, which she was rumoured to have contracted at the age of fifteen, was equally intriguing. In fact, Ekaterina was nearly seventeen years old in the summer of 1907. But this was quite precocious enough – and hardly convenient during the twelve months of mourning that followed her mother Lydia's death. Ekaterina, it must be remembered, had lost her mother when she was on the brink of womanhood, at the moment when she had the greatest need of her. Sergei adored his daughter, but by now there was an unbridgeable gulf between him and his

children on account of those who had died and yet were still so agonizingly present.

Ekaterina was too much her father's daughter not to try and escape from the palace. She therefore drew on her status as a magnificent match and welcomed the first suitor who caught her eye. His name was Petr Khristoforov and he had recently graduated from the mathematics and physics faculty of the University of Moscow. Khristoforov was the Russian equivalent of an English country squire, enjoying a comfortable income from his estates in southern Russia in the territory of the Scythians and Cossacks. His mother brought him an indispensable touch of originality and *piquant*: Kleopatra Khristoforova belonged to Moscow's intellectual and literary clique and was an active member of the Theosophical Society, which was currently all the rage.

The young mathematician and landowner would have none of his mother's fascination with the occult. He maintained, on the contrary, that two plus two made four, and four plus four made eight – an attitude which did not especially recommend him to the Shchukins, either. The result was a young couple who were ill-suited to each other from the start, Petr being more dazzled by his good luck than in love, and Ekaterina merely hastening to take the quickest possible way out, so that she could draw a line beneath the extraordinary trials that had blighted her adolescence.

The commotion generated by the wedding ceremony expressed this fairly clearly. Andrei Bely describes one of the things that happened during the lead-up to it:

> Serezha [son of the philosopher Solovev] was a student friend of Shchukin's son and was also close to Katya Shchukina, a lively girl who was up for anything. She invited him to be the best man (at her wedding) and he accepted on condition that he be allowed to wear a red shirt and shiny boots. Katya liked this idea, but when her father pronounced himself dead against it, Serezha refused to carry out the function.[8]

Clearly, what was amusing and fun for the bride was the idea of getting married, rather than the more prosaic idea of a husband.

When it was announced that the new Madame Khristoforova was expecting a child, those who counted off the weeks before the birth were to be disappointed. Her baby Ilya arrived at the end of 1908 in the most seemly fashion, and anybody who suggested otherwise did not know Katya.

Before long there was a new mystery afoot: the young couple didn't appear to be happy. Khristoforov was spotted lunching on his own at the Prague Restaurant, a huge establishment on Arbat Street, just around the corner from Znamensky Lane, with nobody for company but Silva, his wife's white Pomeranian bitch. It was Shchukin himself who had brought this fluffy, yapping animal back from Paris as a gift for his daughter. Soon her husband and her dog were habitually returning from the Prague heavily primed with champagne, for which Silva, egged on by Khristoforov, had acquired such a taste that she would dance on her hind legs to get it, to the delight of everyone in sight.

It then became clear that Khristoforov, for all his worldly polish, was a violent alcoholic.

Ekaterina, however, was a Shchukin to her fingertips and she immediately applied the Shchukin method. She acted first and managed the situation afterwards, in a way that nobody concerned could have expected. In a lightning move, she gathered up little Ilya and her English governess and flew to the side of the man she loved.

Count Mikhail Pavlovich Keller, born in 1883, was descended from a great family of Baltic Germans that had risen through service to Catherine the Great and had given generations of soldiers, functionaries and professors to the Russian Empire ever since. A doctor in canon law at the University of Moscow, and librarian of the Rumyantsev Museum, he enchanted Ekaterina with his encyclopaedic conversation, his astonishing command of languages both dead and living, the wealth of his collection of illuminated books, the gossamer thinness of his handkerchiefs and the dazzling ease with which he rode his horse (or his motorbike).

In short, Keller would have been a perfect match for Ekaterina – had he not been married and the father of two young children.

All this was kept secret for as long as possible, and nobody knew a thing about the date and circumstances of their meeting, or how they managed the rupture with their respective spouses.

Had Keller forced himself to repress a *coup de foudre* for Ekaterina because of his own marital situation? Did he finally resolve to leave his wife because he couldn't bear the idea of Ekaterina married to another man? Did they come together at the time when Grigory killed himself? And had Grigory, a passionate lover of books, made Keller's acquaintance at the Rumyantsev Library? Whatever the truth, Ekaterina gave birth to Count Mikhail Keller's child in November 1911, meaning that their relationship began at the latest in 1910, during the period of family despair that followed the death of Grigory.

The Shchukin and Keller families thus had to manage a double scandal. The couple were married in Petrograd during the war, as soon as Mikhail Keller obtained his divorce (Ekaterina having arranged her own separation at the end of 1911). The years to come brought them tragedy, war and exile, but through it all they had five children and (as we shall see) played an important role in the history of the Shchukin collection. They were separated only in death.

As for Petr Khristoforov, he vanished into the crowd on Arbat Street. Destiny eventually caught up with him; having taken refuge from the revolution on his estate in southern Russia, he was slaughtered by his peasants, bent on avenging the ill-treatment he had always meted out to them.

The Little Flower Girl

Ivan Sergeevich Shchukin, Ekaterina's elder brother, also attempted to banish the spectre of death with the power of love. He got married in 1910 without waiting for the end of his brother's mourning period, but he and his wife separated after just a few months. The longest and most ardent period of their union turned out to be the negotiation of their divorce.

The ever-malevolent Vishnyakov tells the following story: at a charity event, Nikolai Ryabushinsky introduced his friend, the son of the wealthy Shchukin, to a ravishing and flirtatious young woman who for the occasion was cast in the role of the Little Flower Girl. She responded by threading a lilac blossom into Ivan's buttonhole.[9]

Maria Kononova was the daughter of an employee at the university. To penetrate this society of extremely rich men (who were also very elegant

and rather caddish), she possessed no tools other than her beauty, her figure and the freshness of a girl who made heads turn wherever she went. The young Shchukin was immediately smitten. The pair had a whirlwind affair and got married. As with Ekaterina, Ivan's father did not have the authority to make him pause to consider the wisdom of what he was doing. The couple's conjugal bliss was of short duration, for it quickly emerged that Maria Shchukina and Nikolai Ryabushinsky had previously been lovers, and that Ivan, the wealthy heir, had played the role of Ryabushinsky's valedictory gift to his mistress. Maria, declaring herself a repudiated wife, lost no time in claiming half a million roubles as compensation. Finally, a compromise was reached whereby he would pay her 60,000 roubles a year and the divorce was pronounced in November 1911. Ivan was obliged to serve an *epithemia*[10] of seven years of celibacy, a sentence which he accomplished easily enough. Maria left for Italy, where (according to Vishnyakov) she quickly married a ruined aristocrat and out of love for him renounced the annual pension that she had extracted from Ivan.

All of these events caused Sergei Shchukin great anxiety (and expense) and contributed to his deepening sense of guilt and wretchedness. His pain persisted, despite the discreet and calming presence in his life of Nadezhda Conus.

La Danse and La Musique

On the far side of the broad courtyard stands a splendid aristocratic residence which once belonged to the princely Trubetskoy family. Today it is the property of Sergei Ivanovich Shchukin, a manufacturer of bed sheets. He is also a patron of the arts who organizes concerts on a weekly basis. His musical taste leans towards modern music; Skryabin is his favourite composer. The same goes for painting, though his collection is confined to the works of the very latest and most fashionable French painters. Pictures by the fashionable artists of the moment can be found in his office, but as soon as other names emerge on the Paris market, they are banished to other rooms in the house. Everything here is in constant movement. One wonders which might be the artists whose work is exhibited in his bathroom?

Unfortunately, Mr Shchukin was not in Moscow on the day we visited. He had gone to Paris for medical treatment. Nevertheless, we were authorized to view his gallery. It was already 4 p.m. when we were ushered into the hallway, whence the grey-haired lady in charge of the house, who was dressed in velvet, accompanied us to the first floor. Every room she entered ahead of us was suddenly flooded with electric lighting. '*Very well,*' said she, '*let's begin with the oldest canvases and then move on to the more recent ones.*'[1]

This description is by Natalya Nordman-Severova, the wife of Ilya Repin – the former hero of the Wanderers movement, who had attained the status of quasi-official painter in Russia. She visited Znamensky Lane in December 1909, when Shchukin was receiving treatment in Paris for his sun-damaged eyes.

Ever since July 1908, the reception area of the palace, which contained his collection, had been open to the public every Sunday. There was no entrance fee, provided visitors telephoned the day before. This was so that their numbers could be controlled; more and more people were coming to see Shchukin's pictures and some of them were prone to engage in heated arguments on the spot.

'The walls of the splendid apartments of this great townhouse were literally plastered with paintings,' Madame Nordman went on.

The first ones we saw were by Cottet, Simon and the painters of their generation, executed a decade ago. In the grand salon there were a number of charming landscapes by Monet. To the side hung a work by Sizelet [*sic*], which, seen close up, proved to consist of a multitude of squares of different colours. Viewed from afar, it represented a mountain.[2] I have forgotten the name of the painter of another picture which represents a crooked house with no windows, surrounded by trees that resemble brooms . . .

In the small salon are charming works by Puvis de Chavannes, Degas and other artists of the turn of the century.

'*And now for the grand salon!*' declared the lady in black velvet. We followed in her wake.

The first thing that impressed me was the carpet. I thought of the descriptions of carpets that one reads in novels: *her feet seemed to drown in it*; or, *the carpet absorbed the sound of her footfalls*; or, *her toes caressed the soft wool of the carpet*. Yes, it was exactly like that. We moved soundlessly through the room, floating on the surface of the carpet, beneath a line of Cézannes.

Before long our guide had exhausted all the reserves of her knowledge and after getting the names of the painters hopelessly mixed up she ground to a halt and fell silent.

Mr Shchukin's son was summoned to assist her.

A young man of about 22 years old appeared among us, with his hands in his pockets, Parisian style. Why Parisian? Well, all you had to do was listen: Shchukin junior spoke Russian with a pronounced lisp, as they do in Paris. His years of study abroad would doubtless explain that.

We have learned that originally there were four brothers, all of them somewhat rootless and lacking clear references. One had already committed suicide. With the money that they earned in Russia, the Shchukin parents sent their children to expensive French schools, cutting them off from their Russian roots. All the Cézannes and Gauguins in the long dining room and all the giant Matisses hanging in the holy of holies which was Shchukin's office, were not enough to dispel the feeling of pity that this young man evoked in me.

'*He is the Michelangelo of our era,*' said he of Matisse, in tones that conveyed a certain ironical ambiguity.[3]

Neither their encounter with Ivan Shchukin, the elder son of the collector, nor their visit to the gallery seems to have aroused the enthusiasm of the Repins. Quite the opposite. 'I wanted to get out of that house as quickly as I could,' exclaims Madame. 'It was not a harmonious place.' Indeed, it was Matisse, the very latest of Shchukin's 'fashionable' artists, who shocked them most. 'In the case of Gauguin,' said Repin, 'his deliberate absence of construction and his sheer naïveté have a certain poetry about them. One may suppose that, living in Tahiti in the midst of the native population, he actually turned himself into a savage. But in the case of Matisse, there is nothing but insolence.'[4]

The battle of Paris

Shchukin arrived back in Paris on 1 November, a week before the end of the Salon d'Automne, at which *La Danse* and *La Musique* had caused a sensational controversy. The collector had preferred to let this first skirmish in Paris take place without him, so that he could better prepare the coming battle of the panels in Moscow.

He arrived in excellent spirits, having spent the month of August in Italy with Nadezhda Conus and her two children, Adrian and Natasha, and the month of October at Menton on the Côte d'Azur. These had been the couple's first intimate trips together and they were still attempting to keep their relationship a secret.

Matisse's two panels unleashed a torrent of vindictiveness from his enemies – and silenced his supporters, with the sole exception of Guillaume Apollinaire. Rarely had the attacks been so intense or so bitterly envious: not only was this artist exhibiting horrors, but he was also monopolizing the considerable resources of wealthy foreign clients, notably Germans. Matisse was taking bread from the mouths of 'real painters'. On 1 December, Roland Dorgelès, a future war hero and the eulogist of France's poor infantry soldiers in his novel *The Wooden Crosses*, wrote a piece of extraordinary violence against Matisse, entitled 'Le Prince des fauves', in which he accused the painter of selling his canvasses for preposterous sums to German museums.[5]

La Gazette des Beaux-arts declared that, this time, 'simplification has gone too far'. *La Vie Parisienne* (8 October) published two caricatures in which the violin player in the *La Musique* panel has a bottle in his hand. The caption underneath it read 'BEFORE'; the one below *La Danse* read 'AFTER'.

The Russian critic of *Odessky Listok* (*Odessa News*) reported that

> explosions of indignation, anger and raillery are incessant around these pictures. In effect, their toxic colours give the impression of a demonic cacophony, whilst the lines, which are simplified to such a point that they almost disappear, and the astonishingly ugly shapes, express the painter's idea in a way that is both rash and insistent. The world created by Matisse in his naïvely cannibalistic panels is, I have to say, frankly distasteful.[6]

Matisse himself had chosen not to face the autumn uproar. He left Paris at the beginning of October to visit the Islamic art exhibition that was then under way in Munich. Thereafter the sudden death of his father, on 15 October, obliged him to come back earlier than expected. Profoundly

affected by this, he finally re-joined Shchukin in Paris and accompanied him to see his paintings at the Grand Palais.

So at last Sergei was confronted by the panels he had commissioned. It was a major shock.

The painter had fulfilled his contract to the letter. He had already bled all the ducks in Paris, well before the panels were scheduled to leave for Moscow. Art historians have amply analysed these paintings, which are now universally recognized as being among the two or three works of twentieth-century art that are comparable in their effect to Leonardo's *Mona Lisa*; but our task here is to understand the reaction of Sergei Shchukin.[7]

Matisse was just as excited as his patron. He had felt the Russian's emotion four years earlier, when he saw him in front of *Le Bonheur de Vivre*. Taking the delicate ring of shapes in the centre of that painting as his starting point, he had composed *La Danse*, but with five figures instead of six. In this way he had thrown the original idea out of kilter and injected it with fresh dynamism; especially with the hands of the two dancers in the foreground reaching out to each other, while simultaneously inviting the onlooker to dance between them. The same was true of *La Musique*; from the small sketch that had so moved Shchukin at the Steins' atelier, Matisse had retained the child with the violin, added a flute player and seated the three other figures, who gaze directly at the spectator as they sing.

There are three bright colours: deep blue for the sky, bright green for the earth and vermilion for the figures. Within the confines of a single canvas measuring 2.60 metres by 3.90 metres, an eternal statement had been made: *God is Simplicity* (Socrates) had been answered by *Simplicity is God* (Matisse).

Shchukin refused the panels.

Had Matisse succeeded or failed? No matter. Everyone else was up in arms – yet everyone else was out of the real picture. This was Paris, the capital of the world. What could Shchukin expect to happen in Moscow? The appearance of *La Danse* and *La Musique* on his main staircase would provoke a gigantic scandal. People would take advantage of the situation to talk about Grisha's suicide, Ivan's divorce, Ekaterina's elopement, the weird Shchukin family, Sergei's new relationship with a married woman . . .

He had no need of Matisse's ten red demons, however sublime they might be.

There followed a mad week, during which Shchukin acted swiftly to avert impending catastrophe. This he achieved by the sheer scale of his reaction. He worked out that above all he must not return to Moscow empty-handed; on the contrary, he had to bring with him something monumental that would crush all debate and turn his staircase project into the most stunning, the most absolute attraction of the moment. He went to the Bernheims, who since September of that year had been Matisse's exclusive agents following an arrangement negotiated with Félix Fénéon. The Bernheims quickly suggested a solution. They had in stock an enormous panel by Puvis de Chavannes, 4 metres wide, a still very impressive reduction of the monumental frieze commissioned from the painter by the Boston Library: *Les Muses Inspiratrices Acclamant le Génie, Messager de Lumière*.

This was a major piece by an artist who was far more academic than Matisse and highly celebrated; it offered a Boston Library commission on Shchukin's staircase to offset an Oxford college's Burne-Jones tapestry in his dining room. Together, the two would raise his collection to great heights, easily matching and even surpassing Morozov and his *Psyche*. For once, nobody would dare to criticize Shchukin, draped as he would be in the glory of Puvis and his *Muses*. And all this would cost the trifling sum of 15,000 francs, the same price he had paid for *La Danse* and nearly a year's work from Matisse.

But Shchukin had yet to see *Les Muses*. How could this be arranged? Nobody knows whether it was the Bernheims or Fénéon who had the diabolical idea of asking Matisse to lend them his enormous studio in Issy-les-Moulineaux for a viewing of the Puvis panel – the same studio which had seen the recent birth of the two great works sacrificed to the honour of the Shchukins.

Matisse was in no position to refuse either his exclusive dealer or his principal patron. He drained the poison to the lees when he returned to Paris after his father's funeral, with the critics tearing him to shreds and Shchukin himself forsaking him at the height of the battle.

On 8 November, the final day of the Salon d'Automne, Shchukin took the train to Moscow. He had bought the Puvis painting, having seen it hung in Matisse's studio, where the *Muses Inspiratrices* seemed to sneer

at Matisse himself and his abandoned panels – paid for, but unusable. Naturally, the Bernheim brothers had spread the story all over Paris.

Matisse was finished.

His daughter Marguerite remembered that at this time her father's hands began to tremble and the insomnia which had plagued him for months at a time returned with a vengeance.

On the evening of 10 November, a telegram arrived from Moscow:

Changed mind en route will take your panels please send Danse and Musique post haste cordially Sergei Shchukin.

The next day, 11 November, Shchukin enlarged on his decision in a letter to Matisse:

Dear Sir, while on the train for two days and two nights, I thought deeply about all this and I am now ashamed of my weakness and cowardice. I cannot quit the field of battle without putting up a fight.

For this reason, I am determined to exhibit your panels. People will shout and scream and laugh but I am convinced that your way is the right one. Perhaps time will prove me right and in the end I will emerge victorious.[8]

With customary Shchukinesque pragmatism, the letter went on to discuss what to do about the Puvis painting. Around 100,000 francs' worth of building work would have to be done to adapt the only remaining room in the palace large enough to contain a work as enormous as the *Muses*. The collector therefore asked Matisse to approach the Bernheims and suggest the return of Puvis's *Muses* in exchange for a more modest painting of his own, *La Jeune Fille aux Tulipes*. It was settled at the same price of 15,000 francs as previously agreed for the Puvis, meaning that Shchukin would be paying 15,000 francs for a painting by Matisse that the Bernheims had originally priced at 5,000 francs.

Shchukin's letter ends with an apology for his backpedalling in favour of Puvis. He admits that, alarmed by the scandal his panels were creating, he sought refuge in memories of his youth, when he was

. . . so enchanted by Puvis's work. Here, in a different setting, I can see that his panel, beautiful though it is, appears distinctly limp and even a trifle *pompier*. So I regret nothing about this abortive transaction except that I have lost money by it. Nevertheless, by working hard, I expect to make good my loss.

If the Bernheims refuse my offer, I would ask you to keep the Puvis piece in the studio until my death.[9]

The deal duly took place on this basis. It is worth lingering, however, on this embarrassed letter.

At no point during that awful week in November 1910 did Shchukin – himself a public figure heavily exposed to attack and slander and so prey to agonizing and legitimate doubts – take account of one fact: the agony of an artist who, for a year and a half, had poured all his energy into creating one of the most beautiful masterpieces ever painted. And yet Shchukin fully understood the weight of the blow he had dealt Matisse.

Once again, Shchukin's reactions to whatever fate held in store attest to the precision of his management of people and things – both a great quality of his and a great weakness. People who favour the managerial approach to human relations tend to sterilize matters and create latent, gradually increasing conflict. This is what was already beginning to happen between Shchukin and Matisse. Eventually it was to lead to a lack of frankness and spontaneity between the two men, despite their artistic collaboration, unique in the history of art.

It is more than understandable that Matisse continued to sleep badly for years afterwards.

Shchukin tried (clumsily) to excuse himself by invoking his youthful love of Puvis de Chavannes. It was as if he were lying on the couch of his contemporary, Sigmund Freud. The key to all this lies in the term *pompier*.[10] Sergei mentions a precise childhood memory of a painting hanging in the house of his uncle, the great collector of European art, Dmitry Botkin, to whom the Shchukins were very close. The subject was a burning village, with helmeted firemen in peasant smocks converging on it. Puvis, ever ironical, called this picture *Les Pompiers du Village*.[11]

Hans Purrmann, a devoted German disciple of Henri Matisse, came by to help the artist roll up and pack his panels – he recalled that for a moment, the enormous red figures spread out on the floor of the atelier seemed to writhe under the malignant glare of Puvis's *Muses*.[12]

'It took daring to paint these panels, but it took real bravery to buy them,' was Matisse's final verdict, after all the emotional upheavals of the autumn of 1910.

The battle of Moscow

The panels arrived in Moscow on 4 December.

Shchukin duly installed them on the staircase, which rose from beneath a massive archway. This made it impossible to see the panels from below, and magnified their effect on the landing: *La Danse* erupted in a burst of colour just where the first flight of steps ended. Later, Sergei Ivanovich would say that the ethereal, floating movement of the picture helped him ascend the stairs and even impelled him upward. Immediately after, *La Musique* came into view on the left. Thus the two panels touched each other at right angles; one could only see them both together when one was squarely on the landing.

A reconstruction of the location of Matisse's panels *La Danse* and *La Musique* on the staircase of the Trubetskoy Palace. Drawing by Ivan Saveliev.

The day after the panels were delivered to the Trubetskoy Palace, Ilya Ostroukhov went to see them. He hastened to report back to his cousin Alexandra, the daughter of Pavel Tretyakov: '*What a horror!* Sergei Ivanovich thinks the same, he told me yesterday that the Tretyakov Gallery may refuse to take them [the panels] after his death. *We will have to get that down on paper . . .*'[13] In this, Ostroukhov, a painter and collector himself and the rediscoverer of the art of the Russian icon, was completely wrong.

In his letter to Alexandra Botkina, Ostroukhov also mentions a forth-coming and highly interesting Beethoven concert scheduled at the palace for the following day (6 December). This concert was to be the baptism of fire for *La Danse* and *La Musique*. Shchukin, never one to waste time, would show them to the cream of Moscow society two days after their arrival and installation at his house. And he had just accepted their rejection by the principal administrator of the Tretyakov Gallery . . .

What would he tell Matisse, who must have been on tenterhooks? In a letter to the painter written on 20 December, Shchukin can barely conceal his disappointment:

> Your panels have arrived and are hanging in place. The effect is not too bad, but alas, in the evening, the electric lighting considerably alters the blue in them. It becomes almost dark, almost black. In general, I find the panels interesting and I hope one day I will come to love them . . .
>
> The public is against you, but the future is on your side. Now I would like to make a business proposition. I am thinking about using your paintings as decoration. The room I have in mind is not big, but it would be big enough to receive three paintings the size of *La Chambre Rouge*.

He concludes with a postscript: 'I am getting some rough treatment because of you. People are saying that I am doing Russia and Russian youth a lot of harm by buying your paintings. But one day I hope I will win this battle . . .'[14]

Shchukin, amazingly, had just carried off the most daring coup of his life as a collector. Being branded a fool who tossed money out of the

window, corrupted Russian youth and was 'led by the nose by Parisian crooks' did not affect him in the least. Much more painful to him was his own inner resistance to the pictures, to the point where he confided to Matisse his forlorn private hope that he would 'come to love' the panels one day.

Despite all this, he was ready to make a further major purchase, commissioning three *Chambres Rouges* at once, for the last room that was available to him that could contain such a triptych. Every one of his commissions was for him a kind of victory over his own hesitations and anxieties. Clearly the panels still terrified him, though he knew in his heart of hearts that he could not do without them. He stubbornly persisted in his own dance with Matisse, sowing in this letter the first seeds of what would become the painter's next most famous composition: the four *Intérieurs Symphoniques* of 1911. Within a year, the first two pieces were in place on the walls of the 'not big' room Shchukin had allocated.

Growing to love the panels 'one day' was far from easy for Shchukin. One of the fiercest critics of these 'things of intolerable impertinence' painted by Matisse was Prince Sergei Shcherbatov. The prince recalled that Shchukin complained directly to him, declaring that when he was alone with the paintings he hated them and became almost tearful in his regret for having bought them. But he also mentioned that, little by little, the paintings were 'winning him over'.

Nothing can better explain the way Shchukin functioned as a collector than the violent process he was willing to face before he could accept the clean break with the past represented by *La Danse* and *La Musique*. He was prepared to live with a work of art, wrestle to transform it in his own eyes and thus be himself transformed by it; and finally, to draw everyone else, the public, into the same magic ring of dancers that he had penetrated.

He saw to it that they were beckoned to join the ring, just as he was, by the two leaping figures whose hands are not interlocked.

He describes this process in a letter written to Matisse dated 5 January 1911. *La Danse* was the first of the two pictures with which he was reconciled: 'I am beginning to contemplate your panel *La Danse* with genuine pleasure. As to *La Musique*, the same thing will happen with time.' Then

he turns to the décor, confirming that the panels have blended peacefully into the Shchukin museum of modern art: 'when spring comes, I want to change the colours of the walls and carpet [to go with them]'.[15]

The Sergei Shchukin who confided his deep alarm to Ostroukhov at the beginning of December was now a distant memory.

Outside the palace, the ice began to thaw. An article appeared by one of the highest critical and artistic authorities in Russia, Alexandre Benois. His *Letter on Art* in the 1911 issue of the review *Rech* (*Discourse*) was entitled 'Shchukin's Achievement':

> Every purchase made by this ascetic collector is an exploit, because every time he has to overcome the misery of hesitation. For Shchukin has not bought works of art that pleased him, so much as things that he believed *should* please him.
>
> His most recent achievement has been the acquisition of the two decorative panels by Matisse which caused such violent indignation in Paris last autumn. They are now hanging in the staircase of his town-house on Znamensky Lane ... He is totally impenitent about this provocative gesture, even though his friends, and other art lovers, are viewing him askance and many of his most fervent supporters are shrugging their shoulders.
>
> Matisse's purpose with these panels is to resolve the problem of decorative painting and mural painting ... the result is a virtuoso, magnificent, all-encompassing approach, which comprehends the human soul, rejoices in it and brings into full play an ecstasy of rhythm, linear movement and the bee-like hum of colour.[16]

The first Russians to follow Benois belonged to the most recent genera-tion of artists. Boris Ternovets was a young sculptor who, after the revolu-tion, was to become director of the State Museum of Modern Western Art (which united the paintings from the Shchukin and Morozov collections). He wrote:

> I was at Shchukin's house today. Going often to see the best art in no way diminishes its power; on the contrary, one wants to look at it

forever. Claude Monet's *Déjeuner*, Cézanne's still life, and the works of Gauguin all have this effect. But what truly stunned us, captivated us and took our breath away was the sheer breadth of the final, triumphant wonder, which is Shchukin's new fresco by Matisse, *La Ronde*.

I was intoxicated by this. Against a blue background, young women dance in a ring . . . the ring has just broken, so frenziedly have they danced, but the circle is re-forming and the red figures outlined in black are moving again with fresh energy and power. It is impossible to express in words the perfection, the convergence, the sheer accomplishment of this composition. The extended limbs, all of them extremely contorted, do not shock the eye in any way, so masterly is this painting's relentless inner tension.

If you stand in half-darkness and close your eyes to slits, the impression you receive from these paintings is fantastic and fairylike; every detail is in motion, with an irresistible, wild energy. This is the best thing that Matisse has ever done and perhaps the best thing done in the twentieth century to date. It is not a painting, because it has no form; nor is it a picture. It is monumental decorative art of a completely different sort, a thousand times more powerful and moving than anything that came before.[17]

Gradually, the national press fell under Matisse's spell: here the correspondent of the newspaper *Russkoe Slovo* (*Russian Word*) of 22 October 1911 describes how he was galvanized by Shchukin himself:

'*Come over here! Come with me!*' he cried, hurrying across the room. He opened the door giving onto the staircase inside and then backed, beckoning, into the penumbra of the room beyond . . .
'*Look from here, from where it's darker. Look!*'
We observed the panel hanging above the staircase. Under a bright blue sky was a bright green earth with bright red, naked human silhouettes seeming to dance round and round with great rapidity.
'*Look!*' cried our enthusiastic host again. '*Look at the colours! The panels illuminate the entire staircase . . . don't view them as pictures. Look at them as you would porcelain dishes or ceramic tiles, with painted marks that delight*

the eye. Come on! Isn't it marvellous? Isn't it magnificent? What subtlety in the association of colours . . . what taste, what consummate daring!'[18]

People were astonished at the spectacle of Matisse's two great works. You only had to see them once and you never forgot them. The painter Sergei Vinogradov described his own experience a little later:

> At the ground floor entrance there was a footman in livery. We climbed the stairs. Reaching the first floor, we were immediately rocked back on our heels by the sheer power of Matisse. At that time, his work was so unusual that even we, who are a pretty cynical and worldly crew, were amazed. The panels are daring, quite extraordinary: a ring of yellowy-red, youthful figures leaping and cavorting against a blue background, with the shapes of their naked bodies very different from the academic forms to which we are used. Today things like this have become banal and perhaps even a little boring, but at that time, the combination of Shchukin's marvellous Thursday dinners in the poshest part of Moscow, the glistening frosty evenings, the liveried footmen, and Matisse, had the effect of strong red pepper.[19]

By the end of 1911, Shchukin had won the battle of Moscow. He had raised a powerful, young and enthusiastic army, strong enough to confront and overwhelm the conservative old guard. But for the owner of *La Danse* and *La Musique*, which had caused him so much grief, the real accomplishment consisted in learning to love them himself. Meanwhile, throughout this period of doubt and despite the headwinds blowing against him, he never ceased to commission new works from his artist.

As early as 27 November 1910 – before he even took delivery of *La Danse* and *La Musique* – Shchukin asked Matisse to paint a couple of still lifes for him as quickly as possible. 'The big panels are going to be a major struggle for me; I shall need these still lifes to help get you accepted.'[20] As soon as the panels were safely packed and sent to Russia, Matisse had retired to Spain to lick his wounds. Shchukin's letter found him at the Alhambra in Granada. 'Here I have had ideas for paintings and I can see them almost finished in my mind's eye,' he replied.

The Alhambra, the former residence of the Moorish kings of Andalusia, was designed to represent heaven on earth, Islam's dream of harmony and peace. This was not unlike Matisse's own dream of creating peace and serenity through art. It was at the Alhambra that he formulated his metaphor of a comfortable armchair, which was destined to refresh Shchukin in the evenings as he gazed, exhausted, at the paintings in his salon. Jakob Tugendhold understood this when he wrote:

> The art of Matisse lies in his way of intoxicating himself with the colours he uses to enchant other people. His way has nothing to do with *grand art*, which is architecturally structured and suffused with religion. The art of Matisse is a joyful thing, the work of a happy and fulfilled craftsman of our own twentieth century; it is an antidote to human hyperactivity, at a time when art's only remaining function is to give pleasure.[21]

Within a month, the two *Natures Mortes Espagnoles* were finished and on their way to Moscow, with the sum of 10,000 francs winging its way in the opposite direction.

At the beginning of December – again even before the arrival of his panels – Sergei had written to Matisse: 'I have brought a photograph of Cézanne's *Joueurs de Cartes* . . . I thought perhaps one day you might want to do a picture with clothed figures in it. Perhaps a portrait of your family (Madame Matisse and your three children).'[22]

In Seville, Matisse duly did a sketch, which he filled out on his return to Issy-les-Moulineaux. Amélie Matisse is seated on a sofa working on her embroidery, while her sons play draughts and her daughter Marguerite, standing in a black dress, holds a book with a yellow cover in her hands. The Moorish influence of Spanish art is very clear in this painting, as is that of the Persian miniatures that so delighted Matisse at the October exhibition of Islamic art in Munich. (At the time, he had no inkling that one entire section of the Munich exhibition belonged to the collection of Petr Shchukin, his patron's brother.)

Sergei Shchukin immediately accepted the sketch of *La Famille du Peintre*, which turned out to be the first of the 1911 cycle of four *Intérieurs*

Symphoniques, first suggested in the letter of 20 December, when Shchukin admitted his lack of enthusiasm for the panels when they arrived at his house.

Writing again on 5 January 1911, he returned to what he considered to be the grand affair of decorating his 'not very large' remaining room. We learn that he had already considered hanging Puvis's *Muses* in this space.

What was to be the theme of the new allegorical triptych? Certainly not nudes. 'What would you say to youth, maturity and age? Or spring, summer and autumn?'

Matisse considered this and, as usual, distanced himself from the original commission by suggesting the figures without quite letting them be seen. In the process, he created three more masterpieces out of the fever of creativity which his collector's eye had stimulated: *L'Atelier Rose*, *L'Atelier Rouge* and *L'Intérieur aux Aubergines*. Shchukin took only the first of these, asking the painter for more pictures with figures in them.

By now all the reception rooms in Shchukin's palace were filled with paintings. The only space he had left for a major composition was a small, complicated, ill-lit antechamber, a redundant area which one passed through after leaving the landing where *La Danse* and *La Musique* were hung.

'But actually, it seems to me,' continued Shchukin matter-of-factly in his letter, 'that it might be wiser to make the trip to Moscow and see the situation for yourself.'[23]

The City of All-Night Revels

On 19 October 1911, Matisse and Sergei Shchukin left Paris on the *Nord-Express*. They spent two days in St Petersburg and then continued on to Moscow.

The first day was a serious disappointment. Matisse had dreamed of seeing the Imperial Hermitage, but Sergei Ivanovich, whose agents had told him the museum would be closed all winter, was reluctant to disturb the director. 'Matisse would never have another chance to visit the Hermitage,' wrote Ilya Ostroukhov.[1] The Imperial Hermitage was indeed closed to the public for renovation, but its director, Count Dmitry Tolstoy, had he been alerted by Ostroukhov – his colleague and the administrator of the Tretyakov Gallery in Moscow – would certainly have rolled out the red carpet to receive Matisse and his patron.

It is scarcely believable that Shchukin would have been intimidated by officialdom, any more than would the all-powerful Ostroukhov, who was obliging and efficient but very much liked people to know it. Probably Shchukin, with Matisse on his hands, simply didn't care to run the risk of a rebuff in the land of Gogol, where bureaucracy – then as now – was anything but predictable.

Nevertheless, Matisse's first impression of Russia was formed in the magnificent imperial city of St Petersburg, and he wrote to his wife

describing his amazement. The purpose of his trip was to strengthen the personal links between painter and patron, whose relationship had hitherto been hindered by mutual shyness. This was entirely comprehensible, given that the two men were initiating a direct encounter between very great art and very great wealth, such as had rarely occurred before in history.

'You will not believe me, but throughout the train journey we talked all the time without difficulty,' Matisse informed his wife. 'We are getting on very well so far.'[2]

Ostroukhov's letters make it possible for us to track Matisse's stay in Russia down to the last detail.

> On the third day, they arrived in Moscow. Matisse stayed at Shchukin's. He spent the first day reviewing the collections of his host and of Ivan Abramovich Morozov, and in the evening he joined us at our house. His enthusiasm for our icons knew no bounds. He could not drag himself away from them all evening, going into ecstasies over every one. Then, with great delicacy, he finally declared that these icons alone made it worth travelling for a far greater distance then he had done from Paris, because to his mind they were comfortably superior to the images of Fra Beato [Angelico] . . . Today, over the telephone, Sergei Ivanovich told me that Matisse had scarcely slept all night, so strong was the impression our icons had made upon him. Tomorrow I am taking him to the Cathedral of the Dormition [in the Kremlin], to the Sacristy of the Patriarch and to an oratory of the Old Believers . . . In the evening, we will be at the Opera to hear *Sadko* performed. I hope he will be happy.[3]

It was not unusual for celebrities to come to Moscow, but not all were received with the same honours as Matisse. Ostroukhov cancelled all his other engagements and organized a cultural programme especially for him; apart from his family link with the Shchukins, through Alexandra Botkina, he was interested in Matisse both as a painter and above all because he was 'an uncommonly refined, original and cultivated man'. In putting together his programme, he focused on the old Russian works of art that had been his own principal interest for some time.

Some years earlier, Ostroukhov had conceived a passion for icons. He had read everything on the subject and seen everything there was to see. He had also put together a modest private collection of beautiful icons from the schools of Novgorod, Pskov and Tver. By the beginning of the twentieth century he was spearheading a revolution in Russian art. Before Ostroukhov, icons were viewed as exclusively religious objects, confined to the sumptuous Orthodox ritual. The great works of the masters of the past, blackened by centuries of candle smoke, had been submerged by ever more modern pieces, which were increasingly academic.

As far as Matisse was concerned, if his trip to Russia was unforgettable it was largely thanks to Ostroukhov, who had been nicknamed by somebody, correctly enough, 'the Christopher Columbus of antique Russian painting'. The following is the schedule Ostroukhov proposed to Shchukin for his guest's first three days in Moscow:

Saturday: At 11 o'clock, I will pick you up and we will go to the Novodevichy convent; after that, we will have lunch with the Kharitonenkos.[4] They have a few interesting icons, and Matisse wants to do a study of the Kremlin. Sunday: I will bring the car between 1 p.m. and 1.30 p.m., to visit the Rogozhskoe cemetery at the Edinoverchesky monastery. Tuesday: I will come at 3 p.m. to take you to a concert of the Synodal choir which has been specially organized for us . . . At midnight Matisse will join us at our house and we will go on to the Chauve-Souris, where there will be plenty of people eager to meet him. This will do for the next few days; for the rest, let's see.[5]

In the postcards Matisse wrote to his friends from Moscow, he states that he has 'not yet been able to see the Tsar', but is nevertheless very happy with his trip. The weather was execrable, but Moscow was fabulous: 'Life in Moscow is very chic, people are up all night revelling,' thanks to which 'the city has real character. The primitive paintings in particular are quite beautiful, almost fauvist.'[6]

His apotheosis took place at the highly select and heavily frequented Chauve-Souris cabaret, which was thriving despite the suicide of its founder, Nikolai Tarasov (see above).

Everyone was at the Chauve-Souris last night – artists, commercial painters, dandies, all mingling together in a jolly, elegant, animated throng . . . The painter Matisse arrived with Ostroukhov . . . Matisse was given a caricature depicting him in the company of ladies of decadent aspect, scantily dressed and carrying a sign saying '*Adoration du grand Henri*'.[7]

The artist had longed to see a real Russian winter, with Moscow snowbound, but it was not to be. That year the cold weather arrived very late, and instead of snow there was incessant rain. But he saw the icons. 'I have wasted a full ten years searching for what your artists discovered long ago, in the sixteenth century. You don't need to study in France. We French need to come and study here in Russia!' This, according to Shchukin, was Matisse's comment when he saw the icons in Ostroukhov's Tretyakov Gallery. Ostroukhov left him alone with them for a couple of hours, and even then had great difficulty tearing him away.

The Moscow newspapers published several interviews with Matisse, in which he expressed his wonder at the immense artistic wealth of Moscow: 'I wonder if the Russians have any idea of the artistic treasures they possess . . . Your cathedrals are magnificent and majestic. They are monumental and at the same time they have astonishing style . . . Russian icons are the most interesting primitive paintings in existence.'[8]

Local journalists followed the celebrated Parisian everywhere he went, reporting on reception after reception attended by the man whom 'all Europe viewed as the Raphael of our time'.

It was soon discovered that the painter had a friend of his own within Moscow's younger artistic milieu – in the person of Madame Adel, the sister of his pupil, model and close friend Olga Meerson. Madame Adel organized a reception in his honour on 11 November for which the city's young artists turned out in force. Among them were Mikhail Larionov, Natalya Goncharova and David Burlyuk, all of whom were regular Sunday visitors to the Trubetskoy Palace. They now had a chance to meet the star of the Shchukin museum in person. This *soirée* was to have important long-term consequences for Russian art: galvanized by Matisse, the participants met again at the palace the following day, where

they officially founded the avant-garde Valet de Carreau (Jack of Diamonds) Society, electing Sergei Shchukin as a member of honour, and as president the painter Petr Konchalovsky, whose studio Matisse had promised to visit the night before.[9] This group, which had already held an informal first exhibition, would probably have come together at some point anyway; and it was the Russian avant-garde 'Jacks' that later inspired futurism, supremacism and constructivism. Indeed, the entire artistic movement of the utopian Soviet period was born symbolically on that day, in Sergei Shchukin's museum of modern art, inspired by the presence of Henri Matisse (whether or not he was actually present at their first meeting).

At Shchukin's house, however, nobody said a word about the project for which Matisse had come to Moscow: namely, the decoration – with paintings 2 metres broad – of a smaller room adjoining the entrance. The painter's visit coincided with the sensational arrival of two panels ordered that spring: *L'Atelier Rose* and *La Famille du Peintre*. Matisse himself orchestrated their hanging in the little antechamber on either side of a large ceramic stove. Otherwise he did nothing but sightsee, give interviews, go to the theatre, attend dinners and generally play the hero of the moment.

As Lyudmila Gold, an amateur sculptress who belonged to the Muscovite artistic élite, wrote:

It was hardly surprising. Matisse had come to Moscow in person; Matisse, who for several years past they had wanted to surpass without succeeding in doing so; Matisse, whom they venerated and in whose work they sought justification for their ignorance. They set out to erect a voluntary *laisser-aller* as a principle for art, but in doing so they completely failed to grasp the essence of what he was doing, which was the work of genius.[10]

Andrei Bely was there to comment on Shchukin's remarks about Matisse having rediscovered his taste for life while staying at his house. 'He drinks champagne, eats sturgeon and praises icons to the skies; he says he doesn't want to go back to Paris.'[11]

After a memorable performance of Tchaikovsky's *Queen of Spades*, a reception was organized at the Aesthetic Society, where assembled poets and philosophers acclaimed the artist. Andrei Bely described his appearance: 'Yellow beard, dry, red cheeks, tall, wearing a *pince-nez*, he acted in a friendly way but had the indefinable air of a master.' Bely also noted that 'apparently Shchukin has tampered with a painting Matisse did for him. Matisse pretends not to notice.'[12]

Indeed Sergei had hidden, under a touch of gouache, the already discreet sexual parts of the young flute player in *La Musique* (all the other figures are painted with their knees well together and even their sex is indefinable). Shchukin the censor had not warned the artist of this, which explains his nervousness when, side by side, the two men climbed the stairs for the first time. Shchukin's son Ivan, who witnessed the scene, told Beverly Kean that Matisse pretended to be completely oblivious.[13]

Instead, what really annoyed him was the way his paintings were displayed at the palace. They were all framed behind glass and scattered over several different rooms, leaning steeply away from the walls on which they hung. At this Matisse lost his temper, declaring that such dreadful hanging would kill an elephant stone dead, let alone his art. 'Henri Matisse reduced the whole house to slavery and commanded poor Shchukin *to display his canvasses only* and have all the others removed to the attic. At a pinch Shchukin could have kept a *Pi-Pi-Pi-Picasso* or two, but *Ma-Ma-Matisse* overruled him,' joked the critic and philosopher Emil Medtner, a friend of Bely's.

> Matisse decided to place his paintings in the big pink salon at the heart of the palace, where Cézanne and Degas were currently installed to great advantage. They were all big and did not fit between the medallion mouldings on the walls, but this did not bother him in the least; he simply hung them directly on the medallions themselves, so that their tall frames hid the sculpted cornices behind. Some of the still lifes of ceramics or other objects in pink and green harmonized quite well with their surroundings; indeed some of them almost exactly matched the hue of the sofa fabric.[14]

Ternovets's sister was not the only one to recall that it was Matisse himself who rearranged the pink salon. The critic Jakob Tugendhold agreed: 'The tapestries, carpets, and the ceiling are now part of a decorative *mise-en-scène* orchestrated by Matisse himself.'

The pink salon remained almost exactly as Matisse had left it. Right up to 1914 the canvasses that the collector and the artist had together agreed for the upper rows appeared, one or two at a time. The Matisse section of the Shchukin museum was thus completed at a distance by way of a continuing dialogue between the two men.

And so Sergei Ivanovich carried on putting the pieces of his puzzle in place, in the full knowledge that those pieces were masterworks of world painting.

In the music room, the impressionists with their green shades, pearly pinks and cold blues were hung against a pale, silvery tapestry. In the dining room, in the midst of the sombre silk hangings, was the Gauguin iconostasis, and in the pink salon Matisse was enthroned. 'In the main salon, amid a mass of eighteenth-century furniture, there are thirty Matisses! The effect is simply stunning. That man has real flair.'[15] Thus wrote Vasily Kandinsky to his friend Gabriele Münter after visiting the palace.

Thereafter the pink salon became Shchukin's favourite room in the house. He liked to say that for him it was like a heavily scented orangery, sometimes toxic but always full of magnificent orchids. Pale green walls, ceilings with pink decorative features, white mouldings, a cherry-coloured carpet and a bronze chandelier; gilded picture frames and armchairs, seat-covers of pink silk decorated with flower bouquets; and above all, Matisse's thirty canvases in their shimmering tones of blue, raspberry red and emerald green.

Jakob Tugendhold attempted to explain the charm of this room in a different way:

It is hard to say which of the two, Matisse or the room itself, does the other most credit. Perhaps it is impossible to philosophize in Shchukin's pink salon and no doubt it serves no purpose to apply oneself to Chekhovian introspection in a space like this; yet the audibly vibrating

colours that stream from the walls, the dissonance between the warmth of the primaries and the cold depth of the purples and blues, make me want to try. It all exudes so comforting a warmth and so bracing a cold that it acts like laughing gas, leaving you with a feeling of overwhelming vitality and plenitude. Here, when you get up from your chair, you find yourself sailing between poles and tropics of sensation. Here the colours are pure colours, independent of any subject matter, vectors of pure psycho-physiological pleasure.[16]

Matisse had always dreamed of a form of painting that would bring peace and serenity to men's souls. His 'scented garden' had flowered in Moscow, in the great house on Znamensky Lane which Tugendhold correctly identified as the orangery – and apotheosis – of his art.

From the start of the second decade of the century, well before Matisse's memorable journey to Moscow, Shchukin had begun to buy the paintings by Picasso which would eventually outnumber those by Matisse in his collection – by fifty to thirty-eight.[17] Nevertheless, Matisse's primacy was complete. With him Shchukin accomplished an act of creation, though his eyes were still moist from the grief that had decimated his family. Maybe Matisse himself had no inkling of the full tragic intensity with which his patron viewed him, but he responded as an artist as well as he could, reaching ever greater heights. Significantly, many of the masterpieces that resulted from their relationship were directly commissioned by Shchukin: *Les Joueurs de Boules* and *La Chambre Rouge* (1908), *La Danse* and *La Musique* (1909–10), *La Famille du Peintre* and *L'Atelier Rose* (1911) and later *Le Café Arabe* and the *Portrait de Madame Matisse* (1913). With this extraordinary collaboration, Shchukin concluded in triumph the building of his museum of modern art, which was the first of its kind in human history and remains unrivalled to this day for the sheer quality of its works.

Fascinated though he was by new, ever more provocative and futuristic trends, Shchukin never ceased to love the festival and jubilation in the colours of Matisse. The painter himself had felt the same thing during his stay in Moscow. A few photographs survive of the 'installation' common to the two men, which was the pink salon. The space continued to grow and to become richer, like a garden with a life of its own, until Shchukin's

steady process of collecting was interrupted by the Great War and Matisse went on to recreate many other luxuriant interiors for himself. The combination of his talent for colour and the joy of seeing it flooding down from real walls sustained him for the rest of his life, right through to the Rosary Chapel in Vence.

All this was first revealed to him at the house of Sergei Shchukin, in Moscow, the city of all-night revels.

Picasso the Hypnotist

In 1911, Alexandre Benois called Moscow 'the city of Gauguin, Cézanne and Matisse'. In his *Letter on Art* of 1912, he might have added: 'the city of Picasso'.[1]

No private collection in Europe or America can offer anything comparable to the Picasso room. It is frankly astonishing. Monstrous shapes, with features hacked from stone; clumsy, misshapen, twisted, deformed, lugubrious and menacing. Faces as if gouged from wood, atrocious landscapes like children's drawings, everything sombre and grotesque. There is a creature traced crosswise and abnormally enlarged; what looks like a pitiful signboard of some sordid dive; the bewigged head of an apprentice hairdresser; a forlorn pile of stones or firewood ... Five or six years ago, a display such as this would have aroused no more artistic interest in us than a lunatic asylum. Two years ago, we would have been outraged and called the painter a charlatan. Today we still derive no pleasure whatever from the sight of these hideous pictures. But how is it that S.I.C. [Benois evidently could not bring himself to write Shchukin's name in full, even though the initials left no doubt about who he was referring to] is so attracted by these artworks? Why does he say he prefers them to all others? Why does he spend so much

money to acquire them? He is certainly not mentally ill. Perhaps he has a pressing need to tease his guests and make them talk about him?

By 1912, Shchukin had been surprising people for some time. Indeed, he had been doing so ever since his first purchases of canvasses by Gauguin and Matisse. Every time the paintings of yet another hero of the collector made their appearance on the walls of his house, another wave of gossip would sweep through the salons of Moscow questioning the millionaire's sanity. And now Shchukin was rumoured to have donated another 120,000 roubles toward an Institute of Psychology for the University of Moscow. He was clearly insane. How could it be otherwise? There had already been three suicides in his family. His judgement had to have been affected. His previous enthusiasms were perhaps forgivable, but Picasso . . . well, Picasso was beyond the pale.

Benois went on:

Everyone has grown used to S.I.C.'s impressionists and some appear to rank them alongside the classic paintings in the Imperial Hermitage. Latterly we have become reconciled with Gauguin and Van Gogh, acknowledging the beauty of the former and the profound, tragic vitality of the latter. After a few hesitations, Cézanne too has been accepted. But S.I.C. has not stopped with these and now the staircase of his townhouse and an entire room have been dedicated to the canvasses of Matisse. Most recently of all, the last of his reception rooms has been transformed into a sanctuary dedicated to Picasso and cubism. *This really is too much* is the general reaction, even of those who have swallowed the previous stages of Shchukin's progress as a collector.[2]

The man who could have bought *Les Demoiselles d'Avignon*

It will be remembered that in the spring of 1908, when Shchukin returned to Paris after his expedition of the previous year to the Sinai desert, he paid a visit to Gertrude Stein. He went, essentially, to see *Le Bonheur de Vivre* and other fauvist paintings by Matisse. That day he also saw a series of masterpieces from the classic rose period of the still unknown Picasso, who

had become Gertrude's new favourite painter during the Russian collector's two years of absence from the French capital.

Leo Stein and his sister Gertrude bought their first Picasso for 150 francs in November 1905, in the rue Laffitte shop of the former circus clown Clovis Sagot.[3] *La Fillette à la Corbeille de Fleurs* featured a pale, fragile child with thin simian legs; the legs in particular irritated Gertrude. Unlike his sister, Leo Stein fell in love with Picasso at first sight, declaring that he was a genius and the greatest draughtsman alive. But before long the roles of brother and sister were reversed; Leo, who adored Picasso's brilliant interpretations of classicism, did not follow him when he turned cubist, while Gertrude became one of Picasso's most fervent admirers and a highly effective agent on his behalf within the wealthy bohemian community of Americans in Paris.

Gertrude thought she understood the artist better than anyone else. She knew Russian literature well and she liked to call Picasso 'Bazarov', after the Russian nihilist character in Turgenev's novel *Fathers and Sons*, for, to her, the destructive artist and the nihilist were kindred spirits.

At that time, Picasso's paintings could be seen at the Steins' atelier, or at the galleries of one or two Parisian dealers, and nowhere else. But very soon another address joined this list: 'Maison de S.I. Shchukin – Moscou'.

Matisse was generous to and supportive of his fellow painters and it was ever his habit to share rich buyers with his colleagues. He and Picasso were friends and rivals, but from the moment they met, through the Steins, in 1906, they were both quite sure that one or other of them was destined to dominate modern art. It was Matisse himself, in October or November 1908, who took Shchukin to the Bateau-Lavoir on rue Ravignon, a strange wooden structure in Montmartre which was the headquarters of Paris's community of hard-up artists. There he showed him *The Brothel in Avignon* (from 1916, *Les Demoiselles d'Avignon*), the incomparable masterpiece that Picasso was to keep in his studio until 1916.

Fernande Olivier, Picasso's companion at that time, left a description of their first meeting: 'One day, Matisse brought an important collector from Moscow, M. Stchoukim [*sic*] a Russian Jew [*sic*], very rich and an amateur of modern art.' Her portrait goes on to caricature 'Monsieur Stchoukim':

he reminded her of a pig, with his snout-like nose and porcine ears. The rest of her description is even more unkind. She remembered:

> a small, wan figure, with a heavyset, hoggish head and a terrible stutter. He found it very difficult to make himself understood, which made him ill at ease . . . Picasso's method was a revelation to the Russian. He bought two canvasses, one a beautiful woman with a fan, paying a high price for that time. Later he became a loyal collector . . .[4]

It is unlikely that the facts of this account are entirely accurate – the allusion to pigs is clearly inspired by Picasso's caricature *Monsieur Stschoukim Moscou*, done soon after.[5] Nor can we be entirely sure of Sergei's reaction to *Les Demoiselles d'Avignon*, of which the only account is that of Gertrude Stein, written nearly twenty years later. According to her, he cried out, 'What a terrible loss to French art!' and seemed 'on the brink of tears'.[6]

The scene is not difficult to imagine. Matisse, who had himself only just emerged from extreme poverty, was nevertheless a bourgeois born and bred. Picasso had jettisoned his own origins when he moved to Paris to become an immigrant living in poor but joyous bohemian conditions. In the Bateau-Lavoir, thanks to his extraordinary charisma and obvious talent, he became a real leader. Between Matisse and Shchukin the complex relationship of artist and patron already existed. Shchukin's encounter with Picasso brought two supremos into immediate confrontation. Picasso may have been poor – this was only too evident from the conditions in which he lived – but you had to visit him on the hill of Montmartre if you wanted to see his masterpiece, *Les Demoiselles d'Avignon*. Violently criticized as the painting was, it had already been enthroned in his studio as the future totem of the cubist revolution.

Shchukin may have been ridiculous with his stutter and his curious manners, but he was still the only player in sight with the means and the nerve to buy *Les Demoiselles*, for Picasso would never have relinquished his fetish for anything short of a very high price. Thus, in the autumn of 1908, two years before the appearance of *La Danse*, Shchukin was the one collector in the world who could have bought *Les Demoiselles d'Avignon*, the emblematic painting of Matisse's only rival, Picasso.

Les Demoiselles features a brothel with three Catalan prostitutes from the back streets of Barcelona offering their bodies with aristocratic pride (in the manner of Picasso himself, who was king of the hill overlooking Paris), beside two others who wear African masks and strike obscene poses. Powerful, disturbing – but totally out of the question for the Trubetskoy Palace. What a loss for French art, then, whether or not Shchukin actually uttered the words. We must remember that Gertrude Stein was prone to exaggeration, the better to tell the truth.

The fact that Shchukin did not buy the painting was probably the reason for Picasso's spite and for his pig caricature. The two men sized each other up, understood each other, and clashed. But within six years, the Spaniard had rolled the Russian's modesty back so far that he possessed no fewer than fifty major paintings by Picasso. He had bought them without really wanting to, he would later say. He did so because the world's first museum of modern art was unimaginable without a Picasso room.

The two fans

This fraught context makes it hard to say with any certainty if Shchukin bought his first Picasso in 1908, on his first visit to the artist, or a year later, when we have definite proof that a purchase was made. 'Shchukin has bought a big painting of mine from Sagot, the portrait with the fan,' Picasso scribbled proudly at the bottom of a letter which Fernande sent to Gertrude Stein at the end of September 1909, telling her about their move from the Bateau-Lavoir to a more comfortable studio on the Boulevard de Clichy.[7]

So, now we have two fan paintings: that of 1908, bought at the studio, according to Fernande; and that of 1909, mentioned in her letter. There were indeed two cubist paintings representing a woman holding a fan in the Shchukin collection, one of them apparently executed in 1908 and the other in 1909.

In the former, which Shchukin was to rebaptize *Après le Bal*, a woman is seated in a chair; her face is too stylized to be recognizable. She wears a long dress, white and black, with one strap slipping off her shoulder to reveal her breast. In her hand, she carelessly holds a lowered fan. John

Richardson considers that this relaxed attitude was characteristic of Fernande Olivier, and that Picasso painted his mistress in 1908 during the summer heatwave in Paris.[8] In the second painting, which is predominantly grey and pale green in colour, the face is at once totally cubist and recognizable beneath the multifaceted triangle of the hat; it could indeed be the 'portrait with fan' of 1909, referred to by Picasso in Fernande's letter.

The archives of the Kahnweiler Gallery, where Shchukin might have bought the first *Femme a l'Éventail*, and where he later bought the bulk of his Picasso collection, are not available to us. The date of purchase by Shchukin of a work by Picasso prior to 1909 is hypothetical, the only source being Fernande, twenty-five years later.

We may leave this debate to historians and curators. Nevertheless, it is interesting inasmuch as it highlights a manifest difference in the way Shchukin handled the two great artists who were destined to dominate twentieth-century art.

While Shchukin's adoration of Matisse is reliably recorded by witnesses – and even by the collector himself – there is no trace whatsoever of his reaction to the broad panorama of Picasso's art, which he saw at the Steins when he visited them in 1908. The man who had gone to hell and back in the years 1905–7, who had confronted his personal demons in the Sinai desert, was not ready at that time to launch himself into the strange, wild, disturbing work of a titanic artist capable of veering at lightning speed between the symbolic and the diabolical.

Perhaps it took the dreadful loss of his second son in January 1910 for Sergei Shchukin to comprehend a form of painting that offered no redemption. And this would make it more likely that his first Picasso purchase (which probably took place at Sagot's a few months prior to his son's suicide) was followed quickly afterwards by his first significant foray into the work of the great Spaniard. Shchukin was to say in later years that at the time he had only taken the risk of buying a canvas by Picasso in order to complete his collection. Furthermore, he added, the dealer was selling them so cheaply that it was hard to turn them down.

Shchukin told the writer Nikolai Rudin that he hesitated for a long time before hanging this picture:

It didn't seem to harmonize with the others and indeed it created a distance within my collection. I understood I couldn't display it with the other paintings.

In the end I hung it near the front door, in a dimly lit passage which contained no other paintings. I walked down that passage every day, on my way to the dining room. As I went past the picture, I glanced at it involuntarily. After a while this became a habit. Day by day, unconsciously, I found myself examining it. After about a month, I noticed that if I didn't look at it, I felt something was lacking when I sat down to lunch. After that I started to look more closely and for longer; at first it felt like stuffing pieces of broken glass into my mouth. Then I started going at other times and not just on my way through. The day came when I was vanquished. Despite the absence of any subject matter, I suddenly felt the steely line, the brutality and force of the picture strike home within me . . . I was aghast because right away all the other pictures in my gallery appeared limp, as if they'd been painted with water and I no longer had any desire to look at them. They seemed uninteresting and pointless. They bored me.

So I bought a second painting. I already knew I couldn't live without Picasso. And then I bought another . . . they won me over completely and I began buying Picasso after Picasso.[9]

After 1910, Shchukin became a regular client of Daniel-Henri Kahnweiler, the dealer of the cubists and – more particularly – of Picasso.

Kahnweiler was the son of a German businessman. In the spring of 1907, he opened a small gallery in Paris at 28, rue Vignon. He was twenty-three years old and had no knowledge of the art market; the circle of Parisian art dealers was completely closed to him. Nevertheless, he succeeded in making a name for himself. 'Every period in the history of painting must have its dealers,' Kahnweiler declared towards the end of his life, adding that 'great artists make great dealers'.[10] Vlaminck, Braque, Derain, van Dongen, Léger and above all Picasso made Kahnweiler very famous as a gallerist, publisher and collector. He put his money on his contemporaries and, with the boldness of a true dilettante, he bought the works of young, talented artists.

He began with Georges Braque. After that he organized in his gallery the first exhibition of the cubists, who had invented a new artistic language and revealed a different artistic vision of the world. To begin with, Kahnweiler bought the works of Picasso at moderate prices and sold them – on the painter's own advice – for minimal profit. After 1911, as Shchukin's feverish interest in Picasso increased, things changed.

Shchukin maintained his abrupt way of doing business, refusing to believe that any price was too high when the market was on the rise. Once he had become addicted to the Picasso approach, which clouded his view of other artists, Shchukin began systematically buying Picassos. For example, in the spring of 1912 Picasso's *Composition avec Crâne* so fascinated Kahnweiler himself that he was reluctant to sell it at any price. This still life, a meditation on the brevity of human life, no doubt touched him deeply, just as it did the Russian collector. Shchukin went so far as to offer him 10,000 francs, at which point he surrendered. Kahnweiler later regretted parting with *Composition avec Crâne* and wrote to Picasso, 'the flesh is weak though the spirit is willing', expecting a word of support in return. Picasso answered that he saw nothing shameful about selling a painting for a good price.[11]

Of course, the Picasso of 1912 was not the Picasso of today; even so, Shchukin was dragging the market in his wake. In 1914, Kahnweiler was selling large Picasso paintings for 10,000 or 15,000 francs each and collages for 2,000 francs. Two years earlier, the same work had been priced at one-third as much, explaining why Shchukin was ready to pay twice or even three times more.

Three or four times a year, Picasso brought his latest work to Kahnweiler's gallery; Kahnweiler immediately sent a list of them, with photographs, to Moscow. All this was done with Teutonic precision and punctuality. The black-and-white photograph was stuck on a card stamped by the gallery, with the painting's number and price. Kahnweiler included notes, such as 'important work', 'recommend purchase' or similar, which were clear and imperative. The Kahnweiler list, accompanied by photos, of larger pieces bearing the double-scallop mark of 28, rue Vignon had immense persuasive power.[12] Very often the photograph alone was enough to make Shchukin reserve a canvas. Each time he went to Paris, he went straight to

rue Vignon, concluded his purchases and chose from the latest selection of new works.

'Terrifying dwarves'

Within four years Shchukin was able to put together a Picasso room, which by 1914 contained no fewer than fifty major works and was the largest Picasso museum in the world. The paintings were hung side by side in a room of only 25 square metres; visitors were able to view it immediately after the Gauguin iconostasis in the dining room.

Shchukin had begun by displaying the more disturbing, cubist works which – as he said – left him feeling as if he was chewing shards of broken glass. Once this trial period was over, he went on to complete his collection by attempting to buy examples of the painter's earlier work, just as he had done with Matisse. It was under these circumstances that between 1913 and 1914 *La Buveuse d'Absinthe*, *Portrait du Poète Sabartes* and, in the *bleu de lune* series, *Deux Soeurs*, *Le Vieux Juif* and *Portrait de Benet Soler*, which were among Picasso's best early works in cold, somewhat melancholy colours, found their way to Moscow. Apart from this search for a pure selection of the painter's most beautiful early works, Shchukin's preference was for earlier pieces from the cubist period influenced by African art. In 1912, he bought the red cubist painting *L'Amitié* from Kahnweiler, and in 1914 – when Gertrude and Leo Stein finally decided to part with it – the masterpiece that completed the cycle of the *Demoiselles d'Avignon*, namely *Les Trois Femmes*.

He also placed in the Picasso room a display case of African sculptures, similar to those he had seen in the studios of Derain, Vlaminck and Picasso. According to Alexandre Benois:

> In this room, where cubist painters and more especially the Picassos are exhibited, there are ancient idols from central Africa – strange, clumsily carved sculptures with threatening, primitive expressions. The most impressive of these is a statuette about thirty centimetres tall which exudes such power that merely to look at it makes one feel uncomfortable. Small though it is, its strength is comparable to that of any Syrian colossus.

S.I.C. admires his African pieces and thinks them the equal of Praxiteles'
Hermes; he is convinced that these statuettes, which were carved 500 years
ago in remote African tribal communities, can teach us to understand the
beauty of Picasso's work more fully.[13]

Neither Benois nor Shchukin could know that these antique statuettes
were only a hundred years old at most. But this did not diminish their
effect on people. The African statuettes transformed Shchukin's Picasso
room into an artist's studio, at once a laboratory of art and a place of
primitive magic. Just as he had done with the Matisse pink salon and the
Gauguin iconostasis in the dining room, Shchukin went ahead and
composed what amounted to a full *mise en scène* of Picasso's work, in the
process creating a prototype for a museum of modern art.

After all the challenges, quarrels, jibes and sarcasm, and the galvanizing
of defenders, partisans and unconditional supporters, what new shock
awaited visitors to the Shchukin gallery, when he pointed to the little door
at the end of the dining room, just beyond the final paintings of the
Gauguin iconostasis? No doubt the first to enter were filled with alarm; the
artworks that awaited them were aggressive, to say the least.

It was the same story as it had been with Matisse, with the difference
that Shchukin was now actively battling to convince the world of Picasso's
extraordinary grandeur:

Let's go and look at Picasso. He's a genius. Even I had to fight hard to
make myself accept him. There is something demonic, something
infernal about this artist. He is the great demolisher of all foundations,
but on their ruins he builds new wonders . . . We are his contempor-
aries in this era. We must try to see the future with new eyes, just as
he does.[14]

Shchukin failed at first to sway Muscovite opinion. People could not
accept that henceforth painting was no more than a philosophical disserta-
tion displayed on a canvas with the help of lines and colours. The younger
generation were open to this idea, but their elders protested violently
against what they could not recognize as art.

The painter Mikhail Nesterov – mentioned to Shchukin years earlier by Father Pakhom at St Catherine's monastery – described his own visit to the Trubetskoy Palace just after the cubist paintings had made their first appearance there:

I heard that Shchukin had bought some new Picassos, the latest Picassos . . . We arrived in a small group. He received us himself and invited us to follow him. The visit began with the impressionists: Monet, Manet, Renoir, then Puvis, Cézanne and some magnificent Gauguins. All of these, according to Shchukin, had 'aged'. Next came Matisse and the early Picassos. The last room contained Picasso's most recent work . . .

What we saw was a jumble of cubes, cones, cylinders and other shapes. This chaos of carpentry seemed to hypnotize Sergei Ivanovich, who seemed unable to drag himself away from it. He was like a rabbit in the thrall of a cobra. At last, with his excruciating stutter, he began to define the wisdom of Picasso. We stood listening in silence, none of us willing or able to speak up and declare that the king was naked, that Picasso was chicanery and fraud skilfully packaged in theoretical pathos . . .[15]

Many people thought that Shchukin had lost his reason, that the art he was buying was unworthy of a museum. They saw what he was doing as a fresh manifestation of his provocative temperament and his inclination to mock the money-worshipping rich who were blind to beauty – all the time rubbing his hands gleefully and repeating over and over that good paint-ings were 'going cheap'.

Nevertheless, Shchukin recruited a number of unconditional supporters for Picasso. The artist Kuzma Petrov-Vodkin remembered Shchukin's passionate explanations during the guided Sunday visits to his collection:

Trembling and stuttering with enthusiasm, he showed us the pictures one by one, telling us that the old idea of beauty had drained away with the last century. Everything was different now. With Gauguin, the era of beauty had drawn to a close; with Picasso, a new era of structure without subject matter had begun.[16]

Thus Picasso had joined Matisse in Shchukin's pantheon, despite the original opposition in their respective inspirations: brilliance for the latter, contemplation for the former. Matisse, Shchukin said, could paint palaces; Picasso could paint cathedrals.

As time went by, it gradually became apparent that once again Shchukin had struck a major blow. Above the chatter of his detractors, the art of Picasso, despite its complexity and its mystery, was nowhere stripped as bare or so well understood as it was in Russia. In the way the artist smashed the visual world to pieces, Russian philosophers saw their fears of approaching catastrophe confirmed. His bold advance into the unknown was eerily in line with what many Russian thinkers believed was imminent: namely, the collapse of the Russian Empire.

'When you are in the Picasso room of Shchukin's gallery, you are gripped by a sense of overwhelming horror. What you feel is not attributable to art alone, but also to a cosmic sense of life and of our own human destiny,' wrote the philosopher Nikolai Berdyaev in the spring of 1914, in an article entitled 'Picasso':

In the room before Picasso, Gauguin reigns in splendour. It seems, in his presence, that we are living the last joys of life in a state of nature. The beauty of Gauguin's world is still crystal clear, nourished by warm sunshine and within our reach . . .

But after this golden dream, comes the awakening. We are in Picasso's chamber. It is cold, icy dark and gloomy. All joy has fled, along with life in the sunshine. A cosmic wintry wind has torn away veil after veil, scattered the leaves, and stripped away the fine garments and the living flesh we once saw magnified by intangible beauty. All that is no more.[17]

Alexandre Benois acknowledged the courage of Shchukin in showing to Moscow what the western world's most avant-garde art now owed to primitive idols. Yet he concluded his article with the same insidious sense of anguish:

In the service of what cause have these two forms of art come together? In what does their spiritual proximity consist? We have only to ponder

this question for all our hopes of redemption to falter. Horror invades our minds instead. What if our new Byzantium leads to gods like these? What awaits us within the labyrinth into which modern art is leading? Shall we discover, enthroned in place of the saints, the diabolical god of Picasso – terrifying, invincible, lunatic, dwarfish – who leaps upon those who do not know the dark password, and devours them?[18]

Benois foresaw the future all too accurately. The coming century, though it paid Shchukin's artists the homage they deserved, would indeed be haunted by terrifying dwarves.

Portrait of a Chinese Patriarch

In July 1912, the clouds gathering over the new century were not yet visible on the horizon; the sky was still blue in Paris. Sergei went to Kahnweiler's gallery, where he paid a lot of money for Picasso's *Tête de Mort*. A few days later, he bought the African objects which would later occupy his Picasso room from the Galerie Brummer on Boulevard Raspail.

Later he went to the studio of Matisse, who had just returned from his first visit to Tangier. The painter showed him the works he had finished for him: the side panels of what would later become the bright blue triptych of *La Conversation, Coin d'Atelier* and *Les Capucines à 'La Danse II'*.[1] Because of the various exhibitions to which it had been promised, Matisse's triptych was not installed at the end of the dining room until 1913.

The effect was very striking: Matisse had caught the hieratic simplicity of the icons he had seen for the first time in Moscow the preceding autumn. He revisited them for Shchukin's dining room, the longest side of which was aflame with the golden hues of the Gauguin iconostasis. And all this was in improbable dialogue with the group of Pre-Raphaelite Magi in the Burne-Jones tapestry. The result was incongruous but stylish, not unlike *La Conversation* itself, depicting Henri Matisse in striped pyjamas with Amélie Matisse seated facing him. This dining room 'installation' (as it would be called in our own time) repeats the miracle of the adjoining pink

salon: it was no longer the elements of décor, tapestry and fabric that Matisse used in his paintings that drew the observer's attention to the walls; instead, the paintings themselves seemed to descend into the dining room, so that the room itself became a work of art.

The young critic Jakob Tugendhold, who was soon to become a serious specialist on the Shchukin collection, compared it to the polychrome nave of a cathedral, or the mosaic-lined dome of a basilica:

> It is like stained-glass, shimmering enamel and squares of porcelain. This becomes clear when one sees *Capucines à la Danse* and *La Conversation* from the doorway of Shchukin's salon. The orange-red figures in the first painting glitter from a blue background like arabesques of glass. Look at the Gauguins, then come back to Matisse's *Capucines*; the former resemble matte frescoes, the latter translucent pieces of stained-glass. Matisse's palette is richer, more complex and more sumptuous than that of Gauguin. Indeed Matisse is the greatest and most cultivated colourist of our time; he has absorbed all the riches of the Orient and Byzantium.[2]

Matisse took advantage of Shchukin's visit to Issy-les-Moulineaux to make a sketch for his portrait, a big charcoal drawing exaggerating the Russian's unusual features. He has the slightly slanting eyes of the Botkins and the wide mouth and fleshy lips of the Shchukins.[3] But neither had time at that point to complete the full portrait. This sketch remained the only representation of Shchukin by any of the painters he collected until he commissioned a young Norwegian artist, Xan Krohn,[4] to do two portraits in 1915.

Sergei had another Parisian preoccupation that summer. He was about to break his own rule of buying nothing but contemporary art (and perhaps the art of the future) by revisiting ground he had already covered.

By what mysterious logic did Shchukin, the man of Matisse and Picasso, convince himself to pay out 100,000 francs to secure certain impressionist and post-impressionist works which – as he himself stated in 1912 – belonged to the world of yesterday?

To begin with, the transaction concerned merchandise of the very highest quality, namely twenty-odd paintings which Petr Shchukin needed to sell as

quickly as possible in the spring of 1912 after the court ruled he must compensate his French mistress following his marriage to another woman.

The money had to be paid over as rapidly as possible; the affair was doing great damage to the image of 'General Shchukin' as well as that of the company. But the sum of 100,000 francs determined by the tribunal was not so easy to scrape together. In 1905, Petr had transferred the ownership of his collection, his buildings and the capital that would be necessary for their upkeep to the State Historical Museum in Moscow: he retained nothing but the use of them until his death. Nevertheless, Petr's impressionist masterpieces, purchased in Paris when he accompanied Sergei in his early days as a collector, had no place in the collections of the museum of Russian and oriental antiquities, but were still assets of considerable value.

Ivan Shchukin, the brothers' adviser on the Parisian art market, was now dead, and so Sergei intervened.

'I shall be in Paris at the beginning of July,' he wrote to Petr from Venice:

> and you may rest assured that I will have a word with Durand-Ruel, Bernheim, Druet and a few others about selling your paintings. It saddens me to think that those wonderful pictures might have to leave Russia. I myself would be happy to buy eight or ten of them . . . You have a number of very good canvasses which would suit me very well. I know that dealers put pressure on sellers by declaring that reselling such things is not so easy and they must lower their asking prices accordingly . . . but I will pay you the correct price and I am inclined to buy a Degas, a Renoir, two Monets, a Sisley, a Pissarro, a Denis, a Cottet, a Forain and a Raffaëlli.[5]

After the kind considerations in this letter, the crisp closing precision of Sergei the businessman-collector is wholly admirable. He was quite right in his analysis of the attitudes of dealers and his enquiries in Paris confirmed the fact:

> Dear Petr, all the dealers tell me this is a bad moment to sell. At present, amateurs are only investing in eighteenth-century paintings, so it

would be better for you to wait for a revival of interest in more recent ones. They would also expect your pictures to be sent to Paris and placed on deposit, which would make it easier for them to find buyers. I think their prices are really far too low and I'm ready to make you a better offer . . . In any event, we will find an agreement of some kind. For six paintings and the Denis, I can offer you 100,000 francs. For the moment you can keep the other paintings . . . The only dealer who proposes to take back the canvasses that he originally sold to you is Durand-Ruel. He will buy your pictures, but he wants to see them first. He points out that any painting bought fourteen years ago, whether it is a pastel or an oil, may have become damaged. If the paintings are in good shape he is ready to take them back from you for 80,000 francs.[6]

The two brothers soon reached agreement on seven of Petr's paintings, among them Monet's emblematic *Dame dans un Jardin* and *Falaises près de Dieppe*, and Petr's bedroom nudes by Renoir, Degas and Denis. Sergei decided not to take the Raffaëlli, the Cottet and the Forain, along with ten other works of lesser importance.[7]

At the end of September, Petr received the sum of 37,500 roubles (100,000 francs). A significant weight was thereby lifted from Sergei's mind, and his brother was relieved of his difficulties (at the cost of his beloved naked ladies). Nevertheless, poor Petr had little time to enjoy the tranquillity thus regained; he was carried off by sudden acute appendicitis on 25 October.

During his discussions with his brother from Paris, Shchukin was once again preparing to surprise everybody by buying from Vollard seven canvasses by Henri Rousseau, known as 'Le Douanier' because of his earlier job as a customs official.

The vogue for primitivism was in its infancy. France and Germany were discovering Henri Rousseau; in Russia a self-taught primitive painter, Niko Pirosmani, had just emerged in Georgia. Once again, Sergei Shchukin made a considered choice which anticipated a new trend in art: Mashkov, Konchalovsky, Falk and Tatlin.

Vollard's purchase of the works by Douanier Rousseau had cost him next to nothing; he remembered having paid 100 francs for every canvas that was brought to him shortly before the death of the painter. But

Rousseau refused to part with his masterpiece *La Muse Inspirant le Poète* for less than 300 francs, even though he was penniless and his back was to the wall. This 'landscape-portrait'[8] represents the hero of bohemian Paris, the poet Guillaume Apollinaire, and his lover, the painter Marie Laurencin. Later, Shchukin would also buy three naïve paintings by Marie Laurencin from Clovis Sagot just before the outbreak of war.

Shchukin hung *La Muse* in his Picasso room, sealing the alliance of the innocent Rousseau – who had never eaten of the fruit of the Tree of Knowledge – with the hard, immaterial world of Picasso. As for the other Douanier Rousseaus, his naïve paintings would be displayed in a composite room, in which the collector, finding himself desperately short of space, juggled the most diverse art in his collection: landscapes by Cézanne, and paintings by Renoir, Puvis, Van Gogh and Derain, his most recent enthusiasm. In addition, and in total dissonance, there was a portrait on silk of a Chinese patriarch of the seventeenth-century Ming period.

Like his brother Petr, Sergei was strongly attracted by the Orient. His older son, Ivan Sergeevich, was eventually to emigrate and become an erudite orientalist university professor. His father helped him in his first transactions as a collector of Indian sculptures, Russian icons, oriental miniatures and Chinese, Japanese and Korean paintings. In his apartment in the wing of the Trubetskoy Palace there was no room for modern paintings. The only artworks to be found there were a few Italian and Spanish old masters that he had purchased at the Paris auction of his late Uncle Ivan's belongings, and some Japanese and Chinese silk panels displayed European-style, framed under glass. Ivan had also bought six Chinese handscroll paintings for himself and his father, among them the Ming patriarch, who now found himself unexpectedly sandwiched between a Renoir and a Derain with a couple of Cézannes, *Mardi Gras* and *L'Homme à la Pipe*, close by.

The 'Jack of Diamonds' brotherhood, formed during Matisse's visit to the Trubetskoy Palace in November 1911 in what came to be recognized as the founding act of the Russian avant-garde movement, included naïve expression among its various artistic utopias. The 'Jacks' were particularly interested in *luboks*,[9] which represented popular festivals, village folklore and circuses. They sought in general to bring Russian art closer to western

post-impressionism. A number of France-based artists took part in 'Jack of Diamonds' exhibitions, among them Braque, van Dongen, Vlaminck, Signac and of course Matisse and Picasso. Not for nothing were the 'Jacks' known as the intermediaries of the French school in Russia. Sergei Shchukin, a 'Jack' member of honour ever since the founding of the brotherhood at his house, lent *La Muse* for one of their exhibitions.

On the other hand, he was unable to find a room in his house that he could assign exclusively to Derain, his latest passion.

The brown and black tones of Derain were in stark contrast to Matisse's vivid and light-filled paintings or Picasso's carefully constructed cubist works. Shchukin displayed them in his mixed room, along with the Chinese patriarch. Derain took his inspiration from French Gothic art, African sculpture and children's drawings. With Matisse, he had been the principal inventor of fauvism during the two men's summer of research together at Collioure in 1905, at which time they assembled the fauvist bombshell of that year's Salon d'Automne. But Derain soon gave up his flirtation with pure colour, becoming more interested in the question of form. This brought him closer to Braque and Picasso. He never really became a cubist, though he worked along some of the same lines, inventing a style which he qualified as 'neo-Gothic'. This enthralled Shchukin, who bought sixteen of his canvasses, almost all of them from Kahnweiler.

1914

The time had come for Shchukin to give serious consideration to how his now-overflowing gallery of paintings could be practically managed. Contacts and relationships needed to be established with publishers, artistic societies and galleries. Having been promised to the Tretyakov Gallery in Shchukin's 1907 will, the Shchukin gallery was now functioning more and more like a museum.

> It is my wish that my bequest be recognized for its great artistic value, in consequence of which I have decided that my collection shall not be dispersed; I will do everything in my power to ensure that my paintings are kept together just as they are today.

I understand your position . . . But nevertheless I am unable to help you . . . being myself in the process of putting together a gallery dedicated to new French art which is destined to be given to the city of Moscow.

That was Sergei Shchukin's stock reply of the time to any requests he received for financial support or backing for cultural initiatives, whatever they might be. More specific relations with galleries and the public were managed for him by Vladimir Minorsky, a close friend who combined the posts of private secretary and partner at cards for Sergei.

Minorsky and his family lived in an apartment in one of the palace's outbuildings. It fell to him to compile an inventory of the collection, with 232 entries, and to establish the first catalogue of it, which was published in December 1913. At the beginning of 1914, the photographer Pavel Orlov took pictures of the five rooms in the Trubetskoy Palace which were open to the public.

That spring saw a major cultural event in Moscow, when *Apollon* published an article by Jakob Tugendhold entitled 'The French Collection of S.I. Shchukin'. Shchukin's first catalogue had given no details other than the title and author of each painting, in French and in Russian, and the dimensions of each canvas. By contrast, Tugendhold's article, in addition to a full description of the gallery itself, offered many highly interesting details about different trends in the world of modern French painting. Tugendhold was a brilliant essayist and a rising star of Russian art criticism. Using the masterpieces of Shchukin's collection as examples, he, more than anyone else, succeeded in engaging the interest of the Russian public in modern western art.

Tugendhold had just returned to Russia after eight years of training abroad. In Paris he had studied art history, taken courses in painting at the Académie Ranson[10] and learned the techniques of lithography at Steinlen's studio. Shchukin's collection, whose beginnings he had witnessed, was for him a veritable revelation. The thirty-year-old connoisseur of modern art and the sixty-year-old collector were already closely acquainted; Tugendhold loved French contemporary painting with at least as great a passion as Shchukin. The two had known each other for a long time, Tugendhold's

215

father having been the physician of Kuzma Soldatenkov, Shchukin's father's closest friend. In the spring of 1914, the collector planned to send Jakob Tugendhold to Germany and France to find more paintings for him; but this project had to be abandoned because of the war.

The Shchukin gallery was open on Sundays and sometimes on weekdays. Visitors consulted the new catalogue, which made it possible for them to navigate the various rooms by referring to numbers on copper plaques affixed to each picture frame. Sergei Shchukin himself often took the role of guide, or if he happened to be absent, another member of his household would stand in for him.

At Shchukin's request, Moscow's other great modern art collector, Ivan Morozov, consented to receive visitors at his own house on Prechistenka Street if they wished to see his paintings – though at Morozov's there were no discussions or enthusiastic explanations on offer.

'I went to see the collections of Morozov and Shchukin. The latter is incredibly cordial. Both collections are simply sumptuous. Matisse takes your breath away and . . . Picasso attains summits that have not been seen since the Egyptians of antiquity,' gushed the collector Karl Osthaus on his first visit to Moscow.[11]

The artist Natalya Polenova, the younger daughter of the painter Vasily Polenov, remembered a Sunday in 1914 when, for the first time, Shchukin displayed a picture that had just been delivered to him from Paris, André Derain's *Portrait d'un Homme Inconnu au Journal*:

All the 'Jack of Diamonds' painters were there. Shchukin had trouble with the pronunciation of the letter 'p'. He stood in front of Derain's canvas and shouted: 'All P-P-Picasso disappears in the p-p-presence of this p-p-p-portrait!'
 To begin with, one's head explodes and one gasps for air. But if one is patient, little by little one gets used to it and realist painting begins to seem insipid and bland by comparison.[12]

The last famous foreign visitors that Shchukin received at Znamensky Lane were the Belgian poet and playwright Émile Verhaeren, who experienced an '*émerveillement artistique*' (as he put it), and the German art

historian Otto Grautoff. The latter came to Moscow at the beginning of 1914 to work on a major article about the Shchukin gallery, which was to be published later in Germany. Afterwards he wrote:

> Shchukin collected both for himself and on behalf of many young Russian painters, whom he welcomed – most hospitably – to his house every week. His collection was a clear indicator of his taste. More importantly, the character of his collection highlighted his ability to identify that which was exceptional, and in particular that which was most innovative. In this he was truly Russian.[13]

In the event, because of the war, Grautoff's article was not published until 1919. But nothing that spring gave any hint that the most terrible conflagration that the civilized world had ever known was about to occur.

By May or early June 1914, Sergei was married to Nadezhda Conus. The ceremony was discreet. Shchukin did not wish to install his new family in the Trubetskoy Palace, where his first family still lived with memories of Lydia all around them. Instead, for Nadezhda and the two children of her first marriage, he rented a charming smaller house, slightly west of his own, on the broad circular road known as the Garden Ring. He now moved there himself, before he and his second wife left for a lengthy tour of Europe.

According to family legend, Sergei had planned to retire from business and quietly install himself on the banks of a Swiss or Italian lake. He had transferred his personal fortune to a bank in Sweden, a neutral country bordering Russian Finland. The couple visited several beautiful houses on Lake Geneva and the Italian lakes, but Nadezhda finally admitted to her husband that as much as she appreciated travelling in Europe, she could never live anywhere else but Russia.[14]

The couple were in Venice on 18 June, at which time Shchukin wrote to Matisse to announce that he was coming to Paris between 15 and 20 July.[15] On 28 June, Archduke Franz Ferdinand of Austria was assassinated in Sarajevo, in Austrian Bosnia, by Serb nationalists. Nobody imagined that this latest in an endless series of Balkan crises would not end in the

kind of diplomatic accommodation that had already kept the peace several times since the turn of the century.

In mid-July, the Shchukins stopped in Paris on their way home to Russia. Sergei met Matisse to order the final canvasses that would complete the upper row in his pink salon.

His last commission had been made one year earlier. This was the *Portrait de Madame Matisse* and it finally reached Moscow in March 1914, having been the only picture by Matisse displayed at the Salon d'Automne 1913.

But what a painting! Rendered in a muted range of greys and blues, this portrait with its blindly penetrating, Picasso-like stare represents a woman in full dress with feathered hat, velvet collar and bright orange stole. It took around a hundred sittings to complete, exhausting the model who – after a career of nearly twelve years spent before her husband's easel – was never to pose for him again.

When Amélie saw the finished portrait for the first time in November 1913, she burst into tears. Matisse wrote to his daughter: 'When I show it I can truly say, this is my flesh and blood.'[16] It was the last of the thirty-eight works by Matisse acquired for the Shchukin collection. Apollinaire immediately declared *Le Portrait de Madame Matisse* to be an outright masterpiece and the most accomplished work presented at the Salon d'Automne in 1913.

Shchukin unleashed such phenomena in his usual way, without appearing to have the least doubt about them. In the course of what was to be the two men's last meeting before war broke out, he reserved Matisse's recently completed *Femme au Tabouret* and *Intérieur, Bocal aux Poissons Rouges*, and commissioned the final works required for the upper row of his pink salon. The first was to be a self-portrait, to pair with the portrait of Amélie: another calvary in prospect for Matisse, which he would have to endure alone. Since the painter was about to leave for Collioure, Shchukin completed his order by requesting a seascape.

By 24 July, Shchukin was back in Moscow, where he spent what was to be the last week of peacetime. On 25 July, he wrote to Matisse that he was sending 20,000 francs in payment (probably) for the paintings he had reserved, plus an advance on the double commission, including 'the

painting of boats at Collioure, which I am very much looking forward to'. In the same letter he mentions that he will be leaving that evening for 'Nyschny' (*sic*).[17]

History does not relate exactly when Sergei returned to Moscow from Nizhny Novgorod: on 28 July, when Austria declared war on Serbia and the world suddenly became aware of the gravity of the conflict; or on the 30th, when Russian armed forces were mobilized; or at the latest on 1 August, when Germany declared war on Russia. Along with all their compatriots, Sergei and his family found themselves stranded in Russia for the duration.

Matisse had asked Shchukin for an advance on his commissions because suddenly nobody was buying art.

On 2 November 1914, he received a telegram from Russia: 'Impossible send Moscow exchange closed stop bank and post office refuse transfer money France stop hope send when relations restored stop regards Sergei Shchukin'.[18]

The Acropolis of the Arts

Two military frontlines now separated France from Russia.

The first months of the war made no appreciable difference to Moscow life. The theatres reopened in September and played to full houses. Exhibitions continued to be held, one after another. Meanwhile, more and more uniforms were to be seen in the street. Ivan Sergeevich Shchukin, elegant as ever, wore a made-to-measure tunic for his service with the 'Zemgor' – an organization uniting companies that supplied the military. A repository of military clothing was built up in Znamensky Lane.

As the war intensified, its negative effects steadily increased. Klavdiya Mikhailova, the owner of the Art Salon in Moscow, was forced to abandon the great Picasso exhibition she had expected to organize. The turnover of the Shchukin family firm suffered as demand slumped, and before long the brutal contraction of its core markets forced the Muscovite *kupechestvo* to unite in self-defence. A profound economic depression was forecast, and with it a series of bankruptcies. By the end of 1914, both wholesalers and clients were meeting on a weekly basis in the favourite restaurant of the *kupets*, the Slavic Bazaar in Kitai-Gorod, the heart of the business district. With the support of Shchukin, the 'Minister of Commerce', the first Russian Commercial Union was formed with the aim of sharing out

orders equally and regulating competition in time of crisis. Nobody had predicted that the war would last beyond Christmas.

But the survival of his firm was not Shchukin's sole preoccupation; indeed, his family life now took precedence over everything else. He was intensely happy in his small private house on the Garden Ring, for on 15 March 1915 Nadezhda Shchukina had given birth to a baby, christened Irina. Nadezhda was forty-four years old and Sergei was sixty-one; for him, this undreamt-of birth brought a symbolic end to ten years of sadness. One may only imagine his delight with his miraculous little daughter, whose happiness, health and safety became his reason for living. For the first time in a decade, his museum of modern art was of secondary importance.

Being completely cut off from Europe, and hence unable to continue with his activities as a collector, did not disturb him overmuch. Unlike Ivan Morozov, Shchukin had never dreamed of collecting Russian as well as western art. 'Shchukin never buys anything from me. He is a long way from sharing our ideas. I think that only artists who have been hugely successful in Paris can awaken his interest. But where is such success to be found today?' complained Vasily Kandinsky.[1] 'He believes that the two greatest contemporary artists are Matisse and Picasso. Apparently, he doesn't think about me, truly. Nevertheless, my compositions 2 and 5 would fit in very nicely at his place: I can see them there already.'[2] So wrote the founder of abstract art to his friend Gabriele Münter, adding that his own abstracts were 'just as good' as Matisse's panels.[3]

Although Shchukin did not buy paintings by Russian artists on principle, the artists themselves were regularly invited to his house. Students from the Moscow School of Painting, Sculpture and Architecture attended conferences at the Trubetskoy Palace, where, as Prince Sergei Shcherbatov wrote, 'the role of mentor, commentator, guide and enlightener of Muscovites, as well as specialist and propagandist, was filled by the master of the house himself'.[4] Ivan Morozov, who bought many paintings from young Russian artists, was nevertheless considered by most of them to be 'not one of their number'. It was very different with Shchukin: 'His passionate, slightly hesitant voice rose above the hubbub surrounding him. Often he was unable to keep pace with the questions that came at him from every side. He was enchanted by his visitors' reactions of sincere admiration

and wonder and he enjoyed the attacks and angry remarks just as much,' wrote the sculptor Boris Ternovets, describing Shchukin's conferences.[5]

Shchukin, discoverer as he was of the great talents of European modern art, was severe with his Russian compatriots. At a time when they themselves could not even dream of being one day displayed in his gallery, Shchukin imposed on the young artists of Russia a culture of painting that was completely alien to them. After visiting the palace, the apprentice painters began to produce Cézanne-like canvasses; they were equally enthralled by Gauguin's exoticism and the decorative genius of Matisse. Shchukin had known many of the Europeans personally, and his experience and charm made him a leader in the field of art. Everyone was under the spell of this passionate figure, with his booming voice and loud laughter. 'He talked happily and enthusiastically about Paris, about his encounters with the painters, the way they looked, the things they said,' recalled one of his youthful female visitors.

Shchukin's conferences, which were accompanied by explanations about the most recent trends in painting in France, also had the effect of destabilizing conventional Russian art education and sapping the authority of its teachers. According to Shcherbatov, the paintings in his collection 'revolutionized the ideas of the younger generation and were immediately copied'. The number of imitations painted in Russia at that time was quite amazing: in albums dedicated to the painters of the Russian avant-garde in the early twentieth century, the works that influenced young painters like Larionov, Goncharova or Konchalovsky are immediately obvious. One can even guess with reasonable precision the dates when they first visited the Trubetskoy Palace and the manner in which their painting styles changed as a result. It is no surprise that even Repin's wife declared, after walking through the gallery, that she had found the key that would open the door to contemporary Russian painting. 'The art imported from Paris was very powerful; it made our heads spin like a dangerous drug. It contaminated all our youth.'[6]

Mikhail Larionov broke with the 'Jacks' and invented 'rayonism'. Alexander Shevchenko tried his hand at neo-primitivism. The futurists embraced the beauty of machines and walked along Kuznetsky Most[7] with their faces painted and wooden spoons in their buttonholes. Their behaviour was perceived as a slap in the face of conventional good taste, as were

the paintings of Shchukin. People who saw the canvasses of the most extreme painters in his collection 'were struck dumb like Eskimos around a gramophone'.[8] The rooms containing the impressionists were empty; but crowds swirled around the paintings of Gauguin and Matisse.

The gulf between Russian art and western art, which not so long ago had seemed unbridgeable, had suddenly ceased to exist. The person responsible for this was Sergei Shchukin. Everything about art that was new and interesting had been introduced to Moscow by him; in so doing, he had outpaced both the French and the Americans. His unchallenged status as a leader in the art world was derived from his uncanny foreknowledge of major developments in that world; even when he came across an artist who had been discovered by others before him, he overhauled his competitors either by the sheer quality of his purchases, or by their quantity.

In early 1911, Benois wrote that it would take years for Russian society to become reconciled to collections of modern art. In fact, the process took place very quickly. The former seaman Vladimir Tatlin, who first saw Picasso's work at the Trubetskoy Palace, was even more fanatical for being a recent convert. He travelled to Paris and visited the artist's studio, where he became fascinated by Picasso's collages and returned home full of ideas for *contre-reliefs*. This first step was to lead to the invention of constructivism. In the spring of 1915, it was rumoured in Moscow that Shchukin planned to buy one of the reliefs painted by Tatlin then being shown at Tramway V.[9] This was an advertising hoax in the spirit of the new avant-garde, and there was no truth to it. However, a modest Norwegian painter, Xan Krohn, was to have an extraordinary piece of luck with Shchukin.

'Here is the latest news from the world of Moscow Art. S.I. Shchukin has surprised everybody again,' wrote the husband of the young artist Antonina Sofronova.

> He wanted to have his portrait done, but because he was unable to go abroad – and because of his famous principle regarding Russian artists – one morning he appeared at the studio of the Norwegian painter [Xan] Krohn, with a request to paint his portrait in the simplest way possible. Krohn did as he was asked in two hours flat. Those who have seen the portrait say that it is a flat likeness of Shchukin's

head, above his high collar and overcoat, painted in bright colours *à la française*.[10]

Krohn had moved to Moscow in 1915. He had studied briefly at the St Petersburg Fine Arts Academy, as well as in Munich and at the Académie de la Palette in Paris. He began work on Shchukin's portrait in May and did not entirely finish it until the end of the year. In the end he did two portraits, not just one: the first representing Shchukin's face only, and the second full length, 2 metres in height. In the latter painting, Sergei Shchukin appears in a formal tailcoat against a background of red and white diamond checks, not unlike the floor of the office in which he was wont to display the latest French paintings he had bought.

Red October

The war dragged on, bringing with it hideous losses, demoralization and hunger. The tsar himself went to the front as theoretical commander-in-chief, serving no purpose at all save to complicate the task of the military with problems of protocol. Meanwhile Petrograd, which was at once an industrial centre and a political hub without a leader, was boiling with discontent. Elite troops loyal to the regime were fighting while the barracks of this enormous garrison overflowed with young recruits who lived in terror of being sent to the front. Women feared for their departed menfolk as well as for their sons on the verge of leaving; there was a severe shortage of bread; and clandestine revolutionaries were manoeuvring for advantage.

This led to the revolution of February 1917 (according to the Russian calendar, in fact the monarchy fell in March, just as the October Revolution actually took place in November). It involved the dissolution of the Duma, a popular uprising, the people's fraternization with the army, the abdication of the tsar, red flags and the appearance of diverse political parties. The provisional government, torn apart by the quandary of whether or not to continue the war or break the previous administration's word given to the Allies, was in no fit state to resist the onslaught of anarchy and chaos.

In the midst of this confusion, the euphoria of liberation inspired a number of utopian projects within the Russian cultural establishment, each

more grandiose than the last. Of these the most extraordinary was the trans-formation of the Kremlin in Moscow into an 'Acropolis of the Arts'. Everything seemed to favour this idea; even the universal and symbolic dimension of the place seemed perfect for the housing of works of art. The cathedrals would be left intact and the principal galleries of Moscow would be installed in the imperial palaces. A number of liberal-minded collectors approved this idea, especially Shchukin. Matisse and Picasso at the Kremlin? Who would have dreamed such a thing could happen? Shchukin was more than happy that his world-famous collection should be available to a wider public. Immediately the question arose of where to place the paintings: Shchukin favoured the ground floor of the Grand Kremlin Palace, or the imperial riding school. An area of at least 700 square metres was required.

While the Moscow activists – headed by an old friend of the Shchukins, Igor Grabar – were working on the Acropolis project, *coups d'état* and upheavals continued apace in Petrograd. On 25 October/7 November 1917, the Bolshevik Social Democrats, led by Lenin, supplanted Kerensky's provisional government and occupied the Winter Palace (without serious opposition, contrary to Soviet legend). After a brief and confused period of cohabitation, the Bolsheviks also took full control of power in Moscow. The putative Acropolis of the Arts was damaged in the battles of October, during which the Bolsheviks riddled the towers, palaces and cathedrals of the Kremlin with bullets and shellfire. Outraged by this bombardment, People's Education Commissar Anatoly Lunacharsky, who was later to become the first Soviet minister of culture, tendered his resignation. If this was to be the treatment meted out to the Kremlin, what would be the fate of Moscow's private collections? Sergei Ivanovich Shchukin began to search in earnest for a secure refuge for his paintings.

Russian owners of art collections had been worrying about their safety for some time. At the outbreak of the war, most had placed their collec-tions in storage, some at the Rumyantsev Museum and others at the Tretyakov Gallery. Comrade Shchukin waited until mid-November, after Lenin's seizure of power, before petitioning the Fine Arts Museum to shelter his collection.[11] The museum agreed to take his paintings for a while, on deposit. Shchukin's palace and the Fine Arts Museum were only

a few hundred metres apart, and so the pictures could be carried between one and the other, on foot and at any time. Lack of fuel meant that the stone building, inaugurated in 1912, was no longer heated, and so Sergei Shchukin decided to wait before initiating the move.

It was not long before the Bolsheviks turned their attention to matters of culture. Igor Grabar, who had been at the forefront of the movement to transform the Kremlin into an Acropolis of the Arts, was appointed Vice President of the Committee for Museum Affairs and the Protection of Artistic and Historical Heritage. Nominated as the head of this committee, which reported to People's Education Commissar Lunacharsky, was Natalya Trotskaya, the wife of Leon Trotsky, the powerful people's war commissar. Grabar attempted to relaunch the idea of the 'Kremlin-Acropolis' which had so enthused Shchukin. In the spring of 1918, Shchukin was given a pass to enter the Kremlin and the education and culture section of the Soviet workers' group of representatives received a proposition from the collector to create, based on his private collection, a gallery of paintings in one of the palaces of the Kremlin.

In the meantime, something important happened that completely changed the situation: on 5 March 1918, Lenin, anticipating the advance of the White Armies on Petrograd, moved the revolutionary regime's capital to Moscow, installing it in the Kremlin as a powerful competitor to the Acropolis of the Arts. At the same time, the destiny of the entire nation took so tragic a turn that all grandiose cultural projects had to be postponed indefinitely.

Shchukin had succeeded neither in entrusting his collection to a museum nor in transferring it to the Kremlin. Nevertheless, he had to find somewhere safe for the paintings: anarchists were occupying the old private houses of the city, where they were sleeping on the carpets and using paintings and decorative objects for shooting practice.

On 10 March 1918, shortly after the Council of People's Commissars had moved into the Kremlin, 'Citizen' Shchukin applied to the commission of the Soviet of Workers' and Soldiers' Deputies responsible for the protection of monuments and art treasures with the following request:

Inasmuch as the protection of the Shchukin Art Gallery and its library requires an official who knows it well, who will be able to devote

himself full time to it and who will be able to inventory new acquisitions in detail, I ask the committee not to refuse the confirmation – as curator and librarian of the Shchukin Art Gallery – of Mikhail Pavlovich Keller.

<div style="text-align: right">Signed Sergei Shchukin.[12]</div>

On the same day, 10 March, M.P. Keller was confirmed in post as curator of the gallery.[13]

Mikhail and Ekaterina Keller had returned from Petrograd to Moscow after the October Revolution. They moved into the Trubetskoy Palace with Ilya, Ekaterina's son, and the couple's own four children: Hermann, Rufina, Callista and Rupert. In June 1919, Ekaterina gave birth to a sixth child, Harold, who was never known by any other name than 'Baby'.

The nomination of Mikhail Keller as curator of the Shchukin collection offered the advantages of not leaving the house in the care of strangers, while at the same time keeping the collection safe; but Keller, a highly cultivated aristocrat and bibliophile, was an army officer liable to be mobilized. He did not occupy the function for very long. On 4 October 1918, he officially submitted his numbered inventory of 256 canvasses, pastels and drawings. Keller omitted two portraits of Sergei Shchukin by Xan Krohn, six African sculptures, a bronze mask, a bronze statuette by Maillol, six Chinese paintings, a watercolour by Borisov-Musatov, a drawing by Matisse, a reproduction of one of Matisse's pictures, two sketches by Matisse for *La Danse* and *Les Baigneurs*, and Matisse's sketch for *L'Atelier Rouge* (which Shchukin himself sent to a charity auction during the First World War, though it re-joined the collection later during the Soviet period). Thus the entire Shchukin collection at its zenith consisted of 278 artworks.[14]

Less than a month later, on 29 October, a decree of the Council of People's Commissars signed by Vladimir Ilyich Ulyanov (Lenin) nationalized the collection, an event which Shchukin heard about only in passing in Weimar, where he was awaiting the imminent cessation of hostilities that would make it possible for him to re-enter France.

As of August 1918, the nationalized company of I.V. Shchukin & Sons, the gallery of paintings and the private house at 8, Znamensky Lane ceased to have an owner in Russia.

The Exiles

In April and May 1918, Sergei Shchukin moved with his family to the dacha which he had always rented at Kuntsevo. It had belonged to his father's old friend, Kuzma Soldatenkov, and the Shchukins had only happy memories of the summers spent there in their youth. Little Irina had been born three years earlier, an unexpected joy for her parents given their ages, and now their main anxiety was to protect her after so many tribulations.

On either side of the stone steps leading up the hill to the dacha, two gilded angels stood guard. Beyond these sentries, it was like returning to the world as it had been before, carefree and happy. Many photographs have survived of this last summer spent in Russia. Sergei Shchukin appears relaxed in the garden of the dacha, side by side with a little girl in a white dress.

But suddenly the childish laughter ceased. Nadezhda Shchukina and little Irina disappear from the photographs.

Smallpox had a reputation for striking suddenly and without warning. The family, and above all the youngest child, had to be kept out of danger; in other words, they had to leave the new Soviet Republic, its chaotic new capital and its territory threatened by civil war. This was easier said than done, if one discounted the romantic options of passing through Finland or

through Asia. The central powers were mounting a decisive offensive in France to break through on the Western Front. Anyone contemplating leaving Russia at this time faced huge challenges. The journey was fraught with danger for a woman travelling alone with a three-year-old child and her governess. Like other Muscovites, the Shchukin family was caught in a trap.

Like other Muscovites? Not exactly. Certainly not the 'Moscow Minister of Commerce', as Shchukin had once been known. The closure of any frontier immediately generates a smuggling industry. The effectiveness of the closure varies according to whether one is rich or poor, a leader or a follower.

In Moscow, solutions to the problem emerged in proportion to the number of candidates for leaving who had the means to pay for it; and that was plenty of people, given the magnitude of the rapidly unravelling empire. As usual with Russian bureaucracy, the safest and most comfortable escape route functioned with the active participation of the authorities: the 'Ukraine Train'.

Ukraine, after the February uprising and the tsar's abdication, formed its own provisional government and made a separate peace with the central powers at Brest-Litovsk. Disorders and rivalries with local Bolsheviks then provoked occupation of the country by Austrian and German forces, which, following a coup d'état on 29 April 1918, propped up the authoritarian government of the 'Cossack Hetmanate'.

The Hetmanate and the Russian Soviet Republic then set about a serious repatriation of all Ukrainian nationals living in Russia to their 'country of origin'. Every day, a train steamed out of Moscow bound for Kiev. But how to identify a 'Ukrainian', given the mosaic of territories that had been crossed for centuries by successive waves of migration, voluntary or forced, involving Russians, Poles, Lithuanians, Tatars, Cossacks and Turks?

To placate the German ambassador in Moscow, Count Mirbach, who was highly influential in the first months of Germany's separate peace with the Soviets, People's Commissar for Foreign Affairs Chicherin had issued instructions that candidates for departure on the Ukraine Train should not be questioned too closely at the border. Money further facilitated the composition of the lists of passengers allowed to board the train, which were checked by officials of both governments.

The process worked well and the 'Ukrainians' in Russia proved numerous enough for the train to continue carrying them from Moscow to Kiev all summer and throughout the autumn. There was always a representative of the Ukrainian Foreign Ministry aboard, as Prince Illarion Vasilchikov recounts; for he, like Shchukin, owed his survival to the 'Ukraine Train'.[1]

Nobody saw Sergei seeing off his wife, his daughter and the governess at the Bryansk station, which served Ukraine. He expected to be separated from them for an indeterminate period, at a time of desperate uncertainty.

There was a difficult moment at the frontier station of Orsha. Although little Irina had been prudently dressed, like the adults, in a simple black frock, nobody had thought to change the rich dress of the doll she carried, which immediately aroused suspicion. A soldier tried to snatch the doll (Tamara) from Irina; the child burst out crying, all the other passengers took her side, and the situation quickly became embarrassing for the soldiers of the Great People's Revolution. Tamara was duly restored to her rightful owner, who clung to her tightly until the party reached Kiev. Later, Irina Shchukina recalled that her parents had filled the doll with gold and diamonds, to finance their first steps in exile.

The group travelled on from occupied Ukraine into Germany, where they stopped at Weimar.

Back in Moscow, the situation was growing more tense by the day. Count Mirbach, the German ambassador, was assassinated in July by Socialist Revolutionaries (SR), who did not accept the 'shameful' peace of Brest-Litovsk. The attempt to drag Russia back into the war with Germany failed, and the SR were banished from the Soviet government. Meanwhile, beyond the Urals at Ekaterinburg, the tsar and his family were savagely murdered on 16 July 1918, ahead of the advancing White Russian army of Admiral Kolchak.[2]

It was time to take advantage of the Ukraine Train while it was still running.

Shchukin left behind him in Moscow his daughter Ekaterina, his six grandchildren and his son-in-law Count Mikhail Keller, the curator of his collection. With their large family, the Kellers dared not risk such an uncertain journey out of Russia. Furthermore, Mikhail Keller, who had been an officer in the tsarist army, was susceptible to remobilization; his

departure would have constituted desertion, which was punishable by death if he were caught.

The Keller family's best hope of escape lay in the Latvian nationality which the representatives of Latvia could not refuse to Mikhail and which the Soviet authorities were expected to confirm. But Latvia had yet to be formally recognized as a state by the Russian Soviet Republic, which in the event did not happen until 11 August 1920.

Sergei Shchukin was once again confronted with a cruel choice relating to his first family, just when he had sent his second family far away from him. For him and his son Ivan, it was now pointless to remain in Moscow. The chain of events had made Mikhail and Ekaterina the protectors of his collection. Thrown into the heart of revolutionary artistic life despite their origins as 'class enemies', they were on the horns of a dilemma. In the first month of that summer, Russia was still in the 'vegetarian' period of the regime (as the poet Anna Akhmatova so aptly described it); the 'carnivorous' period would only begin a couple of months later.

Those weeks of July saw a decisive change on the Western Front, brought about by the Allied counteroffensive, upon which the future of all the peoples of Europe depended, no matter what side their governments had taken in the war. The Allies were winning. The powers they had vanquished would not survive in their present form.

A farewell evening was organized in August at the small private house of Sergei and Nadezhda on the Garden Ring. One of the orphan girls who had been raised in the Shchukin household, Anya Titova, remembered this party: 'The young people had lots of fun, there was laughter and music and everyone was quite sure those who were leaving would soon return, within a year at the most.'[3]

An astrakhan hat

The following day, father and son climbed aboard the Ukraine Train. They left just in time, just before the Red Terror began in earnest. In September, after the murder in Petrograd of the head of the Cheka secret police, Moisei Uritsky, and Fanny Kaplan's attempt on Lenin's life in Moscow, people began to be rounded up in huge numbers and hostages executed.

In Kiev, father and son separated. Ivan, who was old enough for conscription, had no choice but to join the White counterrevolutionary forces which were campaigning in the Hetmanate.[4] As for Sergei, he was reunited with his wife and daughter in Weimar. One can only imagine their relief at being together again, freed from the Soviet trap.

But now they were caught in another trap, that of the collapsing German Empire, in which they were stuck until the armistice was finally signed on 11 November 1918. But even then, they had no papers, and Russia's sole representation in Germany was a Soviet delegation. The Shchukins intended to go to France to rejoin the children of Nadezhda, Adrian and Natalya, who had been evacuated to Paris thanks to their father Lev (Leon) Conus, who was of French origin. Theoretically the solution was to go through Switzerland, the only neutral frontier state where Russian consulates continued to function, issuing passports to refugees from the former Russian Empire.

History caught up with the Shchukins even in their German refuge: on 6 February 1919, the nation's constituent assembly met in the Weimar Theatre, which became – for a few weeks – the capital of the new German Republic. More importantly for Sergei, not far away in Dresden lived the great socialist German art critic Julius Meier-Graefe.

Shchukin's incomparable flair once again turned the situation to his advantage. Three years earlier, he had intervened in a decisive way to help Meier-Graefe, who at the time was serving as a volunteer ambulance driver in the German Red Cross. Learning from the newspapers that this great friend of art had been taken prisoner by the Russians, Shchukin wrote to Meier-Graefe to say his books had stimulated and guided him as a collector, and that he now placed himself and his resources at Meier-Graefe's disposal. With this message he sent the forlorn prisoner a magnificent astrakhan toque, a copy of the issue of the magazine *Apollon* dedicated to the Shchukin gallery, three 100-rouble notes, and a grammar and dictionary of the Russian language.

Meier-Graefe had subsequently spoken of his unexpected benefactor with deep gratitude (incapable of pronouncing the strange Russian name, he called him 'Monsieur Zamotchin'). 'A hundred roubles a month! Only in Russia was such a captivity possible!'[5]

For Meier-Graefe, in early 1919 the moment had come to repay his debt of gratitude. Writing from Dresden on 3 and 20 January 1919, he appealed on Shchukin's behalf to the Swiss industrialist, collector and art patron George Reinhart, in Winterthur. This contact proved effective because, on 15 April, Reinhart replied that permission for Shchukin to enter Switzerland would be granted by the authorities.[6]

On 19 June 1919, Sergei, his wife and daughter travelled to Geneva where they obtained passports issued by the strange 'Russian consulate in Geneva', which did not recognise the authority of the Soviets and which issued Russian documentation that simply blacked out the word 'Imperial'. After that, there had to be talks with the all too real consulate of the French Republic, before Commercial Councillor 'Serge Stchoukine', his wife 'Nadéjda' and their daughter 'Irène' could be authorized to enter France. Shchukin's French associates, the former shareholders in the Émile Zindel factory, vouched for the man who had been their Moscow manager. The Crédit Lyonnais gave him a bank guarantee.

Quarrelling is easier than parting

Sergei and Nadezhda now began their new life in Nice. Their choice of the Côte d'Azur, which only a few years before had been a favourite seasonal destination for the aristocracy and the *kupechestvo* of Russia, was typical of the mixture of logic and irrationality that prevailed at the time. As an environment in which to spend the summer, the South of France was and remains ideal, if one has the means to do so. But Shchukin's family of exiles had no idea of how long they would be staying in France and wanted to believe that their time outside their country would be of very short duration.

The peace treaty between Germany and the Allies was signed in Versailles on 28 June 1919. In Russia, the civil war rumbled on, the Soviet regime held its ground and the nation's political future remained in limbo, awaiting the intervention of the Allies. In Nice, like everyone else, the Shchukin family waited to see what would happen. All along the coast between Cannes, Nice and Monte Carlo, with its casinos and palaces, a shadow theatre cast of former crowned heads, ruined millionaires, adventuresses,

profiteers and hangers-on was assembled. The novelists of the 1920s were to exploit the atmosphere to the full.

How did Shchukin function in this phantom society of banished Russians? First of all, he set about reassembling as many members of his own scattered family as he could find: the children of Nadezhda, Adrian and Natalya; Nadezhda's sister Vera; his own son Ivan and his nephew Nikolai Myasnovo, who were still fighting in Crimea as the White Russian Army made its last stand.

Meanwhile, Henri Matisse had moved to Nice – somewhat haphazardly – in 1917. In the event he was to be based there for the rest of his life.

The biographer of the Russian collectors, Beverly Kean, was able to interview Matisse's son and daughter on the subject of Shchukin. The result is a fascinating description of the group surrounding Shchukin in the autumn of 1919 and the bitter mutual disappointment with which the extraordinary collaboration between the two great men came to an end.

To begin with, Matisse took the step that Shchukin could not bring himself to take: he paid his former patron a visit, being eager to show him how his work had developed over the last five years. The Russian informed him with deep embarrassment that his situation had changed and, since he no longer had any money to buy Matisse's paintings, he preferred not to see them. Nevertheless, he invited Matisse for tea at his hotel, where the painter found a crowd of émigrés being lavishly entertained, as usual, by Nadezhda Shchukina. Among these a phalanx of Russians surrounded Sergei himself, effectively preventing any meaningful contact between the painter and his former patron.

A confused anecdote has come down to us through Matisse's daughter, Marguerite Duthuit: apparently the painter suggested to Shchukin that together they should pay a visit to Renoir, who was sick and failing, at Cagnes-sur-Mer (to Matisse's great credit, he looked after his old friend until Renoir died, in December 1919). According to Marguerite, the two agreed to meet at the station, where Matisse looked in vain for Shchukin in the first-class carriages, then spied him in second class, which 'made him understand the position in which the collector now found himself'.[7] In the end, the friendship between the two men was completely broken when Shchukin, seeing Matisse at the end of a street, crossed to the opposite pavement.

Despite their vagueness about things that had happened sixty years earlier, the stories handed down by Matisse's family clearly reflect how deeply the artist was wounded by Shchukin's attitude. Above all, they demonstrate his sorrow at losing access to the Russian's impeccable critical eye, which had once so brilliantly forced him to surpass himself.

Shchukin, for his part, could not bear to tell a great painter who had dedicated his life to art that he had resolved to bid farewell to painting; nor could he express the agony he felt in doing so. The Ukraine Train had torn him forever from his home in Znamensky Lane, from the pink salon with its orangery feel, from the Tahitian dining room, from *La Danse* and *La Musique* on the staircase. . . The revolution had caught him up and swept him away, along with his wife and his little daughter, far from the tragedies which had taken place in and around the Trubetskoy Palace. Memories such as these lie deep.

To visit Matisse in his studio, to admire new works that were bound to be unexpected and striking – Shchukin knew his man all too well – in the knowledge that he could no longer possess such beautiful things? To rekindle a burning pain that he had at all costs to forget if he was to survive? Worst of all: to talk of art with the creator of these marvels and reopen a wound that was still raw? The idea was not to be contemplated without horror.

So ended the ideal relationship of a painter with his patron, because of a latent misunderstanding that had blighted it from the start. Matisse, the proud bourgeois who had faced dire poverty because of his passion for art, was confronted by a patron who had never experienced financial difficulty of any kind in his life. With a single urbane gesture, Shchukin had transformed the existence of Matisse, while at the same time placing his incomparable eye at his service. Both men had known this from the start, but they had never managed to broach the subject face to face. Now things were entirely different. Shchukin was in difficulty and Matisse was rich and successful: and for two such prickly characters the simplest solution was to quarrel.

By the autumn of 1920, the Soviet Republic was on the verge of total victory in the civil war and there were decisions to be taken. The schooling of Nadezhda's children had to be planned. The Shchukin family moved to

Paris, to rue Georges-Ville, between the Étoile and the Place Victor-Hugo, in the fashionable heart of the city.

But while Shchukin took care of his family in France, what became of the beloved collection he had left behind in Russia? And what was the fate of his former home and once prized possession, the Trubetskoy Palace?

The World's First Museum of Modern Art

The decree of the Council of People's Commissars, dated 29 October 1918, read as follows:

Nationalization of the Shchukin Art Gallery

In view of the fact that the Shchukin Art Gallery constitutes an exceptional collection of great European masters, mostly French, from the end of the nineteenth century to the beginning of the twentieth century, and that on account of its major artistic value it presents a national interest for the education of the people,

The Council of People's Commissars decrees the following:

1. The Shchukin Art Gallery is declared the property of the Russian Soviet Federative Socialist Republic [RSFSR] and is consigned to the People's Commissariat for Education, in accordance with the dispositions applicable to public museums.
2. The building in which the gallery is housed (8, Znamensky Lane in Moscow) and the adjoining land, formerly the property of S.I. Shchukin, and all its contents, are consigned to the People's Commissariat for Education.

3. The Committee for Museum Affairs and the Protection of Artistic and Historical Heritage shall work with the People's Commissariat for Education to develop and set in motion a fresh organization of the former Shchukin gallery and its activity, which shall correspond to contemporary needs and to the democratization of the educational and artistic institutions of the Russian Socialist Federative Soviet Republic.

Signed Vladimir Ulyanov (Lenin)[1]

This decree provisionally terminated a bureaucratic struggle, not around the collection, but around the real estate within which it was housed; lack of space being a serious concern in the new capital of Russia.

The Trubetskoy Palace was ideally placed 800 metres from the Kremlin and was thus a considerable prize for the various new government offices and administrations, all of which were chronically short of suitable premises in the centre of Moscow. Interdepartmental hostilities began on 25 October 1918, when Natalya Trotskaya, head of the Museum Affairs Committee, issued an order assigning the private house of S.I. Shchukin to another section of the People's Commissariat for Education and ordered the transfer of his collection to the Petrovsky Palace, a former imperial residence on the north-west side of Moscow.

Lunacharsky, the education commissar, was enraged by the turf wars being waged by comrades within his own administration, with nobody remotely concerned about the artistic value of the buildings they were fighting over. He wrote Lenin an icy telegram: 'I consider the attempt to take over the Shchukin gallery, which is the best modern art collection in the world, as an act of barbarism which dishonours the Soviet Republic.'[2]

Lenin's subsequent decree nationalizing the gallery swept aside the confusion that had hitherto reigned in and around the palace. In this instance, the Lunacharskyists prevailed over the Trotskyists.

By a decision of 19 November 1918, promulgated by the Museum Affairs Committee, Sergei Shchukin's daughter Ekaterina Keller was named head curator.[3] She became, at the age of twenty-eight, the world's first curator of a modern art museum. Ten people were assigned to work with her at the former Shchukin gallery.

By placing the Shchukin gallery first on its list of nationalizations, the new regime (in which experts and high-level progressives exercised considerable influence over cultural and artistic matters) showed itself to be fully aware of the importance of existing Russian collections of modern art. Events had given Moscow an opportunity that was both remarkable and possible in practice, to create a museum of western art and to 'present the entire post-Cézanne era as it deserved, in a way that it had never been presented before, anywhere in the world'.[4]

Pavel Muratov, in his report to the conference of museums in Petrograd, affirmed that *not* to play this strong card would be unthinkable. Ten years earlier, Muratov had written the first major article on the Shchukin collection; now he was defending the position of the Moscow delegation:

> Moscow doesn't want an *ersatz* Hermitage. It wants its own museum, which will be just as alive and just as impressive ... minor Dutch masters, a few Italian Baroque paintings salvaged from the Rumyantsev Museum and one or two pieces sent from St Petersburg collections cannot be the core of our institution. This core will squarely consist of the French masterpieces that are already in Moscow.[5]

Thus, the idea of a socialist 'divvying-up' of works of art among Russia's various museums, beginning with those of the nation's two capitals, came up against Moscow's fierce refusal to allow its treasure to be removed.

In June 1919, Narkompros gave the Shchukin collection the title of the Museum of Modern Western Painting No. 1 (its Russian abbreviation was MNZZh1). The Morozov collection, which was nationalized one month later, became No. 2 (MNZZh2).[6]

On the stroke of noon, 15 August 1920, the Museum of Modern Western Painting No. 1 opened its doors to the public. (A copy of the printed invitation to the opening is held in the archives of the Pushkin Museum.)

To begin with, the arrangement was still dominated by the Shchukin family. Ekaterina, like her father before her, conducted visitors around his collection and told them about the pictures; her assistant was Vladimir Minorsky, Shchukin's faithful friend, who continued to take care of the museum's administrative correspondence and financial affairs.

Meanwhile, elsewhere in Moscow the question of who occupied what premises was high on the government agenda. Though it had failed to take control of the entire Trubetskoy Palace, the Housing Committee clung to part of the ground floor – where forty people were lodged, occupying 3 square metres each. By the end of 1919, the Committee for the Sick and Wounded had moved into the former offices of I.V. Shchukin & Sons. Fearing that this invasion would spin out of control, Ekaterina Keller suggested to Professor Gavriil Gordon that he and his family should move into the palace. Gordon had studied at the University of Marburg in 1906–7, at the same time as Sergei's son Ivan Shchukin. He had just been appointed to run the higher education establishments at Narkompros and was viewed favourably in the corridors of power.

Elsewhere, the civil war was concluding with the victory of the Red armies. The new government was installing and rationalizing itself – and cracking down. In December 1920, the Museum Affairs Committee sent its representatives to Znamensky Lane to begin the process of rehanging Shchukin's paintings in 'historical order'. The disorder of the old display, which was in the personal taste of the former owner, did not suit the new authorities, suffused as they were by scientific ideology. The Matisse and Gauguin rooms were undeniably successful, but even here the reformers tinkered. Some of the Matisses were taken out of the salon; the dark fabrics of the Gauguin dining room were re-covered with grey linen, and the paintings were spaced further apart. This did not make the room any lighter; it merely obliterated the rich tonal bounty of the iconostasis. Worst of all, the incomparable aura given to the place by Shchukin himself was entirely banished.

The nationalization of private collections was now under way in earnest.

At the end of 1921, Ekaterina Keller asked the Museum Affairs Committee to relieve her of her function as curator 'in view of her imminent departure to Latvia'. Her request is held by the Russian state archives, with Natalya Trotskaya's stamp and the comment 'no objection'.[7] And doubtless no regrets either. The curator of MNZZh1 must have been an encumbrance: she was a countess and the daughter of an emigrant capitalist; but her name alone was hugely respected in the avant-garde artistic milieu, and here she was occupying one of the most coveted positions in the department.

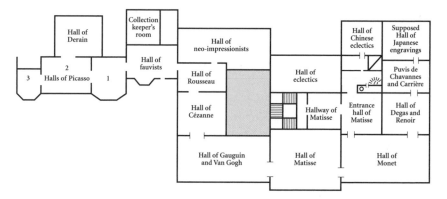

The rehang of Shchukin's collection was finally agreed and drawn up in 1923.

The new scheme, done 'according to the historical principle', was less dense and chaotic as it had been in Shchukin's time, when the artworks had occupied only five rooms: the dining room, dedicated entirely to Gauguin; the pink salon, containing Matisse's paintings; the music salon, with Monet and the impressionists; the study, which featured paintings by Picasso and Rousseau; and the small salon, where Degas, Renoir, Cézanne, Denis and Puvis de Chavannes were shown.

Under the Bolsheviks, all these rooms maintained their attributions. So too did the staircase, decorated as it was with Matisse's panels.

But after the Trubetskoy Palace owner's family moved abroad, additional space became available. For example, rooms previously occupied by Shchukin's eldest son Ivan were now used for exhibiting art: some works by Picasso moved here, as did Derain's paintings which had previously had no space of their own. By and large, the inhabitants of the palace's private apartments all vacated their quarters, and these were used to exhibit art instead. Thus, in the new museum, pictures were not hung as densely as they were before, when the available space consisted only in the common areas and Shchukin's personal lodgings, and this meant that several artists now got their own rooms.

Outside these considerations, Mikhail Keller had succeeded in playing his 'joker'. The Baltic States had achieved independence in 1920; and so, on account of his German–Latvian lineage going back to the Teutonic Knights, Mikhail Keller had opted for the nationality of the new Republic of Latvia.

In January 1922, Ekaterina, Mikhail and their six children, accompanied by their English governess Miss Holman and the elderly mother of Lydia Shchukina, armed with all the necessary authorizations and bringing with them their five dogs, left Moscow for Petrograd.[8]

Farewell to the Trubetskoy Palace

With the Kellers' departure, the fate of the Shchukin collection was finally severed from the fate of the Shchukin family.[9] In 1922, sections 1 and 2 (Shchukin and Morozov) were administratively merged, and the name was changed once again to the State Museum of Modern Western Art, including sculpture and the decorative arts. The abbreviation MNZZh became GMNZI, with the same two sections in the same two palaces. Each palace sheltered its museum, as well as the dozens of human occupants who had been housed in it. This did not prevent the Housing Committee from attacking first one and then the other.

In 1928, the GMNZI was finally driven out of the Trubetskoy Palace, which was allocated to an ephemeral porcelain museum containing nothing but minor pieces.[10] The Shchukin collection was moved hastily to the former Morozov townhouse on Kropotkin Street (Prechistenka Street had been renamed after the anarchist theorist Petr Kropotkin). Of the Shchukin gallery and its decorative masterpieces – Gauguin's iconostasis, the pink salon, the music salon of the impressionists and the Picasso room – nothing remained of their original state save for a few photographs. It was probably at this time that the Shchukin library and archives were left at the premises occupied by Professor Gordon, who was arrested and deported during the purges of the 1930s. He never returned, and his family and property were dispersed.

Moscow had concentrated in one place the most important modern art museum in the world. Some 200 Western works from the Morozov museum were added to Shchukin's similar number of paintings. This gave a total of nineteen Monets, eleven Renoirs, twenty-nine Gauguins, twenty Cézannes,

ten Van Goghs, nine Degas, fourteen Bonnards, twenty-two Derains, fifty Matisses and fifty-three Picassos. The public would never see it: the paintings were too numerous to be displayed all at the same time. Many immediately went into the reserves and it was decided that the question of space would be settled later, in the course of the first five-year plan. This was almost immediately rendered unnecessary, for the business of dismantling the GMNZI began from the moment the museum opened in its unified form in December 1929. Nevertheless, there was still not enough space to hang all the pictures. Denis's panels for Morozov's salon were taken down and the salon itself was transformed into a Matisse room, with *La Danse* and *La Musique* replacing their former rival, *Psyche*. A rough fabric was spread over the oak panelling of Morozov's Gothic room, to hang the paintings of Picasso.

The RSFSR's National Commerce Office, which was responsible for buying and selling antiquities, began to investigate the GMNZI with a view to seizing any paintings worth selling. In 1928, in closed session, the Council of People's Commissars had taken confidential measures to strengthen the export and sale abroad of art objects and items of national heritage; every museum was expected to pay due tribute. Faced with a gigantic foreign debt (which it was neither willing nor able to pay) and desperate to procure foreign currency, the government decided to sell the collections of the nation's museums. Already many individuals had forestalled these measures by exporting works from former private collections. Americans, in particular, were eager clients of the Office of Imports and Exports, known as the 'Antiqvariat'; they bought everything: jewellery, icons, furniture, books and paintings. They even considered taking down St Basil's Cathedral on Red Square and reconstructing it in the United States.

Fortunately, there was little American interest in the impressionists. Only Dr Barnes of Philadelphia made it known, by way of shadowy intermediaries, that he wished to acquire Cézanne's *Mardi-Gras* from the former Shchukin collection. The Antiqvariat promptly overpriced the painting at half a million Reichsmarks (since the mid-1920s, Weimar Germany with its Reichsmarks had played the role of financial intermediary for the Soviet Union). Quite rightly, the American pharmaceutical magnate held his ground, protesting against the state's 'ridiculous' asking price.

The export campaign came in three waves: the first in 1920, the second in 1922–23 and the third during the years 1928–33. The final wave was the most devastating of the three and no-one, not the staffs of the museums nor even the more cultivated elements of society, was able to stop it. Luckily, in 1933 the trade in works of art from Soviet museums abruptly collapsed when Hitler seized power in Germany, forcing the Soviets to abandon their faithful intermediary. The whole world understood that the Soviet Union, whose legitimacy most countries had by then formally recognized, was selling off its museums; but the public outrage of the former owners of great artworks was a serious obstacle to this trade. At a time when items from the Imperial Hermitage were selling by the hundred, only four paintings were taken from the State Museum of Modern Western Art.[11] These four paintings were bought by the American magnate Stephen Clark for $260,000.[12] The paintings that had already been seized for resale by the Antiqvariat were haphazardly given back, and forty-two other works of the GMNZI consequently came to rest in the Imperial Hermitage, which stoutly refused thereafter to return them to their museums of origin.

The great Morozov house on Kropotkin Street no longer bore any resemblance to the sumptuous palace it had once been, and nobody in it dared even to whisper the names of the former owners of its collections. In 1928, in the first catalogue of the museum, its director, Boris Ternovets, had noted quite naturally beside the description of each painting the letter 'S' or the letter 'M' in reference to the collection from which it came. By the 1930s, even this timid mention was tantamount to suicide.

After the Rain

In spite of the intensifying campaign against bourgeois art and the affirmation of socialist realism as the only legitimate artistic current, and although creative people were actively mobilized to 'illustrate' communism, the authorities still dared not launch a direct attack on the State Museum of Modern Western Art. Progressive intellectuals all over the world felt great admiration for the GMNZI, which became an obligatory feature of any visit to Moscow by friends of the Soviet Union. Besides, the museum

displayed collections that Lenin's 1918 decree on nationalization had described as being of 'major artistic value'.

The patience of the authorities ran out in 1937, with the sudden replacement of Boris Ternovets, the museum's director and highly respected advocate, who by the end had become personally identified with the cause of his museum. But it was something much more dramatic that finally sealed the fate of the GMNZI: the Second World War.

In the summer of 1941, with the Wehrmacht advancing deep into the Russian heartland, all artworks that were movable were evacuated in railway convoys beyond the Urals. The collections, packed in cases, were stored in Novosibirsk for much of the remainder of the war. When they returned to Moscow in 1944, the cases were not immediately reopened: the former Morozov house on Kropotkin Street (formerly Prechistenka Street) had been damaged and nobody wanted to risk their neck by suggesting an alternative venue.

Nevertheless, when the euphoria of victory had passed, there were hopes that the life of the nation would take a new course and the museum would soon reopen. These illusions were crushed as the Iron Curtain fell across Europe. Bitter campaigns were unleashed against 'cosmopolitanism' and the 'decadent culture of western bourgeois imperialism'.

One morning, very early, the museum staff were informed that the vice president of the Council of Ministers, Kliment Voroshilov – himself an amateur painter and collector – would be visiting next day, along with the president of the Fine Arts Academy of the USSR, the painter Alexander Gerasimov (who was later awarded the Stalin Prize for his famous painting *After the Rain*, representing Stalin and Voroshilov walking together at the Kremlin.

The employees of the GMNZI tried to call the attention of these senior officials to the very high quality of the museum's realist canvasses, in addition to the works of western artists; but their unnerving visitors knew perfectly well why they had come and what they meant to see. At the time the art historian Nina Yavorskaya was in charge of the teaching department of the GMNZI.[13] She never ever forgot Voroshilov's guffaws, or the sneers on the grey faces peering at *La Danse* and *La Musique* spread out on the floor.

The delegation left in silence.

Alexander Gerasimov was the museum's most implacable enemy. He was already busily installing the staff of the Fine Arts Academy in the place of the GMNZI, himself taking over the former office of Ivan Morozov. His revulsion for the works in the museum was almost physical. It was even said that he had threatened to 'hang' anyone rash enough to 'hang' a painting by Picasso.

On 6 March 1948, the Council of Ministers of the USSR issued decree number 672. It is worth reproducing it in full:

In so far as:

— the collections of the Moscow State Museum of Modern Western Art largely consist of the bourgeois art of western Europe, bereft of ideas, anti-national, formalist, and with no interest for the progressive education of the Soviet public;

— the formalist collections belonging to the Museum of Modern Western Art, bought in the countries of western Europe by Muscovite capitalists in the late nineteenth century and the early twentieth century, have spread formalist views and the veneration of decadent bourgeois imperialist culture, causing severe damage to the development of Russian Soviet Art;

— the presentation of these collections to the masses is politically harmful and contributes to the propagation of foreign, bourgeois and formalist influences in Soviet art;

— at the same time, the fine arts museums of the capitalist countries of western Europe do not exhibit either the contemporary works of progressive Soviet Art, or the works of progressive painters of the great realist Russian school whose major educative interest is beyond dispute;

the Council of Ministers hereby decrees the full liquidation of the Moscow State Museum of Modern Western Art.

This decree, signed by Joseph Stalin, was final. Within two weeks, the most important artworks were to be surrendered to the Pushkin State Museum of Fine Arts in Moscow. The entire Kropotkin Street premises and its inventory were to be transferred to a new owner, the Academy of Fine Arts of the USSR, within ten days. The Ministry of Culture considered that

anything that did not have serious value should be sent to the provinces and that openly risqué artworks should be destroyed on a case-by-case basis.

This last eventuality was not enshrined in the decree, obviously. Nevertheless, Nina Yavorskaya remembers all too well that the order was implicitly given.

It was Antonina Izergina, curator of French paintings at the Imperial Hermitage and the wife of Josef Orbeli, its director, who saved the collections. She compelled her husband to travel immediately to Moscow and bring back whatever he could salvage.

Thus it was that a pair of corpulent, elderly, silver-bearded gentlemen – Orbeli, the orientalist, and Sergei Merkurov, director of the Pushkin Museum[14] – found themselves in the main gallery of the museum on Volkhonka Street sharing out the paintings of the GMNZI on the principle of 'one for you, one for me'. Orbeli also took everything that the terrified Muscovites dared not keep, such as the huge Matisse panels, Picasso's cubist pictures and the brown and black paintings of Derain.

Thereafter all modern western artworks were hidden away in the reserves of both museums. They could only be seen by special permission. The writer Ilya Ehrenburg remembers that the physicist Frédéric Joliot-Curie asked to visit the Imperial Hermitage in 1951, and that some of the paintings he saw had been present fifteen years earlier at the State Museum of Modern Western Art in Moscow:

> At that time, it was felt that even impressionist paintings were off limits to museum visitors, let alone anything by Matisse or Picasso! The most precious artworks were languishing in storage. Joliot was thrilled: the landscapes of Sisley, Monet and Pissarro were what he liked best. On the way out, he said to me: 'I feel as if I have just spent an entire summer in the country – I am a new man . . .' Then, leaning towards me, he whispered in my ear: 'It is not a good thing to deprive the Soviet people of such happiness', before adding: '. . . yet I am sure they won't have long to wait for it'.[15]

The French physicist was right. Stalin died on 5 March 1953, and in December of that year the Fine Arts Museum dared to exhibit the impres-

sionist works. In Leningrad there was even less caution. 'At the Hermitage, five paintings by Picasso, among them *Trois Femmes* and several other works from the cubist period, have been put on display. The interest of these canvasses lies in the importance which they had in their time . . . today there are ten Picassos, nine Matisses, and a Douanier Rousseau on public display,' wrote the translator Alexander Morozov to the young art historian Paola Volkova in 1955.[16]

Khrushchev's accession to power coincided with the period of the 'thaw', and in May 1956 the Pushkin Museum mounted an exhibition of French art, 'From David to Cézanne'. With this event began the legendary period of the years 1960–70, during which Soviet museums took an extraordinary leap forward. Art exhibitions and catalogues won new status as symbols of freedom of thought. In the autumn of 1956 – a year that saw both the ground-breaking Twentieth Congress of the Communist Party of the Soviet Union[17] and the invasion of Hungary by Soviet troops – the Pushkin Museum inaugurated an exhibition devoted to Pablo Picasso. The museum was stormed by visitors, and the police had to be called to restrain the public. 'It was at that moment that the barriers separating us from other countries crumbled,' recalled an eyewitness. 'There was huge excitement in the exhibition rooms. Animated discussions were taking place in front of every painting. Older people were shocked by the purely cubist works, but the young were deeply attracted by their novelty.'[18]

At that point in time, very few people knew that it was a Muscovite, the merchant Sergei Shchukin, who had introduced these paintings to Russia at the beginning of the century.

The impressionist and post-impressionist exhibitions that followed were also immensely successful. People began to realize with every new exhibition that the Russian museums held key works of modern art, works of global importance, and if those works were not present, any display of them – anywhere – would appear dull and impoverished.

Then came the fall of communism, a utopia that had shown itself to be less resilient than the creative power of artists and of those who revealed them to the world – the great collectors and the great merchants. For that creative power had proved beyond doubt that it could not be suppressed by the decrees of people's commissars, ministers, Lenin, Stalin or anyone else.

Time Regained

In 1926, the Shchukin family left the Étoile district of Paris and migrated to Auteuil, a residential zone in the same sixteenth *arrondissement*, where Shchukin had invested in a large new apartment, acquired 'off plan'. The village of Auteuil had been engulfed by Paris under the Second Empire, and now was home to a large Russian colony, which had its own church and its own Russian delicatessen – 'Sukhanov Foods', supervised by the inevitable stout *kupets*. At Orthodox Eastertide, there was a long queue outside the store.

Shchukin's new home was at 12, rue Wilhem, just beside the church of Notre-Dame-d'Auteuil. It consisted of 200 square metres on the fifth floor and was made up of a large salon, a small salon, a formal dining room, three bedrooms and a boudoir, with two maids' rooms two floors above. On one side, the apartment gave onto the quiet rue Wilhem; on the other side was a spacious garden co-owned by the residents. From the windows you could see the River Seine and the Citröen factory on the far side of the Pont Mirabeau. It was an 'exceptional property', as Parisians would say today.

And there were plenty of people living in it: Nadezhda, her sister Vera, Nadezhda's children Adrian and Natalya, little Irina with her governess, a maid and a cook. Nikolai Myasnovo, Shchukin's nephew, occupied a maid's room on the seventh floor.

Sergei supported all of these people and at Easter he threw his home open to the entire Russian colony. The stories relayed back to Russia by Soviet visitors, which had it that Shchukin was destitute and his miserable wife reduced to giving piano lessons for money, betrayed their unwillingness to describe the 'capitalist deserters' as well-off and happy, as they were.

Indeed, the Shchukins never lacked for money. Sergei had transferred his personal fortune before the war to the Svenska Handelsbanken in Stockholm, thus limiting the losses he suffered to his company, his palace and his modern art collection. As early as 1923, once Ekaterina and her family were safe in Europe, Sergei Ivanovich changed his 1907 will, whereby he had bequeathed his collection to the Tretyakov Gallery in Moscow. With clarity and precision, he laid out his new wishes in a will that would supersede all preceding wills: the entirety of his goods and possessions would now pass to his three living children, Ivan, Ekaterina and Irina, and to his wife Nadezhda. The will was established and registered in France, whose state constitution did not condone state confiscation of property, unless it was 'in the general interest of the public' and carried out in exchange for a 'suitable compensation, paid in advance'.[1]

Shchukin's wish that the Tretyakov Gallery preserve his legacy to the city of Moscow was clearly no longer feasible. His family had to stand by helplessly as the collection collided with the Soviet state's de facto administration. Shchukin at no time questioned the principle that the collection ought to be preserved by the national museums of Russia, but he deeply rejected the process of confiscation de jure, which did not respect his wishes and effectively annihilated his museum in the form he had so precisely composed.

During this time, Sergei continued supporting his whole family and the Shchukins continued to entertain and give lunches, dinners and concerts. Nadezhda had an electric button installed under the table in the big dining room: when she pressed it with her foot, the Russian serving maid would promptly bring in the next dish (sometimes the children disrupted this procedure by crawling under the table to press the button surreptitiously). Every summer the family and servants would spend three months in a nice villa at Biarritz, Deauville, La Baule, Lugano or the Lido, often surrounded by their relatives and close friends, just as before.[2]

In Moscow, Shchukin had been nicknamed the 'Minister of Commerce'. Even in Paris, he could quite easily have gone on buying paintings – maybe not Matisses or Picassos, but definitely the works of younger painters.

Matisse himself had been the first to hear about the end of Shchukin's passion for modern art, along with his patronage of artists. Paintings no longer had the same hypnotic, magical hold over the Russian. Now his energy was focused on bringing up his daughter, who supplanted all his other interests. In the morning, he went out and bought the newspapers, then went to watch Irina dancing at the school of Mathilde Kschessinska, formerly a great ballerina in St Petersburg and a favourite of Tsarevich Nicholas, when he was heir to the throne. Shchukin had survived the confiscation of his collection, of his palace and of his slice of Russian industry. In truth, these misfortunes paled into insignificance for him when set alongside the loss of his first wife, two of his sons, and his brothers. Nevertheless, when those personal losses had occurred, his great collection of paintings had been there to sustain him. Now it was no more.

No Paris dealer was able to convince Sergei Shchukin even to pretend to return to the art market – let alone finance it. Nevertheless, he often said that, had he continued to collect, he would have begun with Raoul Dufy, whose wonderfully optimistic pictures reminded him of Matisse.

Still, collectors new to the fray invariably came to him for advice, bringing back memories.

> Dear Serge Lifar,
>
> You have asked me to describe in a few lines my impression of your collection of paintings . . . first of all I note that it is classically based on Picasso, Derain and Rouault. The beginnings of these artists, who have become the great masters of contemporary painting, are very present in my memory. In the old days I was deeply involved in the struggle that raged around their work and around the new principles that they heralded. And when they triumphed I rejoiced. Indeed I cherish these paintings of yours like old friends . . .

An exhibition devoted to the collection of the director of the Paris Opera Ballet was organized in 1929. Lifar published this letter

from Shchukin in the preface of the catalogue which appeared on that occasion.[3]

The letter concludes as follows:

> The principal interest of your collection should be elsewhere. In my opinion it ought to be in the work of younger artists, in the paintings of the new generation. Chirico, Mirò, Max Ernst, Pruna, Bombois, Vivin, Bauchant, Tchelitchev: today these names are only known to a select few, but tomorrow they will be on everyone's lips.[4]

Shchukin claimed to have given up collecting, but the new apartment on rue Wilhem obliged him to make an exception. Pictures were needed for the walls of his fine reception rooms and that meant Shchukin had to go back to the dealers, find what he needed and *stop buying as soon as he had bought enough*; this, for a former art addict, was playing with fire. But it must have been fun. Sergei had bought the apartment 'off plan', as part of a larger development project in 1925. The finished building was of pink brick and stone, in the late Haussmann style; construction work had barely started when he made the purchase, so in his mind's eye he had to visualize the layout of the two big rooms with their tall, glass-paned doors, and the entrance hall between them. On the right as you came in was the long dining room, like the one in Moscow. On the left was the grand salon with its rounded alcove containing a piano. These two spaces were reminiscent of the Trubetskoy Palace in miniature, which offered Shchukin the decorator an opportunity for an exercise in style that he could not resist.

He chose the paintings before he saw the spaces built.

Sergei had envisaged the dining room with dark walls and curtains, Gothic furniture and medieval chairs similar to the ones in Moscow. Five big portraits by Henri Le Fauconnier dominated the room. Le Fauconnier was a well-known painter who had found few buyers; he could do just about anything, from Renoir and Van Gogh to cubism (Shchukin had bought a painting of his for his Russian collection, one which dated from the artist's period as leader of the 'Salon Cubists'). Finally Le Fauconnier had settled on his own brand of neo-impressionism, which might have

been promising, had it not been marred by the incorrigibly gloomy disposition of the painter himself.

Shchukin knew what he was doing when he composed his dining room with this quintuple family portrait, the polar opposite – in identical but reduced surroundings – of the perfumed Gauguin iconostasis in his Moscow palace. The middle picture featured a sombre figure in a plumed cap playing a guitar; on either side of this canvas were four paintings of morose women, one of whom – the saddest – was naked and seen from behind. Le Fauconnier called this *Nu aux Soucis*. Elsewhere, two muted still lifes of flowers, clearly reflecting the painter's morbid cast of thought, did little to raise one's spirits.

The room was a veritable iconostasis of mourning, arranged just so by Shchukin to illustrate his farewell to collecting. These five sentinels, as allegories of the *bourgeoisie*, would keep a jealous eye on his family's well-being. People speculated that the four women surrounding 'the guitarist' Shchukin were Le Fauconnier's models: Nadezhda Shchukina, her daughter Natalya Conus, little Irina, and finally Nadezhda's sister, Aunt Vera, the *Nu aux soucis*. And in a way, as time went by, the paintings did begin to resemble the four female occupants of the house, and vice versa.

There were five Dufys in the salon: *Les Vagues, Fenêtre ouverte sur la Mer, Le Théâtre Antique de Taormina*, a drawing and a small gouache *Portrait d'un Paysan*, under which was written in Dufy's own hand '*Peint en vingt minutes pour un louis, à la suite d'une pari*' (Painted in twenty minutes, for a bet of one gold *louis*). Shchukin had chosen them because – for Dufy – they were more restrained than usual, even though the overall effect was jaunty enough. These pictures chimed harmoniously with the three brazen intruders of *Les Trois Grâces*, a large watercolour by Picasso's disciple Pedro Pruna, who had followed the master's lead back to the classical style. In particular, Pruna specialized in women of ample physical proportions.

Once the artwork was settled, all that had been left for Shchukin to do was build and decorate the room in which it was to hang. Pruna's picture imposed blue as the dominant colour, and Shchukin had selected it for that reason, working on his blue room as if Matisse himself had been at his side. Nevertheless, he had turned on its head the vanished exuberance of the Trubetskoy Palace. Lushness and jungle scenery had been slipped in by

way of a daring and heavily detailed art nouveau wallpaper, and with the rich, blue, ceramic-style patterns of a broad Turkestan carpet. On the other hand, the Louis XV sofas and wing chairs lacked the lavish embroidery and gold leaf of the pink Matisse salon in Moscow. Here in Paris, Shchukin had covered all the furniture in dark blue velvet, leaving the wood bare and ungilded. And just as it had in Moscow, the magic worked: the paintings 'came down' into the salon, which itself became a painting.

On 8 January 1936, the day after Orthodox Christmas, the family was convened in the grand salon, having just come through from the dining room, with their closest friends. The Shchukins had invited a smaller circle of intimates: 'Won't you come and share the leftovers with us?' Nadezhda had asked with her usual smile, which made it clear that any refusal would be taken as an affront (in the matter of 'leftovers', the cook, Maria Georgievna would obviously surpass herself). Sergei was listening to his wife playing a brisk, modern piece to accommodate the young people who had stayed behind. It was a perfect choice for the upright Bechstein, which was more tightly tuned than the monumental instrument Nadezhda had used in Moscow. Those present that evening were Natalya, Nadezhda's daughter, and her husband, the plump dandy Michel Catoire, and Nikolai Myasnovo, the White Russian officer in one of his impeccable English suits (one wonders where he had room to hang them in his tiny maid's room upstairs). Also in attendance were Tatiana Riabouchinska, the breathtaking star of the Monte Carlo ballet, who was Irina's friend and dancing colleague. These two were sitting in armchairs close to the pianist.

Shchukin, shrewd observer that he was, knew that his daughter would never match Tanya as a dancer. Irina was impossibly lovely sitting there; she wore a white dress with a plunging neckline, in a pose of graceful abandon as she listened to the crystalline notes flowing from her mother's fingers. *The dancer and the musician* . . . gazing surreptitiously at his daughter, Shchukin told himself that he had made a star of her: a star not of the ballet, like Tanya, but of life. Tanya was divine when she danced, just as Vera Skryabina had once been on the piano – but Irina was incomparable exactly as she was, in a setting which her father had designed as a backdrop especially for her.

Irina had grown up under a collector's watchful eye, just as Lydia had blossomed under the passionate gaze of a lover. Sergei felt a sudden pang in his heart and a metallic taste spread through his mouth. Soon Irina would have no father; having shaped her growing beauty, he would have to leave her. Would she spread her wings when he was gone?

He drew his watch from his waistcoat pocket, the Swiss fob with a gold chain that had belonged to his father. It was getting late.

He stared at the watch. Hard as he tried, he couldn't see the time. Now people were moving around him, talking to him, but he understood nothing and couldn't answer. His eyes were fixed on the watch face. Someone was holding him up and now he knew he had slipped from the chair. What would become of them all, in a world where something terrible was threatening to happen, just as it had in Russia? At least the money was in Sweden. People were speaking, he heard no sound. He wanted to apologize for the fuss. To die in his own home, in his own living room, seemed easy enough. . . Now he saw the white ceiling, with the faint nuance of blue which he and the house-painter had worked so hard to find. Something soft had been slipped beneath his head. He was lying on the carpet.

Red figures moving on the ceiling. There were five of them, lithe dancers swirling hand in hand above and around him. Now two of them were letting go – no, not letting go, beckoning him into the ring.

Left hand, right hand, they swept him away with the dance.

On 11 January 1936, Alexandre Benois published the following article in *Poslednie Novosti* (*Latest News*), the Russian-language daily paper published in Paris:

One of the most remarkable Moscow figures of the recent past has left us. Sergei Shchukin is dead. He had reached an advanced age and until the end, despite illness and the altered conditions of life amid the Russian diaspora, he had preserved the gusto, enthusiasm, passion and zest for life of a much younger man. Art fascinated him to the end and he took pains to understand and assimilate new directions in the field.

Had he been sufficiently wealthy in his later years he would certainly have collected everything the world of art had to offer, everything that was most innovative and flamboyant.

Shchukin was a highly coloured personality. I don't mean that he was bizarre in his habits, appearance, behaviour or table manners; I mean that he was brilliant, vivacious and impassioned. I remember very well how thrilled I was by his frankness and exuberance when, thirty years ago, I visited his house in Moscow for the first time. That quiet, almost provincial building in the heart of the great tumultuous city, contained marvels of a quality unmatched anywhere in the world. The impression of something unique and marvellous began to dawn on me the instant I crossed the threshold – and found myself in Paris, surrounded by everything about that capital which was most modern and most anti-conformist. The staircase was decorated with large coloured panels painted by Matisse; in the salon, the traditional moonlit nights by Aivazovsky and Greek scenes by Siemiradzki then so favoured by wealthy Russian families, had been replaced by the paintings of Monet, Renoir and Gauguin. Pictures by Cézanne had taken the place of the Tropinin portraits one might otherwise have expected. In the dining room, ranged beside an immense tapestry woven after a design by Burne-Jones (a beginner's mistake of Shchukin when he was a young man), were a number of Gauguins, while nearby was a room with its walls covered floor-to-ceiling with Picassos.

Sergei Shchukin was pilloried by the aesthetic heavyweights of Moscow, who accused him of weakness and addiction to fashion. But his collection was no caprice. On the contrary, it constituted a phenomenal exploit, for in addition to the scorn of his critics he had to contend with his own doubts. Fortunately for us all, Shchukin belonged to that minority of people who are strengthened by difficulties and whom doubt stimulates more than it demoralizes. It may well be that this struggle on two fronts, against himself and against his detractors, toughened him and gave him the courage to venture into further uncharted territory.

A strong feature of Sergei Ivanovich's character was an imperturbable good humour. He never held a grudge, even though some of the

derisory comments he had to endure were made by people who were close to him. At one time he was told, to his face, that he was insane. Nevertheless, through thick and thin he continued with his project undeterred; and I myself cannot visualize Sergei Shchukin in any other mood than a smiling one, with his eyes brimming with joy. A flicker of condescension might occasionally cross his face, but that was very rare indeed; he was fundamentally a kind-hearted, benevolent man. The courtesy with which he welcomed the hordes of visitors attracted by the fame of his collection sprang from an authentic attachment to hospitality as it used to be in Moscow in the old days. He was altogether agreeable, one of the most charming people I have ever known.

Sergei Shchukin was born into an extraordinary family of industrialists and merchants. Every one of them was a collector of some kind and whether they were interested in paintings or antiquities, all of them shared the same quest for excellence. One of the Shchukin brothers collected Russian antiquities and managed with no help from anyone else to put together a museum of extraordinary quality and depth. The second brother collected old master paintings, with a marked preference for those of Holland and France. The third brother acquired remarkable paintings by El Greco and his contemporaries, at a time when the Spanish artist had not yet attained the respect in which he is held today. And finally there was Sergei Shchukin himself, who had made it his task to put together a coherent and representative collection of modern French paintings from the late nineteenth and early twentieth centuries. He had the profound conviction that these artists were in every respect comparable to the greatest masters of the past.

The Shchukins did not collect for themselves alone. Their intention was to bequeath their collections to their country or their city. Princely bequests indeed. Their extraordinary initiative, bearing comparison with those of the Tretyakov brothers, bear proud witness to the high moral sense and patriotism of great Muscovite merchants before the revolution.

Yet, exceptional though these figures were, they did not escape the atrocities committed by the doctrinaire scoundrels who prospered in those troubled times. Dmitry Shchukin, who remained in Moscow

after the revolution, lived in wretched conditions as the guardian of his own museum. Sergei Shchukin, who was incapable of putting up with a similar situation, left the country of his birth for which he had done so much.

The paintings owned by Shchukin were later combined with the collections of Ivan Morozov. Intourist [the Soviet state tourism agency] now includes in its programmes an indispensable visit to the State Museum of Modern Western Art. They can offer a complete panorama of the recent history of the art world and memories that are beyond marvellous. Curiously it is the French who are the most surprised to discover, in Russia, so many works by their own greatest artists. Moreover the works are not minor ones but extraordinary masterpieces, among which Claude Monet's *Déjeuner sur l'Herbe* stands out. The possessions of most French museums are far from equalling the sheer wealth of these collections. One might even, somewhat precociously, congratulate the new lords of Russia for having understood and appreciated the value of these paintings, for having brought them together, and for having kept them safe. But there would have to be a touch of irony in such praise.

The extraordinary Sergei Shchukin, true to his character, fully understood that irony. Such a destiny for his treasures was hardly to be expected; but at no time did he manifest the least acrimony. The only thing that ever worried him was that the Bolsheviks might sell off his collection as they did the pictures at the Imperial Hermitage.

Shchukin was above all a patriot and a patron of the arts. But he was also understanding, humane and generous, a man of great spiritual elegance.

Postscript
The Collector of the Future

In 2014, the State Hermitage named its new modern art space 'The S.I. Shchukin and the brothers M.A. and I.A. Morozov Gallery'. Every descriptive card placed beside each work in the museums of St Petersburg and Moscow now features the name of its original collector, meaning that the name of Sergei Ivanovich Shchukin is inscribed beside all the works that he originally acquired.

In October 2016, a hundred years after his collection was taken from him, Sergei Shchukin received the homage of Paris and of the president of the French Republic. The exhibition *Icons of Modern Art: The Shchukin Collection* was staged to great acclaim in the brand new building of the Louis Vuitton Foundation, where the twenty-first-century art patron Bernard Arnault welcomed the twentieth-century art patron Sergei Shchukin back to the city of his triumph.[1]

ENDNOTES

Prologue

1. Margarita Sabashnikova, 'Journal', 12 February 1903, Manuscript Department, Pushkin Museum, F.13, coll. XI/I, inv. 17.
2. Ibid.
3. Old Believer, an adept of the Old Faith. This describes the descendants of the 1667 schism (*raskol*) who opposed the reforms of Patriarch Nikon, which were aimed at bringing the Russian Orthodox Church closer to the Greek Byzantine Church during the reign of Tsar Alexei. The symbol of this conflict was the sign of the cross: the reform introduced the practice of crossing oneself with three fingers (The Trinity); the Old Believers continued to cross themselves with two fingers (signifying the divine and earthly nature of Christ).

Chapter I The Gentleman Who Slept in His Box at the Bolshoy

1. The word derives from *shchuka*, meaning 'pike' (fish).
2. Time of Troubles: a period that began with the death of Tsar Fedor and the succession of his brother-in-law Boris Godunov in 1598. This time of instability, famine, insurrection and war with Poland ended with the establishment of the Romanov dynasty in 1613.
3. In the sixteenth century, makers of cast-iron tripods (*tagan* in Russian) for mobile kitchens populated the Taganka area on the edge of the city. By the nineteenth century, this district had become the exclusive fief of traders.
4. Merchants of the First Guild were exempt from corporal punishment. They were also authorized to open workshops and factories, to trade outside the frontiers of the empire and to own ships. As an Old Believer, Ivan Vasilevich had to abjure his faith and join the official Orthodox Church, in order to be admitted to the First Guild. He finessed this with Gogol-esque bureaucratic cunning; he registered as a *kupets* in the new port of Eysk, on the Azov Sea, where religion was not so closely controlled, in the hope that anybody would be attracted to live and work there. Probably there was a bribe involved as well, since there is no evidence whatever that Ivan Vasilevich ever set foot in Eysk. He seems nonetheless to

have quietly distanced himself from the Old Faith, reappearing as a registered *kupets* of the First Guild in Moscow in 1868.

5. Kitai-Gorod is the oldest district in Moscow, beside the present Red Square.

6. Pavel Buryshkin, *Moskva kupecheskaya* [*The Kupets in Moscow*], Vysshaya shkola, Moscow, 1991, p. 145.

7. Born in Mulhouse, France, in 1815, Albert Hubner was the brother of Émile Hubner, who invented the Hubner wool carding machine in 1851. Albert left France for Moscow in 1844, where he founded a factory to make *toiles de Jouy* printed textiles (*Indiennes*).

8. Petr Shchukin, *Vospominaniya: Iz istorii metsenatstva Rossii* [*Memoirs: From the history of art patronage in Russia*], State Historical Museum, Moscow, 1997, pp. 123–4.

9. Ibid., p. 97.

10. The owner of cotton mills and founder of banks and insurance companies, Soldatenkov was also a leading publisher of Russian literature, a bibliophile and general benefactor. Among other things, he funded the creation of a hospital for the poor, which was named after the famous medical doctor Sergei Botkin, the uncle of Sergei Shchukin and founder of Russian clinical medicine.

Chapter II Luther's Bible

1. Petr Shchukin, *Vospominaniya*, p. 96.

2. One gold rouble in 1900 was the equivalent of £9 in today's money. Such monetary values are of course relative – for example the cost of services at that time was infinitely less, whilst manufactured products were much more expensive.

3. Petr Shchukin, *Vospominaniya*, p. 9.

4. Ibid., p. 12.

5. Ibid., p. 40.

6. From the memories of the stepdaughters of S.I. Shchukin, collected in 1970 by Alexandra Demskaya, archivist at the Pushkin Museum, quoted in Alexandra Demskaya and Natalya Semenova, *U Shchukina, na Znamenke* [*Shchukin's House on Znamenka Street*], Bank Stolichniy, Moscow, 1993, p. 48.

Chapter III The Tragic Tales of the Older Brothers

1. Petr Shchukin, *Vospominaniya*, pp. 222–3.

2. Alexei Bakhrushin, *Who Collects What?* L.E. Bucheim, Moscow, 1916, p. 35.

3. Vladimir Gilyarovsky, *Moskva i moskvichi* [*Moscow and the Muscovites*], AST, Minsk, 1980, pp. 35, 40–1.

4. Ilya Bondarenko, 'Zapiski kollektzionera' ['Notes of a collector'], *Pamiatniki Otechestva* [*National Monuments Quarterly*], 29 (1993), pp. 21–34.

5. Ibid., p. 29.

6. Ibid., pp. 28–30.

7. Its official title was 'Section of the Alexander III Imperial Russian Historical Museum – Petr Ivanovich Shchukin Museum'.

8. Bondarenko, 'Zapiski kollektzionera' ['Notes of a collector'], p. 30. The main covered market for Moscow, located in Kitai-Gorod, on the far side of Red Square facing the Kremlin, which was converted into a major department store in Soviet times and known as 'GUM'.

Chapter IV Dmitry Shchukin

1. Andrei Bely (1880–1934), symbolist writer and commentator, author of the novel *Petersburg*.

2. Petr Shchukin, *Vospominaniya*, p. 184.
3. Ibid.
4. V. Blokh, 'Dutch masters in Russian collections', *Chez les Collectionneurs*, 8–9 (1921), p. 11.
5. Mikhail Savostin, St Petersburg, State Russian Museum, Manuscript Department, F. 131, inv. 1.
6. Ilya Ostroukhov (1858–1929) learned about painting with Kiselev, Repin and Serov. He was the husband of Nadezhda Botkina, daughter of Petr Botkin who owned the tea firm of P.K. Botkin & Sons, and uncle of the Shchukin brothers. A collector of Russian and French art, he rediscovered icons as an art form. From 1899 to 1912, almost without interruption, he was the administrator of the Tretyakov Gallery.
7. Painted by Johannes Vermeer in 1670–71, *The Allegory of the Catholic Faith* measured 1m x 1m, and is now at the Metropolitan Museum of Art in New York.
8. Mikhail Savostin, St Petersburg, State Russian Museum, Manuscript Department, F. 131, inv. 1.
9. Dmitry Shchukin, letter to the editor, *Starye godi* [*Years Gone By*], January 1914, p. 68.
10. In 1922, the State Fine Arts Museum, built in 1912, became the Moscow Museum of European Classical Art, while the Tretyakov Gallery was entirely given over to Russian art. The Fine Arts Museum took over the collection of Dmitry Shchukin, which was the smallest in terms of the number of pictures, but a cornerstone of quality. It contained 127 paintings (78 Dutch and Flemish, 26 French, 10 German, 6 Italian, 3 English and 4 of other origins), 19 pastels, and assorted drawings, engravings, statuettes, enamels and stained-glass.
11. In the late 1920s, the painter Yury Annenkov, who left a diary of this period, visited the Trubetskoy Palace with Leon Trotsky after it had been transformed into the State Museum of Modern Western Art. Confusing Dmitry with Sergei, Trotsky was indignant that the great collector, who had brought such treasures to the young republic, had been relegated to a small room beside the kitchen of his palace. This legend was repeated by many of the authors who have written about Sergei. Yury P. Annenkov, *Dnevnik moihk vtrech: Tzikl tragediy* [*The Diary of My Encounters: A Round of Tragedies*], Inter-Language Literary Associates, New York, 1966, vol. 2, p. 275.

Chapter V Ivan Shchukin

1. Ivan Shchukin, *Aquarelles Parisiennes*, Paris, 1897, p. 16. Self-published limited edition, twenty-five copies in Russian, twenty-five copies in French.
2. Vanya, diminutive of Ivan.
3. Igor Grabar, *Avtomonografia: Moya zhizn* [*Automonograph: My life*], Respublika, Moscow, 2001, p. 37.
4. Ivan Shchukin, *Aquarelles Parisiennes*, p. 16.
5. Count Ernst Johann von Biron (1690–1772), a favourite of the tsarina and regent of the Russian Empire in 1740. Vladimir and Ivan Shchukin had started a collection of old engravings, which they passed to their brother Petr when they left for Paris (Petr Shchukin, *Vospominaniya*, p. 208).
6. Letter from Ivan Shchukin to Vyacheslav Ivanov, 18 January 1902, Moscow, Russian State Library, Manuscript Department, F. 109, Kart. 39, inv. 52.
7. Andrei Bely, *Mezhdu dvukh revolyutsii* [*Between Two Revolutions*], Khudozhestvennaya literatura, Moscow, 1990, p. 51.
8. Diary of Alexandre Benois, 1906. 'Serge' was probably Sergei Diaghilev, who at the time was preparing the first exhibition of Russian art at the Grand Palais with Benois, for the Salon d'Automne 1906.

9. Ivan Shchukin, *Aquarelles Parisiennes*, p. 32.
10. Letter from Ivan Shchukin to Ilya Ostroukhov, 2 January 1901, Tretyakov Gallery, Manuscript Department, F. 10, inv. 7236.
11. Catalogue de Tableaux Modernes, Pastels & Dessins, Hôtel Drouot, Room no. 9, 24 March 1900.
12. Letter from Ivan Shchukin to Ilya Ostroukhov, 2 January 1901, Tretyakov Gallery, Manuscript Department, F. 10, inv. 7236.
13. Today it is known as *The Vision of the Apocalypse*, Metropolitan Museum of Art, New York.
14. John Richardson, *Life of Picasso*, vol. I, Jonathan Cape, London, 1991, pp. 429–31.
15. Sergei Merkurov, *Vospominaniya, pisma, stati, zametki: Suzhdeniya sovremennikov* [*Memoirs, Letters, Essays, Notes: Comments of contemporaries*], Kremlin Multimedia, Moscow, 2012, p. 122.
16. Maxim Kovalevsky, *Moya zhizn: Vospominaniya* [*My Life: Memoirs*], Rosspen, Moscow, 2005, pp. 88–9.
17. Alois Hauser (1831–1909), art restorer and curator of the Karl-Friedrich Museum in Berlin.
18. Letter from Dmitry Shchukin to his brother Petr Shchukin, 1/14 April 1905, State Historical Museum, Manuscript Department, F. 265, inv. 208.

Chapter VI An Oligarch in Moscow

1. Bely, *Between Two Revolutions*, p. 51.
2. Beverly Whitney Kean, *All the Empty Palaces: The merchant patrons of modern art in pre-revolutionary Russia*. Barrie & Jenkins, London, 1983, p. 135.
3. Letter from Vera Botkina to Nadezhda Botkina, 10 October 1884, State Historical Museum, Manuscript Department. F. 122, inv. 476.
4. Charles Frederick Worth (1825–95), the English inventor of Paris *haute couture*. Worth created the so-called *tournure* (French bustle) dress for the Empress Eugénie, which being light in front of the legs made it much easier for fashionable women to walk untrammelled by hoops. In this way French women – who naturally imitated Eugénie – were freed by Worth from the tyranny of stiff crinolines.
5. The 'Ivan' was a basic one-horse cab with room for two passengers; a sleigh in winter, four-wheeled in the summer; the driver, whose name was invariably Ivan, would appear instantly when summoned to take you anywhere you wanted in Moscow for a few kopecks.
6. Letter from Sergei Shchukin to Petr Shchukin, 16 April 1891, State Historical Museum, Manuscript Department. F. 265, inv. 213.
7. Letter of 18 October 1895, aboard RMS *Caledonia*, State Historical Museum, Manuscript Department. F. 265, inv. 213.
8. Letter of 31 October 1895, Poona, ibid.
9. Letter of 27 October 1895, Candala, ibid.
10. Letter of 12 November 1895, Lahore, ibid.
11. Nadezhda Lamanova (1861–1941) was the foundress of *haute couture* in Russia. She created costumes for Stanislavsky's Theatre (MKHAT). After the revolution, she developed a line of clothing for the people and imagined Art Deco clothes *à la russe* for the 1925 Paris Decorative Arts Exhibition. These were immensely successful and earned her the nickname of the 'Russian Coco Chanel'. She also designed the costumes for Eisenstein's epic film *Alexander Nevsky*. Nadezhda Lamanova died of seizure and stress in October 1941, on a bench in front of the Bolshoy Theatre. Moscow was threatened by the German invasion; she had arrived to find the doors of the MKHAT locked, the theatre evacuated, and its revered costume designer forgotten and left behind.
12. Leonid Pasternak, *Zapisi raznykh let* [*Notes on Various Years*], Sovetskiy Khudozhnik, Moscow, 1975, p. 63.

13. Vasily Petrovich Surikov (1848–1916), a painter from Krasnoyarsk in Siberia, who received a master's degree from the Academy and was a member of the 'Wanderers' group. Surikov specialized in large historical and academic compositions. His daughter Olga married the modernist painter Petr Konchalovsky (1876–1956); the filmmakers Andrei Konchalovsky and Nikita Mikhalkov are his great-grandsons). Surikov is chiefly remembered for his painting *The Boyarina Morozova*, depicting the heroine's departure into exile and death, at Borovsk (cradle of the Shchukin family).
14. Ivan Pokhitonov (1850–1923), a landscape painter from Ukraine, studied and worked in Paris, notably in Montmartre with Eugène Carrière, then moved to an area close to Liège in Belgium. He often returned to Russia, where he belonged to the 'Wanderers' group. Pokhitonov gave a number of pictures to Pavel Tretyakov's gallery.
15. Fedor Bronnikov (1827–1902), attended the Rome Academy and later settled in Rome. He was a specialist in scenes from antiquity, Italian landscapes and scenes from ordinary Russian life. He joined the 'Wanderers'. Much appreciated by Pavel Tretyakov, Bronnikov exemplified the Russian academic *pompier* style, which was used as a vehicle for social criticism by the 'Wanderers'.

Chapter VII Strangers on a Train

1. Vladimir Solovev (1853–1900), a well-known Russian mystical philosopher and proponent of ecumenism and the union of Christian religions. He had recently died, aged forty-seven, on 13 August 1900.
2. Probably a reference to Edgar Maxence (1871–1954), a French symbolist.
3. Vasily Perepletchikov, *Dnevnik khudozhnika: Ocherki* [*Diary of the Artist: Essays*], Gosudarstvenniy Russkiy Muzey [State Russian Museum], Moscow, 2012, pp. 151–2.
4. David Burlyuk et al., *Poschechina obshestvennomu vkusu* [*A Slap in the Face of Public Taste*], Moscow, 1913, pp. 105–6.
5. Perepletchikov, *Diary of the Artist*.
6. The Nabis were a group of Post-Impressionist avant-garde artists active in France in the 1890s, including Pierre Bonnard, Édouard Vuillard and Maurice Denis.
7. Botkin's Parisian cousin, Ivan Shchukin, wrote that he was little known in Russia; there were only vague rumours about him. Since Russians never saw his work, they tended to dismiss him. But in Paris, Fedor Botkin was spotted by Sergei Diaghilev and participated in the first World of Art exhibitions in 1898–99. In the early 1900s, when Russia had finally accorded him some recognition, he developed a hereditary psychiatric illness and had to stop painting. He died in 1905 in a clinic.
8. Durand-Ruel was unhappy with Monet selling paintings direct to a client and bypassing the gallery.
9. We know that Cassirer paid 30,000 francs for it, which was probably the bottom line. Probably Shchukin paid upwards of 40,000 francs; far from the figure of 100,000 francs which was talked about.
10. Alexandre Benois, 'Letters from the World Exhibition' [*Pisma so Vsemirnoi Vystavki*], in *Mir Iskusstva* [*World of Art*], 4 (1900), p. 203.
11. Grabar, *Automonograph*, p. 82.
12. Igor Grabar, 'Upadok ili vozrozhdenie?' ['Decadence or renaissance?'], *Niva* (St Petersburg), 2 (1897), p. 314.
13. Grabar, *Automonograph*, p. 241.
14. Alexandre Benois, *Moi vospominania* [*My Memories*], 2 vols, Nauka Publihsers, Moscow, 1980, vol. 1, p. 648.
15. Ivan Kramskoi, *Pisma, Statyi* [*Letters and Articles*], Iskusstvo, Moscow, 1965, vol. 1, p. 213.

16. At an exhibition of French art and industry held in Moscow from 29 April to 6 October 1891, the Russian public for the first time was able to see the works of Edgar Degas and Claude Monet, including a canvas from the 'Meules' series.

17. Vasily Kandinsky, *Steps: A Text Written by the Artist*, IZO, Narkompros, Moscow, 1918, p. 11.

18. Baron Stieglitz (1814–84) was an industrialist and governor of the Imperial State Bank of Russia. At his own expense he created the St Petersburg Central Technical Drawing School, followed by the Museum of Decorative Arts. Like the Fine Arts Academy, the Stieglitz Academy of Art and Industry still exists in its historic building.

19. A major Russian portraitist and pupil of Repin, Valentin Serov (1865–1911) took advantage of a commission to paint Nicholas II to persuade the tsar to provide a subsidy to save *World of Art*.

20. Jacques-Émile Blanche (1861–1942), whose grandfather was the psychiatrist of Gérard de Nerval and whose father treated Guy de Maupassant, remains a glory of literary portraiture on account of his painting of Marcel Proust.

21. Alexandre Benois, 'Besedi khudozhnika: Ob impressionizme' ['An artist's opinion: On impressionism'], *Mir Iskusstva* [*World of Art*] (St Petersburg), 6 (1899), p. 50.

Chapter VIII The Storm

1. Andrei Bely, *Nachalo veka* [*The Turn of the Century*], Khudozhestvennaya literatura, Moscow, 1990, p. 264.

2. Boris Mikhailovich Kustodiev (1874–1927) was an academic painter and the pupil and assistant of Repin. He evolved a highly personal manner of his own, a mix of rigorous academicism with the colourful, naïve, old Russian style.

3. Wanda Landowska (1879–1959), celebrated Polish pianist and teacher who rediscovered and repopularized the harpsichord. She lived and taught music in Paris, where she founded a harpsichord school. The Shchukins would have needed serious connections – and serious money – to have her play at a private evening.

4. Kustodiev's error: Shchukin never owned or displayed any paintings by Manet, only by Monet.

5. Letter from Boris Kustodiev to his wife, 13 May 1909. Quoted in B.M. Kustodiev, *Pisma, Statyi, Zametk, Intervyu* [*Letters, Articles, Remarks, Interviews*], Khudozhnik RSFSR, Leningrad, 1967, p. 103.

6. Perepletchikov, *Diary of the Artist*.

7. Alexei Sidorov, conversation recorded by Alexandra Demskaya in 1974. Memories of an interview with Shchukin during the 1920s. First publication: Demskaya and Semenova, *Shchukin's House*, p. 94.

8. Ivan Zhilkin, 'V Moskye' ['In Moscow'], *Russkoe Slovo* [*Russian Word*], 22 October 1911.

9. The strike's original aim was to obtain the reinstatement of four workers who had been dismissed from the Putilov steel plant. The procrastination of the authorities, the exhortations of Father Gapon, an Orthodox priest who had become a union leader, and the behind-the-scenes manoeuvring of clandestine revolutionaries had transformed a humble petition to the tsar into a full-fledged demand for a democratic constitution.

10. Letter from Valentin Serov to Ilya Repin, 20 January 1905, quoted in Valentin Serov, *Valentin Serov v Memuarakh, Dnevnikah i perepiske sovremennikov* [*Memoirs, Diaries and Correspondence with Contemporaries*], Khudozhnik RSFSR, Leningrad, 1971, vol. 1, pp. 6–7.

11. *Sergei Diagilev I russkoe iskusstvo* [*Sergei Diaghilev and Russian Art*], Izobrazitelnoe Isskustvo, Moscow, 1982, vol. 1, p. 194.

12. Bely, *Between Two Revolutions*, p. 51.

13. Ekaterina Kamarovska, *Vospominaniya* [*Memoirs*], Sakharov, Moscow, 2003, p. 365.

14. Diminutive for Sergei.

15. Private archive, Moscow.

Chapter IX The Debacle

1. Letter from Lydia Shchukina to Petr Shchukin, 30 January/12 February 1906, State Historical Museum, Manuscript Department, F. 265, inv. 218.
2. *Moskovsky Listok* [*Moscow Broadsheet*], 27 March/9 April 1906, p. 3.
3. *Russkie Vedomosti* [*Russian Gazette*] (Moscow), 29 March/11 April 1906, p. 2.
4. Janet Flanner, 'King of the wild beasts', in Flanner, *Men and Monuments: Profiles of Picasso, Matisse, Braque, and Malraux*, Hamish Hamilton London, 1957, p. 90.
5. Archives of Jean-Pierre Manguin, Avignon.
6. Jack D. Flam, *Matisse on Art*, E.P. Dutton, New York, 1978, p. 133.
7. Kuzma Petrov-Vodkin (1878–1939), symbolist painter affiliated with the Blue Rose, who went on to teach in Leningrad after the revolution; influenced by Matisse and by Russian icons, author of *Red Horse Bathing* (*Le Bain du cheval rouge*).
8. Preface to Société du Salon d'Automne, *Catalogue des ouvrages de peinture, sculpture, dessin gravure, architecture et art décoratif exposés au Grand Palais des Champs-Élysées du 6 Octobre au 15 Novembre 1906* [*Catalogue of Paintings, Sculptures, Drawings, Engravings, Architecture and the Decorative Arts exhibited at the Grand Palais des Champs-Elysées from 6 October to 15 November 1906*], Paris, 1906. See https://archive.org/details/cataloguedesouvr1906salo

Chapter X In the Footsteps of Moses

1. The Weinzettelwand Semmering; postcard from Sergei Shchukin to Petr Shchukin, State Historical Museum, Manuscript Department, F. 265, inv. 213.
2. Letter dated 27 October 1907, State Historical Museum, Manuscript Department, F. 265, inv. 213.
3. Original manuscript, Pushkin Museum, Manuscript Department, F.13, coll. XI. We have excluded repetitions and routine remarks.
4. Valery Bryusov (1873–1924), leading Russian symbolist poet, famous and scandalous in his youth for his one-verse poem 'Oh, close again your pale, pale thighs'.
5. Carlo Dolce (1616–86), Florentine religious painter.
6. Viktor Vasnetsov (1848–1926), an academic painter, a 'Wanderer' and a pupil of Repin, Vasnetsov specialized in scenes from Russian folk tales and legends; he designed the layout for the Tretyakov Gallery.
7. Mikhail Nesterov (1862–1942), Muscovite 'Wanderer' and symbolist, painter of Russian religious and historical scenes.
8. Marguerite Duthuit, Matisse's daughter, when she was interviewed in the late 1970s by Beverly Whitney Kean, claimed that Shchukin found a reproduction of one of her father's works on the wall of one of the monks' cells at St Catherine's monastery. This is not corroborated by Shchukin's own description, written in real time at the monastery, of his meeting with the icon-painting monks there. Madame Duthuit seems to have embroidered the facts; but after an interval of sixty years, her story testifies to the vast impression made on the Matisse family by the arrival from the Holy Land of this enormously wealthy Russian, who in a single year completely transformed her father's destiny.
9. Konstantin Korovin (1861–1939), Moscow painter, the first Russian impressionist; in 1900, he was made painter-decorator and in 1910 artistic director of the Imperial Theatres of Moscow and St Petersburg. Korovin emigrated to France in 1921.

Chapter XI The Price of a King's Wife

1. Maxim Kovalevsky collated several reports of 'Jean de Wagram's' last New Year's Eve party in Paris, 1907–8; Kovalevsky, *My Life*, pp. 88–9).
2. Details from the invoice for the funeral. The graves would be for Sergei, his second wife Nadezhda and their last child, Irina (as yet unborn), as well as for Ivan himself.

3. All the details regarding Ivan Shchukin's death and his estate are from the recent exhaustive research by A.V. Asheshova, *Novoe o biografii I.I. Shchukina po materialam frantzuskikh arkhivov* [*New Findings on the Life of I.I. Shchukin in the French Archives*], St Petersburg, March 2018.

4. *Russkoe Slovo* [*Russian Word*] (Moscow), 18 June 1908.

5. E. Belov, 'In memoriam: Under the hammer', *Russkoe Slovo* [*Russian Word*] (Moscow), 18 November 1908.

6. Letter from Ivan Sergeevich to Alexandra Demskaya, 3 December 1972, Pushkin Museum, Manuscript Department.

7. Nikolai Vishnyakov (1844–1927), a Moscow dealer, a passionate geologist and collector of rare stones.

8. N.P. Vishnyakov, 'Memoirs', Moscow Central Historical Archive, F. 1334, inv. 10, part. IV, pp. 115–16.

9. Jakob Tugendhold, 'Frantsuzskoe sobranie S.I. Shchukina' ['The French collection of S.I. Shchukin'], *Apollon*, 1–2 (1914), pp. 19–20.

10. Sergei Makovsky, *Stranitsi khudozhestvennoi kritiki* [*Notes of an Art Critic*], St Petersburg, 1913, p. 179.

11. The art critic Jakob Tugendhold (1882–1928) wrote the major 1914 article in *Apollon* on the subject of the Shchukin collection. Shchukin named him artistic director of the gallery, a function which was interrupted by the outbreak of war.

12. Paul Gauguin and Daniel de Monfreid, *Lettres de Paul Gauguin à Daniel de Monfreid*, ed. Victor Ségalen, G. Crès et Cie, Paris, 1918.

13. Magali Rougeot, 'Gustave Fayet – Itinéraire d'un artiste collectionneur' ['Gustave Fayet – Itinerary of an Artist and Collector'], dissertation, Université de Paris X – Nanterre, École du Louvre, 2011, p. 215.

14. Invoice held by the Art Library of the Victoria and Albert Museum. See Linda Parry, *William Morris Textiles*, Weidenfeld and Nicolson, London, 1983, pp. 113–14 and note 41.

15. Error or not, Shchukin has remained in good company with this tapestry. Example Number 8, commissioned at the time by a French banker, was eventually bought by Pierre Bergé and Yves Saint-Laurent, who finally gifted it to the Musée d'Orsay.

16. In 1910, Ivan Morozov bought *Nature Morte aux Perroquets* from Gustave Fayet for 27,000 francs, but rumours abounded in Moscow about the crazy sums Shchukin was spending on his collection of paintings.

Chapter XII *Harmonie en Rouge*

1. Gertrude Stein, *The Autobiography of Alice B. Toklas*, Harcourt, Brace & Co., New York, 1933, p. 10.

2. Ibid. That evening, all the talk was of the forthcoming opening of the Salon des Indépendants on Friday, 20 March. We are thus talking about Saturday, 14 March 1908, even if Gertrude, who was not very accurate when it came to dates, is mixing up works shown in 1908 with those shown in 1907. Furthermore, in her account everyone is summoned to a temporary construction in the Jardin des Tuileries . . . for the 1909 Salon. Despite Stein as writer/ghostwriter conflating, for the sake of drama, the events of three Salons des Indépendants in 1907, 1908 and 1909, the main events described nevertheless confirm that Mrs Toklas's initiation was to the Indépendants of 1908 – precisely when Sergei Shchukin first visited the Steins.

3. Karl Ernst Osthaus (1874–1921), German collector and art patron, who bought Matisse's *Les Baigneurs à la tortue* in 1908.

4. Kathleen Brunner, Anne Dumas et al., *Matisse and His Textiles: The fabric of dreams*, Royal Academy of Arts, London, 2004.

5. Eugène Druet (1867–1916), who had started out as a café owner on the Place de l'Alma, became a passionate photographer and a pioneer of colour reproductions of artworks. Using Lumière autochrome plates, he developed what came to be known as the Druet photographic procedure. Later he opened a gallery on the rue du Faubourg Saint Honoré where he sold paintings and negatives and became a kind of official photographer for contemporary painters.

6. Letter from Ilya Ostroukhov to Alexandra Botkina, Tretyakov State Gallery, Manuscript Department, F. 48, inv. 524.

7. Kostenevich and Semenova, *Collecting Matisse*, p. 161.

8. *Les Joueurs de Boules*, State Hermitage, St Petersburg.

9. Kostenevich and Semenova, *Collecting Matisse*, letter of 30 July 1908, p. 162.

10. Pierre Schneider, *Matisse*, Flammarion, Paris, 1992, p. 316.

11. Kostenevich and Semenova, *Collecting Matisse*, p. 92.

12. Ibid., p. 162.

13. *Gil Blas* (Paris), 30 September 1908 (author's emphasis).

14. *Mercure de France* (Paris), 1 November 1908.

15. Isaac Grünewald (1889–1946), modernist Swedish painter and writer who was responsible for the frescoes of the Grünewald Hall, where the Nobel Prizes are presented.

16. Hilary Spurling, *The Unknown Matisse: A life of Henri Matisse: Vol. I, 1869–1908*, Hamish Hamilton, London and New York, 1998, p. 419.

Chapter XIII The Two Orphans

1. Charles Etienne, interview with Henri Matisse, *Les Nouvelles*, 12 April 1909.

2. Kostenevich and Semenova, *Collecting Matisse*, p. 163.

3. In the event there were only two girls. See below for their stories.

4. Kostenevich and Semenova, *Collecting Matisse*, p. 163.

5. Nikolai Ryabushinsky (1877–1951), scion of a wealthy *kupets* family, was a sort of Muscovite Diaghilev. A painter and collector, he founded and published the lavish revue *Zolotoe Runo* [*Golden Fleece*] (1906–9), defending the Russian symbolism represented by the painters Pavel Kuznetsov, Mikhail Vrubel, Viktor Borisov-Musatov and the writer Andrei Bely, whose name appears frequently in this book.

6. Serezha is the Russian diminutive for Sergei. *Dyadya* means 'uncle', but also an old man whom one knows well.

7. Baba, in popular slang, means 'woman', and Liza is the Russian diminutive for Elizaveta (Elizabeth).

8. Anna Titova, speaking to Alexandra Demskaya, 1970s.

9. Kostenevich and Semenova, *Collecting Matisse*, p. 164.

10. Ibid., letter of 31 March 1909.

11. Ibid., letter of 31 March 1909.

12. Giverny is a commune in northern France, the location of Claude Monet's garden and home.

13. As St Petersburg was renamed early in the war.

14. Lev (Leon) Conus (1871–1944) collaborated with Tchaikovsky, Rachmaninov and Skryabin. In 1920, he emigrated to Paris, where he took part in the founding of the Rachmaninov Russian Conservatory. After 1935 he was a piano teacher in Cincinnati.

15. Kostenevich and Semenova, *Collecting Matisse*, letter of 30 May 1909, p. 164.

16. *La Danse 1*, now at the Metropolitan Museum of Art in New York.

17. Kostenevich and Semenova, *Collecting Matisse*, p. 178.

18. Letter from Sergei Shchukin to Petr Shchukin, 21 December 1909, State Historical Museum, Manuscript Department. F. 265, inv. 213.

Chapter XIV Quo Vadis?

1. *Utro Rossii [Russia's Morning]*, Saturday, 9/22 January 1910.
2. Ibid.
3. Diminutive of Grigory.
4. Diminutive of Ekaterina.
5. One of his nephews, Leon Tarasov, emigrated to France and became a writer and academician under the pseudonym of Henri Troyat.
6. Vishnyakov, 'Memoirs'.
7. Sergei Vinogradov, *Segodnya [Today]* (Riga), 19 January 1936.
8. Bely, *Between Two Revolutions*, p. 51.
9. Vishnyakov, 'Memoirs'.
10. Penance imposed by the Orthodox Church, in which divorce is tolerated but carefully managed.

Chapter XV *La Danse and La Musique*

1. Natalya Nordman-Severova, *Intimnye stranitsy [Intimate Pages]*, St Petersburg, 1910, p. 154.
2. Madame Nordman-Severova was clearly confusing 'Sizelet' (Sisley) and Cézanne, in describing Shchukin's *La Montagne Saint-Victoire* as being of pre-cubist inspiration.
3. Nordman-Severova, *Intimate Pages*, pp. 155–6.
4. Quoted in ibid.
5. *Fantasio* (Paris), 105, 1 December 1910, pp. 299–300.
6. P. Strotsky, 'Iz Parizha' ['Report from Paris'], *Odessky Listok [Odessa News]* (Odessa), 267.
7. See, especially, Schneider, *Matisse*, p. 277ff.
8. Kostenevich and Semenova, *Collecting Matisse*, p. 166.
9. Ibid.
10. The expression *pompier*, used to mock the supporters of academic painting, comes from the helmets worn by Greek and Roman figures in nineteenth-century pictures of antiquity, which resembled the headgear of contemporary French firemen.
11. Now in the State Hermitage Museum.
12. Quoted in Hilary Spurling, *Matisse the Master: A life of Henri Matisse: Vol. II, 1909–1954*, Hamish Hamilton, London and New York, 2005, p. 57.
13. Kostenevich and Semenova, *Collecting Matisse*, p. 35.
14. Ibid., p. 168.
15. Ibid.
16. Alexandre Benois, 'Khudozhestvennie pisma' ['Letters on Art'], *Rech [Discourse]* (St Petersburg), 4/17 February 1911.
17. Boris Ternovets, *Pisma, Dnevniki, Statii [Letters, Journals, Articles]*, Sovetskiy khudozhnik, Moscow, 1977, p. 121.
18. Ivan Zhilkin, 'V Moskye' ['In Moscow'].
19. Sergei Vinogradov, *Prezhniaya Moskva: Vospominaniya [Old Moscow: Memories]*, MultiCentrs, Riga, 2001, p. 132.
20. Kostenevich and Semenova, *Collecting Matisse*, p. 167.
21. Jakob Tugendhold, *Pervy muzei novoy zapadnoy zhivopisi [The First Museum of Modern Western Art]*, Moscow, 1923.
22. Kostenevich and Semenova, *Collecting Matisse*, p. 168.
23. Ibid., letter of 5 January 1911, p. 169.

Chapter XVI The City of All-Night Revels

1. Kostenevich and Semenova, *Collecting Matisse*, p. 24.
2. Spurling, *Matisse the Master*, p. 88.

3. *Sadko* was an opera by Nikolai Rimsky-Korsakov. Kostenevich and Semenova, *Collecting Matisse*, p. 24.
4. Pavel Kharitonenko (1852–1914), the Moscow sugar magnate, and his wife, were both collectors. Their townhouse was on the other bank of the Moskva River, opposite the Kremlin; since 1931, it has been the residence of the British ambassador.
5. Ibid., p. 30.
6. Ibid., p. 31.
7. Ibid. 'V *Letuchei myshi*: Nabroski s natury' ['The *Chauve-Souris*: Sketches from life'], *Vechernyaya Gazeta* [*Evening News*], 2 November 1911.
8. Kostenevich and Semenova, *Collecting Matisse*, p. 52.
9. Spurling, *Matisse the Master*, p. 88.
10. Kostenevich and Semenova, *Collecting Matisse*, p. 27.
11. Bely, *Between Two Revolutions*, p. 198.
12. Ibid.
13. Kean, *All the Empty Palaces*, p. 216.
14. Kostenevich and Semenova, *Collecting Matisse*, p. 34.
15. Georg-W. Költzsch (ed.), *Morozov and Shchukin, the Russian Collectors: Monet to Picasso*, Museum Folkwang, Bild-Kunst, Essen, 1993, p. 329.
16. Tugendhold, 'Frantsuzskoe sobranie S.I. Shchukina' ['The French collection of S.I. Shchukin'], pp. 24–5.
17. His Matisses consisted of thirty-seven oils and one drawing, to be exact.

Chapter XVII Picasso the Hypnotist

1. Alexandre Benois, 'Khudozhestvennie pisma: Novie napravleniya v zhivopisi' ['Letters on art: New directions in painting'], *Rech* [*Discourse*] (St Petersburg), 20 December 1912/2 January 1913.
2. Ibid.
3. Clovis Sagot (*c.* 1870–1913), French art dealer known as 'Le Frère Sagot' to distinguish him from his brother, a publisher and bibliophile.
4. Fernande Olivier, *Picasso et ses amis* [*Picasso and His Friends*], Librarie Stock, Paris, 1933, p. 118 (2nd edn, 1954, p. 143).
5. Reproduced in Richardson, *Life of Picasso*, vol. 1, p. 392.
6. Gertrude Stein, *Picasso*, éditions Christian Bourgois, Paris, 2006, p. 39.
7. Gertrude Stein and Pablo Picasso, *Correspondance* [*Correspondence*], Gallimard, Paris, 2005, p. 87.
8. John Richardson, *A Life of Picasso*, vol. 2, *1907–1917*, Alfred A. Knopf, New York, 2012, pp. 87–9.
9. Nikolai Rudin, 'V galerii Shchukina vospominaniya' ['In the gallery of Shchukin'], preserved in the Russian State Art and Literature Archives (RGALI), Moscow, cited by Demskaya and Semenova, *Shchukin's House*, p. 117.
10. D.-H. Kahnweiler and G. Cremieux, *My Galleries and Painters*, New York, Viking, 1971.
11. Ibid.
12. Cards from the Kahnweiler Gallery with black-and-white photographs of works by Picasso and Derain were discovered by the author, Natalya Semenova, and Alexei Petukhov, at the Pushkin Museum visual department in Moscow.
13. Benois, 'Khudozhestvennie pisma' ['Letters on art'].
14. Zhilkin, 'V Moskve' ['In Moscow'].
15. M.V. Nesterov, *Vospominaniya* [*Memoirs*], Sovetskiy Khudozhnik, Moscow, 1989, p. 305.
16. K.S. Petrov-Vodkin, *Khlynovsk, Prostranstvo Evklida, Samarkandia* [*Khlynovsk, Euclidean Space, Samarkandia*], Iskusstvo, Leningrad, 1982, p. 366.
17. Nikolai Berdyaev, 'Picasso', *Sofia*, 3 (March 1914), pp. 57–62.
18. Benois, 'Khudozhestvennie pisma' ['Letters on Art'].

Chapter XVIII Portrait of a Chinese Patriarch

1. Shchukin also bought Matisse's first Moroccan pieces, *Les Poissons Rouges* and *Amido le Marocain*, at this time.
2. Tugendhold, 'Frantsuzskoe sobranie S.I. Shchukina' ['The French Collection of S.I. Shchukin'], pp. 27–8.
3. This portrait is now at the Museum of Modern Art (MoMA), New York.
4. Xan (Christian Cornelius) Krohn (1882–1959) moved to Kiev, his wife's home town, in 1908. In 1915, the couple moved again to Moscow. Krohn returned to Norway after the revolution.
5. Letter from Sergei Shchukin to Petr Shchukin, 19 May 1912, State Historical Museum, Manuscript Department, F. 65, inv. 213.
6. Letter of 13 July 1912, State Historical Museum, Manuscript Department, F. 65, inv. 213.
7. The French works that Sergei did not buy from Petr stayed with his own inventory, eventually coming to rest in the Historical Museum, to which he had bequeathed everything in 1905. In the early 1920s, when the Soviet authorities were dividing up private collections according to the themes of the various new museums, these works were placed in the collections of the State Museum of Modern Western Art (GMNZI, see above), where they joined the Shchukin and Morozov collections (Mikhail Morozov's collection, having been given by his widow to the Tretyakov Gallery, went the same way).
8. The term coined by Rousseau to define the new style which he had created by combining green jungle backgrounds with powerful portraits.
9. Popular Russian prints inspired by literature, religion and folk tales. The *lubok* was in some ways a Russian version of the French *image d'Épinal*.
10. The Académie Ranson, founded in 1908 by the painter Paul-Élie Ranson. Among those teaching there were several Nabi artists.
11. Költzsch, *Morozov and Shchukin, the Russian collectors*, p. 241.
12. Natalya Polenova, 'Otryvki iz vospominanii' ['Extracts from memoirs'], *Panorama Iskusstv* [*Arts Panorama*] (Moscow), 10 (1987), p. 183.
13. Otto Grautoff, *Die Sammlung Serge Stchoukine in Moskau* [*The Moscow Collection of Sergei Shchukin*], Kunst und Kunstler, Berlin, 1919, pp. 81–97.
14. Nadezhda Shchukina to her grandson.
15. Kostenevich and Semenova, Collecting Matisse, p. 176.
16. Spurling, *Matisse the Master*, p. 143.
17. Kostenevich and Semenova, *Collecting Matisse*, p. 176; 'Nyschny' was the Nizhny Novgorod Fair.
18. Ibid., p. 177.

Chapter XIX The Acropolis of the Arts

1. Letter from Vasily Kandinsky to Gabriele Münter, 7 November 1912, archives of the G. Münter and J. Eichner Foundation, Munich. Quote from Költzsch, *Morozov and Shchukin, the Russian collectors*, p. 143.
2. Letter of 9 November 1912, archives of the G. Münter and J. Eichner Foundation, Munich.
3. Letter of 7 November 1912, archives of the G. Münter and J. Eichner Foundation, Munich.
4. Sergei Shcherbatov, *Khudozhnik v ushedshei Rossii* [*An Artist in the Russia of Old*], Soglasie, Moscow, 2000, p. 33.
5. Ternovets, *Letters, Journals, Articles*, p. 119.
6. Shcherbatov, *An Artist in the Russia of Old*, p. 34.
7. A street in central Moscow.
8. Shcherbatov, *An Artist in the Russia of Old*, p. 34.

9. The Tramway V Exhibition was the first exhibition of futurist Russian painting. It opened on 3/16 March 1915 in Petrograd.

10. Antonina Sofronova, *Zapiski nezavisimoy: Dnevniki, pisma, vospominaniya* [*Notes of an Independent: Notebooks, letters, memoirs*], RA Publishing, Moscow, 2001, p. 60.

11. After 1937, this became the Pushkin State Museum of Fine Arts.

12. Pushkin Museum, Manuscripts Department. F. 13, coll. XI, inv. 12.

13. Pushkin Museum, Manuscripts Department. F. 13, coll. XI, inv. 12.

14. Today, all the items in the collection have been traced except the Matisse reproduction and Borisov-Musatov's watercolour. What appears to be a small painting of a young woman's head, noticeable when zooming in on the 1914 photograph of the Gauguin dining room, was not included in the inventory. A portrait identical in size and layout, signed by Shchukin's cousin and friend of the early collecting years, the painter Fedor Botkin, was on view in Shchukin's Paris apartment from the early 1920s and is still in the family collection. But the circumstances of its departure from the Trubetskoy Palace before October 1918, whether it remained with Sergei Shchukin, and indeed the identity of the mysterious woman are all unknown.

Chapter XX The Exiles

1. Prince Illarion Vasilchikov, *Vospominaniya* [*Memoirs*], Olma Press, Moscow, 2002, p. 152.

2. The execution of Nicholas II was announced on 19 July in the Moscow press. The shooting of the six other members of the tsar's family and four attendants was kept a secret until the early 1920s. Thus Sergei knew nothing about the demise of his first cousin, Dr Evgeny Botkin.

3. Conversation with Alexandra Demskaya in the 1970s.

4. *Docteur en histoire* at the Sorbonne, Ivan was to become one of the world's greatest specialists in Persian miniatures. After the Second World War, he became a professor of Persian history of art at the University of Beirut. But at the age of eighty-nine, a violent end befell him, just as it had Shchukin's other two sons. On 30 September 1975, he and his wife were killed when their Malev flight from Budapest was shot down as it approached Beirut airport at the beginning of the Lebanese civil war. The crash remains a mystery to this day.

5. Költzsch, *Morozov and Shchukin, the Russian collectors*, pp. 145–6. Julius Meier-Graefe (1867–1935), German critic, art historian, publisher, dealer and writer specializing in French impressionism. In 1914, at the age of forty-seven, Meier-Graefe joined up as a volunteer ambulance driver in the Red Cross on the eastern front. Captured by the Russians in 1915, he was sent to a prisoner-of-war camp in Siberia.

6. Julius Meier-Graefe, *Kunst ist nicht für Kunstgeschichte da* [*Art is Not There for the Sake of Art History*], ed. Catherine Krahmer, Wallstein Verlag, Göttingen, 2001, pp. 187–9.

7. This is an example of how relative such stories can be, especially when recalled after an interval of sixty years. The distance from Nice to Cagnes-sur-Mer is only 15 kilometres, meaning that the cost of a ticket was minimal, whatever class one travelled in. French trains supplied second- and third-class carriages until 1956. 'Second' was the bourgeois class used by the Shchukins, for it was common knowledge that 'First' was used only by *nouveaux riches* and *expensive ladies* (that is, high-class prostitutes). On the other hand, for long journeys one definitely booked sleeping cars, paying a supplement on a first-class ticket. This standard arrangement is confirmed by one of the authors of this book, Sergei Shchukin's grandson.

Chapter XXI The World's First Museum of Modern Art

1. *Sobraniye uzakoneniy i rasporyazheniy pravitelstva za 1917–1918 gg.* [*Compilation of the Legislation and Executive Orders of the Government for the Years 1917–1918*], Publishing House of the Council of People's Commissars of the USSR, Moscow, 1942, p. 1129.

2. Russian State Archives, F. 130, op. 2, inv. 758, f. 511.

3. Russian State Archives, F. 2306, op. 28, inv. 76, f. 18.
4. *Khudozhestvennaya Zhizn* [*Artistic Life*] (Moscow), 11–12 (1920), p. 45.
5. Ibid.
6. Ivan Morozov was nominated assistant curator of MNZZh2 on 11 April 1919. He did not remain long; at the beginning of May he went missing, having fled to Paris with his wife and only daughter. He died suddenly while taking the waters at Carlsbad on 22 July 1921.
7. Russian State Archives, F. 303, op. 22, inv. 429.
8. From Petrograd, the Kellers continued on to Riga, the capital of Latvia, then to Dresden, where the family was ruined by the 1923 hyperinflation in Germany. They had to head to France and seek Sergei's support. They settled down in Le Lavandou, then a poor fisherman's harbour in Provence. Ekaterina was to suffer the same fate as her father, losing two of her sons: Ilya, the son of the 'gentleman' Khristoforov, vanished in the chaos of 1940. Harold, her youngest boy, was drafted by the Germans into forced labour and died of starvation in Berlin in 1945. Ekaterina Shchukin de Keller, curator of the first Russian museum of modern art, passed away in 1977.
9. Ekaterina Keller was succeeded by the curator of MNZZh2, the sculptor and historian Boris Ternovets, who became the curator of both museums separately before they were officially merged under his directorship.
10. A very powerful body took over the palace for a while – the Institute of Marxism-Leninism, which was affected by the project to construct the Palace of the Soviets on the site of the Cathedral of Christ the Saviour, which had been dynamited in 1931. The war brought an end to these disputes: in July 1941, the impetuous civil war hero Marshal Semen Budenny mobilized the palace. It has been used by the Russian Defence Ministry ever since.
11. These were Cézanne's *Madame Cézanne dans la Serre* and Van Gogh's *Café de Nuit*, which came from Ivan Morozov's collection, plus a Renoir and a Degas which had belonged respectively to Prince Sergei Shcherbatov and Mikhail Ryabushinsky (a rich banker and the brother of Nikolai of the same name).
12. See Natalya Semyonova and Nicolas Iljine (eds), *Selling Russian Treasures: The Soviet trade in nationalized art, 1917–1938*, Abbeville Press, New York, 2014, p. 224.
13. Nina Yavorskaya, 'Rasskaz ochevidtsa o tom, kak byl zakryt Muzei novogo zapadnogo iskusstva' ['Eye-witness account of the closing of the State Museum of Modern Western Art'], *Dekorativnoe iskusstvo SSSR* [*Decorative Art of the USSR*], 7 (1988).
14. Sergei Merkurov (1881–1952), sculptor, notably, of the Dostoevsky monument in Moscow and a giant statue of Stalin. From 1944 to 1949, he occupied the post of director of the Pushkin State Museum of Fine Arts, Moscow.
15. Ilya Ehrenburg, *Lyudi, Gody, Zhizn* [*People, Years, Life*], vols 6 and 7, Tekst, Moscow, 2005, p. 173.
16. Extract from the correspondence of Alexander Morozov (1906–92) and Paola Volkova (1930–2012), Moscow, private archive.
17. The Twentieth Congress of the Communist Party of the Soviet Union made 'destalinization' official.
18. Tatyana Anchugova, 'Ot frantsuzkikh shirot: Vospominaniya studentki 1950-kh godov' ['From French latitudes: Reminiscences of a student of the 1950s'], Informprostranstvo website at: www.informprostranstvo.ru/N156_2011/okno.html

Chapter XXII Time Regained

1. 'Testament de Serge Stchoukine chez Maître Robert Revel, Notaire à Paris 28 avenue de l'Opéra', 27 February 1923, Archives La Collection Chtchoukine, Paris, and The Paris Chambre des Notaires Archive.
2. After Sergei's death in 1936, his wife had sufficient resources to maintain her style of living until she ran out of money and passed elegantly away in 1954. In 1940, the family fled to

the southern 'zone libre' and had the means to live throughout the war moving from hotel to hotel. Not without good reason: Nadezhda's youngest daughter Irina had a liaison with an officer of the Free French forces and hero of the resistance, Pierre Delocque-Fourcaud, known as *le Colonel Fourcaud*. He was arrested twice – by Vichy agents and then by the Germans – escaping both times, and he married Irina while in hiding. In 1942, they had a son, André. Nadezhda's son from her first marriage, Adrian Conus, joined the Free French forces of General Leclerc in Africa in 1940, and was parachuted as a liaison agent into the Vercors *maquis* in 1944, escaping a firing squad by the skin of his teeth by jumping into a ravine.

3. Galerie Vignon, *Collection de peinture de nos jours appartenant à Serge Lifar*, catalogue for an exhibition at the Vignon Gallery in December 1929, with prefaces by Cocteau, Waldemar George, Sergei Shchukin and B.K. (Boris Kokhno), Paris, Quatre Chemins, 1929.
4. Ibid.

Postcript

1. Within four and a half months, the exhibition had received 1.2 million visitors – the largest turnout ever for an art exhibition mounted in Paris.

SELECT BIBLIOGRAPHY

Annenkov Yury P. *Dnevnik moihk vtrech: Tzikl tragediy* [*The Diary of My Encounters: A round of tragedies*], 2 vols, Inter-Language Literary Associates, New York, 1966.

Bakhrushin, Alexei. *Kto chto sobiraet?* [*Who Collects What?*] L.E. Bucheim, Moscow, 1916.

Bely, Andrei. *Mezhdu dvukh revolyutsii* [*Between Two Revolutions*], Khudozhestvennaya literatura, Moscow, 1990.

—. *Nachalo veka* [*The Turn of the Century*], Khudozhestvennaya literatura, Moscow, 1990.

Benois, Alexandre. 'Besedi khudozhnika: Ob impressionizme' ['An Artist's Opinion: On impressionism'], *Mir Iskusstva* [*World of Art*] (St Petersburg), 6 (1899).

—. 'Khudozhestvennie pisma' ['Letters on Art'], *Rech* [*Discourse*] (St Petersburg), 4/17 February 1911.

—. 'Khudozhestvennie pisma: Novie napravleniya v zhivopisi" ['Letters on Art: New directions in painting'], *Rech* [*Discourse*] (St Petersburg), 20 December 1912/2 January 1913.

—. 'Sergei Ivanovich Shchukin: Obituary', *Poslednie Novosti* [*Latest News*] (Paris), 11 January 1936.

Berdyaev, Nikolai. 'Picasso', *Sofia*, 3 (March 1914).

Blokh, V. 'Dutch masters in Russian collections', *Chez les Collectionneurs*, 8–9 (1921).

Bondarenko, Ilya. 'Zapiski kollektzionera' ['Notes of a collector'], *Pamiatniki Otechestva* [*National Monuments Quarterly*], 29 (1993).

Brunner, Kathleen, Anne Dumas et al. *Matisse and His Textiles: The fabric of dreams*, Royal Academy of Arts, London, 2004.

Burlyuk, David et al. *Poschechina obshestvennomu vkusu* [*A Slap in the Face of Public Taste*], Moscow, 1913.

Buryshkin, Pavel. *Moskva kupecheskaya* [*The Kupets in Moscow*], Vysshaya shkola, Moscow, 1991.

Demskaya, Alexandra and Natalya Semenova. *U Shchukina, na Znamenke* [*Shchukin's House on Znamenka Street*], Bank Stolichniy, Moscow, 1993.

Ehrenburg, Ilya. *Lyudi, Gody, Zhizn* [*People, Years, Life*], vols 6 and 7, Tekst, Moscow, 2005.

Flam, Jack D. *Matisse on Art*, E.P. Dutton, New York, 1978.

Flanner, Janet. 'King of the wild beasts', in Flanner, *Men and Monuments: Profiles of Picasso, Matisse, Braque, and Malraux*, Hamish Hamilton, London, 1957.

SELECT BIBLIOGRAPHY

Galerie Vignon. *Collection de peinture de nos jours appartenant à Serge Lifar*, catalogue for an exhibition at the Galerie Vignon, with prefaces by Cocteau, Waldemar George, Sergei Shchukin and B.K. (Boris Kokhno), Quatre Chemins, Paris, 1929.

Gauguin, Paul and Daniel de Monfreid. *Lettres de Paul Gauguin à Daniel de Monfreid*, ed. Victor Ségalen, G. Crès et Cie, Paris, 1918.

Gilyarovsky, Vladimir. *Moskva i moskvichi [Moscow and the Muscovites]*, AST, Moscow, 1980.

Grabar, Igor. *Avtomonografia: Moya zhizn [Automonograph: My life]*, Respublika, Moscow, 2001.

—. 'Upadok ili vozrozhdenie? [Decadence or renaissance?]', *Niva* (St Petersburg), 2 (1897).

Grautoff, Otto. *Die Sammlung Serge Stchoukine in Moskau [The Moscow Collection of Sergei Shchukin]*, Kunst und Kunstler, Berlin, 1919.

Kamarovska, Ekaterina. *Vospominaniya [Memoirs]*, Sakharov, Moscow, 2003.

Kandinsky, Vasily. *Stupeni: Tekst khudozhnika [Steps: A text written by the artist]*, IZO, Narkompros, Moscow, 1918.

Kean, Beverly Whitney. *All the Empty Palaces: The merchant patrons of modern art in pre-revolutionary Russia*, Barrie & Jenkins, London, 1983.

Költzsch, Georg-W. (ed.). *Morozov and Shchukin, the Russian Collectors: Monet to Picasso*, Museum Folkwang, Bild-Kunst, Essen, 1993.

Kostenevich, Albert and Natalya Semenova. *Collecting Matisse*, Flammarion, Paris, 1993.

Kovalevsky, Maxim. *Moya zhizn: Vospominaniya [My Life: Memoirs]*, Rosspen, Moscow, 2005.

Kramskoi, Ivan. *Pisma, Statyi [Letters and Articles]*, Iskusstvo, Moscow, 1965.

Kustodiev, Boris. *Pisma, Statyi, Zametk, Intervyu [Letters, Articles, Remarks, Interviews]*, Khudozhnik RSFSR, Leningrad, 1967.

Makovsky, Sergei. *Stranitsi khudozhestvennoi kritiki [Notes of an Art Critic]*, St Petersburg, 1913.

Meier-Graefe, Julius. *Kunst ist nicht für Kunstgeschichte da [Art is Not There for the Sake of Art History]*, ed. Catherine Krahmer, Wallstein Verlag, Göttingen, 2001.

Merkurov, Sergei. *Vospominaniya, pisma, stati, zametki: Suzhdeniya sovremennikov [Memoirs, Letters, Essays, Notes: Comments of contemporaries]*, Kremlin Multimedia, Moscow, 2012.

Nesterov, Mikhail. *Vospominaniya [Memoirs]*, Sovetskiy Khudozhnik, Moscow, 1989.

Nordman-Severova, Natalya. *Intimnye stranitsy [Intimate Pages]*, St Petersburg, 1910.

Olivier, Fernande. *Picasso et ses amis [Picasso and His Friends]*, Librarie Stock, Paris, 1933.

Parry, Linda. *William Morris Textiles*, Weidenfeld & Nicolson, London, 1983.

Pasternak, Leonid. *Zapisi raznykh let [Notes on Various Years]*, Sovetskiy Khudozhnik, Moscow, 1975.

Perepletchikov, Vasily. *Dnevnik khudozhnika: Ocherki [Diary of the Artist: Essays]*, Gosudarstvenniy Russkiy Muzey [State Russian Museum], Moscow, 2012.

Petrov-Vodkin, K.S. *Khlynovsk, Prostranstvo Evklida, Samarkandia [Khlynovsk. Euclidean Space. Samarkandia]*, Iskusstvo, Leningrad, 1982.

Polenova, Natalya. 'Otryvki iz vospominanii' ['Extracts from memoirs'], *Panorama Iskusstv [Arts Panorama]* (Moscow), 10 (1987).

Richardson, John. *A Life of Picasso: Volume 1, 1881–1906*, Jonathan Cape, London, 1991.

—. *A Life of Picasso: Volume 2, 1907–1917*, Alfred A. Knopf, New York, 2012.

Rougeot, Magali. 'Gustave Fayet – Itinéraire d'un artiste collectionneur' ['Gustave Fayet – Itinerary of an Artist and Collector'], dissertation, Université de Paris X – Nanterre, École du Louvre, 2011.

Schneider, Pierre. *Matisse*, Flammarion, Paris, 1992.

Semyonova, Natalya and Nicolas Iljine (eds). *Selling Russian Treasures: The Soviet trade in nationalized art, 1917–1938*, Abbeville Press, New York, 2014.

Sergei Diagilev I russkoe iskusstvo [Sergei Diaghilev and Russian Art], Izobrazitelnoe Isskustvo, Moscow, 1982, 2 vols.

Serov, Valentin. *Valentin Serov v Memuarakh, Dnevnikah i perepiske sovremennikov [Memoirs, Diaries and Correspondence with Contemporaries]*, Khudozhnik RSFSR, Leningrad, 1971.

Shcherbatov, Sergei. *Khudozhnik v ushedshei Rossii* [*An Artist in the Russia of Old*], Soglasie, Moscow, 2000.

Shchukin, Ivan. *Aquarelles Parisiennes*, Paris, 1897.

Shchukin, Petr. *Vospominaniya: Iz istorii metsenatstva Rossii* [*Memoirs: From the history of art patronage in Russia*], State Historical Museum, Moscow, 1997.

Sofronova, Antonina. *Zapiski nezavisimoi: Dnevniki, pisma, vospominaniya* [*Notes of an Independent: Notebooks, letters, memoirs*], RA Publishing, Moscow, 2001.

Spurling, Hilary. *Matisse the Master: A life of Henri Matisse: Vol. II, 1909–1954*, Hamish Hamilton, London and New York, 2005.

—. *The Unknown Matisse: A life of Henri Matisse: Vol. I, 1869–1908*, Hamish Hamilton, London and New York, 1998.

Stein, Gertrude. *The Autobiography of Alice B. Toklas*, Harcourt, Brace & Co., New York, 1933.

—. *Picasso*, éditions Christian Bourgois, Paris, 2006.

Stein, Gertrude and Pablo Picasso. *Correspondance* [*Correspondence*], Gallimard, Paris, 2005.

Ternovets, Boris. *Pisma, Dnevniki, Statii* [*Letters, Journals, Articles*], Sovetskiy khudozhnik, Moscow, 1977.

Tugendhold, Jakob. 'Frantsuzskoe sobranie S.I. Shchukina [The French collection of S.I. Shchukin]', *Apollon*, 1–2 (1914).

—. *Pervy muzei novoi zapadnoi zhivopisi* [*The First Museum of Modern Western Art*], Moscow, 1923.

Vasilchikov, Illarion. *Vospominaniya* [*Memoirs*], Olma Press, Moscow, 2002.

Vinogradov, Sergei. *Prezhniaya Moskva: Vospominaniya* [*Old Moscow: Memories*], MultiCentrs, Riga, 2001.

—. 'S.I. Shchukin: Pamyati primechatelnogo moskovskogo kollektzionera' ['S.I. Shchukin: In memoriam of the notable Moscow collector'], *Segodnya* [*Today*] (Riga), 19 January 1936.

Yavorskaya, Nina. 'Rasskaz ochevidtsa o tom, kak byl zakryt Muzei novogo zapadnogo iskusstva [Eye-witness account of the closing of the State Museum of Modern Western Art]', *Dekorativnoe iskusstvo SSSR* [*Decorative Art of the USSR*], 7 (1988).

Zhilkin, Ivan. 'V Moskye' ['In Moscow'], *Russkoe Slovo* [*Russian Word*], 22 October 1911.

ACKNOWLEDGEMENTS

Natalya Semenova

I wish to thank all my colleagues and friends, who with their concern and advice have given me immeasurable help throughout these years of work on the life and work of Sergei Shchukin, especially Inna Agapeva; the art historians Vladimir Polyakov and Olga Kabanova; the historian of photography Mikhail Zolotarev, who made all his treasures available to me; and Tanya Rakhmanova in Paris, who directed the marvellous documentary *Sergueï Chtchoukine, le roman d'un collectionneur* (Arte, 2016).

I also had the good fortune to meet the late Beverly Whitney Kean, the first biographer of Sergei Shchukin, through the writer Hilary Spurling in London. The heroes of our respective biographies, Matisse and Shchukin, brought Hilary and me into close contact, and I owe much to our conversations.

I also wish to express my deepest gratitude to the staff of the scientific libraries of the Tretyakov State Gallery and the Pushkin State Museum of Fine Arts, along with the archivists of those museums and of the research and documentation department at the Musée d'Orsay in Paris.

My thanks are also due to the head of the Manuscripts Department at the Pushkin Museum, Natalya Alexandrova, who so kindly responded to

all my requests and never ceased to help me with my documentary research. In earlier years I wrestled with these archives myself, and it was at the Pushkin Museum that my mentor Alexandra Demskaya passed on her passion for Sergei Shchukin; the proof that it is still burning just as brightly forty years on, is the existence of this book.

I owe a similar debt of gratitude to my colleague at the Department of Manuscripts of the State Historical Museum, Natalya Gorbushina, who has dedicated many years of research to her own personal hero, the collector Petr Shchukin, Sergei's brother.

I also wish to thank my art historian and archivist colleagues in other cities: Irina Arskaya and Ilya Bass (St Petersburg), Irena Buzhinska (Riga), Tanya Chebotarev (New York), Flavie and Jean-Paul Durand-Ruel and Elena Lavanant (Paris). Without their careful assistance, many important documents included here would have gone undiscovered.

Above all, I could never have devoted so many years to researching the history of the collection of Sergei Shchukin had it not been for the support of my relatives and close friends.

These include my sister, Lena Sigareva, who enabled me to work under the best possible conditions, helping me tirelessly with her perfect mastery of French and her critical advice as the first of my readers; my son Mitya Raev, who because of this work probably did not receive the full attention he had a right to expect from his mother, yet has always supported me with the encouragement that only a loving son can give; and Lyuba and Richard Wallis, who have sustained me with their wonderful friendship these many years.

And finally, I would like to express my deepest gratitude to my 'sworn brother' André for his significant contribution to this book: he has illumi-nated my original fact-based biography of Sergei Shchukin with invented dialogues that his grandfather could have had with other protagonists. With deep and touching emotion, he has also recreated the dying hours of the great collector, which he did not witness himself, but could vividly imagine, having spent his childhood years in the same apartment at rue Wilhem. I hope that readers will duly appreciate my co-author's intention to make their reading experience even more fascinating.

André Delocque

Natalya Semenova, the author, paid me the inestimable compliment of entrusting me with her three books, the fruit of thirty years of work on the life of my grandfather. In her own acknowledgements, above, she has mentioned her close friends in Moscow who are now all friends of mine and deserve my equal gratitude.

As the grandson of Sergei Ivanovich Shchukin, I wish to express my gratitude to those representatives of state institutions who joined our small crew of 'Shchukinists', as we call ourselves: beginning with Mikhail Borisovich Piotrovsky, director of the Hermitage Museum, and Marina Loshak, director of the Pushkin Museum of Fine Arts. These high officials and their staffs are responsible for the welfare of the Shchukin collection on a daily basis, and it is they who bring it to life for the general public.

LVMH, the Louis Vuitton Foundation and their president Bernard Arnault became the first French Shchukinists, bringing with them their generosity and their dynamism.

I owe a debt of special gratitude to my brother-in-arms Jean-Paul Claverie, special adviser to President Bernard Arnault, who like myself was a member of Jack Lang's staff during his time as minister of culture in the government of François Mitterrand. During the artistic and political adventure we shared thirty years ago, we learned together that there is no greater happiness than to follow our dreams to heaven and make them come true on earth. Together we did it again, with Sergei Shchukin.

From 1993 to 2017, Bernard Jouanneau was the Shchukins' family lawyer. He passed away in June after serving for fifty years as attorney at law in Paris. His skill, dedication and advice proved invaluable in restoring Sergei Shchukin's memory without ever yielding over any principal matter.

Finally, I wish to include in these expressions of gratitude the other living descendants of Sergei Shchukin: Arielle Badiou and Harold Brody, the granddaughter and grandson of Countess Catherine Shchukin de Keller, the daughter of Sergei Shchukin and the world's first curator of a museum of modern art. In addition, I am confident that my daughter Aliénor Delocque-Fourcaud and my grandsons Jolan, Colin and Paul-Arlet, will continue this work of memorial; indeed, so present and alive is

the Shchukin collection among us today that I believe the work will never be ended.

Countess Irène Shchukin de Keller, my mother, who died in 1994, was the first of our family to resurrect in Russia the memory of her father, when – on 1 December 1993 – she formally wrote to President Boris Yeltsin. My mother personified the elegance and allure of the women who knew and loved Sergei Shchukin, and her example remains infinitely precious to me.

The work of my wife Christine lies at the very heart of this book, not only because she is responsible for all the photographs and illustrations, but also because of her leading role in getting it into print. It would take me many pages to document her vast contribution – over a period of twenty-five years – to the rediscovery of Sergei Shchukin and his collection. Natalya Semenova has especially asked to join me in paying homage to Christine, and in thanking her for everything she has done for us.

INDEX